FRENCH ART

THE RENAISSANCE

1430–1620

This work is dedicated to the thousands of artisans and artists who have built and loved this country.
And to the hundreds of scholars who have saved them from being forgotten.

A.C.

ANDRÉ CHASTEL

FRENCH ART

THE RENAISSANCE
1430–1620

Translated from the French by Deke Dusinberre

Flammarion
Paris - New York

PUBLISHER'S FOREWORD

André Chastel's study of the history of French art, like his book on the history of Italian art, was initially conceived as a single volume. However, it quickly assumed an exceptional importance within his life's work as a historian. Chastel's interest in the undertaking grew as the complexity of the task increased. Only illness prevented him from completing this ambitious project whose very magnitude spurred his enthusiasm.

The resulting thousand or so pages of manuscript engendered several volumes, the second of which is now appearing in English under the subtitle, *The Renaissance, 1430–1620.* The work was to have been preceded by a long introduction that Chastel left uncompleted at his death; its various sections, organized according to the precise plan he set out, have been published separately in France in a paperback edition. The publishers, nevertheless, decided that it would be useful to append relevant fragments from this unfinished introduction to each of the volumes of *French Art.*

Following Chastel's death, the editing of the text and the production of this volume would have been impossible without the generous collaboration of Madame André Chastel and of all those from whom the author himself sought advice, assistance, or criticism, notably Jean-Pierre Babelon, Michel Laclotte, Marie-Geneviève de La Coste-Messelière, and Anne-Marie Lecoq, as well as Sylvie Béguin, Jean Guillaume, and Nicole Reynaud. They all deserve our grateful acknowledgment.

Page 6: Detail from the tomb of Henri II and Catherine de' Medici, 1561–1573. Abbey Church of Saint-Denis.

The French text was edited by Marie-Geneviève de La Coste-Messelière, who also established the bibliography.
The English edition was edited by Christine Schultz-Touge with Camille Cloutier.
The captions and bibliography were adapted and translated by Sophy Thompson.

DESIGNED BY Martine Mène
PICTURE RESEARCH BY Béatrice Petit
TYPESET BY Octavo Editions, Paris
ORIGINATION BY Pack Edit, Paris
PRINTED BY Clerc S.A., Saint-Amand-Montrond
BOUND BY Brun, Malesherbes

Flammarion
26, rue Racine
75006 Paris

ISBN: 2-08013-583-X
N° d'édition: 1008
Dépôt Légal: September 1995

Printed in France

CONTENTS

THE RENAISSANCE: 1430–1620

THE RENAISSANCE

THE LATE MIDDLE AGES AND THE RENAISSANCE

PRE-RENAISSANCE: 1420–1500
EARLY RENAISSANCE: 1490–1540
HIGH RENAISSANCE: 1540–1570
A TIME OF CRISIS

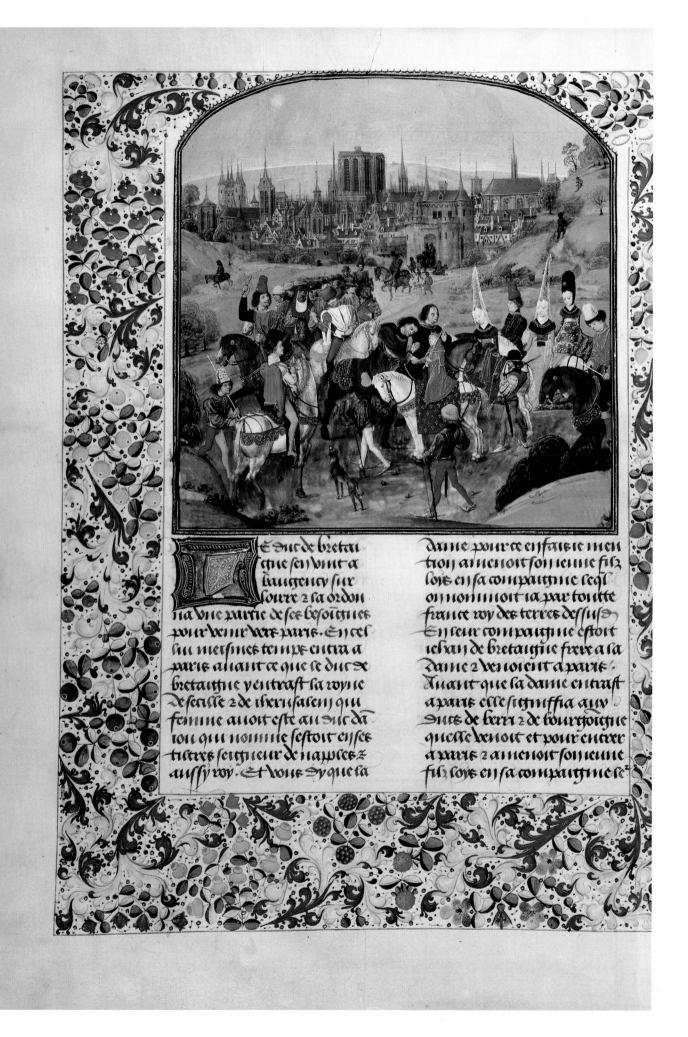

E duc de bretai
gne sen vint a
laugency sur
loere ⁊ sa ordon
na vne partie de ses besoignes
pour venir vers paris. En cel
luy mesmes temps entra a
paris auant ce que se duc de
bretaigne y entrast sa royne
de secille ⁊ de iherusalem qui
femme auoit este au duc dā
iou qui nomme sestoit en ses
tiltres seigneur de nauples ⁊
aussy roy. Et voue sy que sa

dame pour ce enfaibte men
tion amenoit son ieune filz
loys en sa compaignie legl
on nommoit la par toutte
france roy des terres dessus
En leur compaignie estoit
iehan de bretaigne frere a la
dame ⁊ venoient a paris.
Auant que sa dame entrast
a paris elle sifiniffia aux
ducs de berri ⁊ de bourgoigne
quelle venoit et pour entrer
a paris ⁊ amenoit son ieune
filz loys en sa compaignie se

Louanges de la France: Charles VIII
and the royal crown (detail). c. 1497. Bibliothèque Nationale,
Paris (Ms. Fr. 228, fol. 1).

Left: *Froissart's Chronicles:*
the arrival of young Louis II of Anjou, king of Naples,
in Paris. c. 1470. Bibliothèque Nationale,
Paris (Ms. Fr. 2645, fol. 321v).

THE LATE MIDDLE AGES AND THE RENAISSANCE

In a briefly famous article published a century ago, Louis Courajod asked what part France played in the Renaissance—was its role active or passive?[1] That, however, is not really the best way to address the issue. The original contribution of French art during the fifteenth and sixteenth centuries is not easy to grasp, for it evolved between two unquestionably solid poles—Flanders to the north and Italy to the south. From Flanders and Hainaut, a regular stream of painters and sculptors flowed into Burgundy, the Rhône region, and Provence. Meanwhile, contact had never been completely broken with Italy, notably via Naples in the fourteenth century, and via Lombardy and Naples again in the fifteenth. There was therefore no sudden discovery of the south at the time of Charles VIII's invasion in 1494, nor a sudden adoption of new styles, but rather a steady relationship that manifested itself through princely marriages, financial accords, missions to Rome, and, in the artistic sphere, periodic borrowing of motifs likely to enrich the local repertoire. A clear intensification of Italian influence did nevertheless occur around the year 1500, reaching something of a high point around 1540. And France's subsequent defensive reactions did not preclude ongoing exchange, as symbolized by two queens drawn from the

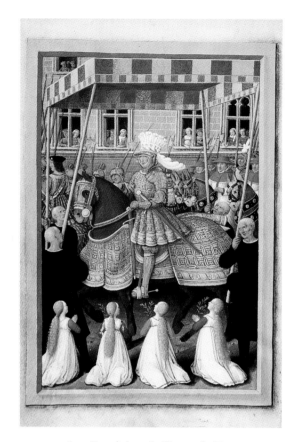

Jean Bourdichon, *Le Voyage de Gênes*
by Jean Marot: Louis XII's triumphal
entry into Genoa. c. 1508. Bibliothèque Nationale,
Paris (Ms. Fr. 5091, fol. 22v).

Medici family, both of whom, as fate would have it, were destined to govern France—Catherine de' Medici becoming regent upon the death of Henri II in 1559, while her distant cousin Marie assumed the regency after the assassination of Henri IV in 1610.

Therefore, although French circles were aware of the considerable accomplishments of northern workshops, the hypothesis that France was merely an auxiliary engine of a "Northern Renaissance" is as misguided as the theory, generally accepted since Michelet in the nineteenth century, of a sudden "Italianization" of French attitudes around 1500. The phenomenon of the French Renaissance is richer in nuances and complex developments than is generally acknowledged by the conventional—and naïve—view held of the period as a "march toward classicism" based on a sudden discovery of the southern world.

This erroneous view can be explained by a lack of awareness of the intense vitality of the French kingdom in the mid-fifteenth century (too often perceived as being merely an extension of the Gothic period). Even more serious is the mistaken assumption that the French nobles who followed Charles VIII and Louis XII across the Alps had attitudes similar to distinguished nineteenth-century travelers, when in fact those vigorous knights were driven by the usual thirst for conquest and were far more attracted by *la dolce vita* than by culture. All contemporary texts

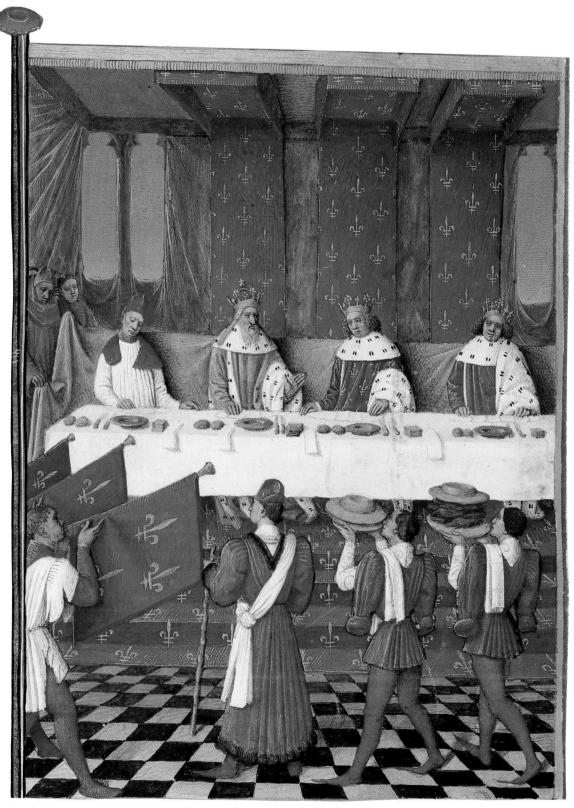

Jean Fouquet, *Les Grandes Chroniques de France:* banquet given by Charles V of France in honor of the emperor Charles IV. c. 1460. Bibliothèque Nationale, Paris (Ms. Fr. 6465, fol. 444v).

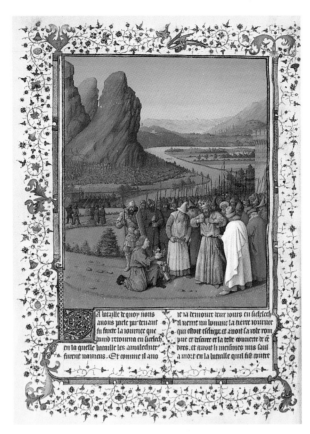

Jean Fouquet, *Les Antiquités judaïques* and *La Guerre des Juifs*
by Flavius Josephus: David learns of the death of Saul. c. 1465.
Bibliothèque Nationale, Paris (Ms. Fr. 247, fol. 135v).

present another perspective, one that requires a preliminary appreciation of cultural attitudes within French society. The major feature of the fifteenth century was quite simply the steady emergence of a "national" consciousness. Once peace and prosperity returned, this consciousness manifested itself as a diffuse—and therefore difficult-to-channel—quest for power. The absolute monarchy only emerged after a series of challenges arising from ducal ambitions—all of them important for art—ranging from the duchy of Burgundy (until 1477) to the duchy of Bourbon (a well-behaved province under the Beaujeu family, but which the swashbuckling Charles III of Bourbon nearly withdrew from the royal domain when he switched allegiance to the Holy Roman Emperor in 1523), not forgetting the duchy of Lorraine under the sway of the Guise family. French behavior can be broadly characterized by the fealty of the masses, the overweening pride of the nobility, and a tendency toward civil strife.

Whatever the case, the period was extraordinarily dynamic. There reigned a drive for expansion and an appetite for novelty poorly conveyed by the dull and indistinct term "Late Middle Ages." Of course, everything still functioned, by definition, according to the forms, practices, and context inherited from the Gothic world. But on taking a closer look, it quickly becomes apparent that the tone adopted by a painter like Jean Fouquet or a poet like François Villon no longer belonged to the Middle Ages, any more than did the even-tempered style of miniaturist Jean Bourdichon or playwright Pierre Gringore, official poet to Louis XII and Francis I.

Chronique abrégée des Rois de France by Guillaume de Nangis,
frontispiece miniature by the Master of Michault Le Peley:
eight kings in a walled garden surrounding the tabernacle
of the Lily. Bourges or Paris, c. 1470–1480.
The Walters Art Gallery, Baltimore (Ms. W 306, fol. 11).

BIRTH OF TWO CULTURES

All historians recognize the years 1430–1440 as representing something of a historical watershed. Once the Lancasters failed to revive the Plantagenets' "double kingdom" (which in 1415 had still seemed feasible), the moving saga and tragic end of Joan of Arc (1431) marked a turning point—a transformed Charles VII, began a reconquest of France on an unexpected wave of popular support. The long period of Anglo-French wars essentially ended when the English bastion of Bordeaux fell in 1453. The outcome for both France and England was a major transformation: each began an existence as a specific "nation," and new relationships were forged within society.[2] As has been rightly pointed out, this represented a shift from an era of "vassals" to one of "subjects."[3] In France, identification with the king assured him a legitimacy without which it would be difficult to understand the development over the following two hundred years of what would be called absolutism. The title of *Rex Christianissimus* endowed French kings with an almost imperial status and made them the effective head of the Gallican church.[4] Everything had changed in the vast and henceforth confident nation—not yet a state—that apparently boasted a population of more than fifteen million inhabitants in 1500.

The legend of France's "Trojan" roots (traced back to mythological figures Priam and his son Francio) was revived in chronicles and imagery with increased ardor, thereby asserting the historical prestige of a land that

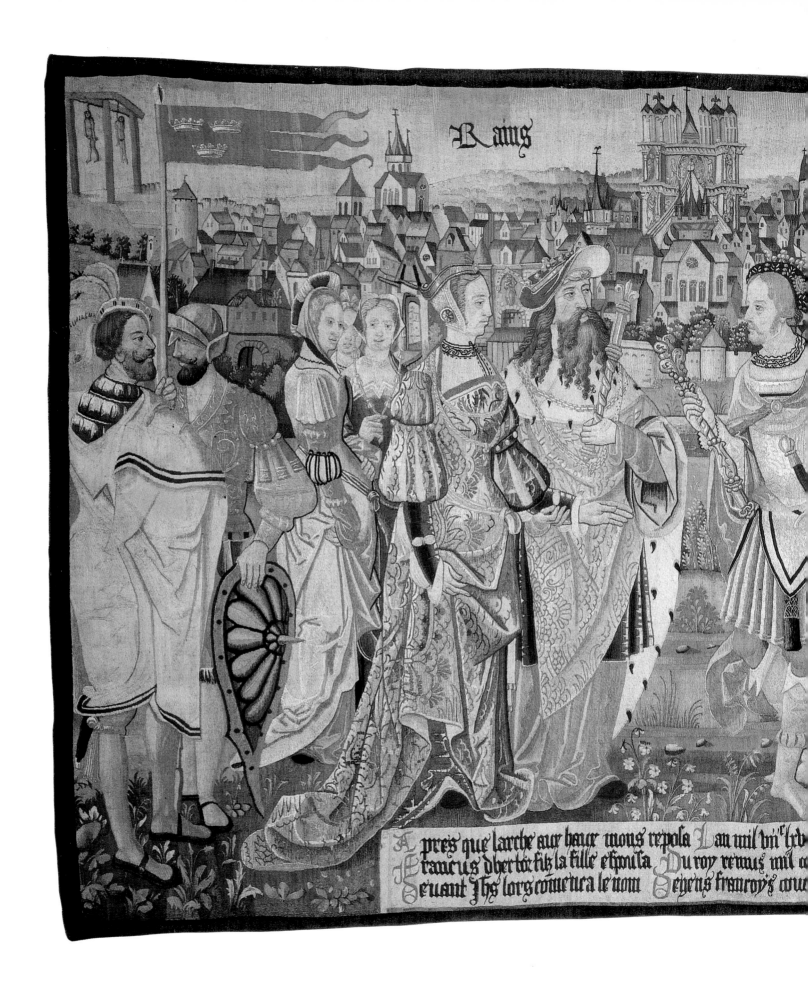

Raius

Apres que larche sur hault mons repola Lan mil vii lib[...]
Francus dhertor fitz la fille espousa Du roy remus mil a[...]
deuant Jhs lors come[n]tra le nom de pe[n]s fra[n]croy's cone[...]

L'Histoire fabuleuse des Gaules.
Remus gives his daughter in marriage
to Francus. Tapestry. Flanders, c. 1530.
211 x 358 cm. Musée départemental
de l'Oise, Beauvais.

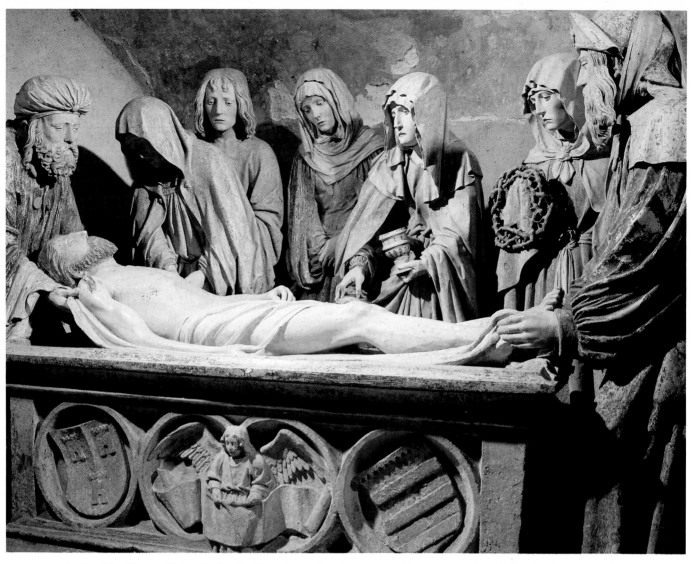

Studio of the Master of Saint Martha, *The Entombment.* Polychrome stone. Troyes, c. 1515. Parish church, Chaource (Aube).

owed nothing to any other. There could no longer be any doubt about divine election, or natural preeminence. All these flattering ideas converged in a new image when "the Garden of France," a literary theme from as early as 1300, began "appearing in the mid-fifteenth century both in tapestry and manuscript illumination."⁵ The delightfully visual concept of another "Eden" became durably, perhaps indelibly, etched in the national consciousness in the form of a *hortus conclusus.* This "enclosed garden" was usually polygonal in form (and sometimes even hexagonal, the geographic shape of France), and featured kings seated around the fleur-de-lys throne, as seen in a circa 1475 illustration of Guillaume de Nangis's royal chronicles (p. 13).

Once underway, the momentum toward unification progressed from reign to reign in complementary fits and starts. The Atlantic facade was consolidated quickly, and the large provinces to the south and east fell to the Crown: Aquitaine in 1453, Burgundy in 1477, Anjou in 1480, Provence in 1484, Brittany in 1510, Bourbon in 1523, Dauphiné in 1560. The danger of breakup nevertheless subsisted for a long time—Henry VIII of England conducted several campaigns in France and even threatened Paris in 1523, while the 1526 Treaty of Madrid obliged Francis I to promise to return Burgundy to the Holy Roman Emperor Charles V. Henceforth, however, serious threats of disruption arose only from internal conflicts. The fusion of north and south in fact occurred gently, since thriving local traditions did

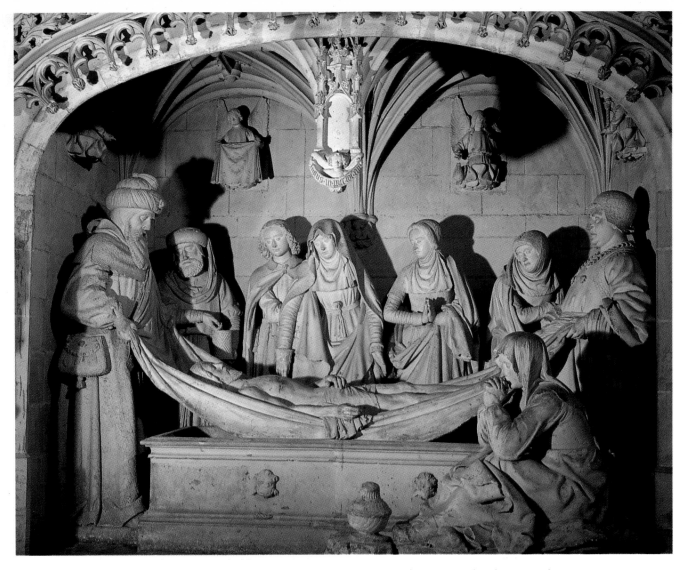

The Entombment. Stone. Central France, 1496. Abbey church of Saint-Pierre de Solesmes (Sarthe).

not preclude a new circulation of art forms. One of the most surprising features of the new, evolving situation was the analogous development of high-quality sculpture in Champagne, in the Loire region, and in the south. Monumental *Entombments* of Christ in all three areas attest to a quiet, solid art around 1500 that emerged in a symmetrical fashion strangely recalling the twelfth century (when a new approach emerged simultaneously in Vézelay to the north and Moissac to the south). Almost all these sculpted groups were executed by artists who remain anonymous. Something was occurring that cannot be explained by the artistic preferences of noble patrons alone—it is impossible to ignore the existence of a "French taste" or "French manner."

The aristocracy, meanwhile, was devising and extolling its own originality. There was enthusiasm for accounts of heroic adventures, amply illustrated in manuscripts, as well as for works in a new tone, such as Antoine de La Salle's *Petit Jehan de Saintré* (1456), a sentimental romance that recounted the difficult love between a valiant captain and a princess at the court of Charles VI. Chivalry was redefined as the grandiose and fleeting ideal of a society that expressed itself through ubiquitous recourse to emblems and games. The Burgundian model, based on pomp and court festivities, was adopted by the entire nobility and spurred the emergence of "modern" painting and sculpture. Although it suddenly disappeared with the death of Charles the Bold in 1477, the Burgundian

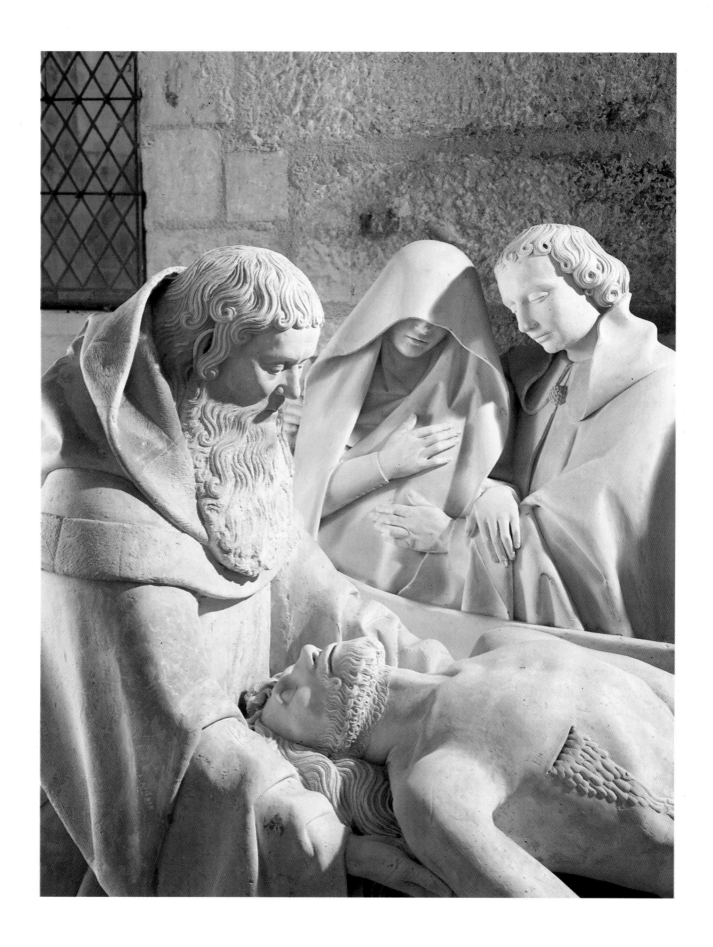

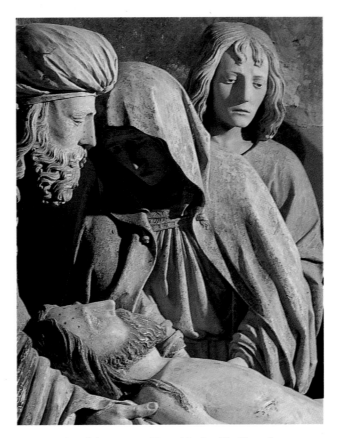

Studio of the Master of Saint Martha, *The Entombment*
(detail). Polychrome stone. Troyes, c. 1515. Parish church,
Chaource (Aube).

Left: Burgundian workshop, *The Entombment* (detail). Fifteenth
century. Stone. Chapel of the Ancien Hôpital, Tonnerre (Yonne).

example left a long and nostalgic imprint on aristocratic memories. The eccentricities of the period have been noted. "Right in the mid-fifteenth century, when artillery was triumphing over armor and crenellated walls, when printing was about to spread bourgeois culture, when church institutions overflowed with wealth and an entire class greedy for profit struggled to establish its future greatness on money, contemporaries felt that the only source of political power was still and forevermore a nobleman's bravura and chivalric virtue."[6]

But perhaps less disdain should be used when discussing these "carryovers" from the past, which, in fact, endured to become lasting traits found at various levels of French life. There was a romance-inspired attitude that the nobility never completely cast off—nor, for that matter, did commoners. The real-life bravery and spotless character of Pierre Terrail, lord of Bayard (who fought his way across Italy alongside Gaston de Foix, and later Francis I) enthralled all of France. Just as castles were losing their purely military aspect and adopting more ornamental features, courtly romances and books of peerage became increasingly popular. More than ever, the French mentality was impregnated with this "romantic" dimension. But, thanks to a concentration of political power and the establishment of what might be called the "administrative monarchy," another form of culture and a new "class" were emerging. From the late fifteenth century onward, two distinct registers of cultural interest

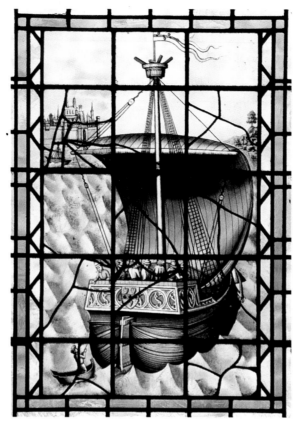

Hôtel Jacques-Cœur, Bourges.
Stained-glass window: Ship. c. 1440–1450.

and comprehension coexisted within French society. Historian Lucien Febvre has aptly pointed out on several occasions that most of the military and cultural initiatives reflecting the ambitions of the ruling classes are incomprehensible unless seen through the filter of these "anachronistic chimera." The French Renaissance, then, simultaneously sketched the broad outlines of the absolute monarchy alongside something that resembles the humanist, secular aspirations of the Enlightenment. These two potential visions of the future were mutually inclusive; action and ideas both functioned as touchstones during that highly extroverted period.

The royal court, still peripatetic, was the site of scheming and, under Louis XI, of bold policy, with or without the collaboration of powerful lords inevitably motivated by their taste for grandeur. Such lords sought adventure in Italy alongside Charles VIII. Paris, although neglected, was far from empty. The nobles sitting in the city's *parlement* and the court of exchequer became, in a way, the representatives of the body politic—their solidarity led to the constitution of veritable political institutions.[7] The corps of "notaries and secretaries to the king," previously powerful under Philip the Fair (reigned 1285–1314), was revived in 1440 and became permanently established by a major decree in 1482; it grew steadily in importance and became responsible for expediting royal acts. The corps ultimately became linked to the financial milieu, whose impact and efficiency were already considerable, as witnessed by the influence and prestige enjoyed by a mere commoner like financier Jacques Cœur (circa 1395–1456) at the court of Charles VII. The nobility had to mount a highly visible trial for extortion in

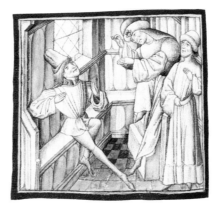

Left and center: Master of the Champion des Dames,
Le Champion des Dames by Martin Le Franc. c. 1460.
Bibliothèque Municipale, Grenoble (Ms. 875, fol. 413 and 122v).

Right: Master of Philippe de Gueldre,
Traité sur le défaut du Garillant by Jean d'Auton: the treasurers. c. 1505.
Bibliothèque Nationale, Paris (Ms. Fr. 5087, fol. 5v).

order to rid itself of Cœur in 1451, and his audacious maneuvering throughout the Mediterranean world illustrates the new spirit of international relations. "Monsignor Treasurer," as the Florentines nicknamed Cœur, was a bona fide member of the "silk trade," lured Milanese armorers to France, and was known throughout Italy.[8] The point worth retaining is the emergence of an extremely wealthy group of people, halfway between bourgeoisie and nobility, which, in many instances, replaced the latter class. Key "early Renaissance" figures such as Bohier and Robertet belonged to this milieu.[9] Family networks began seizing the reins of finance, municipal offices, and the Church, thereby dominating the scene. In fact, the revival of architecture depended on dynasties of such "officers," as well as recently ennobled families like the Chaumont d'Amboise clan.

France's aristocratic framework thus became more flexible, politically speaking. The nobility still controlled its vast holdings, but it no longer displayed the same authority. Historians draw attention to the rising social category of gray-and-black-gowned state officers, which formed a literate, cultivated group inspired by Italian models that it often managed to impose on the nobility. In both arts and letters, the taste of the upper bourgeoisie differed from that of the aristocracy. Heroic imagery was replaced by moral discourse, both of them being subject to the fashion for allegory and emblems. On one hand, there were knightly romances, such as *Amadis de Gaula*, and on the other hand, humanist translations by Jean Martin and Jacques Amyot, complete with fine illustrations (the effects of this double culture persisted into the days of Louis XIV). The people who then began

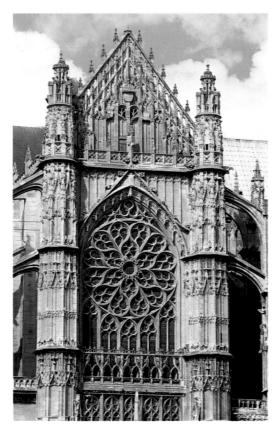

Beauvais Cathedral (Saint-Pierre).
Facade of the south transept.
First half of the sixteenth century.

Right: Church of Saint-Maclou, Rouen.
Lantern tower. 1436–1521.

to climb to power were, in a way, the distant forebears of those who were applauded in May 1789 when they marched through the streets of Paris as representatives of the Third Estate.

The term Renaissance, therefore, is used here to cover a period of two centuries during which France's intellectual and aesthetic heritage was enriched enormously. A revealing comment can be found in a highly appreciated contemporary text, *The Book of the Courtier* by Baldassare Castiglione, dedicated to Francis I. Castiglione had one of his characters assert that the French aristocracy made the grave mistake of showing no interest in "letters" (which meant culture in the broadest sense). The book expressed the hope that Francis of Angoulême (the king) would redress the situation. Numerous texts shared this assessment—a 1510 commentator regretted that the French nobility was interested only in war and hunting (the likes of Gaston Phébus, count of Foix, come to mind), at the expense of literature and architecture. What needed changing, then, was the attitude toward books and toward buildings, for architecture would become—following the spectacular example set by the king—the prime art of the epoch.

Much exploration remains to be done in this sphere, for too little is known about the wealth and diversity of French activity. It traces a striking curve in which the provinces provided an almost simultaneous counterpoint to artistic initiatives taken in and around Paris. These initiatives were rapid and brilliant up to 1560, slumped during the subsequent political and religious crises, and rose again in the days of Henri IV.

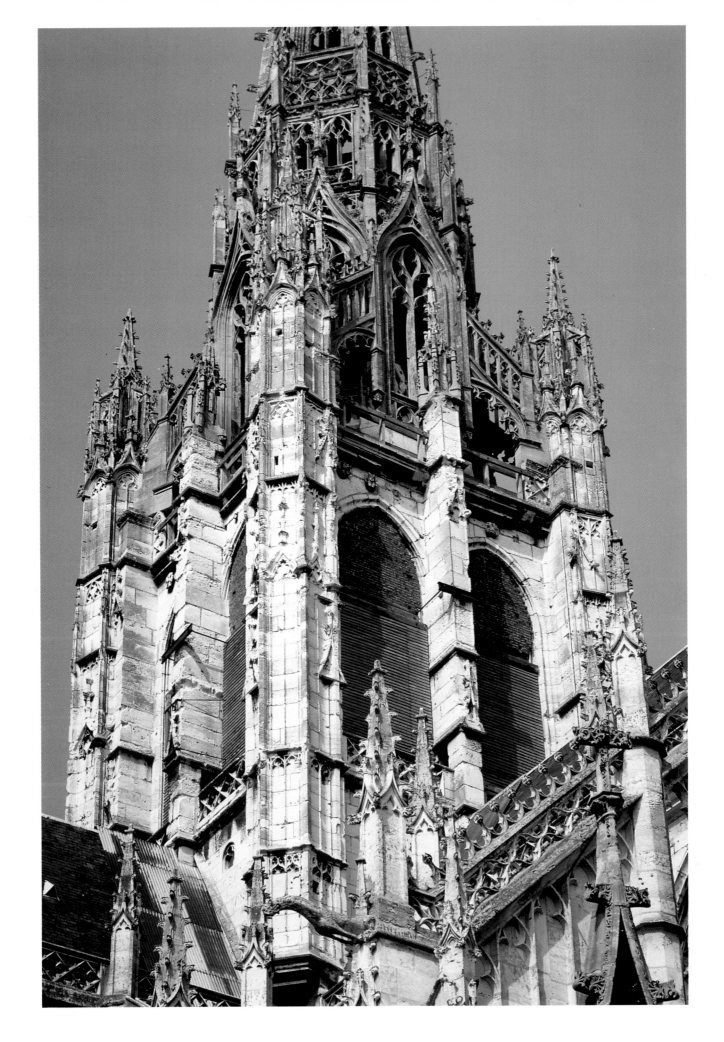

Left: Albi Cathedral (Sainte-Cécile).
Outer choir screen: Judith. Painted wood.
Late fifteenth century.

Right: *The Lady and the Unicorn:*
Taste (detail). Tapestry. c. 1495–1500.
Musée national du Moyen Âge, Paris.

VISUAL PROFUSION AND SPECTACLE

The remarkable longevity of a Gothic approach to architecture and decoration would seem to preclude perceiving any break in French art until the mid-sixteenth century, that is to say the moment when all across the land there appeared buildings (especially châteaux) in a new style accompanied by a new, classically-inspired decorative repertoire. At first sight, Gothic persistence appears evident in terms of ecclesiastical architecture, for people were primarily concerned with completing the countless unfinished churches dotting the country, as clearly demonstrated by Beauvais Cathedral, where work on the transept and two facades continued throughout the century. The same thing occurred in Troyes, for example, and in Rouen, where magnificent towers that might be called "Hyper Gothic" were added to Saint-Maclou and to the cathedral even as the local cardinal, Georges d'Amboise (died 1510), was endowing his château at Gaillon with a new look. That was because Gothic was, and would remain for two centuries, France's "national" style of religious architecture. The Gothic style continued to have its supporters even after a different way of conceiving sacred architecture became dominant.

It is nevertheless worth noting that bishops and canons increasingly ignored architectural logic and, more generally, the Gothic system. Interest had shifted. Architecture, in the sense of structure, no longer dictated the rules—primacy passed to stained-glass windows, tapestries, polychrome sculpture, furnishings, wall niches, and credences, all the more or less spectacular elements that enlivened the interior of a building. The shift occurred

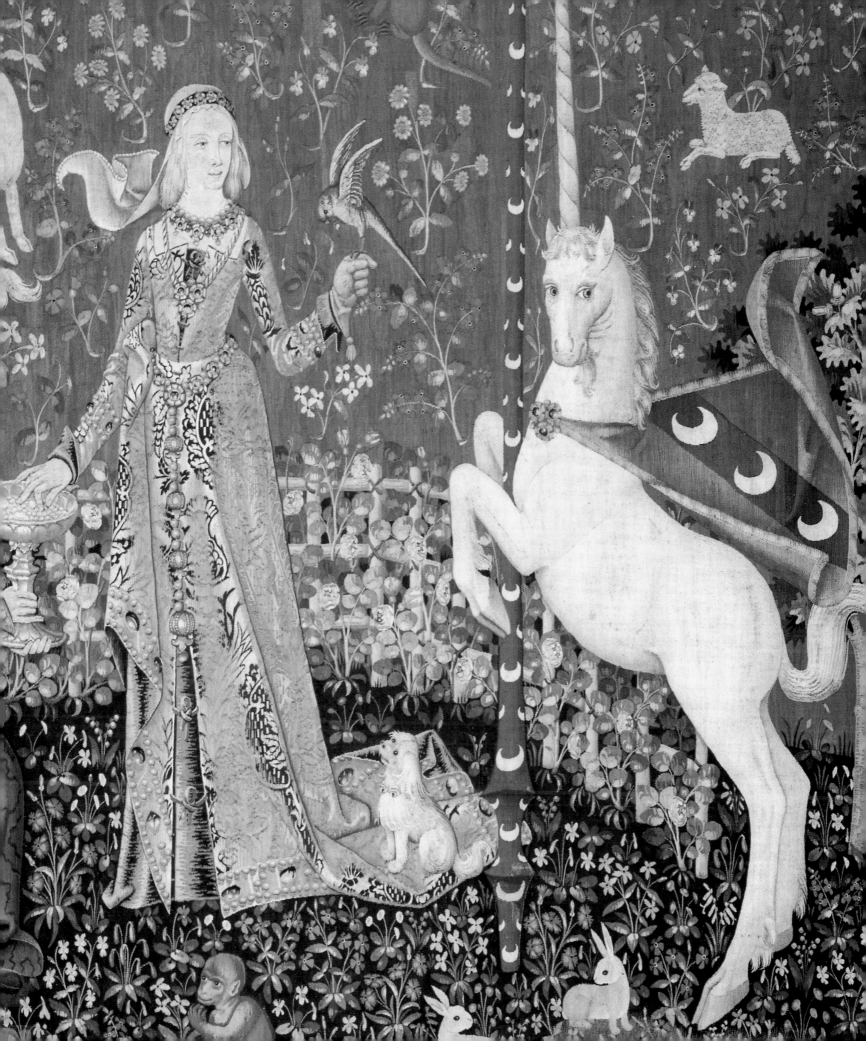

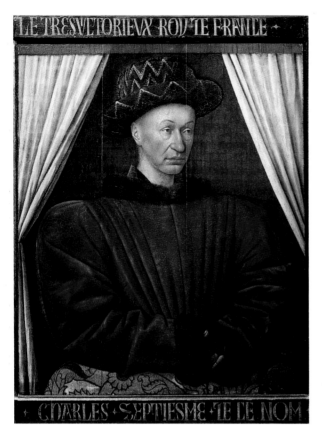

Jean Fouquet, *Portrait of Charles VII*. c. 1450 (?).
Oil on panel, 86 × 71 cm. Musée du Louvre, Paris.

Jean Fouquet, *Melun Diptych* (left-hand panel):
Étienne Chevalier with Saint Stephen. c. 1450–1460. Oil on panel.
96 × 88 cm. Gemäldegalerie, Staatliche Museen, Berlin.

first in châteaux with chimneys, architraves, and stairways. Picturesque forms borrowed from Lombard art (such as the Carthusian monastery in Pavia and the Colleoni Chapel in Bergamo) were wedded to Gothic features undergoing decorative fragmentation. French stone carvers unhesitatingly combined all these elements, resulting in a new artistic repertoire that was pleasant, capricious, and often absolutely delightful.

Even when antique models were assimilated more earnestly, the classical orders becoming more than a mere ornamental motif, French builders clung to their traditional floor plans. Italian architect Sebastiano Serlio, who arrived in France in 1540, was not long in distinguishing *la maniera francese*, which had its own legitimacy, from the *maniera italiana* or *antica*. Indeed, the crux of the French Renaissance is to be found in this distinction.

Painters and sculptors, meanwhile, still followed specific genres, in response to precise commissions. As in Flanders and Italy, portraiture assumed new importance, notably with Jean Fouquet—his portraits of Charles VII and Étienne Chevalier display a surprising accuracy that, in fact, would be rarely equaled in subsequent years, when greater stress was placed on producing "state portraits." Miniatures—that is to say, paintings in books—remained a medium of experimentation and discovery in at least three regions (the Loire, Burgundy, and Provence), although such innovation has been ignored by art history until quite recently. It is somewhat foolish to consider miniatures from the standpoint of easel painting, which blossomed so slowly in France; the marvelous thing about miniatures was the way they condensed all the impressive features of image-making into a reduced, sometimes miniscule, form. Once landscape was included, the entire physical universe seemed wonderfully concentrated: the world's diversity

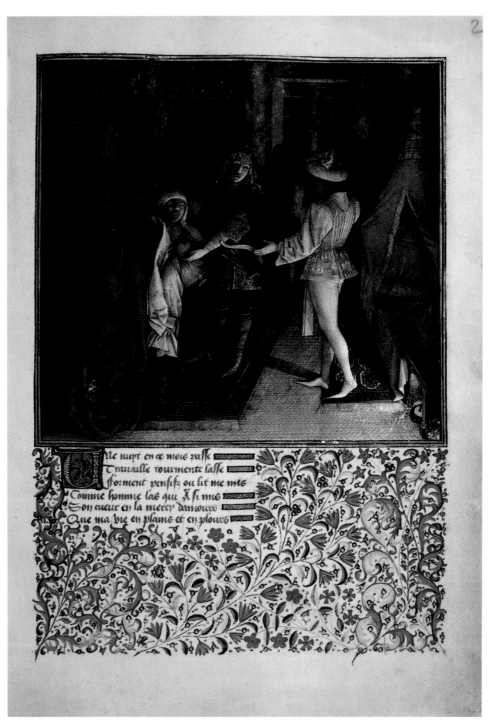

Barthélemy d'Eyck, *Le Cuer d'amour espris* by René of Anjou:
King René in bed and the allegory of the heart. c. 1460. Österreichische Nationalbibliothek,
Vienna (Cod. 2597, fol. 2).

Jean Goujon (?), interior panel from the "Fonts" door (detail).
Church of Saint-Maclou, Rouen.

Right: Engrand Le Prince, The Last Judgment. Stained-glass window (detail).
c. 1522–1525. Church of Saint-Étienne, Beauvais.

was played out in scenes whose golds and blues would be less dazzling and moving if they were enlarged. This is as true of the work of Jean Fouquet as it is of that of the illustrator of *Le Cuer d'amour espris* (The Heart Smitten by Love), and even of the work of Jean Bourdichon. In France, miniatures and stained glass outstripped other forms of painting during most of the period in question.

Exchange with Flemish regions to the north, though less common than in 1400, never ceased. Toward the south, contact with Italy was regular between the time of Fouquet's trip to Rome (circa 1447) and Simon Vouet's return to Paris (1627); although somewhat episodic at first, depending on the affinities of French miniaturists and painters of retables with their colleagues in Savoy and Lombardy, these exchanges became more marked and unmistakable—indeed wonderful—with the arrival of Rosso and Primaticcio at Fontainebleau and their surprising impact on the future of French art. Meanwhile, major and minor crafts such as engraving and medal casting were often closely tied to their Italian counterparts. That said, the arts closest to French hearts—stained glass and sculpture—underwent remarkable local development in the fifteenth century and throughout the sixteenth century, at least until the disruption caused by decades of civil war that pitted Protestants against Catholics. Contrary to what is often asserted, the use of engraved models (especially German) for stained glass and the assimilation of antique forms for sculpture reflected not decadence but rejuvenation via new stimuli. The genius of Engrand Le Prince and Jean Goujon can be appreciated only from that standpoint.

Geoffroy Tory, *Champfleury,* Paris, 1529. Bibliothèque Nationale, Paris (Rés. V 516, fol. 77v–78).

Everywhere there was a tendency to enrich images with emblems and symbols. This legacy of the courtly art of Anjou and Burgundy, of King René and Philip the Good, was reinforced by scholarship until all books, chapels, carvings, and residences abounded in learned symbolic signs. A book like Geoffroy Tory's *Champfleury* (1529), intended for artists and printers, is typical in this respect—a letter was perceived to be a sign with philosophical import, the human body became a repertoire of correspondences. What had merely been intimated in a previous era became full-blown theory, the upshot of which was visible in the increasingly elaborate staging of royal ceremonial entries into a city.

It was a time when a princess in mourning adopted the punning motto *fortune infortune fort une* (literally, "one is much mistreated by fate"). The phrase, like the setting, is studied, ambiguous, and ultimately cryptic. Coats of arms had already become extraordinarily complicated, as those of King René demonstrate; but even such blazons no longer sufficed, for they henceforth required the addition of a *device,* a symbol that was personal rather than familial. This produced a "discourse shaped by enigmas," in which verbal and visual elements were united in compositions of disconcerting beauty. Far from disappearing with the new age, this practice grew. The Italian adventures of Charles VIII, Louis XII, and especially Francis I after the battle of Marignano (1515) spurred celebration via symbols on a major scale. Such symbols—that is to say, images—ultimately found their way into paintings or onto walls and objects. Artists, as "devisers," outdid themselves in displaying ingenuity,

Hôtel Lallemand, Bourges. Chapel:
credence with initials RER.
Early sixteenth century.

culminating in the astonishing series of rebuses in the gallery at Fontainebleau, which created an obscure, pow-erfully original yet charming setting. Similarly, the wonderful tapestry, *The Lady and the Unicorn*, had already displayed, back in the fifteenth century, that element of hermetism appropriate to monarchic art and to the Renaissance.

This garrulous vitality also transformed noble residences. Quatrefoils, small niches, and canopies provided multiple opportunities for fanciful decoration and representation. Then there were high friezes, compartmental-ized ceilings decorated with paintings, and—accompanying the vogue for straight staircases and long galleries—coffered ceilings with carved motifs. A profusion of emblems, mystical inscriptions, and forms both unusual (labyrinths, pyramids) and mythical ("wild men") sprang up everywhere. The Lallemand residence in Bourges and the ceilings of the galleries in Dampierre-sur-Boutonne are just two of countless examples. These freely employed decorative devices were deliberately hermetic, and in time came to be interpreted as esoteric, inspir-ing many legends about alchemical motifs (to the delight of the Romantics and some modern admirers).[10]

Art historian Emile Mâle was certainly correct to establish a link between the theater and painted or sculpted forms during the period he called "the Late Middle Ages"—labeled "pre-Renaissance" here—when he noted that the fifteenth century was the great century of mystery plays. It might be more accurate, however, to focus on the second half of the fifteenth century and a good part of the sixteenth. Arnoul Gréban's *Mystère de la*

Hôtel Lallemand, Bourges. Details of sculpted caissons on the chapel ceiling. Early sixteenth century.

Above and right: Château de Dampierre-sur-Boutonne (Charente-Maritime).
Upper gallery on the facade: detail of sculpted caissons in the ceiling
and general view. c. 1547.

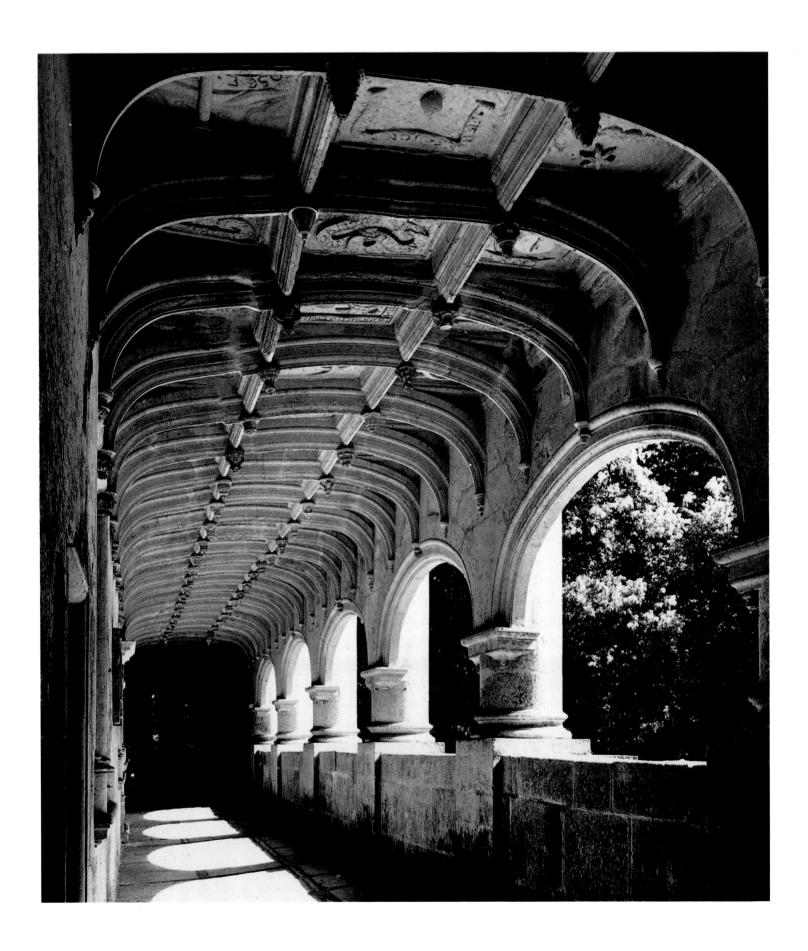

Former Cathedral of Notre-Dame, Saint-Bertrand-de-Comminges.
Detail from a choir stall. Early sixteenth century.

Passion, a somewhat cumbersome masterpiece more than thirty thousand lines long, was performed in Paris in about 1450, while a version by Jean Michel, somewhat less wordy, was presented in Angers in 1486. A whole host of performances then followed in northern cities like Amiens, Douai, and Valenciennes (where, in 1547, two illuminated manuscripts recorded in detail the staging of a grand spectacle that lasted twenty-five days). In short, the entire period was full of these interminable yet extremely popular spectacles, to the extent that the authorities criticized the disorder created by the colossal stagings and the crush of spectators. A document dated 1486 indicates the precautions taken in Angers to prevent the *Mystère de la Passion* from degenerating into chaos. It was for the same reason that the Paris *parlement* put an end in 1548 to the monopoly enjoyed by the confraternity in charge of organizing mystery plays, prior to completely dissolving the organization in 1576.

The staging of mystery plays obviously interested the "image makers." One of Fouquet's most striking miniatures is The Martyrdom of Saint Apollonia in the *Heures d'Étienne Chevalier* (circa 1460), which places a cohort of characters in front of platforms harboring *tableaux vivants*. This magistral presentation has been construed as "theater in the round," which does not accord with the later but reliable manuscript of the *Passion* performed in Valenciennes, where the "mansions" (or sets) are all in a row. The main point is that these productions employed painters and decorators, requiring them to organize space and place figures just as they would do in paintings or sculpted groups. This very relationship was suggested by a chronicler known as the "Bourgeois de Paris" when

Pierre de L'Estoile, *Les Belles figures et drôleries de la ligue:* "To the people of Paris." 1589.
Bibliothèque Nationale, Paris (Rés. La²⁵ 6, fol. 24v).

he compared the stage to "images raised against a wall" (that is to say, the figures on a portal). The question of theatrical influence on painting may turn out to be a false issue.

All this animation had a certain comic appeal. Satirical literature took to the stage by mocking courtly morality in the *Farce de la Pipée* (Farce of the Lure), and by ridiculing legal institutions in *Maître Pathelin* ("Lawyer Pathelin," performed circa 1465, printed in Lyon, and illustrated with fine engravings in 1485). Comedy met with the same instant success two centuries later with the works of Molière. French comedy, in short, developed the free tone usually associated with classical mythology, yet with a heretofore unknown theatrical agility. The same vein of irony and bawdiness can be found in the work of French artisans, notably in that singular by-product of sculpture, the misericords in choir stalls. The vogue for small carvings on misericords dated from the fifteenth and especially sixteenth centuries—the Late Middle Ages, so to speak. This decorative device derived from figurines wedged onto the capitals of columns and the arch moldings of portals, where they had to fit into a limited space. The monsters and realistic scenes of the Romanesque period were thus resuscitated, although the idea of decorating misericords with motifs so free, comic, and sometimes indecent represented a more recent development belonging to a new age of humor. Squeezing domestic scenes, craft activities, and animals into the tiny volume of the bracket inevitably assumed a comic tone. Although Hieronymus Bosch was not French—far from it—some of his mischievous wit filtered into France. The idea of human folly was in the air. Realism had

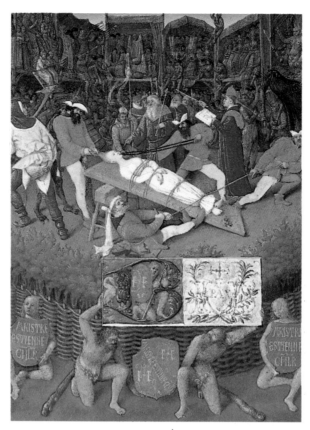

Jean Fouquet, *Heures d'Étienne Chevalier:*
The Martyrdom of Saint Apollonia. c. 1452–1460.
Musée Condé, Chantilly (Ms. 71, fol. 39).

become clownish, as typified by Rabelais.[11] But then there came a time when folly was no longer tolerated—the choir stalls in the abbey of Saint-Victor in Paris, installed in 1530, were dispersed sometime around 1780.

All these facts point to a general trait of the period, namely the strong tendency to exteriorize expressiveness, to render everything explicit through figures, mimicry, and gesture, to bring everything alive through robust, direct forms. This inclination toward realism favored production of the greatest possible number of *tableaux vivants*, as occurred in the theater with religious subjects drawn from the Passion and the Bible. The resulting "religion-as-spectacle" was all the more important since it closely paralleled "politics-as-spectacle." The two popular phenomena of the day, mystery plays and ceremonial entries, thus shed light on one another.[12] In September 1461, Fouquet supplied the plans for the "scaffolding and mysteries" to be used for Louis XI's ceremonial entry into Tours.

The theater henceforth abandoned the forecourts of churches and liturgical settings, taking to the streets in its new form. Similarly, monarchical ceremonies no longer took place exclusively at the royal castle, but rather throughout the entire city. In both cases, this expansion led to the exterior deployment of temporary structures and to the increased use of *tableaux vivants*, employing actors, painted canvases, and statues. Much of the artistic inventiveness of the period was thus invested in ephemeral celebrations and elaborate pageants.

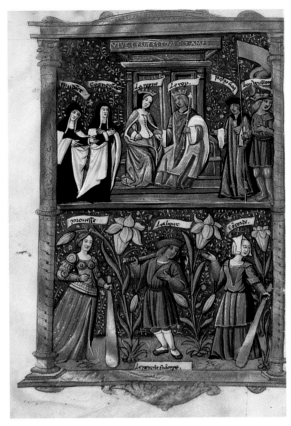

The ceremonial entry of Queen Claude of France
into Paris, 12 May 1517. Bibliothèque Nationale,
Paris (Ms. Fr. 5750, fol. 40v).

A rather coherent and efficient way to trace this evolution is provided by documentation on triumphal entries. Chronicles and booklets published on such occasions made clear that the function—one might say political necessity—of these manifestations was to provide direct contact between sovereign and city. With Charles VIII, a cavalcade no longer sufficed—scaffolding with statues was erected, as were loges with *tableaux vivants*, which varied depending on whether the site was Lyon, Amiens, Rouen, or Toulouse. Francis I's entry into Lyon in 1515 provides a good example of the way in which the emblematic idiom and its emphatic forms were wedded to imagery that carried motifs from miniatures and romances into the streets.[13]

This idiom favored a cumulative effect, so that novelties were integrated into the repertoire, to be enriched and reused for the following event. Thus by 1549, Henri II's entry into Paris constituted a veritable manifesto. Such was the development of French art, for another function of these celebrations and entries was to provide visible forms for the nation's ideology, thereby serving as a sort of laboratory for allegories and formalized symbols. Hence the repertoire began expanding in 1470–1480 with the small motifs and models found in the frontispieces of books and in public decorations, such as antique-style tabernacles, putti, garland-bearers, and pagan gods. Although the original models were Flemish and Italian, they were mixed and matched with an ingenuity and shrewdness that was simultaneously very local and very French.

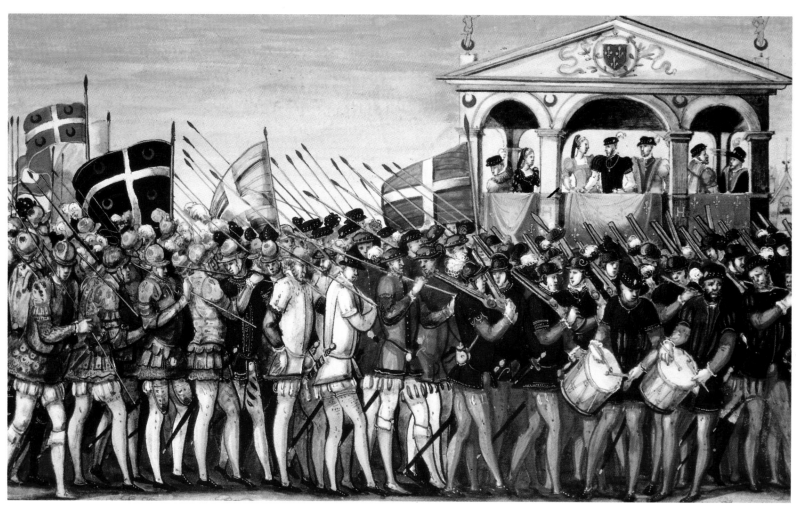

The ceremonial entry of Henri II into Rouen, 1 October 1550: procession of drummers and soldiers.
Bibliothèque Municipale, Rouen (Ms. Y28).

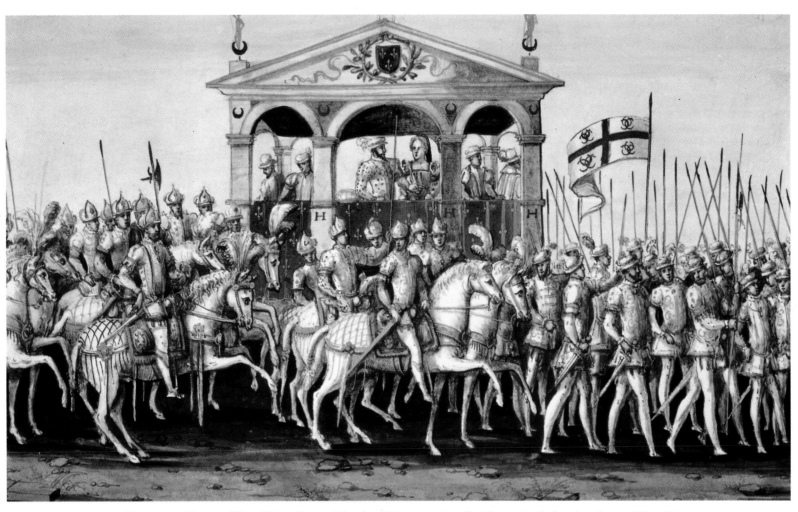

The ceremonial entry of Henri II into Rouen, 1 October 1550: procession of knights passing before the tribune of Henri II.
Bibliothèque Municipale, Rouen (Ms. Y28).

Master of Moulins, *Nativity* (detail). c. 1480. Oil on panel, 55 × 73 cm.
Musée Rolin, Autun.

BETWEEN FLANDERS AND ITALY

Ever since the French Romantics rediscovered the nation's history, it has been customary to look to—and to credit—the Middle Ages for all sorts of practices and features that stem precisely from the moment when medieval forms and usages were being discarded. The case of mystery plays is typical. Victor Hugo's enormously popular novel *The Hunchback of Notre Dame*, takes as its hero Pierre Gringore, a poet during the reign of Louis XII (1462–1515), and describes a turbulent Paris that has little in common with the world that actually produced the cathedral. The Middle Ages as conventionally conceived in the nineteenth century was largely based on features properly belonging to the pre-Renaissance period of the half-century following the watershed years around 1440. Many things had matured or were maturing, such as the increasingly marked domination of secular attitudes and the new importance, even in miniatures, of picturesque details such as animals and ordinary objects, not to mention the mastery of spatial representation demonstrated by Jean Fouquet and the illustrator of *Le Cuer d'amour espris*. The impact of Flemish art was becoming perceptible. In religious art, everything became more intense and explicit—Nativity scenes could never be too moving, nor the Passion too dramatic.

It was long thought that the artistic sphere lacked clear expression during this confused period in French history. But in the past forty years, the study of miniatures and primitives (by scholars such as Charles Sterling, Millard Meiss, Michel Laclotte, Nicole Reynaud, and François Avril) has shed light on the extraordinarily rich

Jean Fouquet, *Pietà de Nouans* (detail). Oil on panel. c. 1450–1460.
Church of Saint-Martin, Nouans-les-Fontaines.

landscape of painting. At the same time, research has clarified the original meaning and scope of stained glass (in particular the studies of Jean Lafond and Louis Grodecki) and tapestry (Francis Salet). Hundreds of overlooked works have been steadily reappraised, and a clearer picture of the relatively original aspect of later architectural projects is beginning to come into focus.

A more detailed approach reveals how miniaturists and sculptors actually worked, which has considerably loosened the stranglehold of the double influence—Flemish and Italian—in which French art was summarily held. This does not mean, obviously, that one should ignore the fact that styles and forms were circulating throughout Western Europe to such a remarkable extent in 1400 that the convenient concept of an "international style" emerged. This circulation continued, and even accelerated, as cross-references multiplied—Northern art spread down to Provence, while Italian models could be found in the Loire region. Sculpture became unified, decorators varied their repertoire, interdependence increased. Nevertheless, the French ideal of "selective assimilation" continued to hold sway, as art historian Erwin Panofsky has pointed out. The artistic history of the French Renaissance cannot be accurately traced unless the effect of that ideal is considered, for it points to interesting lines of development in both painting and architecture. These lines may have appeared a little ragged around the year 1500, yet they were always stimulated by the enormous accomplishments of previous ages, and by authentic convictions and practices.

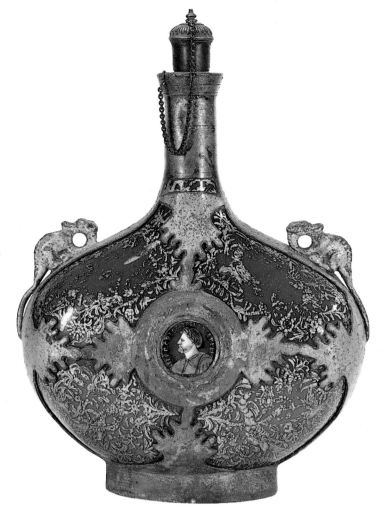

Flask. Blue glass, gilt decoration, brass mounting, and painted enamel.
French, sixteenth century. Height: 32 cm. Musée du Louvre, Paris.

Right: Masséot Abaquesne, tiles from the chapel of the Château de la Bastie
d'Urfé (Rhône-Alpes). Detail of the altar step. High-temperature colors
on earthenware. Rouen, 1557. Musée du Louvre, Paris.

No line is simple in that period of great vitality from 1490–1500 onward, when the arts and crafts were heavily influenced by engravings (generally Rhenish and Italian prints, apart from the Fontainebleau school). Ceramics, furnishings, and precious metalwork were all constantly inspired by freely circulating prints.

The other instrument of transformation to the modern world was, of course, the printed book. France was hardly precocious in that sphere. The invention of movable type occurred in the mid-fifteenth century in Mainz and Strasbourg. Despite the interest shown by Charles VII, who in 1458 dispatched a medal caster from Tours to Mainz to gather information, the new technology only reached Paris in 1470 and Lyon in 1473. Yet France had perhaps begun to take major initiatives in that other crucial sphere of multiple reproduction—printed engravings and etchings—as early as the end of the fourteenth century; a woodblock known as the *Bois Protat* (circa 1370, Bibliothèque Nationale, Paris) may be the vestige of an attempt by Burgundian monks to print pious images. Rhenish workshops, however, ultimately forged ahead thanks to Martin Schongauer, just as Mantegna and the Florentines did with Maso Finiguerra. Not long afterwards, French workshops—like others throughout the West—were stunned upon discovering the magnificent prints of Dürer and Marcantonio Raimondi, which altered the course of artistic life.

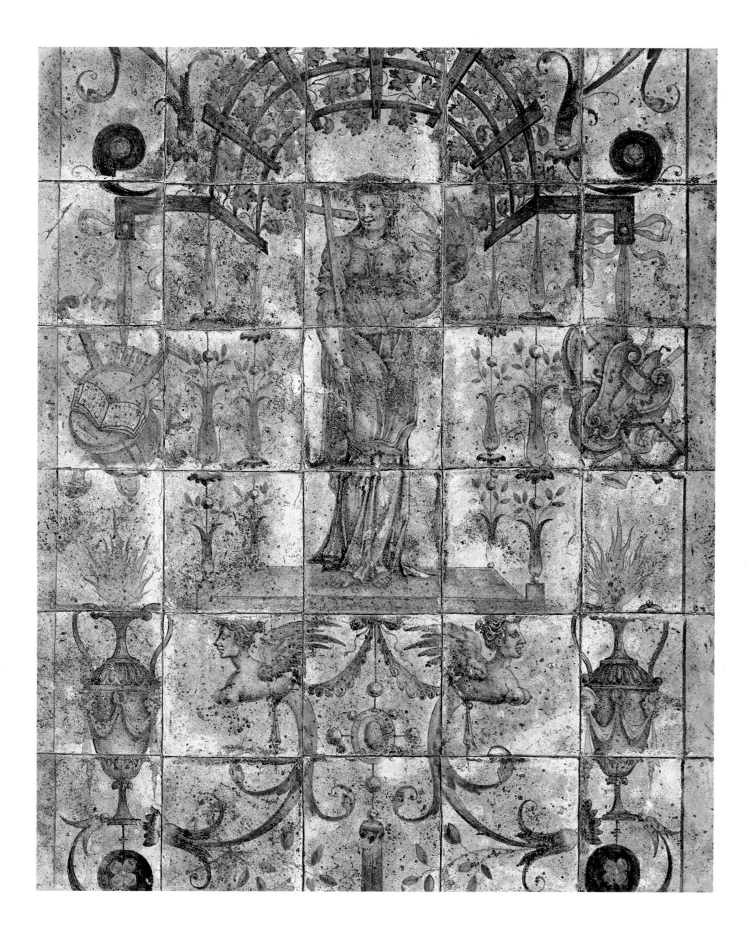

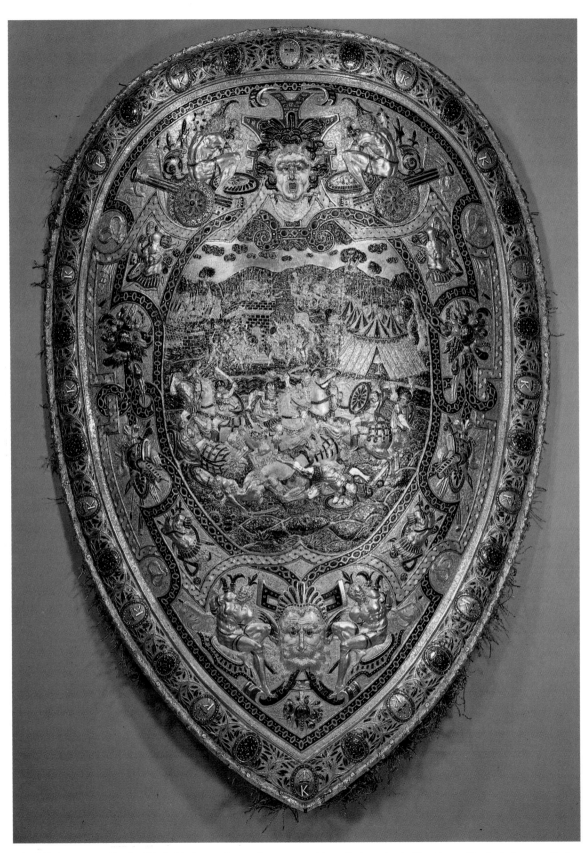

Shield belonging to Charles IX. Gold plate and enamel on repoussé iron. Paris, c. 1572. 68 x 49 cm. Musée du Louvre, Paris.

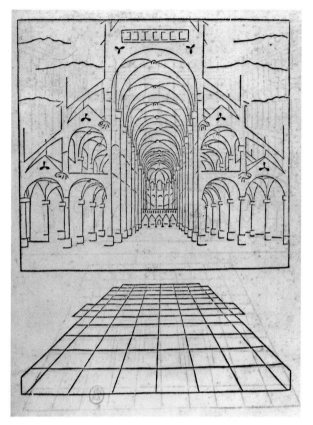

Geoffroy Tory, *Heures à l'usage de Rome:*
the Adoration of the Magi. 1525.
Bibliothèque Nationale, Paris (Rés. V 1529, fol. 3).

Viator (Jean Pélerin), *De artificiali perspectiva:*
the vaults of Notre-Dame of Paris. 1505.
Bibliothèque Nationale, Paris (Rés. V 167, fol. C²r).

In Paris, imported presses were set up at the Sorbonne, which printed a number of books of hours illustrated by Antoine Vérard's workshop (between 1485 and 1513), as well as calendars (that is, almanacs) produced by other craftsmen like Guy Marchand. Such wood engravings naturally enriched the repertoire of ornamental decorators and even designers of stained glass. After 1520, the dominant figure was Geoffroy Tory. Regional printshops were established, and it was in Toul that a canon named Jean Pélerin (called Viator) published a remarkable book, *De artificiali perspectiva* (1505). Repeatedly plagiarized and reprinted, it was the first practical treatise on perspective and, significantly, contained the plans of Paris buildings such as Notre-Dame and the royal palace. The thirty plates display a fairly basic level of drawing, and in many cases it is just a sober, abstract rendering of compositions found fifty years earlier (with no doctrinal precedent) in the work of Jean Fouquet—such was the work of the pre-Renaissance. In the 1521 edition of the treatise, a poem on the frontispiece cites the great painters, both "departed and living" that Viator admired for "decorating France, Germany, and Italy." Although half of the two dozen names concern France, they remain hard to identify. The difficulties still encountered today in constituting this history come from the marked absence of artistic chronicles in France.

The ceremonial entry of Henri II into Rouen, 1 October 1550:
a tableau of "Brazilians" before the bridge of Saint-Ouen
(detail). Bibliothèque Municipale, Rouen (Ms. Y28).5

Right: The ceremonial entry of Francis I into Lyon in 1515:
pageant on the Saône River (detail). Herzog August
Bibliothek, Wolfenbüttel (Cod. Extrav. 86.4, fol. 8).

France was no longer the principal engine of change, except during the Fontainebleau period, which func-tioned as a crucial relay north of the Alps. Art was reinvigorated in France on its own terms, based on multifari-ous contacts, without assuming a leading role in the West. Political, commercial, military, and cultural thrusts did extend its sphere, however, and the French descent into Italy in 1494 did not appear chimerical at the time, for short-term ambitions were masked by glorious calls for a crusade. Indeed, Ottoman expansion had throttled Eastern Christianity when Constantinople was captured in 1453. But this path was never reopened, and the clos-ing of certain routes to Asia spurred the West's search for new ones. The era of distant exploration thus began, driven by the desire for expansion and conquest. Yet it took fifteen to twenty years for the significance of Christopher Columbus's voyages, which lasted from 1492 to 1506, to sink in. The strange jewels and finery of Native Americans that so startled artists like Dürer in Antwerp in 1521 were first seen in Hapsburg lands; in France, "exoticism" entered culture only through festive disguises, parades, and celebrations, as in Henri II's ceremonial entry into Rouen, which perhaps gave Montaigne the idea for his chapter on "Cannibals."[14]

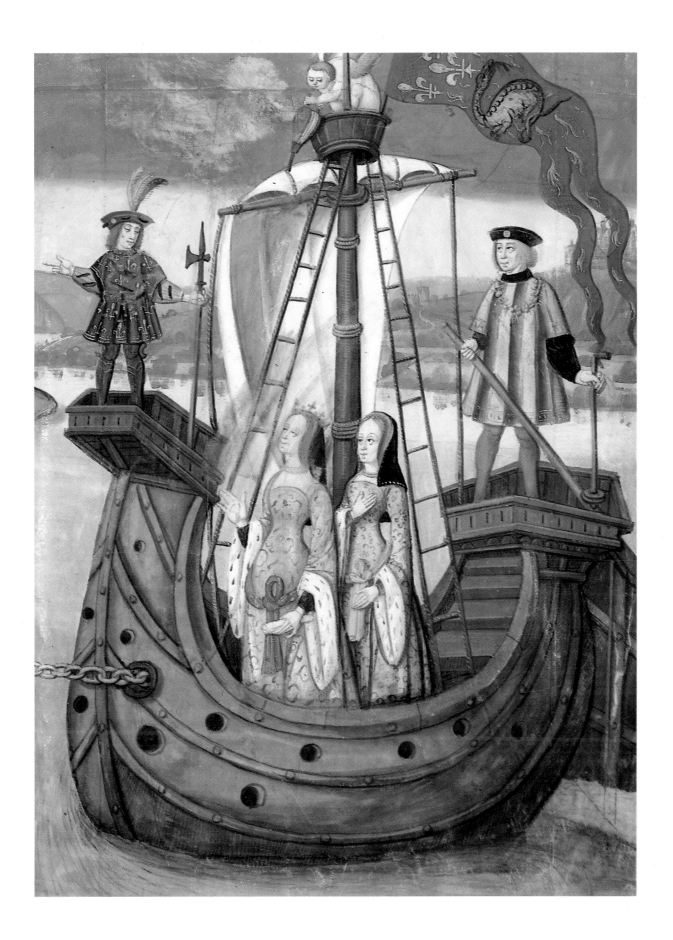

I
PRE-RENAISSANCE
1420–1500

1. ECCLESIASTICAL ARCHITECTURE, STAINED GLASS, SCULPTURE

ARCHITECTURE

The term "flamboyant" has been used since the nineteenth century to designate the abundantly decorative Gothic architecture of France during the fifteenth and sixteenth centuries. Flamboyant Gothic is characterized by ogee arches, tracery with filleted moldings, and above all a trend toward the fragmentation and repetition of increasingly tiny details. But the term does not adequately convey the changes that occurred after 1430–1440, when construction projects became more frequent. In Paris, for instance, where there was much updating to be done, Saint-Séverin was rebuilt with Parisian-style double aisles and a superb spiral pillar in the ambulatory, Saint-Germain-l'Auxerrois was endowed with a large porch, and the nave of Saint-Nicolas-des-Champs received new bays. Construction nevertheless took a long time, and work progressed very slowly due to lack of funds. Most churches begun during this period but only completed several generations later, therefore, increasingly diverged from a pure Gothic style.

English, American, and German historians thus tend to use the term "late Gothic baroque." Champagne, Picardy, and Normandy were the most active regions, and every long-term construction campaign produced something original, which moreover blended quite well with the traditional overall design. At Saint-Riquier (formerly

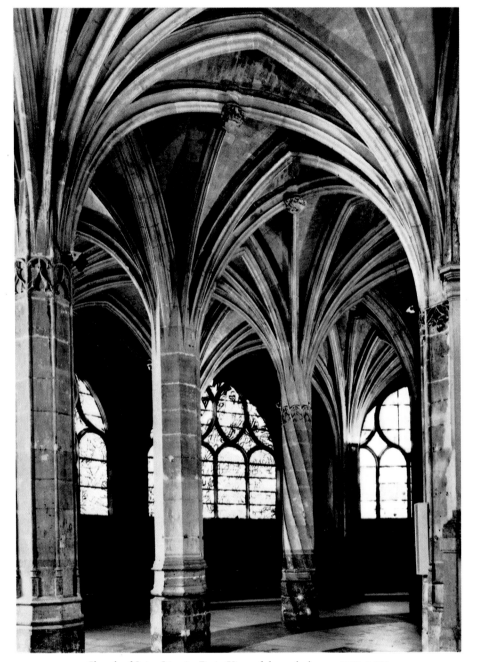

Church of Saint-Séverin, Paris. View of the ambulatory. 1489–1496.

Centula) in the Somme region, an abbey that suffered from years of warfare was given a nave that remained faithful to the thirteenth-century chancel, yet boasted dense rib vaulting with marvelous pendant bosses. Between 1488 and 1539, the colle-

giate church of Saint-Vulfran in Abbeville was completely rebuilt up to the transept (the chancel having to wait until the seventeenth century); its three-storey facade followed the basic models but was decorated with admirable statues of innovative style

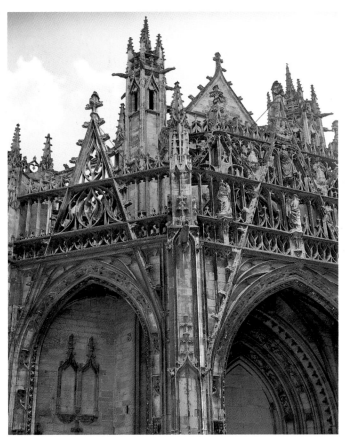

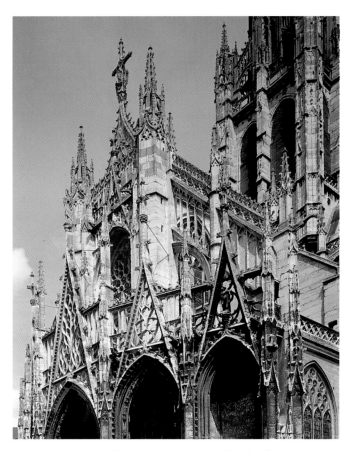

Church of Notre-Dame, Alençon (Orne). West facade,
view of the porch built by Jean Lemoyne (detail). 1500–1516.

Church of Saint-Maclou, Rouen. West facade,
view of the outer porch. 1436–1520.

and dress (heavily damaged in 1940). Saint-Nicolas-de-Port, started in 1481 once Lorraine regained a measure of independence following the death of Burgundian invader Charles the Bold, is fairly similar in plan to the cathedral in Toul, but with strange, vertical decorative molding under the windows in the nave (perhaps echoing the English perpendicular style).

Meanwhile, the reconstruction of churches in Normandy began during the English occupation (such as Notre-Dame in Caudebec after 1426 and Notre-Dame in Alençon in 1444), yet they display no English features. In Alençon, the three-faceted porch (erected from 1500 to 1516 by Jean Lemoyne) is covered with statues, like an outdoor rostrum. It roughly imitates Saint-

Maclou in Rouen, where the five sections of the outer porch are topped by tall gables. Saint-Maclou, begun in 1436 and completed in 1520, boasts all the extravagant features I have called "Hyper Gothic"—everywhere, the apparently traditional play of forms gives way to virtuosity taken to a paradoxically elegant extreme. Structural subtleties therefore become evident only upon analysis. The arrangement of the apse with four radiating chapels, for instance, lends great scope to the chancel, while originality can be detected in details like the prismatic ribbing that descends from the vaulting. The cathedral in the same city of Rouen was given an ornate, flamboyant tower known as the "Tour de Beurre" ("Butter Tower," 1487–1507). At the

Mont-Saint-Michel, which managed to resist English assaults, the abbey received a new chancel in the same spirit, after 1448.

Votive chapels were also revealing. In the Marne region, Notre-Dame de l'Epine (Our Lady of the Thorn), whose name alludes to a relic and therefore to miracles, was so popular that new work on it began around 1410. Charles VII made a pilgrimage to the chapel in 1445, and Louis XI conferred an endowment upon it. Work continued throughout the sixteenth century. Its enormous facade (restored and rebuilt in the nineteenth century) seems almost to be embroidered in stone, with gargoyles that won Victor Hugo's admiration. The interior design is typical of churches in the Reims area, but with a

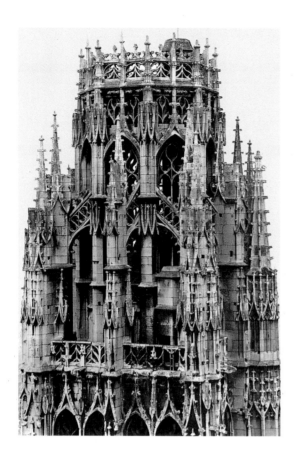

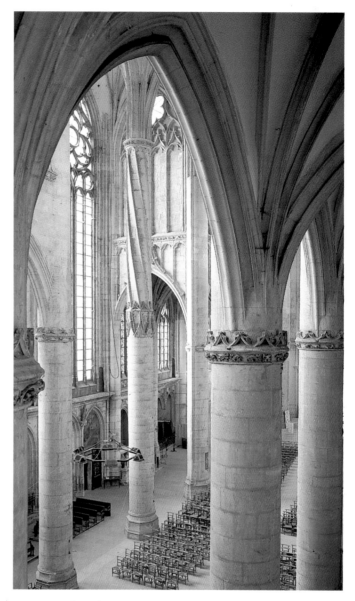

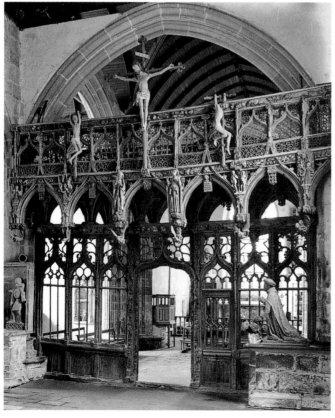

Basilica of Saint-Nicolas-de-Port (Meurthe-et-Moselle).
Decorative ribbing on the upper columns. 1481–1515.

Top left: Rouen Cathedral (Notre-Dame).
The "Tour de Beurre," eastern facade. 1487–1507.

Bottom left:
Saint-Fiacre Chapel, Le Faouet (Morbihan).
View of the wooden rood screen. 1480.

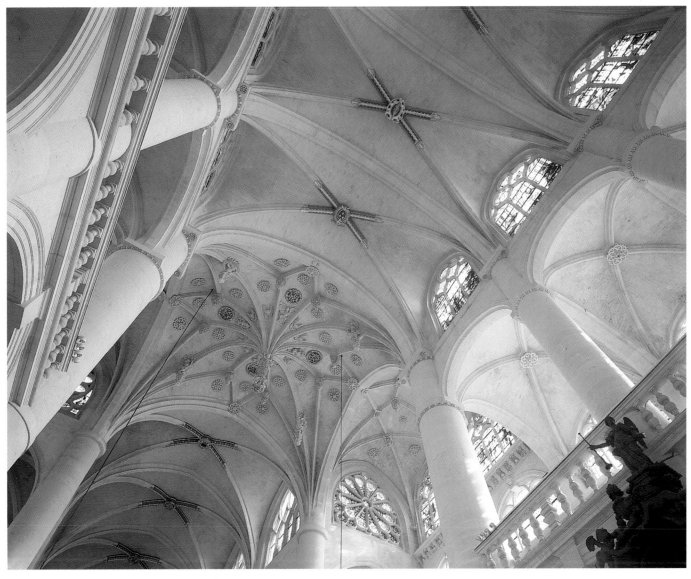

Church of Saint-Étienne-du-Mont, Paris. View of the vaulting in the nave. Sixteenth century.

rood screen (circa 1490) that crosses the nave like a passageway, as well as an admirable choir screen (circa 1540) that is composite in style. All aspects of the period are visible here.

An even clearer example of ornamental proliferation can be seen in the late fifteenth-century transformation of the Saint-Esprit Chapel in Rue, Picardy, which was popular among the English and Bur-gundians thanks to a miraculous cross. The chapel is a good French example of the exaggerated Gothic style (also found in Portugal and England) that might be labeled "floral" due to a wealth of plant-like stems and motifs. Inside, two doors with basket arches are topped by giant linenfold panels. The vaulting is covered with ribbing that ostentatiously marks the traditional weight-bearing supports and allows for superb pendant bosses, although the builders did not go so far as to adopt that singular English invention of fan vault-ing. The collegiate church of Notre-Dame in Cléry near Orléans, dear to Charles VII, was made a chapel royal in 1467 and reno-vated with surprising sobriety—it was to have served as the site for royal tombs, a sort of Saint-Denis on the Loire (Louis XI was buried there, but his bronze tomb was

destroyed in 1562). In contrast, three side chapels, built from 1515 onward, were decorated with composite elements.

One of the most typical signs of the decorative masking of structure was the emergence of round columns swathed in ribbing, as seen at the church of Saint-Malo in Brittany (after 1484), Saint-Nicolas-de-Port in Lorraine (1481–1515), and Saint-

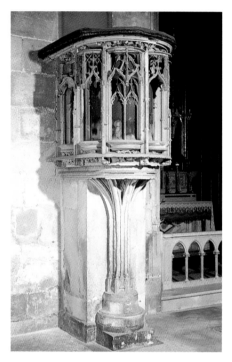

Church of Saint-Pierre, Avignon.
The pulpit. 1497.

Étienne-du-Mont in Paris (circa 1500). As explicitly structural features were eliminated, the nature of the interior space was altered. Perspectives were systematically broken by the widespread erection of rood screens and choir screens. In 1480, for instance, a wooden rood screen executed in a delightfully provincial Gothic style was placed in the chapel of Saint-Fiacre in Le Faouet (Brittany). Furthermore, it was always possible to add accessories and appendages that had little Gothic

influence, or even—when it came to credences and tombs—none at all. The sanctuaries of old were treated somewhat like vacant dwellings of an evolving, flexible nature; modifications were often made on their exteriors, and almost always on their interiors, with additions no longer related to the initial stylistic idiom. Pulpits had remained portable until the mid-fourteenth century, but once fixed they took the form of a raised, highly decorative barrel, as seen at Chavoy in Normandy (circa 1450) and Saint-Pierre in Avignon (1497).

It was perhaps at the rather singular cathedral of Sainte-Cécile in Albi (southern France) where a series of original features was combined most successfully. As early as 1282, Bernard de Costanet had designed a large nave to serve as a red fortress for Christ, which was completed a century later. Bishop Louis d'Amboise, who administered the city from 1474 to 1503, endowed the interior of the cathedral with two decorative features. First, he decided to have the inside wall of the facade painted with a gigantic Last Judgment, which set the requisite figures in semi-

Albi Cathedral (Sainte-Cécile). Outer choir screen: The Prophet Jeremiah (detail). Painted wood. Late fifteenth century.

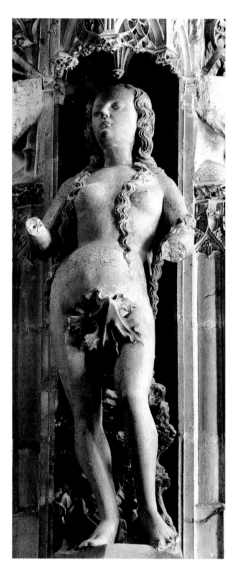

Albi Cathedral (Sainte-Cécile). Back of rood screen: Eve. Late fifteenth century.

vaulted compartments, a large if rather grim penitential work. Then, going to the opposite extreme, he had the interior decorated in white stone in the form of a rood screen that occupies more than half of the nave. The highly chiseled, open-work screen contained a host of statues and was probably the work of Burgundian artisans (perhaps from Cluny "lent" by the bishop's brother). Of the seventy figures originally decorating the outer facade of the screen, only the Virgin and Saint John in painted

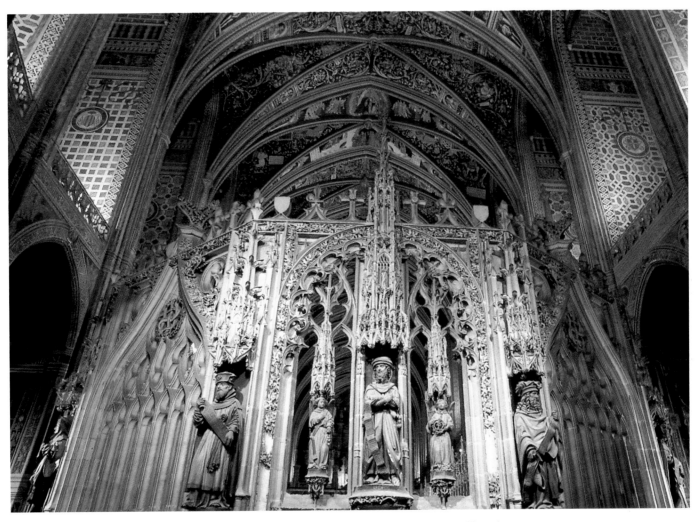

Albi Cathedral (Sainte-Cécile). View of the outer choir screen. Late fifteenth century.

wood survive, but on the inner compartments, canopied niches house a gallery of saints and angels of striking quality, not to mention a magnificent, provocatively nude Eve and a Saint Cecile dressed in the latest fashion. On the back of the choir screen, prophets clearly derived from their forebears at Champmol, as well as a carved decor of tiny sculpted elements and blazons, testify to an obvious desire to enliven and add color to the enormous nave. This masterpiece thereby sheds light on an entire epoch.

The bishop's nephew, Louis II d'Amboise, occupied the episcopal chair in 1504, and completed his uncle's initiatives. From 1509 to 1512, he had the compartments of the vaults decorated with arabesques and figured medallions, commissioned from a group of Italian artisans from Bologna, in an obvious attempt to disguise the original Gothic nature of the vaulting. Around 1514, a triumphal doorway with baldachin was erected on the southern flank of the cathedral. This struc-

ture of semicircular arches with superficial, curvilinear decoration of fleurons masks the logic of the old system.

The Amboise family dominated the highest echelons of the Church for some twenty years. But their approach to ecclesiastical art was ultimately not very revolutionary. It was, above all, in the family's châteaux at Meillant and especially at Gaillon (where Cardinal Georges d'Amboise resided) that their search for a grand style emerged most clearly.

Albi Cathedral (Sainte-Cécile), choir, rood screen, and nave, looking west. Late fifteenth century.

Left: Albi Cathedral (Sainte-Cécile). Inner west wall. *The Last Judgment* (details). Fresco. Late fifteenth century.

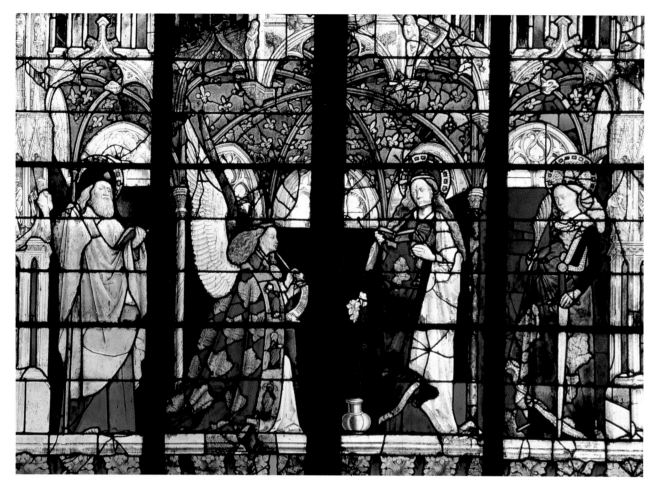

Bourges Cathedral (Saint-Étienne). Stained-glass window in the Jacques-Cœur Chapel:
The Annunciation with Saint James and Saint Catherine. 1448–1450.

ECCLESIASTICAL STAINED GLASS

Stained-glass windows bathed Gothic churches in a special atmosphere that precluded painting—with only a few exceptions (such as Châteaudun), fifteenth- and sixteenth-century French churches afforded little possibility of hosting the monumental paintings seen in Tuscan churches. Since the French were as passionately attached to their own design as the Italians were to theirs, revived artistic ambitions were largely expressed through the medium of stained glass. Two technical developments transformed the art of stained glass to such an extent that the work produced after 1400 should be understood in terms of painterly art. First

of all, the fourteenth-century introduction of lead white helped to diversify the range of colors, and second, improved cutting techniques made it possible to use larger pieces of glass, thereby making them less fragmented by lead and more conducive to pictorial effects. A sophisticated inlay technique permitted original patterns and refined workmanship. Moreover, the great painters of the period—Beauneveu, Nicolas Froment, and the Master of Moulins—were also masters of stained glass.

There is an almost endless list of ecclesiastical (and also secular) stained-glass windows that no longer exist but are known through documents. Yet the highly colored windows in the chapel of the Innocents at

Rouen Cathedral (circa 1450), the Virgin and Saints at Tours (circa 1460), and the unforgettable Annunciation at Bourges (1448–1450) are vestiges that suffice to rivet attention. The Bourges Annunciation, commissioned from an unknown artist by Jacques Cœur, provides outstanding testimony to the quality of revitalized activity. Under a celestial canopy studded with fleurs-de-lys, an angel with upraised wings emerging from his red-and-gold dalmatic greets a monumental Virgin flanked by the highly distinctive figures of Saints James and Catherine.

The overall composition, stature of the figures, and quality of the drapery immediately bring to mind Jan van Eyck, whom

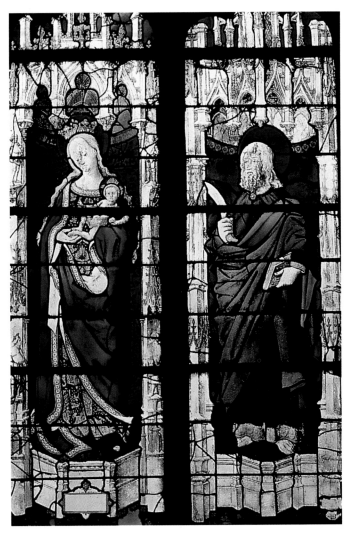

Church of Notre-Dame, Louviers (Eure).
Stained-glass window in the nave:
Virgin and Child with Saint Bartholomew. c. 1490.

Church of Saint-Séverin, Paris. Stained-glass window in the apse:
Saint Michael, bearing a crest and neck chain of the Order
of Saint-Michel, presents the donor and his family. c. 1460–1470.

the designer of the cartoon must have known. But this Van Eyck-style picture was assimilated, adapted, and conveyed with a serene authority that makes it an unmistakably French stained-glass window.[1] Since it was probably executed by the same artist who worked on the chapel of Cœur's mansion, names have been proposed from among the artists linked to the financier, including Jacob Littemont (or Lichtemont) who subsequently worked for Louis XI. Whatever the case, this key artwork attests to the fact that central France had assimilated the realism and symbolism of the

great Flemish experiments in art by the mid-fifteenth century.

Stained glass could be found throughout France. A partial idea can be given by mentioning, among others, the rose window at Angers with its medallions of the months (1541–1452), and the figures of Saints Barbara and Catherine against a background of fleurs-de-lys at Châlons-sur-Marne (circa 1475). Normandy was a particularly active region, and would remain so during a good part of the sixteenth century. An interesting precursor of the masterpieces to come was the Virgin with Child,

depicted standing in front of a backdrop of deep red fabric and wearing a damask gown that is a marvel of inlay work (Louviers, circa 1490).

Meanwhile, in Paris at about the same time, the Sainte-Chapelle was endowed with a rose window abounding with a wealth of dense effects (circa 1490, restored). At the church of Saint-Séverin, tall windows were installed showing the Trinity with the Father on a gold throne of great style, while in the apse, figures under a canopy include Saint Michael bearing the crest of the chivalric Order of Saint-Michel.

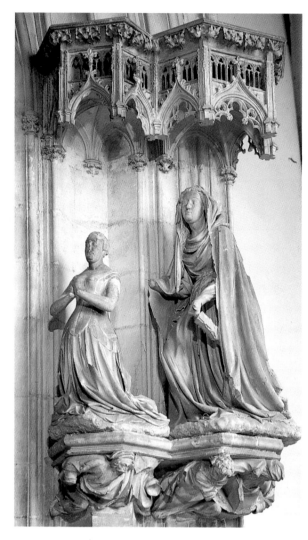

Claus Sluter. From left to right: Duke Philip the Bold and Saint John the Baptist, Margaret of Flanders and Saint Catherine.
Details of the portal of the Virgin. Carthusian monastery of Champmol, Dijon. 1389.

TOMB SCULPTURE

Monumental sculpture tended to abandon the facades of churches in favor of tombs, either in the form of the increasingly numerous noble and episcopal commissions or as decoration for pious institutions (usually Entombments of Christ ordered and paid for by religious confraternities). Burgundy benefited from the startling artistry of Claus Sluter (circa 1350–1406) and his nephew Claus de Werve (circa 1368–1439). Sluter's *Well of Moses* (which in fact served as the base of a crucifix) at the Carthusian monastery of Champmol was so powerfully conceived and in such

profound harmony with its day that it became the example followed more or less everywhere. The base had six sides featuring angels' wings that formed niches housing Moses, David, and four prophets, all very strongly characterized, announcing the Passion of Christ. The strange elegance of this massive group brooked no direct imitation; the same could not be said of Sluter's portal for the church, featuring the praying figures of Philip the Bold and his duchess facing a Virgin wrapped in the immense folds of her gown.

The cortege of mourners on the tombs executed by Sluter and de Werve did not

constitute an entirely new innovation, however, since this motif had already been used in Saint-Denis on the tomb of one of Louis IX's sons. Finally, not far from the tomb of Philip the Bold (1410) stands that of John the Fearless and his wife Margaret, begun by Jean de la Huerta in 1443 and completed by Pierre Antoine Le Moiturier in 1466–1470. The recumbent figures on the gilded alabaster tomb are shown with hands in prayer and feet resting on lions, while angels with upright wings act as magnificent pages. There was nothing terribly new in all this ostentation, except for the way the folds of drapery conveyed

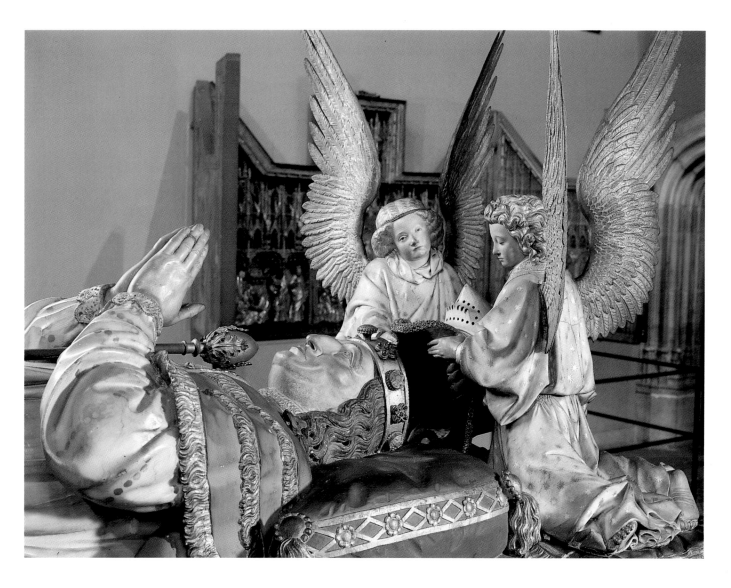

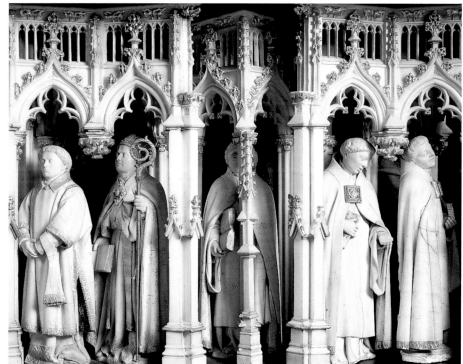

Jehan de Marville and
Claus Sluter, completed by
Claus de Werve. Tomb of Philip
the Bold: details of the effigy and
the funerary procession.
Alabaster. 1386–1410.
Musée des Beaux-Arts, Dijon.

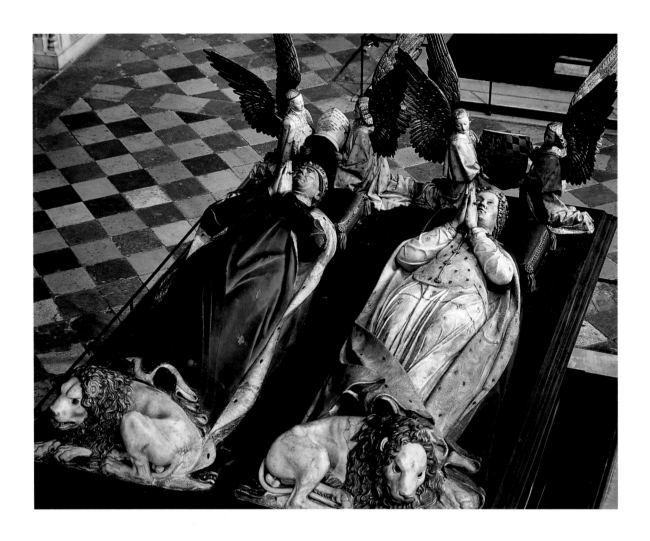

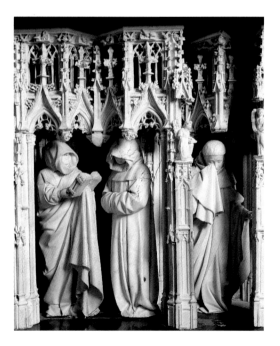

Claus de Werve and Jean de la Huerta, completed by Antoine Le Moiturier. Tomb of John the Fearless and Margaret of Bavaria: effigies and detail of the mourners. 1443–1470. Alabaster. Musée des Beaux-Arts, Dijon.

mourning and meditation, thanks to the artist's virtuosity. At Souvigny, sculptor Jacques Morel drew inspiration from these models in 1453 when executing the tomb of Charles I of Bourbon and his wife, the daughter of John the Fearless (destroyed, except for the recumbent figures). A bolder approach was taken on the tomb of the seneschal Philippe Pot in Cîteaux, where the eight mourners actually carry a flat slab bearing the deceased, a knight of the Order

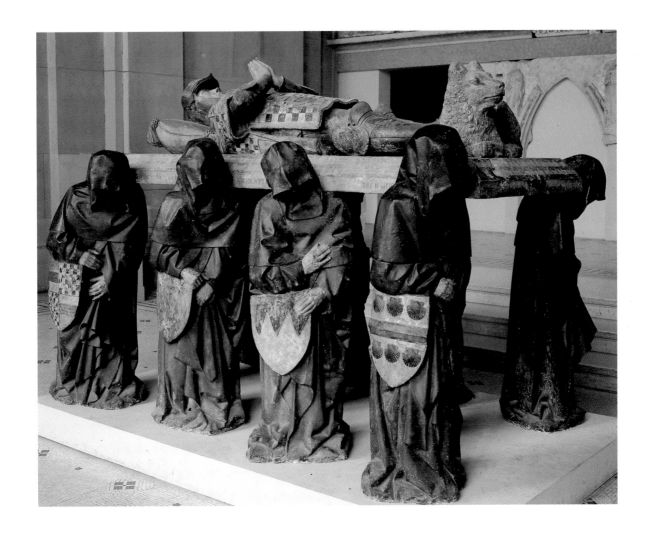

Antoine Le Moiturier.
Tomb of Philippe Pot
from the abbey church in Cîteaux:
general view and detail of the mourners.
Polychrome stone. Last quarter
of the fifteenth century.
Musée du Louvre, Paris.

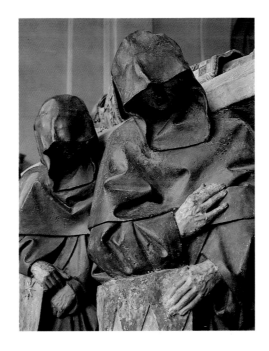

of the Golden Fleece dressed in armor and blazoned tunic. The bent and hooded mourners also carry heraldic escutcheons.

Burgundian sculptors started the fashion for figurines and statues characterized by highly distinctive faces and expressive use of drapery. They were also responsible for the taste in Virgins and saints with serene, sweet expressions as well as, in contrast, highly pained expressions on the face of Christ. Concerning such effects, it has

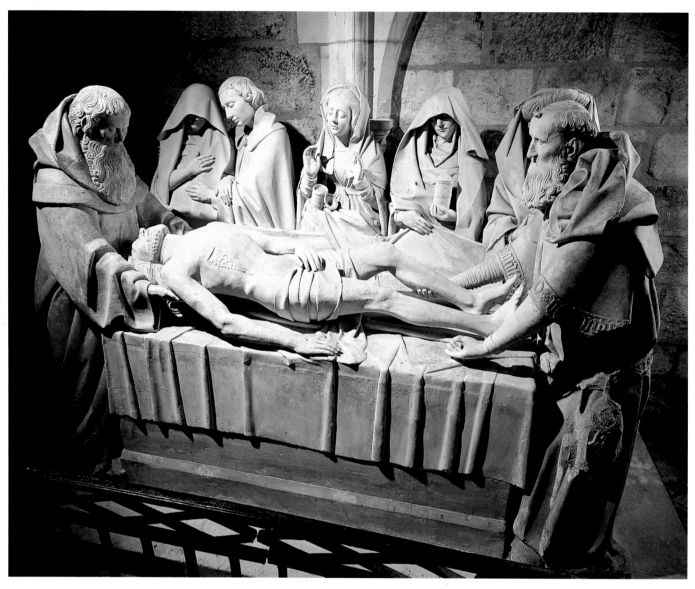

Burgundian workshop, *The Entombment*. Stone. 1454. Chapel of the Ancien Hôpital, Tonnerre (Yonne).

been noted that "in the France of 1440, the formal system of drapery that developed around 1400 evolved in a more measured way, with a sort of coherence entirely opposed to what was happening on the east bank of the Rhine."[2] Indeed, France had no sculptor equal to Nicolas Gerhaert van Leyden (Strasbourg) or Veit Stoss (Nuremberg, Cracow).

The century's great sculptural development entailed the grouping of figures, expressing a full range of pained emotions around the body of Christ, in a scene from the Passion known as the Entombment. One of the earliest of these works was commissioned for the hospital in Tonnerre by a rich citizen in 1454. It has rightly been suggested that the piousness of the confraternities and perhaps the vogue for mystery plays were behind these compositions that resemble *tableaux vivants*, with their occasionally striking sense of introspective measure and balance. At Solesmes Abbey, under an arcade no longer Gothic but "modern" in style, the group of mourning saints form a circle around the shroud lifted by the two traditional witnesses—Nicodemus at the head, Joseph of Arimathaea at the feet, rendered as likenesses of two pious burghers. This practice spread throughout the country, the theme becoming as frequent as would that of the Pietà in the following century.

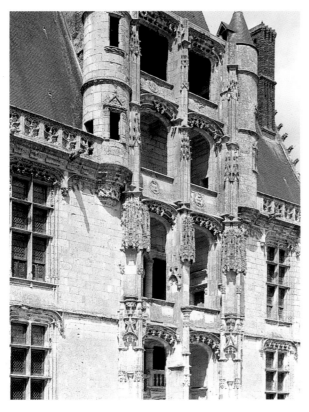

Châteaudun (Eure-et-Loir). François de Longueville wing: the open staircase. c. 1510.

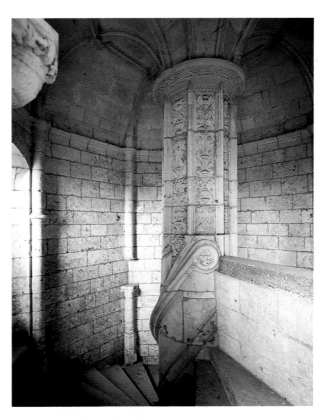

Châteaudun. The spiral staircase. c. 1468.

NOBLE RESIDENCES

The vagaries of politics, sieges, and neglect were hardly favorable to castles. The evolution of military equipment rendered their defensive apparatus obsolete, and the slow rebuilding that followed often gives the impression of great hesitation. Charles of Orléans, freed in 1440 from captivity in England, recovered possession of his castle at Blois; when modernizing the family seat around 1460, he took an interesting initiative by placing a gallery over a stone arcade of basket arches, topped by a storey in brick with simple horizontal moldings— opulence was not the order of the day. At Châteaudun, Jean Dunois, known as the bastard of Orléans, developed the west wing above a superb terrace that overlooked the Loir River. A chapel with large windows, completed prior to his death in

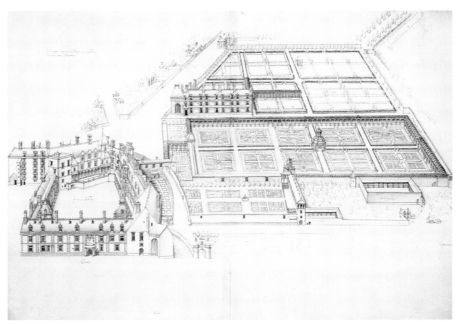

Jacques Androuet du Cerceau. Château de Blois, aerial view of the château with its gardens. Pen and watercolor. 1576–1579. 51 x 74 cm. British Museum, London.

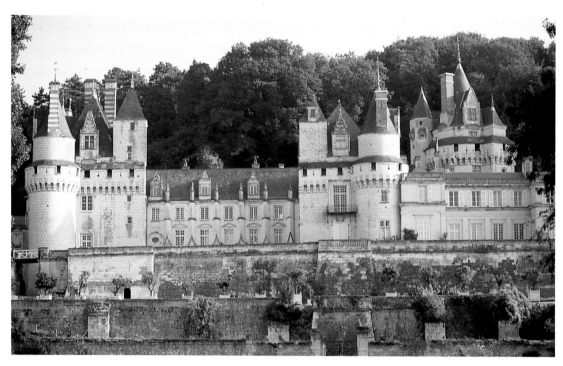

Ussé (Indre-et-Loire). General view of the château.
Late fifteenth to early sixteenth centuries.

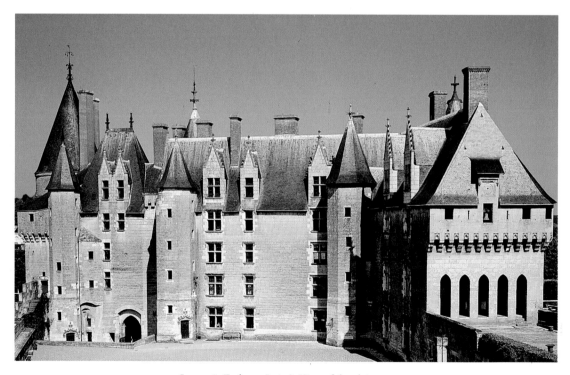

Langeais (Indre-et-Loire). View of the château
built under the direction of Jean Bourré. 1462–1469.

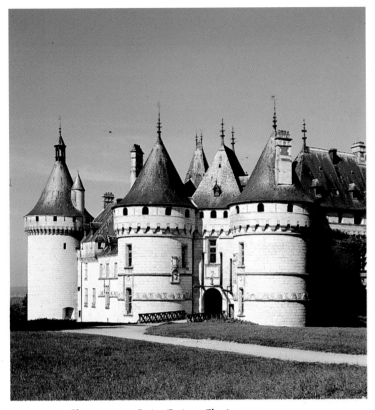

Chaumont-sur-Loire (Loir-et-Cher).
View of the entrance and details of the canting arms
decorating the towers. 1498–1511.

1468, contains an impressive gallery of twelve statues of female saints that convey a somewhat surprisingly noble simplicity by eschewing Gothic torsion. The enclosed spiral staircase located on the north corner (circa 1468) served as a point of departure for the four-storey wing erected by Jean's grandson, François II de Longueville, featuring its own superb, open staircase flush with the facade (circa 1510). A comparison of the two structures gives a good idea of the slow evolution toward "modern" architecture, for staircase design served as an architectural touchstone throughout the Renaissance.

Turning to the Loire (as distinct from Loir) Valley where, after all, a great deal had occurred since Joan of Arc's unexpected victory over the English forces at Orléans in 1429, it is worth mentioning the

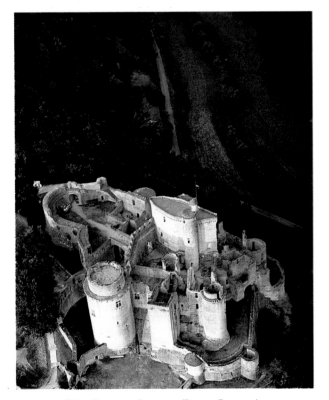

Saint-Front-sur-Lemance (Lot-et-Garonne).
View of the Château de Bonaguil. 1485–1500.

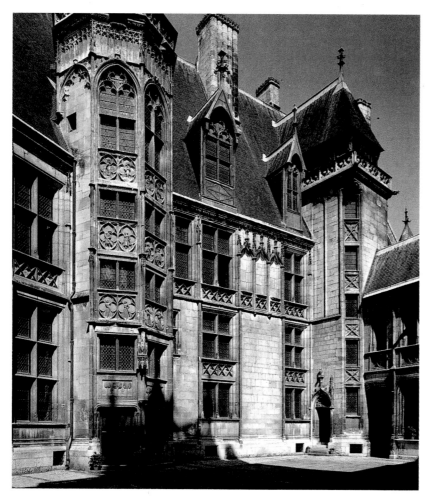

Hôtel Jacques-Cœur, Bourges. Inner courtyard. 1440–1450.

construction of a massive royal fortress at Langeais by Jean Bourré (starting in 1462) and, in a similar vein, the eastern section of the rebuilding of Ussé, undertaken by the Bueil family. As early as 1470 military features had disappeared from the new castle at Montreuil-Bellay, built alongside a more ancient residence.

The French word *plessis* originally referred to a palisade or stockade, yet châteaux bearing that name were regarded as being, not forts, but country manors. Such is the case for Plessis-lès-Tours, acquired by Louis XI, with its central residence surrounded by gardens, modified under Louis XII. Plessis-Macé, to the north

of Angers, was a sort of château-farm (in the words of André Mussat), a vast compound with a keep and major outbuildings. Also in the same area, the four distinct flanks and total absence of military architecture on the quadrilateral château at Plessis-Bourré (circa 1470), set off by a pool of water, constituted a new model of enormous importance. Its straightforward organization was repeated at Le Verger, the famous château erected by Maréchal Pierre de Gié (demolished in the eighteenth century). To appreciate variations in this general evolution, one need only compare the north and the south. Chaumont-sur-Loire, belonging to the Amboise family, was reno-

vated and built taller over a thirty-year period (1480 to 1511); the large windows and reduced towers, in conjunction with heraldic decorative features such as canting arms, reveal that although the function of the fortress was abandoned, pseudo-military features indicating a noble residence were retained. In the southern province of Lot-et-Garonne, unaffected by the war that ravaged the north, "the last of the medieval-style castles"—namely Bonaguil (1485, then 1500)—was being built at that very time.[3] This may be less paradoxical than it appears, if the strengthening of the keep by enormous round towers and a bastion-like barbican (without machicolation) was indeed planned to receive artillery—it has been compared to the new design used at Tonquédec in Brittany around 1474, with a tower stronghold intended for installing cannons. Then there is the remarkable modernity of the defensive organization of Salses, in the Pyrenees, a square citadel flanked by round towers with a network of casemates; completed prior to 1500, it should be credited to the genius of the Catalonian engineer Ramirez.

The noble family of Anjou, torn between their possessions in Naples and Provence, struggled to triumph over disorder—the castle at Tarascon was rebuilt starting in 1400 by Louis II, continued by Louis III, and completed under King René. The fortress, built on a rock overlooking the Rhône, was endowed with two round towers facing the city and was ringed by a moat. Its profile offers interesting analogies with Castel dell'Ovo in Naples. Like the Bastille in Paris, the Tarascon castle had machicolation (projecting ramparts set on corbels) running along the length of the walls. A rear courtyard flanked by square towers stretched to the north, while the main courtyard was endowed with a gallery, a porch, and a rather elegant spiral staircase leading to the royal apartments.

Among the lavish town mansions then springing up, two are particularly famous. Jacques Cœur's residence in Bourges was

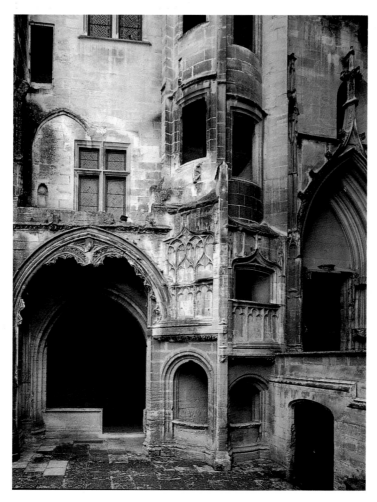

Tarascon (Bouches-du-Rhône). The château's main courtyard. 1400–1450.

basically organized around an enclosed courtyard where two staircase turrets mark the corners of the main body and the wings. The mansion was decorated throughout with stained-glass windows whose "extensive iconography fully corresponded to the figure cut by Jacques Cœur—chivalric romances, images of the king and court, blazons and emblematic devices, all revealing a sort of heraldic mania or nobiliary obsession on the part of this great fifteenth-century 'capitalist.'"[4] In Paris, the residence of the abbots of Cluny, erected between 1485 and 1498, on the site of a previous dwelling by Jacques d'Amboise, presents a rather similar

arrangement, though with an attractively corbeled chapel over the portico on the north facade. In both cases, the external staircase constitutes the key element of the architectural setting. The point is worth stressing: the polygonal turret henceforth enclosing the main staircase was made clearly evident in the courtyard or on the facade of noble homes. Thus it already appeared in front of the main hall of the Pierrefonds residence built by Louis of Orléans in the fifteenth century.

Conceived in this way, spiral stairs played the role of a veritable grand staircase in countless town and country residences. Naturally, these staircases then

expanded, and rose higher, though they were often topped by upper rooms reached by a lateral turreted staircase. They also provided the facade with a main axis, made entry more ceremonial, and were conducive to new decorative features. The evolution of the staircase was not limited to the introduction of the system of multiple flights, which already existed in Italy, nor to the adoption of antique-style lintels, pilasters, or niches. In both royal and more modest residences, the staircase became a special feature of civil architecture in France, the object of increasingly attractive and inventive experiments and developments starting in 1470–1480.

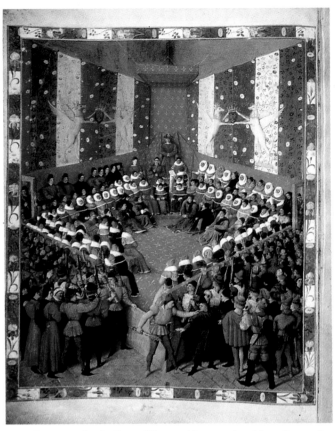

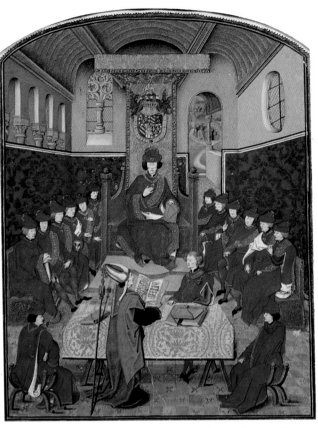

Jean Fouquet, *On the Fates of Famous Men,* translated from Boccaccio: the trial of the Duke of Vendôme, or the Bed of Justice. 1458. Bayerische Staatsbibliothek, Munich (Cod. gall. 6, frontispiece).

Armorial of the Order of the Golden Fleece by Guillaume Fillastre: chapter of the order. 1456. Bibliothèque Municipale, Dijon.

2. PRINCELY DEVICES AND TAPESTRIES

Reference was made earlier to a miniature in Guillaume de Nangis's royal chronicles (circa 1475, p. 13), known as "The Garden of France," in which eight kings surround the Tabernacle of the Lily. This painting was done by a follower of a miniaturist known as the Master of Coëtivy, who worked for Louis XI.[5] As had occurred during the reign of Charles VII, nothing was spared to give symbols greater impact than words in a long-practiced style of political propaganda. The rivalry between the houses of Orléans and Burgundy, for instance, manifested itself as a battle between emblematic figures—a knotty club versus a plane that smoothes it.

In addition to heraldry, whose rules were complicated but rigid, there existed the more personal and flexible sphere of symbolic emblems and colors. Charles VII, for example, changed colors—as dauphin from 1419 to 1421, he wore red, white, and blue, which later became red, green, and white, the colors he sported around 1429 and during his entry into Paris in 1437. These latter colors are seen in the tapestries decorating the room of the Bed of Justice in the famous miniature in the *Munich Boccaccio*, where they are repeated again in the border frieze. This miniature, of exceptional importance, also boasts the "winged stag" motif, which was Charles VI's emblem. That surprising symbol was inspired by a miraculous incident from the legend of Clovis, who one day was guided

by the marvelous animal. It was significant that Charles VII "the Victorious" adopted the symbol dear to his father, as seen on his large banner.[6]

For it was the grand era of chivalric orders, lay confraternities that hinged on an emblem or legend, providing a vocation for members of the nobility received into their closed society. The list of orders is long and disconcerting, since an order was founded by every high-ranking noble keen on "illustriousness" (in the etymological sense of "to illustrate"). Thus in 1352, Louis of Anjou founded the Order of the Knot (or Holy Ghost of Virtuous Desire) in Naples, superbly illustrated in a manuscript that associated the tasks of his knights with the adventures of a crusade. The Order of the Garter, instituted by Edward III of

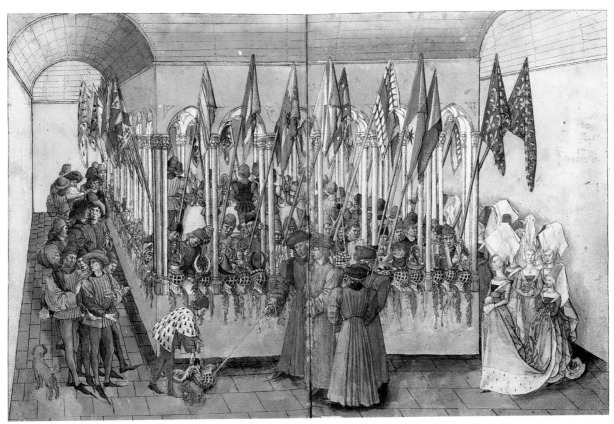

Barthélemy d'Eyck, *Le Livre des tournois* by René of Anjou: presentation in a cloister of the banners, pennants, and helmets of knights taking part in the tournament. c. 1460. Bibliothèque Nationale, Paris (Ms. Fr. 2695, fol. 67v–68).

Below: Barthélemy d'Eyck, *Heures de René d'Anjou:* the device of the *toupin.* c. 1459–1460. Bibliothèque Nationale, Paris (Ms. Lat. 17332, fol. 31).

England in 1348, perhaps owed its initial notoriety to the Countess of Salisbury's blue ribbon, but once Saint George became the order's patron saint and it adopted strict rules and magnificent ceremonial costumes, it emerged as England's great national order (Henry VIII would revise the statutes in 1522).[7]

Three of these institutions assumed particular importance in the fifteenth century: the orders of the Golden Fleece, of the Crescent, and of Saint-Michel. The Order of the Golden Fleece, which was instituted by Philip the Good in 1429, maintained remarkable ambiguity over its founding symbol, whether it was the object of the legendary quest of the Argonauts (illustrated in a famous tapestry) or the Biblical fleece that Gideon used to gather the heavenly dew (Judges 6:36–40). The bizarre and glamorous emblem was depicted everywhere. In an *Armorial*, or Book of Heraldry, dating from 1456, the order's members were displayed in all their heraldic splendor. Guillaume Fillastre's history of the order (1492–1498, Bibliothèque Nationale, Fr. 138) includes an illustration of a meeting of the order in which the "valiant knights" flank Charles the Bold— the frontal, well-ordered composition is inevitably compared to the somewhat earlier depiction of the Order of Saint-Michel.

The appropriation of figurative symbols was accompanied by the adoption of saints. Burgundy claimed Saint Andrew as patron, the French monarchy adopted Saint Michael, and Anjou chose Saint Maurice. This process yielded numerous coded

Passio Mauritii et sociorum ejus: chapter
of the Order of the Crescent Moon. 1453.
Bibliothèque de l'Arsenal, Paris
(Ms. 940, fol. Cv).

associations in religious as well as secular
imagery. The great expert in this field was
King René of Anjou (1409–1480)—just
studying his blazons illustrates the diversity
of his connections.[8] He emerges as the
greatest and most amazing representative
of what was the final salute to the chivalry
of yore. A nostalgic note marked all René's
undertakings and all were rendered in
imagery of superior quality. *Le Livre des
Tournois*, a treatise on tournaments, docu-
menting customs and devices, includes a set
of large watercolor illustrations of great ele-
gance, executed by Barthélemy d'Eyck and
not by René himself, as was once believed.

René, the son of Louis II of Anjou and
Yolande of Aragon, had to divide his atten-
tion among the highly diverse lands that
had fallen to him by the circumstance of
inheritance and which he subsequently lost,
one by one, through lack of resources,
political support, and military skill (making
him the antithesis of his cousin, Louis XI of
France). René first tried to defend his

duchy of Lorraine against the duke of Bur-
gundy, another cousin, but he lost the bat-
tle and was imprisoned in the ducal palace
in Dijon by Philip the Good in 1431, the
same year that Joan of Arc was burned at
the stake in Rouen. He then became duke
of Anjou and Provence after the death of
his elder brother in 1434. Finally, upon
inheriting Italian lands from Queen Jeanne
and the House of Anjou, René took the
title of king of Naples and Jerusalem in
1435, which led to several unsuccessful
attempts to install his court in Naples. His
Neapolitan adventures at least enabled him
to bring to France a local sculptor and
medal engraver, Francesco Laurana, and
perhaps a painter; as a mobile aesthete and
art patron, René served as a link between
north and south, Burgundy and Italy, at a
time when the shifting pattern of kingdoms
encouraged political dreams such as those
pursued by Charles the Bold or the House
of Anjou.

Being an enthusiast for heraldic
devices, René demonstrated exceptional
inventiveness in what would later be
termed "discourse shaped by enigmas."
Walls, manuscripts, and stained-glass win-
dows were adorned with symbols that
served as the good king's poetic signature,
which varied depending on his mood: a
truncated stick, a shoot with new leaves, a
chaplet, a foot warmer, a "turquoise" bow
with broken string. These symbols are not
always easy to decipher. On a medal exe-
cuted by an Italian artist in 1461 and in the
margin of a manuscript from the same
period, there appears a *toupin*, a tool used
by rope makers in Angers; given the
accompanying motto "In One," the cryptic
meaning must be political, alluding to
René's weaving together of disparate lands
like strands of rope.[9] His active imagination
compensated for the uncertainties of exis-
tence—the king must have surprised the
Florentine Pazzi family with the escutcheon
he granted them, composed of an obscure
rebus superbly preserved in a multicolored
ceramic (Victoria and Albert Museum).

When René, as an archivist of bygone
chivalry, founded the Order of the Cres-
cent in 1448, he was probably paying
homage to the originator of such institu-
tions, Charles of Anjou, who had placed a
crescent and two stars over his own
escutcheon when founding the Order of
the Moon in 1268. René's Order of the
Crescent established its altar at the church
of Saint Maurice in Angers in 1451. Cere-
monial dress was declared to be a crimson
cloak, gray gown, and black hat, with
under the right arm an enamel heraldic
crescent bearing in blue the motto "loz en
croissant" (Praise that Waxes). The
emblem adorned countless manuscripts
and ornaments. The Venetian senator
Antonio Marcello was a member of the
order, and in 1453 he sent King René the
gift of a book, *Passio Mauritii et sociorum
ejus*, which includes a depiction of the
assembled order, comparable to those of
the Golden Fleece and Saint-Michel.[10]

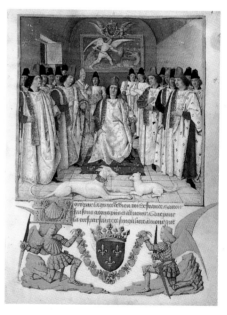

Jean Fouquet, *Statutes of the Order
of Saint-Michel:* the king and the first fifteen
knights nominated to the order.
1470. Bibliothèque Nationale,
Paris (Ms. Fr. 19819, fol. 1).

Studio of Pasquier Grenier, *Woodcutters.* Tapestry.
Tournai, c. 1464. 315 × 495 cm. Musée des Arts décoratifs, Paris.

The Order of Saint-Michel was founded 1469 by Louis XI partly in response to the lavish Burgundian order. The first chapter was convened in Amboise in 1470, as depicted in a balanced and sober miniature by Jean Fouquet, featuring fifteen nobles in ceremonial ermine robes, wearing the order's neck chain with distinctive shell. Saint Michael was doubly suited to be the patron saint of France. Not only did the shining figure of the archangel who "turned the demon out of heaven" resemble that of a knight, but Mont-Saint-Michel, off the coast of Normandy (a famous place of pilgrimage, and origin of the shell symbol), had "always been surely saved, preserved, and defended, never subjugated," an allusion to the island's victorious resistance to English occupation. The order was therefore regularly associated with French national celebrations, and became affiliated with the Order of the Holy Ghost founded by Henri III.

The Splendor of Tapestries

A tapestry called the *Baillée des Roses* shows figures in a rose garden against a backdrop of red, green, and white bands, the colors of Charles VII, which suggests a date of around 1440. Tapestries were a key item of furnishing and featured prominently in the artistic revival of the mid-fifteenth century. But our knowledge of production methods remains approximate, so although the use of tapestries was widespread in French royal domains and in the duchy of Burgundy, it is difficult to be precise concerning the origin of the cartoons that provided initial designs.

There is no longer any point in referring to Parisian or Loire workshops, for the former had ceased production and the latter never existed. There simply were no fixed, well-implanted establishments supplying on demand.[11] Weaving was almost always Flemish, but the organization of labor might include French artisans. In fact, production of this major domestic item was in the hands of entrepreneurs like Nicolas Bataille (mentioned in 1400) and Pasquier Grenier (who supplied ecclesiastical tapestries to Philip the Good in 1461). It was Grenier who furnished the strange "rustic" *Woodcutters* tapestry in red and blue. Woven in the Tournai region, dated circa 1464, it depicts woodcutting activities with uncommon descriptive vitality. It is perhaps of French design—who can say?

Whether commissioned in advance or not, tapestries presuppose a composition

L'Histoire du fort roy Clovis (detail). Tapestry. Mid-fifteenth century. Cathedral Treasury, Palais du Tau, Reims.

Right: *La Baillée des roses* (detail). Tapestry. c. 1440. The Cloisters, The Metropolitan Museum of Art, New York.

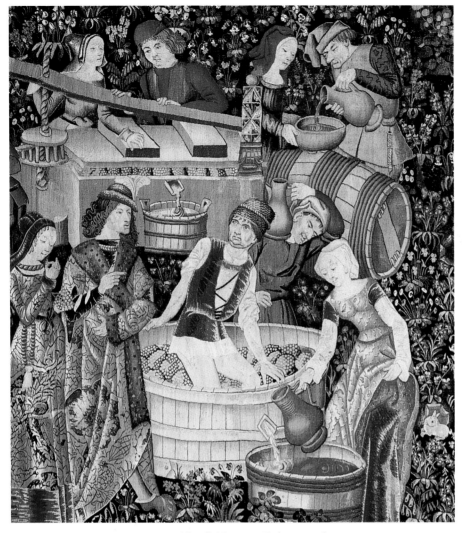

Grape Harvesting (detail). Tapestry. Early sixteenth century.
Musée national du Moyen Âge, Paris.

donations or episcopal commissions. A complete list would be incredibly long. At Reims, the six-tapestry cycle of the legend of King Clovis, apparently donated to the cathedral by Philip the Good, provides a detailed illustration of France's national legend. The principle was one of contiguous tableaux crowded with figures, free of all perspective, in a lively juxtaposition of colors, gold thread, and inscriptions that rendered legible these delightfully teeming compositions. There were, however, exceptions to the rule. In 1474, Cardinal Jean Rolin commissioned a tapestry on the *Life of the Virgin* for the collegiate church in Beaune; its lighter, less dense style was based on cartoons by Pierre Spicre (or Spicker), a Dutch artist working in Burgundy. Large hagiographic tapestries were very costly and were always specially commissioned. Courtly or romance compositions, on the other hand, might be produced in several copies, using stereotyped models of men on horseback and ladies in finery. Only details of dress permit the attribution of a date, for fashion changed swiftly and produced a wealth of droll and unusual features. The hennin (or conical headdress) that had been so pervasive around 1400 had disappeared; embroidered, padded hems evolved; late in the

that might be borrowed from a painter or developed by a designer, who produced the cartoon. The heddles of the loom could only be set up by weavers with the help of the cartoonist, who supervised the full-scale transfer of the model. In a certain number of cases, it has been established that French artists were involved; thus a Parisian heir to the Master of Coëtivy has been credited with the *Lady and the Unicorn* series. Others may have adapted items destined for French clients, although the major cycle of ten tapestries depicting *The Life of Saint Peter*, commissioned in 1460 by the bishop

of Beauvais (now dispersed, eight still belonging to Beauvais Cathedral), was directly or indirectly based on a work by the Flemish artist Jacques Daret (circa 1403–circa 1468).

It is not too far off the mark to relate the art of "princely devices" to the numerous hagiographic tapestries installed in major churches during the fifteenth century. They were probably placed on walls to provide warmth and protection, just as in private residences, but they also brought honor and prestige. Indeed, they were almost always the product of princely

Lady Rohan at the Organ (detail).
Tapestry. Late fifteenth century.
Cathedral Treasury, Angers.

The Life of Saint Peter: vision of Saint Peter, the baptism of Cornelius, Saint Peter imprisoned by Herod.
Tapestry. 285 × 338 cm. c. 1460. Beauvais Cathedral.

century, slashes in footwear became fashionable. An amusing and colorful tapestry of *Grape Harvesting* dated to that period, shows peasants in red or blue tunics working under the gaze of fine ladies in reddish brown gowns.

Throughout the entire period, figures in tapestries were always shown in contemporary dress—subjects from the Gospels or historical events were illustrated with gentlemen wearing breeches and ladies in brocade gowns. Indeed, this great epoch of tapestry coincided with the rise of textile artistry in the manufacture of garments.

These vital industries could not tolerate historic dress, which would have situated images in some distant past. Everything had to be up-to-date.

The six tapestries in the *Lady and the Unicorn* series (p. 25) were discovered by writer Prosper Mérimée (1803–1870) in the Château de Boussac, made famous in 1844 by George Sand's novel *Jeanne,* and acquired by the Musée de Cluny (now Musée national du Moyen Age) in 1882. Woven in wool and silk, with no gold or silver thread (which means that it was not an exceptional commission), the series is

one of the most remarkable and certainly most famous tapestries from the period. Against a red ground dotted with floral motifs is a flowery platform on which appears a lady, flanked by a heraldic lion and unicorn. She changes in dress and pose to symbolize the five senses, each invoked in turn. In the central panel, under a tent struck with the motto "A mon seul désir" (To My Only Desire), she returns jewels to a chest. Everything here accords with aristocratic custom; the coat of arms figuring in each piece belongs to the Le Viste family, so the cycle might have been a wedding

Master of the Hunt of the Unicorn, *Hunt of the Unicorn:* the unicorn defends itself.
Tapestry. 368 × 400 cm. 1480–1510. The Cloisters, The Metropolitan Museum of Art, New York.

present from Antoine or Jean IV Le Vistre to a fiancée. It was probably produced in a Paris workshop, which must have produced other pieces such as the magnificent *Hunt of the Unicorn.* The sumptuous tapestry exhibits the same light, elegant style but provides a dynamic counterpart to the more hieratic tapestry in Paris. This constitutes a typically French ensemble, particularly if the artist who drew the cartoons was

heir to the Master of Coëtivy, documented as being active in Tours and Bourges. That would date them to roughly 1480–1490.[12]

Countless tapestries depicting scenes of courtship and noble pastimes described in fifteenth-century poetry are set against backgrounds of wild flowers (notably in narrative scenes), which often took the particular form of dense, vertical floral patterns on blue, green, or even red grounds.

One of the finest examples of these millefleur designs is the large tapestry called *Lady Rohan at the Organ* (Angers Cathedral). Princely art found its purest expression here, for the themes presented in these mobile, graceful furnishings are the same as those found a century earlier, in the days of Gaston Phébus: courtship, hunting, war. Yet they heralded developments that would usher in a new age.

3. PRE-RENAISSANCE ALONG THE LOIRE

The vicissitudes of politics had led to an unusual concentration of royal authority in the Loire Valley. This was a golden age for a region stretching from Bourbon and Berry to Brittany—the abundant, original, and sustained artistic production over three-quarters of a century yielded what could be called the "Central France" style. Jean Lafond's description of fifteenth-century stained-glass production as a "magnificent chain of regal works that started at the Rhone and ended in Brittany"[13] is equally valid for painting, especially for manuscript miniatures (the wealth of which has not been completely revealed even after a century of historical research).

The artistic heritage established by those famous miniaturists, the Limbourg brothers, did not evaporate all at once. Upon the death of the duke of Berry in 1416, several manuscripts he had commissioned remained incomplete, notably the *Seilern Hours* (private collection), similar to

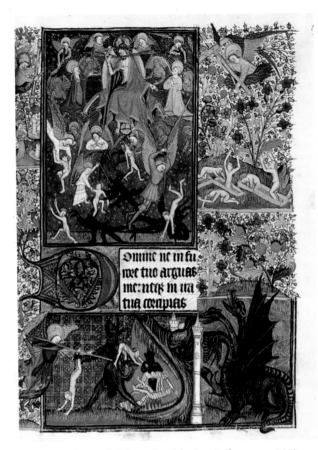

Heures de Jean de Montauban: The Last Judgment. c. 1440. Bibliothèque Nationale, Paris (Ms. Lat. 18026, fol. 136).

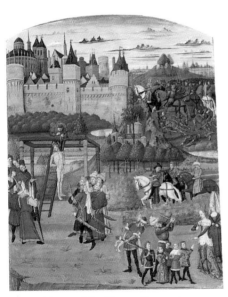

Master of the Geneva Boccaccio, *Mare historiarum* by Giovanni Colonna: scenes from the history of King Aristonicus, the Gracchi, Queen Laodice, and others. 1453–1458. Bibliothèque Nationale, Paris (Ms. Lat. 4915, fol. 149).

the duke's *Belles Heures* (circa 1409, The Cloisters, New York, Acc. 54.1.1) and a miscellany of *Antiquités judaïques*, which Jean Fouquet completed fifty years later by painting a series of historical scenes set in marvelous landscapes. Lessons learned in the Limbourg studio had been assimilated by a certain number of artists who remain anonymous, their work usually identified by the name of their patron, since mention or a personal symbol of ownership was far more common than any reference to the name of the artist. Three such artists stand out, the others who gravitated around them being less easy to distinguish. First there is the Master of the Duke of Bedford Hours, who illuminated a densely populated prayer book for the duke, at the time English regent in Paris (British Library, London, Add. Mss. 18850). Then there is the

Boucicaut Master, remarkable for the quality of the interiors in the miniatures he contributed to a book of hours commissioned by the Maréchal de Boucicaut (Musée Jacquemart-André, Paris, Ms. 2). A third Parisian painter, with whom the other two seem to have worked for a time around 1420, later freed himself from commercial constraints by entering the service of Yolande of Aragon, widow of Louis II of Anjou. He illustrated a book of hours for her in a style of unparalleled intensity (circa 1420–1425, Bibliothèque Nationale, Lat. 9471). Because this manuscript was later owned by the Rohan family, the artist is known today as the Master of the Rohan Hours. The surprising forcefulness of the eleven full-page miniatures in this large volume (29 × 20 cm), especially evident in the Last Judgment and the Pietà, does not

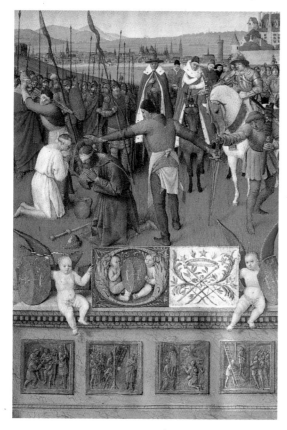

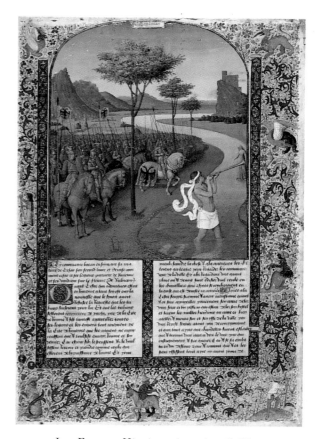

Jean Fouquet, *Heures d'Étienne Chevalier:*
the martyrdom of Saint James the Great. c. 1452–1460.
Musée Condé, Chantilly (Ms. 71, fol. 32).

Jean Fouquet, *Histoire ancienne jusqu'à César
et Faits des Romains:* Caesar crossing the Rubicon. c. 1475.
Musée du Louvre, Paris (R.F. 29493).

Below: Jean Fouquet, *Hours of Simon de Varie:* emblems and coat of arms
of Simon de Varie. c. 1455. The J. Paul Getty Museum, Malibu (Ms. 7, fol. 2v).

preclude the use of delicate colors, such as the pale pink of the Virgin's cloak or the gold-spangled background against which the angels are set. The Rohan Master was the most anguished artist of the century. Several other books of hours reflect the tradition of the Rohan workshop, such as the one executed for Admiral Jean de Montauban (circa 1440).

Charles VII did not build a great deal, nor did his son Louis XI. Their construction was primarily political rather than architectural. But tradition required that they retain painters at court, who acted as "personal valets" monitoring everything that entailed decoration and display. Documents of the period mention the names of Flemish painters whose exact role has yet to be determined; one of them, Jacob Littemont, was probably responsible for the elegant angels decorating the vaults of the chapel in the residence of Jacques Cœur in Bourges. The master swiftly adopted the French idiom if, as has been suggested, he also provided the cartoon for the admirable stained-glass window of the Annunciation in Bourges Cathedral.

Another painter active in Tours and Bourges was Henri de Vulcop (or Villecocq). He was formerly thought to be the anonymous Master of Coëtivy, an artist whose work was widely imitated (the "Garden of France" and cartoons for unicorn tapestries have already been cited as examples).[14] Another, probably important, figure was the Master of Jouvenel des

Ursins, known for a manuscript called *Mer des Hystoires* (circa 1448–1449, Bibliothèque Nationale, Lat. 4915), written for the chancellor of France. Several historical and religious books were produced by the master's workshop. His style is somewhat Flemish in tonality, while being sharper and tauter than that of Jean Fouquet, with whom he has sometimes been confused. Along with Fouquet and the Master of King René, the Master of Jouvenel des Ursins dominated French miniatures in the mid-fifteenth century.[15]

Certain names have survived through sheer luck, like that of Master Paoul Goybault (or Grymbault), cited as the artist who painted the chapel of Châteaudun (between 1461 and 1468), including a large Last Judgment featuring an azure ground that makes the warm colors of the celestial court come alive. The full forms and clear composition are typical of art from the Loire Valley, yet the influence of Enguerrand Quarton (or Charonton) has also been detected, despite the poor condition of the work. Paoul, therefore, like Quarton, may have been a painter from Provence.[16]

JEAN FOUQUET (CIRCA 1420–1480)

Jean Fouquet of Tours was the prince of pre-Renaissance painters, for his art represents the most convincing and efficient fusion of the component elements of Western art of the day, and his oeuvre conveys an unmistakably "French" tone. At a period when what would be called the French nation was just emerging, Fouquet's miniatures and a few surviving panel paintings betrayed a fine yet firm presence, ingenious yet serene, unmatched elsewhere. But his name is known almost by chance, thanks to François Robertet, secretary to Duke Pierre II of Bourbon, who felt it appropriate to inscribe at the end of the *Antiquités judaïques* "good painter and illuminator to King Louis XI, Jehan Foucquet, a native of Tours." Without Robertet's note, Fouquet would probably be known today as the Master of Étienne Chevalier,

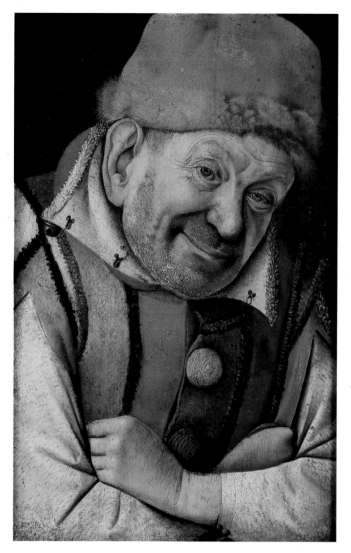

Jean Fouquet, *Portrait of a Fool*. c. 1444. Oil on panel, 36 × 24 cm. Kunsthistorisches Museum, Vienna.

alluding to a book of hours that predates the *Antiquités judaïques* (circa 1470) by several years and is marked by a rigorously beautiful and totally new vision of religious history.

Born around 1420 and trained, it is assumed, by followers of the Limbourg brothers (perhaps the Bedford Master), Fouquet found himself in Rome in 1447 and was invited to paint the portrait of Pope Eugenius IV (lost, now known from engravings). He had evidently arrived in Rome as a representative of northern art, appreciated for its depiction of the human face. At the same moment, Fra Angelico was decorating the chapel of Nicolas V at the Vatican. Decisive contact and exchange occurred between the young French artist and the fresh, clear art of the master of the early Tuscan Renaissance. Fouquet's famous portrait of Charles VII—sad, weary face, broad shoulders framed by curtains—perhaps predates his trip to Rome. But every page from the book of hours commissioned by treasurer Étienne Chevalier (unfortunately dispersed in the eighteenth century, and now reduced to forty-seven pages) exudes ingenious mastery of the

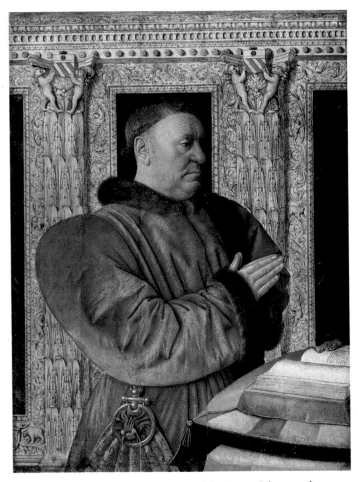

Jean Fouquet, *Guillaume Jouvenel des Ursins.* Oil on panel.
c. 1460. 96 × 73 cm. Musée du Louvre, Paris.

(p. 68) that functioned as a paradigm thanks to the royal authority it illustrates through a strong, diamond-shaped composition and magisterial distribution of figures (*Munich Boccaccio*). Another frontispiece, to the aforementioned statutes of the Order of Saint-Michel (p. 70), may have been painted when the order was founded in 1469 but was more probably executed during the first chapter meeting in 1470; it demonstrates once again Fouquet's striking mastery of the placement of individualized figures in a clearly unified space. As part of his services to the king, Fouquet also organized the decorations and settings for court festivities and ceremonial entries.

Fouquet headed the studio that painted the miniatures for the Boccaccio translation, and he himself provided five recently identified miniatures for a small book of hours commissioned by Simon de Varie.[17] He might have supplied cartoons for stained-glass windows and was also an

construction and arrangement of forms. Fouquet henceforth completely mastered all the problems posed by painting.

Following on from his new Christian imagery, Fouquet executed fifty-one miniatures for the *Grandes Chroniques de France* (1455–1458), a history of royal rituals over the centuries. Like the text, the images concern only rites of coronation and ceremonial entries, handled with a calm firmness all the more impressive for being unprecedented. Fouquet undertook yet another task—the depiction of crowds—in *Antiquités judaïques* (circa 1470), begun for the duke of Berry. It was as though, in illustrating the text of first-century historian Flavius Josephus, Fouquet was consciously

employing Biblical events to illustrate the history of a chosen people. In square groups, the children of Israel move, divide, and do battle across the most stable, best ordered landscape in the world—namely, the landscape around Tours. The miniatures that survived from a miscellany on ancient history and the deeds of the Romans (circa 1475) are somewhat posterior; on its large vellum pages Fouquet developed a truly epic style. His Crossing of the Rubicon might almost be a fresco (Musée du Louvre, Paris, R.F. 29493).

Meanwhile, in 1458 Fouquet had provided a frontispiece for a translation of Boccaccio's *On the Fates of Famous Men*, depicting a scene of the Bed of Justice

Jean Fouquet, *Guillaume Jouvenel des Ursins.*
Black chalk with colored chalk highlights.
c. 1460. 26.7 × 19.5 cm. Kupferstichkabinett,
Staatliche Museen, Berlin.

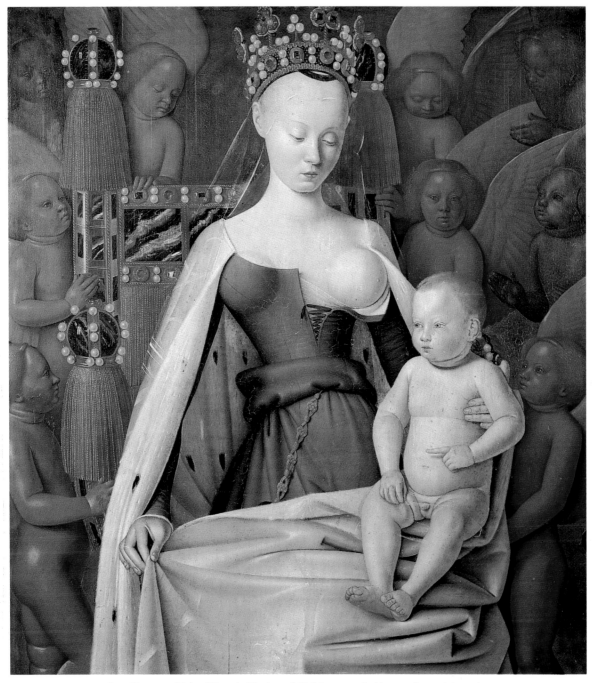

Jean Fouquet, *Melun Diptych:* Virgin and Child surrounded by angels. c. 1450–1460.
Oil on panel, 91 × 81 cm. Koninklijk Museum voor Schone Kunsten, Antwerp.

easel painter—a portrait of a fool (perhaps the jester of the king of France) has been attributed to him (circa 1444). A diptych, painted circa 1450–1460 as a complement to the *Heures d'Étienne Chevalier,* was long kept at Melun but is now divided between Antwerp and Berlin. The right panel depicts an extraordinary Virgin and Child—a geometric distillation of feminine beauty against a background of red and blue angels—while the left panel (Staatliche Museen, Berlin) shows Étienne Chevalier and his patron saint in a setting of receding classical architecture. It might be wondered how two panels so original and so different could have been displayed together. The answer probably lies in the unusual importance of the frame, which

Jean Fouquet, *Heures d'Étienne Chevalier:*
Saint Martin. c. 1452–1460.
Département des Arts graphiques,
Musée du Louvre, Paris (R.F. 1679).

was covered with blue velvet and silver embroidery, and featured medallions. Two of these medallions are known, although only one survives : a precious piece of black enameling painted in gold with the artist's portrait and name—an extremely rare practice for the time. Finally, there is the portrait of Jouvenel des Ursins (circa 1460), his heavy face set against a background that is simultaneously geometric and fanciful. The head was the object of a preparatory study, drawn on gray-blue paper in the Italian manner, yet employing several colors of chalk—white, reddish brown, and black—which seems to have been a new approach specific to Fouquet himself.

Fouquet also painted altarpieces. Florentine writer Francesco Florio claimed that Fouquet produced *imagines sanctorum* in 1478 for Notre-Dame-la-Riche in Tours (Florio may have been referring to stained glass, but it is unlikely), and an archbishop of Tours planned to commission an Assumption from Fouquet around 1466. Only one retable survives, discovered as

late as 1931 in the church of Nouans-les-Fontaines, but nothing is known of its provenance or white-robed donor pictured on the right. Despite its poor condition, there is no longer any doubt about the painting's attribution, given the simple rigor of the forms, the beauty of the whites, and the almost sculptural strength and serenity of the group set off from the rest of the world by a sober background.

This inevitably incomplete catalogue is nevertheless striking. Fouquet innovated in every sphere. In the miniscule vellums of the *Heures d'Étienne Chevalier* he developed two-tiered compositions featuring a horizontal divide—in the foreground, heraldic creatures flank a panel that bears the initial letter of the text and serves as a repoussoir into the deeper space, where the carefully studied episode is elaborated. Fouquet mastered the use of diamond-shaped compositions, which he particularly liked and which distinguish French taste from oblique Flemish forms and straightforward Italian perspective—his *Saint Martin* on horseback (Musée du Louvre, R.F. 1679) employs a geometric schema; the bridge, seen at an angle, becomes one side of the triangle traced by the road. The work provides a perfect and justly famous

Jean Fouquet, *Self-portrait.* Copper,
painted enamel, and gold. c. 1450–1460.
Diameter: 6.8 cm. From the *Melun Diptych.*
Musée du Louvre, Paris.

Maître François, *Book of Hours:* the Trinity,
the Virtues, and the Annunciation.
c. 1473. The Pierpont Morgan Library,
New York (Ms. 73, fol. 7).

example of French synthesis, especially since it includes, as always, references to everyday life (contemporary dress, wooden houses, cobbled street).

Two divergent aspirations were thereby fulfilled: the fully integrated deployment of representation in a fictive yet coherent space as sought by painters, and the monumentality to which sculptors aspired. This achievement perhaps stemmed from Fouquet's great experience in the tiny format of miniatures. He also addressed other, more general problems of representation, such as individual versus crowd, past versus present. The two main elements of overall layout—landscape and architecture—were defined, characterized, mastered, and endowed with rare poetic feeling by Fouquet. No literary author, even the greatest among them, was able to manage so many things at once. Everything seems included here, thanks to the relationship established between figure and form.

A look at framing devices used by Fouquet in the years 1460–1470 points in

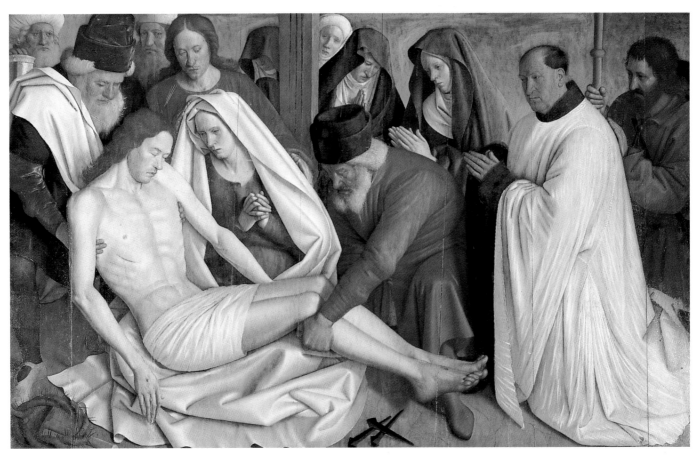

Jean Fouquet, *Pietà de Nouans*. c. 1450–1460. Oil on panel, 146 × 237 cm.
Church of Saint-Martin, Nouans-Les-Fontaines.

the same direction—sometimes they followed the scrollwork tradition conducive to a range of fanciful details but increasingly reliant on floral motifs and patterns; sometimes they more or less freely adapted a Donatello-style architectural framework (say, the Cavalcanti tabernacle at Santa Croce, Florence); and sometimes they employed a thin border, or edging, to detach the "painting" from the page (as in the *Le Cuer d'amour espris,* pp. 27 and 96).

It is easy to see why it has been claimed that Fouquet's art "put an end to the analytic and fragmentary vision"[18] typical of the Gothic Middle Ages, and why it "took traditional French pictorial forms to their logical conclusion."[19] One need merely add "plastic forms" to "pictorial

forms," as art historian Henri Focillon recommended, to realize that painterly style was henceforth focusing on immutable problems. Focillon wisely excluded Fouquet's œuvre from the sphere of medieval miniatures. As precious and, it would seem, as indispensable as the strict framework of the page may have been to Fouquet's virtuosity, it can hardly be doubted that his paintings actually took precedence over the putative reason for the manuscript, namely the written text.

Fouquet's death in 1481 came too soon, much too soon. He left behind him a school of manuscript painters. His son François, who had collaborated on certain manuscripts, has sometimes been mistakenly identified with the Maître François

who around 1473 illuminated an undistinguished copy of Saint Augustine's *City of God* (Bibliothèque Nationale, Fr. 18–19). But the same *egregius pictor Franciscus* has been credited with a fine book of hours from roughly the same date, featuring some rather virtuoso two-tiered scenes employing foreshortened *sotto in sù* perspective.

Along the same lines, though without the masterful qualities attributed to Fouquet, there is the abundant if uneven production of Jean Colombe (circa 1400–circa 1493). The *Hours of Louis de Laval*, for instance (circa 1485, Bibliothèque Nationale, Lat. 420), teems with small pictures executed by various hands; and when Colombe tried to innovate, he only rendered the compositions clumsier, as seen in

Master of Charles of France, *Hours of Charles of France,*
The Annunciation: Virgin. c. 1465. The Cloisters,
The Metropolitan Museum of Art, New York (Ms. 58, fol. 71).

Jean Poyet, *Missal of Guillaume Lallemant:*
Christ seated on Mount Calvary. c. 1510–1515.
The Pierpont Morgan Library, New York (Ms. 495, fol. 85v).

the *Histoire de Troie* (completed circa 1500, Bibliothèque Nationale, Nouv. Acq. Fr. 24920), in which the large paintings collapse into that picturesque jumble often typical of the sixteenth century. Colombe belonged to a family that dominated the artistic scene around 1500 thanks to the great artist and multifaceted sculptor Michel Colombe (circa 1430–circa 1515).

The golden architecture meticulously deployed by the Master of Charles of France around his evangelical scenes created a sort of enchanted forest far removed

from Fouquet's art (*Hours of Charles of France*, circa 1470, the Cloisters, New York). The exceptionally strong artist who provided sixteen miniatures for King René's *Le Cuer d'amour espris* displayed rare and positive qualities, and was attentive to tonal harmonies. If, as everything suggests, the artist was Barthélemy d'Eyck, who was in the king's employ and worked under his supervision, it raises the question of whether the illumination of René's romance occurred before or after his permanent move to Provence in 1471.

Many other miniaturists active around Tours in the years 1480–1490 abandoned Gothic habits (if only through their modeling and use of antique-style framing devices), yet most remain to be identified (one of the most interesting was Jean Poyet, a contemporary and rival of Jean Bourdichon). The artist who depicted the members of the Order of Saint-Michel flanking Charles VIII in 1493 was certainly the official artist, and his style is similar to the anonymous painter known as the Master of Moulins, who will be discussed later.

4. PRE-RENAISSANCE IN BURGUNDY

Burgundian precursors pose problems for the appreciation of fifteenth-century French art. The vast duchy of Burgundy—almost a kingdom in itself, rising to the height of its power under Philip the Good (1419–1467) before suddenly collapsing with the fall of Charles the Bold in 1477—was simultaneously part of France and distinct from it. The duchy was not only dispersed geographically, it also lacked cultural unity. Its language was French, its ideology chivalric, its poetry rich, oratorical, and torrential. Artistically, it created two lasting impressions: the sculpture of Claus Sluter, who worked in Dijon and heavily influenced the Saône and Rhône provinces, and the Netherlandish painting of Robert Campin, Rogier van der Weyden, and the Van Eyck brothers. In the second quarter of the fifteenth century, their manner of suggesting texture, modeling, and atmosphere was admired throughout the West, including Italy. This new, "modern" manner sparked reactions from painters in every land, beginning with the French workshops in the Loire Valley.

That, however, is not really the issue. The Burgundian model summed up the preceding century's aristocratic ideal on a scale and with a power unmatched by the hedonistic courts of Louis of Anjou and Charles VI. No ruler anywhere could remain unaffected by the "magnificence" of the style adopted by Philip the Good, of which the pomp surrounding the superb Order of the Golden Fleece was just one aspect. The festivities accompanying the "Vows of the Pheasant" in Lille in 1454 (designed to relaunch the Crusades) and the wedding celebrations held in Bruges for Charles the Bold's marriage in 1468 were the object of detailed descriptions by chroniclers like Olivier de La Marche and Georges Chastellain, who were responsible for recording, glorifying, and disseminating the accomplishments of artists, couturiers,

After Rogier van der Weyden, *Portrait of Philip the Good*. c. 1445.
Oil on panel, 31 × 23 cm. Musée des Beaux-Arts, Dijon.

set designers, and cooks. Decorative feats became instant legends, and huge centerpieces featured miniature castles, statues (such as the mythical serpent-woman Mélusine), and churches with working organs. Then there was the "table setting" at Bruges which, if Olivier de La Marche is to

be believed, included the forty-six-foot-high Gorcum Tower and automatons of trumpet-playing boars, flute-playing wolves, and singing donkeys—the Burgundians liked to amuse as well as amaze.

And yet Burgundian portraits, like the one of Philip the Good, are terribly serious,

with unsmiling, impassive countenances. It was only around 1500 that a less tense approach began to emerge—it took a generation or two before portraits smiled.

In a famous and still stimulating book, Dutch art historian Johan Huizinga linked all these phenomena, including the new painting, to a powerful and extravagant lifestyle.[20] He saw it as the stunning—and almost moving—conclusion to a typically medieval ardor. This view needs to be nuanced, however. Burgundian modernity was imitated even in Italy—recently discovered frescoes in the ducal palace at Mantua, painted by Antonio Pisanello toward the middle of the fifteenth century, show Arthurian scenes accompanied by French names, like those on tapestries produced in northern lands. Thanks to the spread of tapestries from Tournai and Arras, Burgundian culture reached all of Europe, stimulating a taste for a heroic wonderland of medieval romance, a taste that persisted long after the fall of the ephemeral duchy. After the political collapse, then, there survived an ongoing fiction, or blueprint, for civilization that would surface again in Tudor England, in the Hapsburg empire under Maximilian I, and in France under Charles VIII, whose accession to the throne was marked by a "chivalric" and ultimately futile Italian campaign replete with endless symbolic emblems and ornaments. In certain respects, therefore, the Burgundian model of an aristocratic lifestyle that glorified nobility, finery, and adventure should be considered as a prelude to the Renaissance—Henry VIII, Holy Roman Emperor Charles V, and Francis I, each in his own way, were heirs to this attitude.

The rich, ambitious duchy of Burgundy exhibited a marked taste for luxurious manuscripts of works by fashionable Italian authors (Petrarch, Boccaccio) and Latin historians (Livy, Valerius Maximus). The story of Julius Caesar, as recounted in the widely read anthology of texts known as *Faits des Romains*, delighted Charles the Bold. Yet it is not always clear whether or

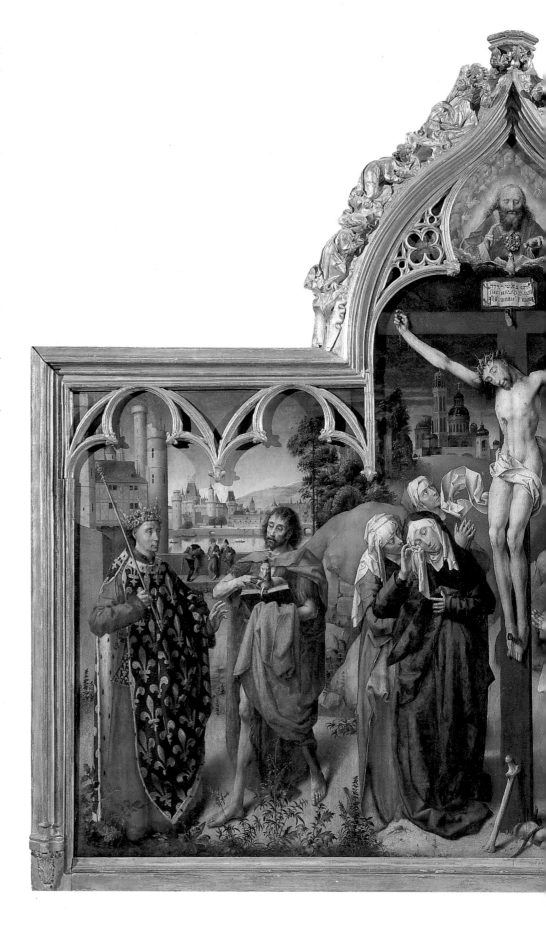

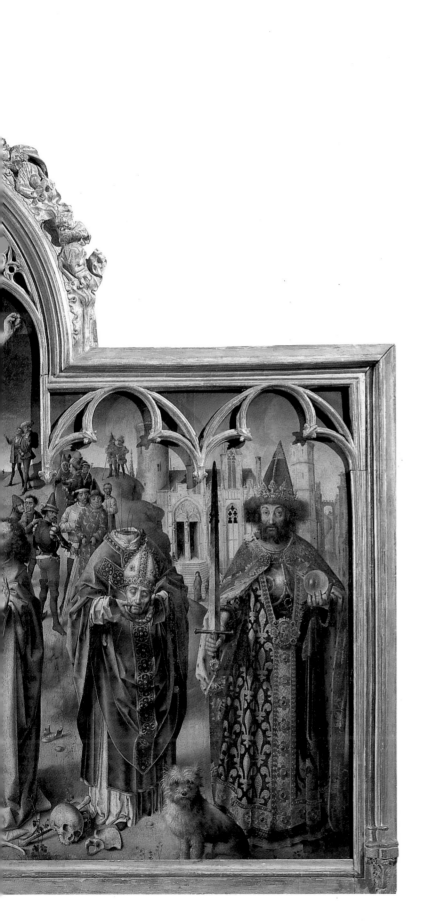

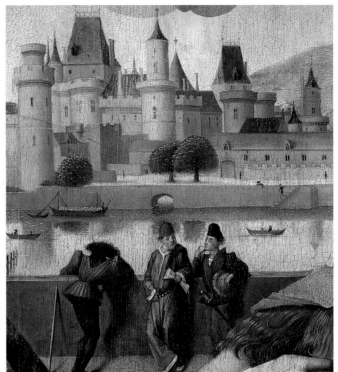

Flemish painter, *Retable of the* Parlement *of Paris,*
overall view and detail. 1453–1455.
Oil on panel, 226 × 270 cm. Musée du Louvre, Paris.

not the miniatures decorating such manu-
scripts should be classified as "French" art.
Among the countless illuminated copies of
Saint Augustine's *City of God*, Philip the
Good acquired one around 1460, for use in
Paris or Tours, that would seem to be the
work of a Parisian painter, the Master of
Guillebert de Mets (circa 1430, Biblio-
thèque Royale, Brussels). Two successive
manuscripts of Jean Miélot's *Miracles de
Notre Dame*, with grisaille miniatures of
Philip the Good praying to the Madonna
flanked by his patron saint, Philip, and
Saint Andrew, patron of the Order of the
Golden Fleece, also suggest French deriva-
tion (circa 1460, Bibliothèque Nationale,
Fr. 9198). But this is a sphere in which
such classifications are meaningless.

Two important artists illustrate this
cultural interpenetration. The first, an
anonymous Flemish artist residing in Paris
in 1454, left a famous, even key work in the
form of a retable for the grand chamber of
the Paris parlement.[21] A crucified Christ,

very much in the style of Rogier van der Weyden, is surrounded by saints associated with France—Saint Louis and John the Baptist in front of the Louvre, and Saint Denis (holding his head) next to Charlemagne in front of the Royal Palace. "It was Fouquet's example that permitted this solemn alignment, . . . this dramatic grandeur of a group around the Virgin, in which Flemish models were completely refashioned."[22]

The second artist, Simon Marmion (circa 1420–1489), lived in the northern city of Valenciennes, which at that time belonged to the duchy of Burgundy. Yet his composition and use of color are not exactly Flemish, as seen in the large *Saint Bertin Altarpiece* commissioned by Bishop Guillaume Fillastre for the cathedral of Saint-Omer (1454–1459, central section destroyed, panels at the Staatliche Museen, Berlin, and the National Gallery, London). The same applies to *The Finding of the True Cross* (circa 1460). The hybrid artist Marmion was highly active, moreover. Contemporary commentator Jean Lemaire de Belges called him the "prince of illumination" and several works commissioned by Fillastre on behalf of Duke Philip are ascribed to Marmion. Fillastre (died 1473) was a major figure in Burgundian circles, having played a key role in Burgundian Picardy as abbot of Saint-Bertin. He was also chancellor of the Order of the Golden Fleece, and wrote the great book on the order, which was illuminated with miniatures. Bishop Fillastre commissioned his own tomb from the Della Robbias in Florence during a journey there in 1463. The sculpted tomb was sent via Pisa and then transported on ships belonging to Florentine merchant Tomaso Portinari as far as Bruges, where it finally made its way to Saint-Omer. The tomb must have created a sensation, to judge from the brilliance of surviving remnants of majolica, shell-motif niches, and garlands. Precocious relations with Italy and an interest in ceramics are thus clearly attested; yet apart from these

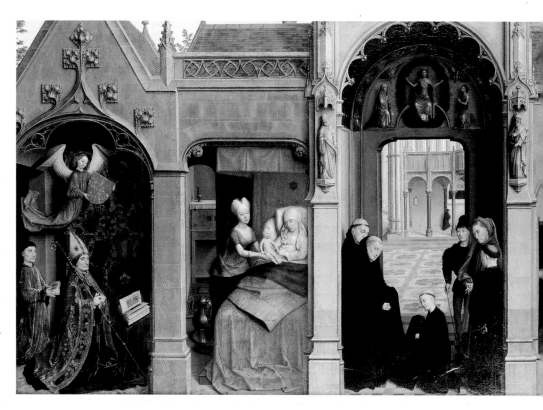

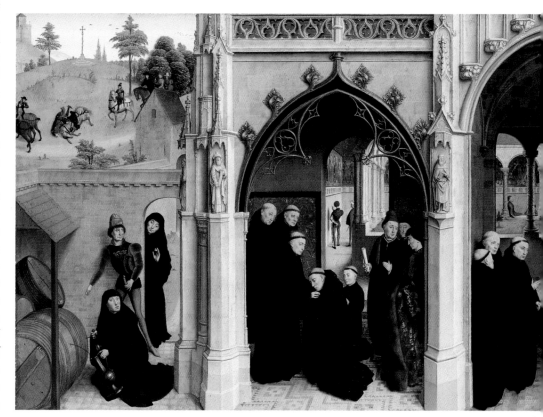

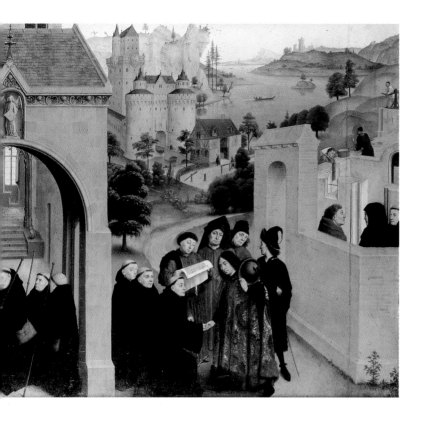

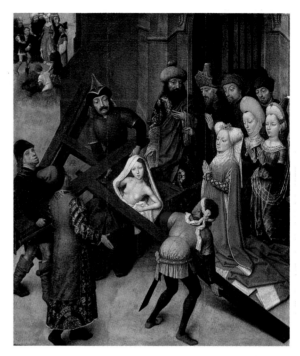

Simon Marmion (?), *The Finding of the True Cross.* c. 1460. Oil on panel, 68 × 58 cm. Musée du Louvre, Paris.

Left: Simon Marmion, *Saint Bertin Altarpiece.* 1454–1459. Oil on panel, 56 × 147 cm. Gemäldegalerie, Staatliche Museen, Berlin.

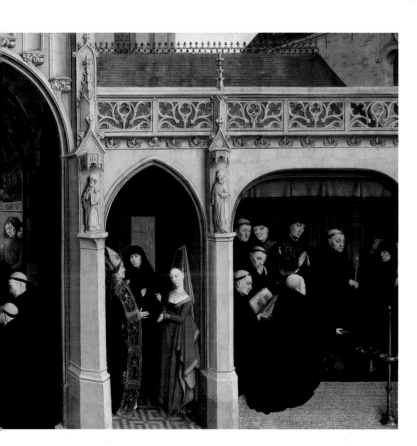

elements, the spirit of the tomb had nothing Italian about it—it depicted an Annunciation with Jeremiah and featured an allegorical skeleton near the epitaph.

There was no lack of artistic exchange. In 1450, Rogier van der Weyden made the pilgrimage to Rome as a good Christian. Jean Fouquet had also made the journey shortly before. Trade routes favored not only sea voyages to Flanders, but also overland passages across the Alps. In 1460, Bianca Maria Sforza wrote to Duke Philip to recommend a young painter, Zanetto Bugatto, who wished to work under van der Weyden. Bugatto must have gone to France because Louis XI bought a portrait of the duke of Milan from him in 1468. He was probably one of the go-betweens linking connoisseurs and studios, thereby weaving a

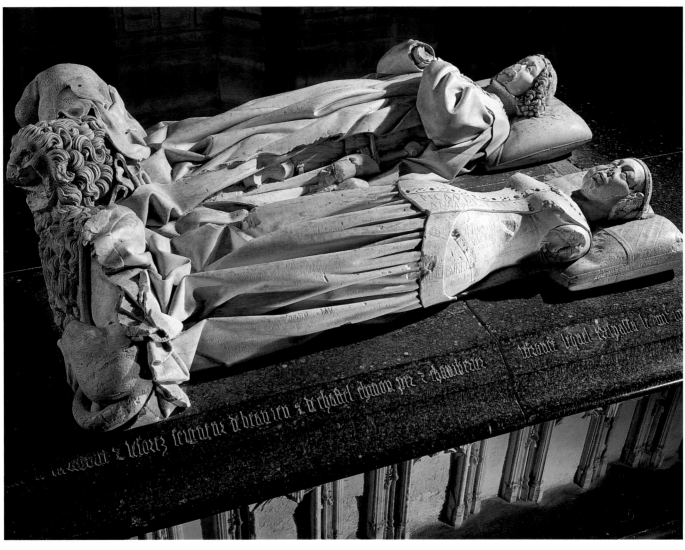

Jacques Morel and Pierre Antoine Le Moiturier. Effigies of Charles I of Bourbon and his wife Agnes, daughter of John the Fearless. 1453. Church of Saint-Pierre, Souvigny (Allier).

new pictorial culture in which the movements of artists counted a great deal.

The great Flemish artist Hugo van der Goes (circa 1440–1482) decorated the church in Bruges where the funeral service for Philip the Good and Isabel of Portugal was held in 1473—it is possible that he accompanied the solemn cortege that transported their mortal remains back to Champmol in Burgundy. Contacts of this type might explain a certain filtering of French traits into Flemish art and, more especially, the point of departure of the greatest painter (after Fouquet) active in France in the late fifteenth century—Jean Hay (or Hey), alias the Master of Moulins, whose broad, robust manner is linked to that of the artist who painted the *Portinari Triptych* (Uffizi, Florence).

The development of sculpture also merits better illustration. Burgundian production was remarkably abundant throughout the fifteenth and sixteenth centuries, although Claus Sluter's highly dramatic idiom did not survive in all the tomb sculpture and pious statues of the Virgin. Alongside local workshops, there were notable artists who migrated along the Saône-Rhône line to the rhythm of commissions; Jacques Morel (circa 1395–1459), worked at Souvigny yet also produced a tomb for King René at the church of Saint-Maurice in Angers. Morel's nephew, Pierre Antoine Le Moiturier, was summoned to execute the tomb of John the Fearless in 1464. If he were also the sculptor of Philippe Pot's tomb around 1480 (p. 61), then in that flash of genius he composed a superb visual funeral march for Burgundian knighthood.

5. PRE-RENAISSANCE IN THE SOUTH

Provence, which was not yet part of the royal domain, remained, by and large, free of disturbances, though less so than is generally believed, since the authorities deemed it necessary to erect the powerful fortress at Tarascon, near Arles. Provence fell to the House of Anjou by the bequest of Queen Jeanne of Naples, along with her Italian kingdom, creating an unusual political entity divided into three geographical areas: along the Loire, on the Rhône, and, theoretically at least, on the shores of the Tyrrhenian Sea. This axis turned out to be of considerable import for the history of art at a time of incessant traveling back and forth.

The hero of the story was King René, lord of a hundred vicissitudes who was also poet, aesthete, occasional painter, and enthusiastic connoisseur. Divided between his domains, he was driven from Naples in 1442, but not before he came into contact with the sculptor Francesco Laurana (1430–1502), whom he later summoned to his service. René also showed up in Lorraine, then resided in Angers, only to settle finally, after 1471, in Aix-en-Provence.

Laurana's importance should not be overstated. His carved retable of *Christ Bearing the Cross* for the church of Saint-Didier in Avignon, a late work, is heavy-handed and disappointing. At the cathedral of Marseille, the Saint-Lazare Chapel, with its arcades set on two pilasters at either end and a column in the middle, is little more than a fine demonstration of antique-style forms with additional ornamentation suited to French taste. But Laurana was also a medal maker, and his portraits of René, in competition with those of another medal maker, Pietra da Milano (active 1450–1460) are by no means negligible.

Provence did not await the advent of King René to produce paintings midway between the historically ineluctable poles of vigorous Flemish objectivity (modeling, minutely analyzed objects, strong shadows, etc.) and airy Italian spatial precision. This meeting of north and south has led historians to make vacillating attributions concerning a triptych commissioned by a merchant named Pierre Corpici in 1443 for Saint-Sauveur Cathedral.[23] The work in question comprises an Annunciation and two prophets (central panel now in the church of the Madeleine, Aix-en-Provence, side panels divided between the Musées royaux des Beaux-Arts, Brussels, and the Boymans-van Beuningen Museum, Rotterdam). Corpici probably turned to a local painter—perhaps even two painters, given the distinct differences between the central section and the side panels. Unless, of course, it was executed by a southern artist who reportedly served as master to Enguerrand Quarton and as mentor to King René himself—that is to say, Barthélemy d'Eyck.

Francesco Laurana, *Christ Bearing the Cross*. 1479-1481. Carved retable. Church of Saint-Didier, Avignon.

Barthélemy d'Eyck (?), *Triptych of the Annunciation of Aix,* central panel: The Annunciation. 1443–1444. 155 × 176 cm. Church of La Madeleine, Aix-en-Provence.

Right: Barthélemy d'Eyck (?), *Triptych of the Annunciation of Aix,* right panel: The Prophet Jeremiah. 1443–1444. 152 × 86 cm. Musées Royaux des Beaux-Arts, Brussels.

Barthélemy d'Eyck, *Heures à l'usage de Rome:* Virgin and Child. c. 1440–1450. The Pierpont Morgan Library, New York (Ms. 358, fol. 20v).

Indeed, consideration of contemporary miniatures has shifted the basic assumptions of the problem. A brilliantly colored book of hours, with margins of scrollwork and drolleries (circa 1440–1450), has been fruitfully compared both to the œuvre of the young Quarton and to the famous *Annunciation* triptych. Another manuscript, dated 1466 (Bibliothèque Nationale, Nouv. Acq. Lat. 2661), composed for Chancellor Jean des Martins, contains scenes of a great maturity of style that invite comparison, this time, with Quarton's *Coronation of the Virgin* in terms of the size of the folds in the cloaks, a certain hardness in the setting, the tense features on the faces.[24] As clues begin falling into place, Provence assumes an increasingly impor-

tant role covering the period from 1440 to the 1470s and beyond.

Alongside Quarton, Barthélemy d'Eyck merits attention. D'Eyck (or de Clerc) also belonged to King René's circle of artists, and both painters worked on a manuscript dated 1444. A global solution of the Provençal enigmas would emerge if the *Annunciation* were by d'Eyck, while other major works like the *Coronation* and the *Pietà* were attributed to the great master Enguerrand Quarton.

Quarton (circa 1415–after 1462) was born in Laon but was working in Avignon by 1447. The *Virgin of Mercy* (1452, Musée Condé, Chantilly) was commissioned from him in collaboration with Pierre Villatte; it is a wide panel in which clearly arranged

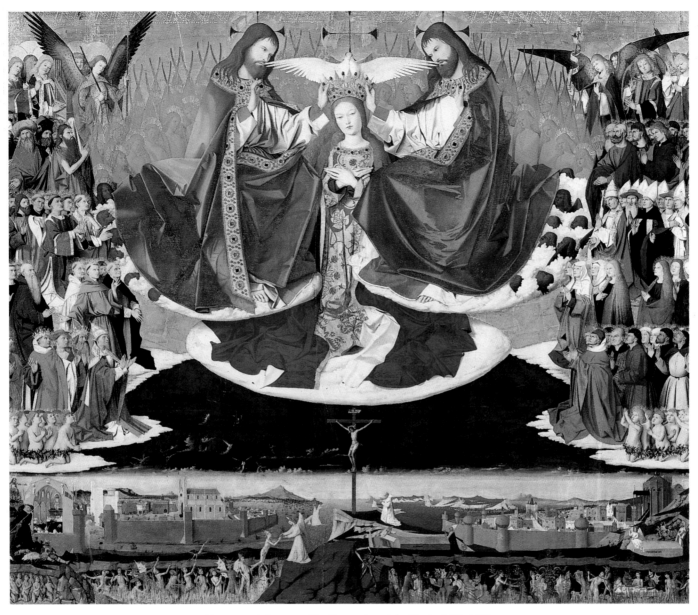

Enguerrand Quarton, *The Coronation of the Virgin*. 1453–1454.
Oil on panel, 183 × 220 cm. Musée Municipale, Villeneuve-lès-Avignon.

groups stand out symmetrically against the gold ground. This painting was immediately followed by the *Coronation of the Virgin*, for which the commissioning contract still exists (dated 24 April 1453). In it, Jean de Montagnac set out the precise content of the retable, destined for the Trinity altar in the church of the Carthusian monastery in Villeneuve-lès-Avignon. Rarely were plans so detailed: above the earth (repre-

sented by the cities of Rome and Jerusalem flanking a crucifixion scene) was a celestial coronation in which the Father and Son of the Trinity had to be strictly identical. Below the earth, meanwhile, Purgatory and Hell were to be depicted. All details were not necessarily carried out to the letter, but the two large red cloaks of the divinity below a gold band, underscored by the deep blue of the sky, lend surprising

authority to the composition, just as the highly detailed rendering of the lower register, like a predella, is the work of a virtuoso who might have been a miniaturist. This magistral orchestration, with no equivalent either in Flanders or Italy, displays a finesse and monumentality that must, in short, be labeled French.

The Villeneuve-lès-Avignon *Pietà*, for which neither date nor artist has been

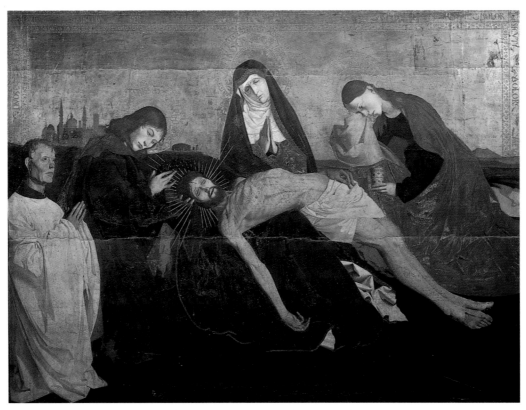

Enguerrand Quarton (?), *The Pietà of Villeneuve-lès-Avignon.*
Oil on panel. c. 1455. 163 × 218 cm. Musée du Louvre, Paris.

definitively established, is sober and moving in tone. It is a work of striking originality in its use of a gold background from which the church of Saint Sophia in Constantinople mysteriously emerges on the left, almost suggesting that the fall of the Christian capital to the Turks in 1453 had inspired the tragic subject of the sorrowful Virgin with the body of Christ. This strict, taut composition is of a rare nobility. The eventual identification of the donor, a canon dressed in white, might shed more light on its origins. Perhaps it is correct, after many hypotheses, to settle on the name of Quarton. At a later point in his career, he might have "purified" his style in this *Pietà*, a pious theme that had been important to both Rogier van der Weyden and Jean Fouquet. There is an increasing tendency to ascribe the painting to Quarton, which would make him

one of the most powerful painters of his day.

Despite appearances, discussion has not strayed far from King René since we now return to the illuminator of *Le Cuer d'amour espris* (pp. 27 and 96). The manuscript of 1444 on which Quarton collaborated with Barthélemy d'Eyck, features, in the section executed by d'Eyck, the same style of squat figures and the same dense meadows found in *Le Cuer d'amour espris*, illuminated around 1460. The tone of the poetic text is one of unequaled concreteness and picturesqueness, echoed by the no less refined pictorial strength and power of the illustrations (meticulously detailed interiors, the emblem of the flying heart, luminous landscapes). So who was the artist? King René would certainly have supervised the production of this masterpiece, but it is unlikely that he himself painted it—the accounts of this great patron record payments to many

artists. In fact, *Le Cuer d'amour espris* comprises a series of sixteen tableaux with a melancholic quality similar to the poetry of René's contemporary, Charles of Orléans. This realistic yet highly refined tone, along with a taste for minute detail, is also evident in the illustrations by d'Eyck for Boccaccio's *Teseida* (Legend of Theseus), which convey an astonishing romantic and sentimental image of antiquity.

Following the aristocratic custom of the day, René himself commissioned his various funeral monuments and planned their decoration. First there was the tomb for his body in Saint-Maurice Cathedral in Angers (which also housed the chapel of the Order of the Crescent). The recumbent figures of the royal couple rested on a foundation, above which was placed the fantastic painting of the *Deceased King* (no longer extant, but known from a 1710 drawing).

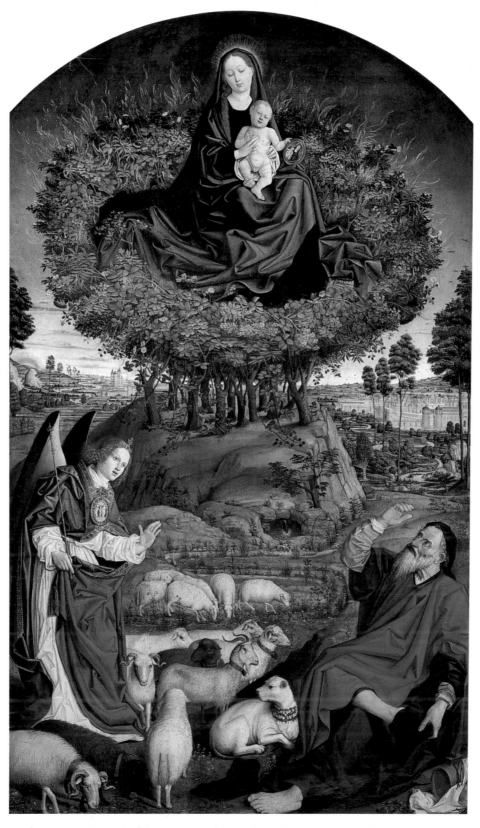

Nicolas Froment, *Triptych of the Burning Bush* (central panel): The Virgin and Child appear to Moses. 1475–1476. 305 × 225 cm. Aix-en-Provence Cathedral (Saint-Sauveur).

Barthélemy d'Eyck, *Le Cuer d'amour espris*
by René of Anjou: Heart and Ardent Desire with Hope.
c. 1460. Österreichische Nationalbibliothek,
Vienna (Cod. 2597, fol. 5v).

Barthélemy d'Eyck, *Teseida* by Boccaccio:
Arcitas and Palamon looking at Emilia in the garden.
c. 1460–1470. Österreichische Nationalbibliothek,
Vienna (Cod. 2617, fol. 53).

The escutcheons were set under a large blind arcade, while a second arch framed a crowned skeleton that tottered on the large throne, the globe and scepter having already fallen to the ground. The grotesque cadaver replaced the standard figure kneeling in prayer. René hoped this macabre scene would illustrate the vanity of royal power that had brought him only humiliating disasters, a theme also reflected in his poetry. The House of Anjou had already produced astonishing tombs in Naples and Aix, but the one in Angers was the most extravagant. The special tomb for René's heart, was reserved for the chapel of Saint-Maurice, the sanctuary of the chivalric order. Finally, his entrails were to be buried within the Carmelite church in Aix.

A large altarpiece was commissioned in 1474 from Nicolas Froment (circa 1425–1483?), an Avignon-based painter with a good Flemish or Picardian background. The main subject of the triptych was the story of the Burning Bush. This rarely depicted scene from the life of Moses (Exodus 3:1–10) was perhaps chosen in relation to René's "flaming footwarmer" emblem used as a decorative detail in Angers, for example. It is a work of large dimensions, quite different from the fascinating, if tiny, universe of miniatures. On the two side panels, the king and his queen, Jeanne de Laval, flanked by their patron saints, are handled with an attention to drapery and facial features that harks back to Flanders, as does the grisaille arched portal (with carved figurines in the style of Rogier van der Weyden) that frames the main scene. The scene itself, however, has become a pleasant pastoral one, with a horizon that seems more Florentine (in the manner of Pollaiuolo) than Flemish. There are peculiar features—the Christ Child, seated on his mother's knees, herself perched in the tree-like bush, holds a medallion of the Madonna and Child, echoed in the clasp worn by the angel, depicting the Fall of Man. Debate continues over Froment's background and the reasons he was recruited by René shortly before the king's death in 1480.

6. THE YEAR 1500

A new style of secular architecture was already emerging by 1480–1490. The fashion was to embellish, renovate, and lighten castles, rather than completely rebuild them. This can be seen in the work begun in 1492 at Amboise, Charles VIII's favorite residence, which long remained a showcase, without however becoming an architectural model to be imitated. For the only real watchword of the day was convenience—at Amboise, for instance, the large towers with a straight ramp were designed to facilitate entry for men on horseback. Nor is it certain that the king's advisers ever assumed that modern additions would entail the subsequent demolition of antiquated buildings. At Blois, for instance, around 1498, under Louis XII, a new entrance wing was built at right angles to the one erected by Charles of Orléans; France already had a long tradition of heterogeneous construction, featuring diverse additions and a lack of unity. It is pointless to try to place these transformations in the outmoded historical context of Gothic architecture; nor should they be interpreted as precocious inklings of Italian developments. Rather, they represent attempts to renovate by using all available repertoires. Improvements were made, rooms were refurnished, tapestries were installed, windows were enlarged, gardens were redone. The urge was widespread but unfocused, lacking a particular direction.

It was generally known that French nobility was open to brilliant suggestions. In 1495, Cardinal Della Rovere, fleeing Pope Alexander VI Borgia, visited Lyon; Vasari recounts that the cardinal "offered the king of France the model of a palace made and presented by Florentine architect Giuliano da Sangallo. It was a proposal worthy of admiration, richly decorated and sufficiently spacious to receive the entire royal court. The court was at Lyon when Sangallo presented his model."[25] During his stay, moreover, the architect took note

Blois. Louis XII wing: detail of the facade overlooking the courtyard. c. 1498.

of several buildings in the area. His proposed model for a château—the details of which are lost, though they probably featured a regular plan with antique elements—nevertheless left certain traces. The large villa Sangallo had built several years earlier at Poggio a Cajano, near Florence, based on the principle of spacious rooms flanking a grand hall, displays certain

analogies with what was later achieved at Chambord and at the Château de Madrid in the Bois de Boulogne (demolished).

Yet it would seem that local inspiration stemming from a search for security (moat and stronghold) and comfort (improved arrangement of rooms) was behind Maréchal de Gié's château at Le Verger, designed and built when he fell out

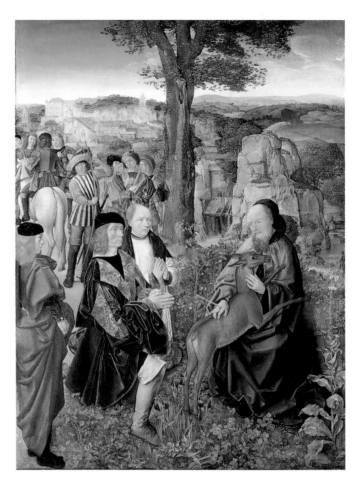

Josse Lieferinxe, *Saint Sebastian Destroying the Idols.*
Panel from the altarpiece of the Saint Sebastian chapel of
Notre-Dame-des-Accoules, Marseilles. c. 1497. 81.6 × 54.6 cm.
Philadelphia Museum of Art, John G. Johnson Collection.

Master of Saint Giles, *Saint Giles and the Hind.*
Oil on panel. c. 1500. 61.6 × 46.4 cm.
National Gallery, London.

of favor around 1499. According to François Gébelin, it may have been based on the plans used at Plessis-Bourré. Whatever the case, Le Verger represented the birth of Renaissance châteaux in France.

General prosperity was accompanied by demographic growth at the end of the century and France was considered the most powerful country in Europe. So it is often somewhat frustrating to be unable to point to a truly first-rate artist during that period; although the work of sculptors and painters was very strong, it was largely executed by artists who remain (or long remained) anonymous. All art produced in the provinces displayed a modified, tem-

pered (and, in a sense, outmoded) northern influence, but it in no way constituted a distinct school.

In Provence, for example, the dispersed elements of a retable commissioned in 1497 by the priors of the confraternity of Saint Sebastian at Notre-Dame-des-Accoules in Marseille have now been identified. The main parts are the work of two painters, Josse Lieferinxe and Bernardino Simondi, whose names alone point to complementary backgrounds.[26] The retable displays the mixed and somewhat luminous style then emerging in the Provençal context, a style more supple than the rather violently simplified art of the

panels ascribed to Nicolas Dipre, a painter first mentioned in Provence in 1495.

In the Loire Valley, Fouquet's heritage survived in diluted, softened form via Jean Colombe and Jean Bourdichon (an exception was the masterful artist Jean Poyet, capable of vigorous spatial composition in a circa 1490 psalter for Anne of Brittany now in the Pierpont Morgan Library, New York). Colombe was a rather undisciplined narrator, while Bourdichon (circa 1457–1521) is known for his calm compositions that exploit the charm of delicate forms, attenuated modeling, and round, somewhat empty faces. It is not very likely that Bourdichon painted the *Crucifixion*

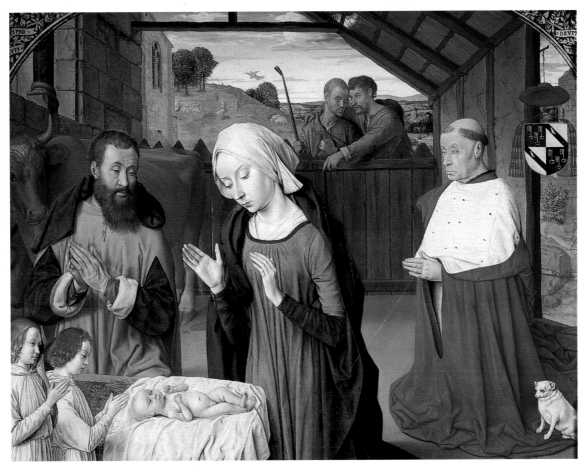

Master of Moulins, *Nativity.* c. 1480.
Oil on panel. 55 × 73 cm.
Musée Rolin, Autun.

Master of Moulins, *Charlemagne
and the Meeting of Saints Joachim
and Anne at the Golden Gate* (detail).
Oil on panel. 1490–1495.
National Gallery, London.

Master of Moulins: *Moulins Triptych:* center, Virgin in glory surrounded by angels; side leaves, Saint Peter
presenting Pierre II of Bourbon and Saint Anne presenting Anne of France with her daughter Suzanne.
1498–1500. 157 × 283 cm. Moulins Cathedral (Notre-Dame) (Allier).

triptych at the Carthusian monastery in Le Liget (1485, now in the Musée du Château, Loches), since it largely surpasses in scope Bourdichon's known work, namely the modest Naples triptych (Museo di Capodimonte). That leaves us with Bourdichon's *Grandes Heures*, a book of hours that he illuminated for Anne of Brittany around 1500; but this will be discussed later, along with the work of Jean Perréal, called Jean de Paris (circa 1455–1530), a decorator who devised aesthetic programs and organized ceremonial entries like the ones held in Lyon in 1494, 1495, and 1499, yet whose artistic personality remains difficult to grasp.

Around 1490 there emerged an anonymous artist known by the unsatisfactory name of the Master of Saint Giles, after the fragments of an altarpiece. His highly skilled and colorful style can also be seen in two panels, one showing the life of Saint Denis (or Saint Remi), the other the life of Saint Leu (at, respectively, the National Gallery, London, and the National Gallery, Washington). The striking feature of these paintings is that each hagiographic scene takes place in an identifiable setting (Sainte-Chapelle and Notre-Dame in Paris in the former case, the royal château of Loches in the latter), which indicates a desire both to update the holy legend and

to feature "modern" buildings. The master's *Saint Giles Mass*, depicts the abbey of Saint-Denis and provides important visual documentation on the precious retable and cross over the altar, refurbished by Abbot Suger. The artist comes across as having been something of an archaeologist in his concern to record a range of famous architecture—it would be interesting to know the patron who commissioned such works. As regards the artist himself, some scholars have suggested that the Master of Saint Giles might be the northern painter Jean Hay, although Hay should probably be identified with another nameless artist, the Master of Moulins.

The Master of Moulins, with whom the fifteenth century comes to a close, was long the most irritatingly anonymous of painters. He was called the Master of the House of Bourbon or of Moulins due to a superb triptych of the Virgin painted for Moulins Cathedral around 1498–1500, featuring portraits of Pierre II of Bourbon and his wife. The figures are almost sculptural in their modeling. The artists to whom this masterpiece has been attributed include Jean Perréal and Jean Prévost, but it is now generally considered to be the work of Hay.[27] Lemaire de Belges referred to Hay as the outstanding painter—*pictor egregius*—who executed an *Ecce Homo* for Jean Cueillette, treasurer to the Bourbons, in 1494 (Musées Royaux des Beaux-Arts, Brussels). A *Nativity* with a fine portrait of Jean Rolin (circa 1480), and a portrait of Cardinal Charles II of Bourbon (Alte Pinakothek, Munich, which was probably painted on the occasion of the cardinal's entry into Lyon in December 1485), attest to the artist's masterful characterization of his sitters. Great attention is paid to the beauty of the hands and the elegance of the drapery, visible in the green dalmatic worn by the angel in the *Annunciation* (Art Institute, Chicago), and to the red, ermine-lined cloak worn by Charlemagne, where colors assume an almost heraldic function.

In the year 1500, the master was working on the *Moulins Triptych*. The faces are handsome, the forms soft, but it is above all the play of light that conveys the perfect mastery of the composition. A huge, multicolored halo rings the Madonna who, to judge by the inscription held by angels beneath her, perhaps constitutes one of the earliest depictions of the Immaculate Conception. Other adolescent angels hold Mary's crown aloft, sing, and pray—their faces are illuminated by the rays of the aureole. In another painting, showing a kneeling donor with a warrior saint, the donor is reflected in the saint's armor, a distant echo of the art of Jan van Eyck, whereas the measured balance of the forms

Le Puy Cathedral (Haute-Loire).
Reliquary chapel, fresco of the Liberal Arts: Music. Late fifteenth century.

reflects the influence of Fouquet (*Saint Maurice and a Donor*, Art Gallery, Glasgow). A certain Flemish virtuosity of color and landscape always married well with the serene figures and noble poses so prized in France. The Master of Moulins occupies a key historical position at the very moment when the art of painting (with the exception of painterly stained glass) was slowly ceasing to be a major preoccupation of the

French. Hay's technique can be detected in the four surviving frescoes of a cycle on the Liberal Arts commissioned by Canon Pierre Odin for the chapter library in Le Puy, although the humanist subject matter supposes Italian influence. This influence could be explained by the circulation of books—indeed, the graphic arts associated with printing were already leading to the spread of new models and themes.

II EARLY RENAISSANCE 1490–1540

1. CROSSING BORDERS

ITALIAN ARTISANS IN FRANCE

The spoils of Charles VIII's brief incursion into Naples (1494–1495) included Pacello da Mercogliano, a garden designer who created large landscaped and terraced ensembles marked by long alleys and pergolas at Amboise and especially at Blois. Even prior to the spectacular work at the château de Gaillon, the gardens of these two châteaux represented the point of departure for the Italian-style landscaping progressively adopted by the French aristocracy, who usually entrusted the Italian specialists with the work. Often, as at Blois, the vast landscaped areas were near the stables for prized horses that were frequently presented as noble gifts (elegant stables were built at châteaux in Fontainebleau, Oiron, and Compiègne). Landscaped grounds and horses were thus emblematic of that period when people were moving about a great deal.

Things happened by chance rather than through deliberate policy. Fra Giocondo, a Veronese architect who was also brought back from Naples, spent ten years in Paris, where he drew up plans for the Notre-Dame bridge before returning to his own country.[1] He knew his Vitruvius well, and had scholarly contacts with the great French humanist Guillaume Budé. Another Italian, Guido Mazzoni (known as Master Paguenin or Paganino), traveled to France with his wife and child, and became part of a group based at the Nesle mansion, a haven for numerous Italian artists (Benvenuto Cellini would lodge there in 1535). Mazzoni was a sculptor, and worked on the tombs (now lost) of Charles VIII, Philippe de Commynes, and others in the Grands-Augustins Monastery in Paris. A specialist in sculpted compositions in the form of veritable *tableaux vivants*, whose descriptive vigor perfectly suited the French context, Mazzoni borrowed the motif of a kneeling figure, already employed on the tomb of Louis XI at Cléry, for use on Charles VIII's tomb at Saint-Denis, but added "humanist" roundels to the sides of the sarcophagus. Mazzoni and his colleagues did not, however, constitute a new school; he returned to Modena in 1507.

The sculpture of this period yielded a series—one might almost say a family—of works in which local artisans collaborated with visiting Italians. "Modern" decoration entailed a shift from cabbage-like crockets to acanthus leaves, from a niche with a basket arch to one with a shell design, and from dense scrollwork to Italianate candelabras, as can be seen on the tomb of Bishop Thomas James at Dol Cathedral, executed in 1507 by Antoine Juste (Antonio Giusti). In 1499, Girolamo da Fiesole received a commission to sculpt the tomb of the royal children at Saint-Martin in Tours (now in the cathedral)—figures on the side include

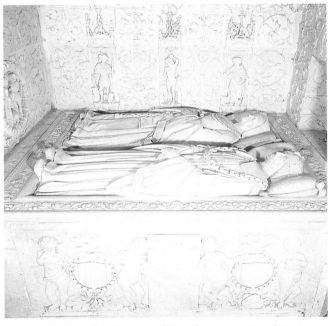

Tomb of Raoul de Lannoy and his wife. 1507–1508 and 1524.
Parish church, Folleville (Somme).

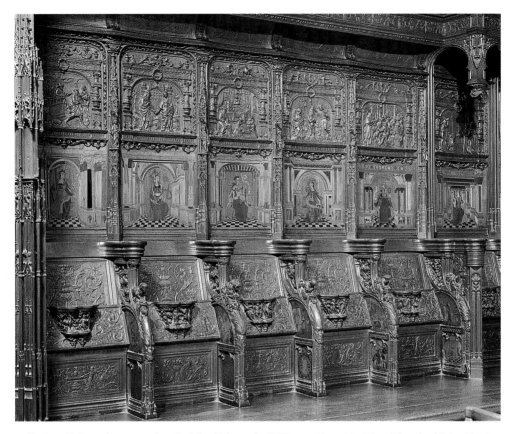

Choir stalls from the upper chapel of the Château de Gaillon. 1508–1509. Abbey Church of Saint-Denis.

Hercules and Samson within large foliate scrolls, while the style of the recumbent figures on the top recalls the work of Michel Colombe, thereby constituting a combination of two robust artistic trends.

A certain number of Italian artists worked for Cardinal Georges d'Amboise at Gaillon starting in 1505. The evolving situation can be fully appreciated in the choir stalls of the château's upper chapel (1508–1509), where the bays feature vertical supports covered with arabesques under a projecting cornice endowed with a floral frieze. The woodwork is astonishingly elaborate and, as though incarnating the twin sources of this emerging art, the back of each chair contains two panels, one above the other: below, figures of the virtues are shown in an obviously imported wood inlay, while above, martyrs are framed by candelabras that function as columns. The style is no longer purely Gothic, but mixed, eclectic, open to every inflection. The same lesson can be drawn from the tomb of Raoul de Lannoy for which the carved sarcophagus with funerary effigies, the work of Tamagnino and Pace Gagini, executed in 1507–1508, was imported from Genoa and set in a modified Gothic recess (1524). The two elements were not perceived as incompatible. Another example is the 1526 door to the sacristy at Saint-Martin-aux-Bois (Picardy), which successfully combines the two repertoires by setting a charming credence with shell motif in the midst of Gothic panels.[2]

The conquest and annexation of the duchy of Milan dominated French thinking during the reigns of Louis XII and Francis I. The French presence lasted longest at Milan and Genoa, and Lombard art was much appreciated. Early sixteenth-century historian Philippe de Commynes, upon seeing the Carthusian monastery in Pavia, wrote that "this beautiful Carthusian church is in truth the most beautiful I have ever seen, all of fine marble." He also found Venice's Grand Canal to be the "best housed" street anywhere. The fine carved decoration of the former, and the elaborate, gilded details of the latter were in perfect harmony with what was being done in France. As governor of Milan, Charles d'Amboise (nephew of the cardinal) combined French habits with Italian decor. He commissioned Leonardo da Vinci, whose services he hoped to wrest from the lords of Florence, to draw up plans for a villa and garden for his Milan residence, plans known in France even before Leonardo was summoned there

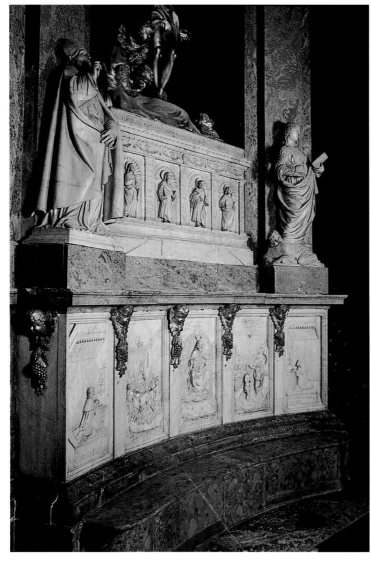

reliefs, a reliquary chest, and a statue of Saint Susanna. This set of sculptures constituted a perfect example of standard Italian art, with its highly fluent decorative details yet rather conventional figures. It has been correctly noted that these works sparked no immediate imitations in France.[3] They nevertheless pointed in a certain direction. Gaillon was completed from 1507 to 1510, thanks to a colony of Italian specialists in ceramics, stucco work, marquetry, garden landscaping, and painting, including the artist Andrea Solario. These on-site contacts helped to progressively define what was meant by "modern."

Artistic borders did not exist. Lecterns, for instance, were always commissioned from metalworkers in the Meuse Valley in Flanders, while offerings and statuettes of gilded wood came from Brussels or Antwerp. Wooden altarpieces, often donated or bequeathed, so teemed with bas-relief figures that Jacques Mesnil somewhat

Girolamo Viscardi, high altar. 1507–1508. Trinity Abbey,
Fécamp (Seine-Maritime).

by Francis I in 1516. To flatter Charles d'Amboise, an Italian nobleman had the chapel of his small castle of Gaglianico—whose name distantly echoed that of Gaillon—decorated with frescoes depicting its namesake (1510). Gaillon was considered to be the most modern château in France—in 1517, a traveler from Italy, Cardinal Louis of Aragon, particularly admired two French châteaux, Gaillon and Le Verger.

Louis XII, as grandson of Valentine Visconti, considered the duchy of Milan to be rightfully his, and triggered the first, rela-

tively long French occupation (1499– 1512), based at Milan and Genoa. Numerous artworks were commissioned and executed locally, then sent to France. Like Cardinal Georges d'Amboise, Antoine Bohier accompanied the expedition to Genoa in 1507, and there he placed a major order with Girolamo Viscardi for local marble, to be used at the abbey of Fécamp, where Bohier had just been named abbot. Bohier commissioned a refined, Florentine-style tabernacle for the relic of Christ's precious blood, an altar with carefully executed bas-

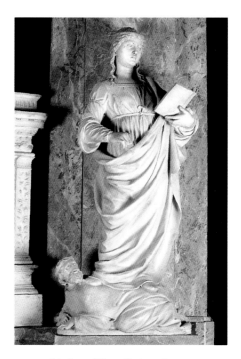

Girolamo Viscardi, *Saint Susanna*.
1507–1508. Trinity Abbey,
Fécamp (Seine-Maritime).

irreverently called them *retables-guignols* ("Punch-and-Judy retables"); the triptych of Ambierle in the Loire Valley, bequeathed in 1476, is a good example of these picturesque Flemish productions, featuring evangelical scenes under tall Gothic canopies. Such work abounded in central and western France, and could even be found at Aigueperse in the Auvergne region where, in a revealing juxtaposition, the Montpensier Chapel harbored a *Saint Sebastian* by Andrea Mantegna, brought back from Italy by Gilbert de Montpensier around 1490, along with statues of the Virgin and a Burgundian-style statue of a king with a cloak of gold patterned with fleurs-de-lys. Such juxtapositions were far from rare.

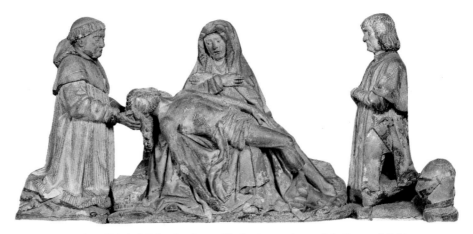

Studio of Michel Colombe, *Pietà* with the donors Armand de Gontaud (left) and his brother Pons de Gontaud (right). Touraine, c. 1500. Sculpture from the chapel of the Château de Biron (Dordogne). Limestone. The Metropolitan Museum of Art, New York, Gift of J. Pierpont Morgan.

FRENCH ARTISANS IN ITALY

Papal politics drew more and more of the French to Rome. The French king had many influential representatives there during the papacies of Alexander VI and Leo X.[4] Guillaume d'Estouteville, a cardinal from Normandy, helped in the rebuilding of the church of Sant'Agostino, with its purely quattrocentro facade. Two years before his death in August 1499, another French cardinal, Bilhères de Lagraulas from Gascony, who was the king's ambassador to the Holy See, commissioned a marble *Pietà* from a twenty-three-year-old sculptor named Michelangelo. The sculpture was destined for the Cappella del Re di Francia—the chapel in Saint Peter's in Rome allocated to the king of France in the eighth century and restored under Louis XI. Since the *Pietà* was to decorate this chapel, it appropriately echoed French models—as seen, for example, at Champmol or at Biron where the sculpture was perfectly contemporaneous with Michelangelo's work.[5]

Inaccurate tradition holds that French representatives, sometime after 1515, proposed a circular design for a French church to be built in Rome, which would indeed have been remarkable. On 1 September 1518, Cardinal Giulio de' Medici, as patron of the French, laid the first stone of the

French "national" church at Rome in the presence of the French cardinal, Briçonnet. An architect from Normandy, Jean de Chenevières, had designed a church that was not circular (as Vasari claimed), but rectangular, comprising a nave and two aisles of nine bays, bearing comparison both with square-apsed French churches and with the designs proposed by Italian architect Donato Bramante.[6]

Meanwhile, the superiority of French masters in the realm of stained glass was generally recognized. The most striking case is that of Guillaume de Marcillat. Vasari, his pupil, recounts how Marcillat came to Rome at Bramante's invitation to install stained-glass windows (destroyed 1527) in the new episcopal palace; Marcillat subsequently worked at Cortona and Arezzo (circa 1518–1520), where his Italianized stained glass can still be seen.

A similar phenomenon occurred on the Iberian Peninsula, where French masters were appreciated for their eclectic style—a modified Gothic enriched with small antique-style motifs that remained fashionable for some thirty years. The best-known was sculptor Nicolas Chanterène, who

worked in Portugal at Belém (the west portal) in 1517 and then at Coimbra (the Santa Cruz pulpit) in 1522. His virtuosity in floral decoration and fine jewel-like carving was highly esteemed. In short, this eclectic style was considered a French invention.

Movement and exchange among ruling cliques ultimately changed the order of things, as strongly entrenched families like those in the Italian principalities—the Gonzagas, the Estes, and later the Medicis—placed their agents and informers everywhere. In France, ecclesiastical networks formed among the numerous Amboise brothers and the extensively allied Briçonnet family.

The Renaissance was the intelligent, lively expression of unprecedented social networking. More than ever, fine objects were sought as collector's items. For his Saint-Merry Chapel, Jean de Ganay, president of the French *parlement*, ordered a "mosaic painting" from Ghirlandaio's Florentine workshop in 1496, translating the conventional enthroned Virgin motif into a then-fashionable medium. Maréchal de Gié requested a statue by Michelangelo from the powers that be, and was promised a bronze

Blois. Exterior view of the Francis I staircase. 1515–1519.

David; when the maréchal fell out of favor, however, and withdrew to his château at Le Verger, the *David* was claimed by Florimond Robertet, who placed it first in his residence in Blois, then in his château in Bury (from whence it went to Villeroy, before dropping out of sight).

COMPOSITE DECORATION

Clever combinations made it possible to establish a decorative repertoire that obviously delighted sculptors and "image-makers." Fillets, ovolo molding, new framing elements, volutes in the form of dolphins, putti, and so on, became generally fashion-

able and could be assimilated without provoking a revolution. Antique forms were adopted independently of the logic of classical orders, their ornamental vocabulary adapted to settings completely distinct from those found in antiquity, such as gabled windows and stairways. The old Gothic taste for superimposed, interconnected elements found new life through the shift to square lintels, round piers, and triangular pediments, while needles and flame ornaments replaced pinnacles, and volutes became S-forms. One need only look at the lively ornamental sculpture on the Francis I staircase at the royal château in Blois or, bet-

ter still, the brilliant spiral staircase at Chambord, to see the extent to which the new motifs played a stimulating role. This was true in the Loire Valley, the Île-de-France region (Écouen, with its gables), and Quercy (Montal, with its medallions).

In Paris, the little anthology published by Gilles Corrozet in 1550, *Antiquitez et singularitez de Paris, ville capitale du royaume de France*, confirmed the growing importance of the city in which every influential person henceforth had to have a residence. In the rue des Bourdonnais, not far from the Louvre, the magnificent private residences known as *hôtels particuliers* were erected in

Chambord. North corner of the grand courtyard:
Francis I staircase. Completed in 1546.

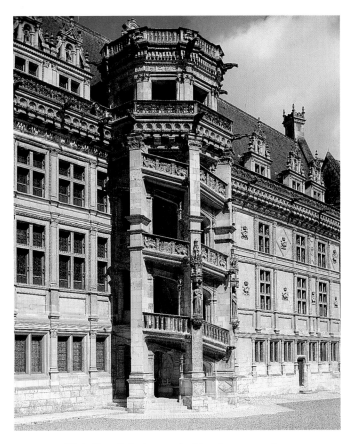

Blois. Francis I wing overlooking the courtyard.
1515–1524.

quick succession. One example is La Tré-moille, the opulent residence built around 1506 by royal treasurer Pierre Legendre (circa 1465–1524), which was the object of a nineteenth-century publication, as well as a survey by Viollet-le-Duc.[7] These are the only documents that now provide an idea of this magnificent residence, whose sumptuous furnishings are known thanks to an inventory of 1525. Skillfully using the oblong parcel of land, the main three-storey building was strongly marked by horizontal balustrades running below the tall roof, adorned with gables and ornamental shafts in a highly modified flamboyant style. A turret on the left covered a long passage leading to the back garden (and probably to an upstairs chapel), while to the right a tall panel adorned the facade with emblems. The *hôtel*

boasted the latest mode in spiral staircases, complete with a twisting newel, while the courtyard featured galleries and porticoes on two sides. The rear courtyard included a garden. In short, La Trémoille constituted a clear prefiguration of designs to come.

A proliferation of new decorative elements also occurred in domestic interiors. In Bourges, for example, the Cujas residence, completed in 1515, displayed its modernity with roundels and putti among foliate scrollwork; nearby, the Hôtel Lalle-mand, from the same period, boasted palmettes, a loge at the top of the staircase, a shell-motif credence in the chapel, and a thirty-panel coffered ceiling in the oratory. In hundreds of town houses and châteaux, decorative sculpture was the bearer of Renaissance delights. Sometimes, as at the

Château de Chanteloup, it constituted a sort of mural-embroidery through the bold juxtaposition of scrollwork, arabesques, and paneling featuring grotesques, an effect also seen on the outside of the apse of Saint-Pierre in Caen (Normandy), where the walls almost seem to vibrate with decoration.

For Charles VII's ceremonial entry into Lyon in November 1495, houses were festooned with wreaths of fruit in stucco or wood, subsequently called "triumphal crowns" in "the Italian fashion," according to chronicler André de la Vigne. Gothic medallions took on new meaning as sculpted profiles and features borrowed from miniatures (themselves imitating antique models) were placed amid floral garlands. At Gaillon, accounts reveal that the galleries were decorated with "medals brought by Master

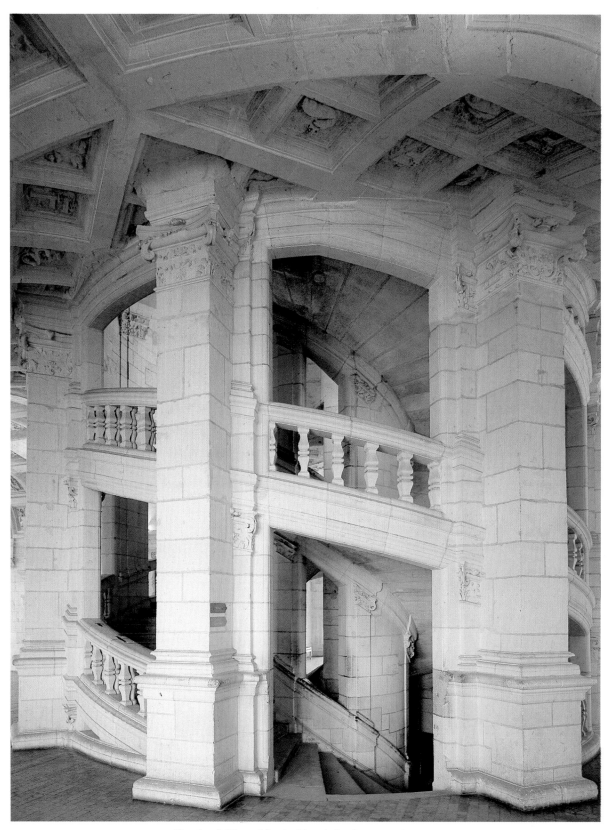

Chambord. View of the double spiral staircase. 1519–1540.

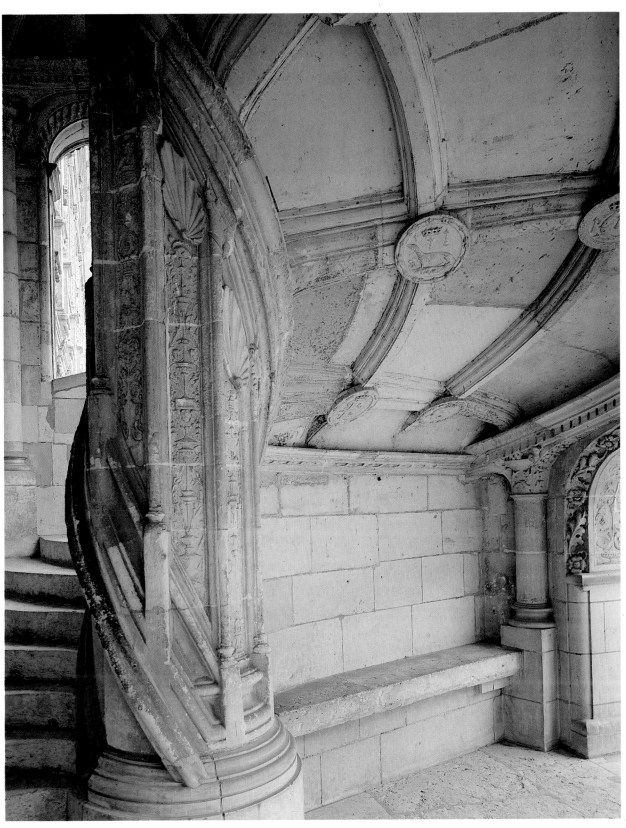

Blois. Interior view of the Francis I staircase. 1515–1519.

Hôtel Lallemand, Bourges. Stairway
overlooking the court, detail of a window.
Early sixteenth century.

Paguenin," that is to say, medallions of
Roman emperors probably produced in
Paganino's Paris workshop and sent to Gail-
lon to create an original setting. Soon they
would be seen everywhere—a series from a
house in Grenoble, dated 1510–1520, bears
the signature of Lorenzo da Mugiano
(Musée des Beaux-Arts, Grenoble).

Scholars wonder whether Mugiano
ever went to France. Whatever the case, in
1508 he executed a signed and dated mar-

Chanteloup (Manche).
Detail of main facade. c. 1533.

ble statue of Louis XII for Gaillon (provi-
sionally repaired around 1800 by restorers
working under Alexandre Lenoir—the
torso, the only original part to survive, is
now in the Louvre). This highly accom-
plished work was probably executed in
Genoa; the king is dressed as a Roman war-
rior, with a decoratively mantled breast-
plate. It is one of the earliest-known French
importations of this type of antique model
(which, moreover, would not be immediately
imitated). In his left hand, Louis holds a map
of Italy bearing an ideogram for each city—
Milan, Genoa, Venice, Florence, Rome—
reflecting his ambition to annex parts of Italy.

The synthesis of Italian decoration and
Gothic forms achieved by French masters
appeared in England, as seen in the pendant
bosses in Hampton Court (prior to 1529)

Medallion of a Roman emperor
from the Château d'Assier (Lot). 1526–1535.
Musée du Louvre, Paris.

and on the rood screen and choir stalls in
King's College, Cambridge (1532). Echoes
of the decoration found at Gaillon, or of the
Limoges rood screen can be detected in the
Winchester area and in the Layer Marney
tombs in Essex. The skill of carvers from
Normandy and Poitou enabled them to
develop new models fairly swiftly.[8]

THE FLOWERING OF ENAMEL

The inventiveness of French artisans could
be detected in the emergence of an unprece-
dented type of decorative art—painted
enamels—which first appeared in Limoges
around 1500. This was a new version of the
craft that had made the city internationally
famous in the twelfth century, based on the
technique of multiple firings; a copper plate
would be covered with white enamel, then
the subject would be painted in black, and
finally, colors would be added, employing
underlying silver leaf to intensify the tones.
This process tended to produce a sumptu-
ous brilliance.

Such decorative features were swiftly
adopted by Limoges enamelers. Approxi-
mately thirty items have been attributed to an
anonymous master known for two small trip-
tychs of the *Annunciation* (Orléans, 1503,
and Baltimore), similar to miniatures in tech-
nique. A plaque of the *Crucifixion*, dated
1503, bears the signature of Nardon (or
Léonard) Pénicaud, who was the first in a
long line of enamel specialists—his three
sons, especially Jean I, enhanced Pénicaud's
deep blue-and-gold palette with more varied
colors and less provincial forms, though still
relying on drawings based on prints and illus-
trated books. Models already in circulation
provided the imagery for this new approach.

Under Jean de Langeac, bishop of
Limoges, the visual idiom associated with
Fontainebleau was employed on enamels,
with instant success. The bishop's favorite
artist was Léonard Limosin (circa 1505
–1575), who came to his attention in 1532
with eighteen plaques depicting the *Life of
Christ* after Albrecht Dürer, and again in
1535 by a grisaille series on *Psyche*, based on
engravings executed by Bernardo Daddi (or
Beatricus Dado), not to be confused with
the Florentine painter of the same name,
died 1348. But Limosin's repertoire and
style evolved along with his new noble
patrons and according to the objects to be
decorated—this evolution will be discussed
in the section devoted to decorative arts in
the High Renaissance.

Triptych of the Annunciation. Limoges, fifteenth century.
Painted enamel. 1503. 21.5 × 25.5 cm. Musée des Beaux-Arts, Orléans.

Nardon Pénicaud, *Crucifixion*. Enamel on copper. 32 × 24 cm.
Musée national du Moyen Âge, Paris.

PRINTS

The conditions of artistic creativity changed completely with the widespread availability of prints. In France, great use was made of them at an early date, despite the absence of French initiative in developing the technique. The engravings came from either Italy or the Rhineland. Lyon woodcuts were copies of German prints, and Jean de Pré's *Limoges Missal* (1484) was the work of Venetians. It took two generations before French artisans became adept at printing and engraving. Engravings by Dürer and Lucas van Leyden, for instance, circulated extremely rapidly, as did Marcantonio Raimondi's reproductions of Raphael. All were used in the workshops of French stained glassmakers, decorators, and enamelers. The situation changed only later, with the great ambitions of the Fontainebleau school. The same syndrome occurred with the limited production of printed books in France, marked by Guy Marchand's *Kalendrier des bergers* (Shepherds' Almanac), with its popular woodcuts, and Pierre Le Rouge's *Mer des Hystoires* (Sea of Tales) with its vignettes, figures, and decorated

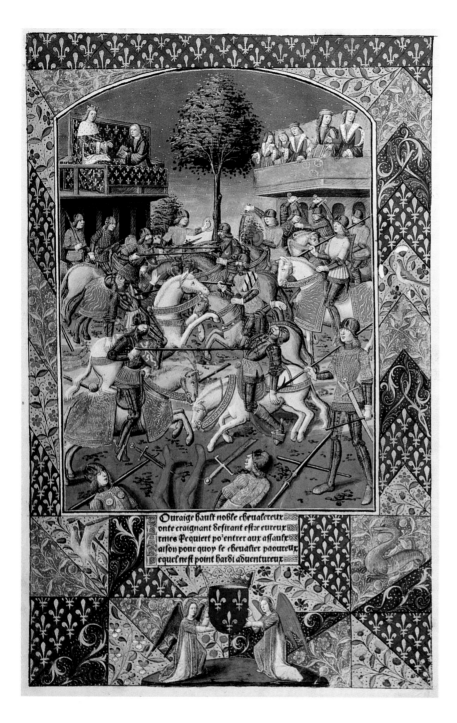

Le Kalendrier des bergers.
Guy Marchand (printer), Paris, 1491.
Bibliothèque Nationale,
Paris (Rés. m.V. 33, fol. a³).

Left: *Lancelot du Lac*: a tournament.
Antoine Vérard (printer), Paris, 1494.
Bibliothèque Nationale,
Paris (Rés. Vélins 614, fol. 2).

initial letters. Antoine Vérard, active between 1485 and 1513, printed every type of book, from romances (*Lancelot du Lac*) to pious works (*The Art of Living and Dying Well*), to books of hours that made the century-old vogue for lay missals accessible to a wider public. Some three hundred publications have been credited to book merchant Simon Vostre between 1488 and 1520, yet despite such abundance the illustrations betray lazy imaginations—visual development was slow. However, Geoffroy Tory (1480–1533), a humanist cleric familiar with Italy, carefully illustrated books of hours and in 1529 formulated his ideas on typography and the alphabet in one of the most jumbled yet delectable publications of the day—*Champfleury*. Tory's widow published

La Mer des Hystoires. Pierre Le Rouge
(printer), Paris, 1489. Bibliothèque Nationale,
Paris (Rés. Vélins 676, fol. 2).

Right: Jean Bourdichon,
Grandes Heures d'Anne de Bretagne.
c. 1503–1508. Bibliothèque Nationale,
Paris (Ms. Lat. 9474, fol. 204).

a translation of Diodorus Siculus in 1535, with a frontispiece based on a miniature depicting an offering to the king. Only from that point onward did books play a cultural role by illustrating and disseminating works of greater variety and brilliance.

PAINTERS

Royalty always had its official artists, but for a long time they executed only portraits, books of hours, and ceremonial decorations. That was the case with Jean Bourdichon. His style clearly reflects artistic détente—softened forms and conventional landscapes of a vaguely Umbrian type as seen above all in his masterpiece, the *Grandes Heures d'Anne de Bretagne* (circa 1503–1508). It is not necessary to assume that Bourdichon studied Italian

Jean Perréal (or Jean de Paris), *Énigmes*, previously known as *Emblesmes et devises d'amour* by
Pierre Sala: bust-length portrait of Pierre Sala. c. 1500. British Library, London (Stowe 955, fol. 16v–17).

paintings, for the circulation of miniatures
suffices to explain his sources. But Bourdi-
chon also had a personal predilection for
original, detailed, and boldly colored mar-
ginal decoration of insects and flowers,
yielding an amusing, strange, and even
modern design perhaps unique among
miniaturists.

Jean Perréal was often mentioned as an
official painter throughout several reigns.
Works attributed to him include an
"alchemical" miniature for the *Complainte
de Nature à l'alchimiste errant* (Nature's
Lament to the Wandering Alchemist,
Musée Marmottan, Paris, Ms. 147), pre-
ceded by an acrostic signature (1516, Bib-
liothèque Sainte-Geneviève, Paris, Ms.
3220, fol. 5v). The apparent inconsistency
dissipates, however, when it is realized that
the royal artist had to be an "artisan for all
seasons." He orchestrated the ceremonial
entries that were decorated with medallions
of his own devising, and he was also respon-
sible for producing portraits—Perréal's

Triptych of Saint-Pantaléon, central panel: Virgin, Saint John the Baptist,
Infant Jesus, and an Angel. 1520. Oil on panel. 109 × 92 cm.
Church of Saint-Pantaléon, Autun (Saône-et-Loire).

Triptych of the Eucharist, central panel: The Last Supper; side panels: The Offering of Abraham and Melchizedek and Manna from Heaven. 1515. Oil on panel. 201 × 419 cm. Musée Rolin, Autun.

Charles VIII (Bibliothèque Nationale, Lat. 1190) and *Pierre Sala* are each characterized by the caps worn low on the subject's forehead. In addition, Perréal supplied plans for tombs, the execution of which was carried out by Michel Colombe (in Nantes) or Conrad Meit (the Brou Monastery in Burgundy). It was perhaps this very diversity and mobility that made Perréal a representative of the new era, a modest imitation of Leonardo, with whom he might have exchanged certain technical tips.

In eastern provinces like Burgundy and Champagne, a great number of church paintings, generally minor, escaped destruction. They demonstrate that such painting did not cease in the early sixteenth century, but that it lacked inspiration to such an extent that painters regularly borrowed visual models from Flanders (the interesting *Last Supper,* 1515, Autun), or from Dürer (*Presentation of the Virgin,* 1521, Musée des Beaux-Arts, Dijon), or, more intriguingly, from Leonardo da Vinci

(the central panel of the Saint-Pantaléon triptych, which imitates the organization of his *Virgin of the Rocks*). Models henceforth circulated widely.[9] In southern and southwestern France, during the first quarter of the sixteenth century, decorative projects were either confided to Italian artists (like the Bolognese artisans who worked on Albi Cathedral) or were based on their works—the Virgin in an *Adoration of the Magi* in Lafitte-sur-Lot is obviously based on Leonardo's *Saint Anne.* The ambitious *Adoration* can be roughly dated 1520, a period when Antoine de La Rovère occupied the nearby episcopal see of Agen which, like Nérac, was a center of humanist culture.[10] More difficult to interpret are the frescoes (1510–1520) in the chapel of the Château de Meyrals in the Dordogne, featuring apostles and other holy figures that appear to derive equally from Flemish and Leonardesque models.[11] These are vestiges of historical crosscurrents impossible to reconstitute.

Many talented artists continued to illuminate manuscripts. But even when a text has survived, the artist usually remains to be identified. Such is the case of a prayer book, executed in around 1510 for Queen Claude of France, which is full of charm and imagination, notably in the landscapes that fill the margins (A. Rosenberg Collection, New York, Ms. 8). Another, by the so-called Master of Ango after a book of hours done around 1520 (Bibliothèque Nationale, Nouv. Acq. Lat. 392), delightfully mastered the complicated borders, perspectives, and unusual coloring typical of what is sometimes called the Rouen school. A book offered to Louise of Savoy, mother of Francis I, by a certain Étienne Leblanc (during her regency provoked by Francis I's captivity in 1525–1526) contains artfully constructed compositions with antique-style borders, designed to underscore a series of moral allegories boldly translated into images. This book constitutes one of the

Godefroy le Batave, *Commentaires de la guerre gallique* by François Demoulins: Swiss dancing as their villages burn. 1519–1520. British Library, London (Harley 6205, fol. 9v).

style that reflects awareness of the Lombard masters. In general, Provençal art was hybrid in nature, perhaps due to a heavy reliance on engravings, which might explain the stiff, dry quality that is evident in many of these Italo-Flemish panels.

Miniatures were more than ever designed to glorify monarchs and nobles. A profusion of historical works, which tended to be moralizing and theological, accompanied Francis I's initial victories, thus providing a new role for illustrated books.[12] François Demoulins, chaplain to the king as well as adviser and pedagogue, collaborated with two painters, Godefroy le Batave and Jean (or Janet) Clouet, to produce three volumes of commentaries on the "Gallic War" (now dispersed in London, Paris, and Chantilly).[13] Everything hinged on the battle of Marignano, with allusions to the defeated Swiss and the famous medallions of the victorious

more original works of the period (Bibliothèque Nationale, Fr. 5715).

The recently studied case of Provence is highly revealing of the uncertainty that still exists. Numerous churches there had—and often still have—retables that were somewhat hastily judged to be insignificant. What is surprising is the number of painters such as Nicolas Dipre and Josse Lieferinxe, recruited from the north, either directly or via Amiens and Paris. As in the preceding century, these painters went to Aix or Marseille more readily than did the Italian artists, even if some of them, like a certain Christian Valumbres (in Salon-de-Provence around 1537) were simply passing through. Works like the *Adoration of the Christ Child* (circa 1505–1515) are marked by an authoritative

Above: Jean Clouet, *Commentaires de la guerre gallique* by François Demoulins: Artus Gouffier portrayed as Quintus Pedius. 1519–1520. Bibliothèque Nationale, Paris (Ms. Fr. 13429, fol. XXVv).

Left: *Le Triomphe de Vertuz* by Jean Thenaud, vol. II: Queen Claude and her daughter arrive at the palace of Clemency and receive necklaces of hearts. 1517. Bibliothèque Nationale, Paris (Ms. Fr. 144, fol. 124v).

Adoration of the Christ Child. Provence, c. 1505–1515. Oil on panel. 94 × 121 cm. Musée du Petit-Palais, Avignon.

"valiant knights," constituting a gallery of historic portraits. Another manuscript, by Jean Thenaud, *Le Triomphe de Vertuz* (1513–1520, Saint Petersburg and Paris, Bibliothèque Nationale), includes highly symbolic illustrations of unusual, densely composed allegorical groups. A certain esotericism was apparently required for this type of illustration, which would long influence royal imagery and emblems.

PORTRAITS

Portraits of the monarch were always topical. Around 1530–1535, a Flemish specialist, Joos van Cleve (circa 1480–1540), was invited to the French court, where he painted a half-length portrait of Francis I, who is wearing a superb embroidered tunic, his gloves held in his left hand and his right hand placed on the hilt of his sword (Museum of Art, Philadelphia). Van Cleve

replaced Holbein, who had traveled to France in 1524, but who was no longer available, having settled in England in the service of Henry VIII. Around the same time, Titian executed an imposing profile of Francis I based on a medal designed by Cellini. But what was needed was an official portrait of the king by a *French* artist, and François Clouet—Jean Clouet's son—was chosen. Around 1535, he painted a portrait

School of Clouet, *Louis I of Bourbon, Prince de Condé.*
Black and red chalk. 34.6 × 24 cm. Musée Condé, Chantilly.

School of Clouet, *Leonora de Sapata.* c. 1530–1537. Trois crayons:
black, red, and white chalk. 31 × 21.7 cm. Musée Condé, Chantilly.

whose detailed damask background and rich silk tunic earned it a prime place in the royal gallery (Musée du Louvre). It has been suggested that Jean Clouet designed the composition, while his father François was responsible for the highly accomplished execution.[14]

Some of the most original artworks produced at the French court were the chalk drawings rendered in two or three colors (black, red, and white). Collections of exceptional scope exist at the Musée Condé in Chantilly (363 drawings from the first half of the sixteenth century, p. 118) and at the Bibliothèque Nationale (569

items). The art of sketching lightly modeled faces on paper had already been practiced by Jean Fouquet, and court artists like Jean Perréal were expected to employ this succinct yet precise technique to record both the profiles and features of important personages.

For skillful practitioners like Jean Clouet (circa 1485–1541) and his son François (circa 1515–1572), it became customary to produce such portraits so that relatives or members of foreign courts could picture lords and ladies who were currently in the limelight. The fashion, which hit full stride around 1560 but suddenly ceased

around 1610, perfectly reflected the emerging psychological awareness and increased sociability of French society.

In the early sixteenth century, Paris, with a population of at least 200,000 inhabitants, had once again become a capital city. Although the court remained itinerant, the king traveled regularly to Paris, and documents record the steep bills accumulated by Francis I among Parisian suppliers, especially goldsmiths and jewelers. The luxury trades were henceforth firmly established there. The king's famous declaration of March 1528, "to make the greatest part our residence and sojourn in our good town and

Jean and François Clouet, *Francis I*. c. 1535. Oil on panel. 96 × 74 cm. Musée du Louvre, Paris.

city of Paris and its surroundings, more than in other places in our Kingdom," was above all symbolic, but it nevertheless spurred urban renewal. In 1533, Francis I ordered that a town hall be built (burned in 1871, rebuilt and enlarged during the Third Republic), based on plans that were probably furnished by Domenico da Cortona and featuring a facade of artfully deployed antique-style elements under a steep, conventional roof. It was an expensive undertaking; the construction was extremely slow and was only completed, after a long halt in the second half of the century, during the reign of Henri IV.

Beauvais Cathedral (Saint-Pierre). Facade of the south transept: detail of one panel of the portal sculpted by Jean Le Pot. First half of sixteenth century.

1506, was replaced by an ambitious pyramidal structure by Jean de Beauce in 1513; the octagon set on a square base created a highly successful telescopic effect, featuring dense, curving decoration that included numerous original motifs. In Rouen, interestingly, there was a certain hesitation over whether the Tour de Beurre should be flat-topped or given a steeple. Jacques Le Roux, who headed construction in 1496, was obliged to submit two designs in 1501. Other work having monopolized the architect, it was finally decided to settle for a crown, though one less modern than those placed on Saint-Gatien in Tours by Bastien François, where the two towers received fish-scale domes topped by lanterns. The "royal staircase," attached to the north tower like an open-work cage (1507), represented a fine example of the master builder's virtuosity, which came to be increasingly appreciated.

Throughout France, there were various indications that illustrated the need to establish a new rapport between structure and decoration. Only a few can be mentioned here. The justly famous chancel of Saint-Pierre in Caen (1518–1545), known to

2. Ecclesiastical Settings

Like the nobles with their châteaux, the canons of major cathedrals wanted to modernize and, on occasion, enlarge their religious edifices. Thus in 1499, the chapter of the still-incomplete cathedral of Saint-Pierre in Beauvais called on Martin Chambiges to raise the transept, thereby accentuating the transparency and lightness of the facades. The southern facade was ultimately completed by Chambiges' successor, but both of them received emblematic portals and superb panels carved by Jean Le Pot. The rest was less successful—it was decided to place an extraordinarily intricate tower over the crossing of the transept, perhaps in competition with Jean de Beauce's steeple at Chartres. But the tower, not completed until 1564, lacked buttressing and collapsed in April 1573. This incident more or less

marked the end of the late Gothic phase, capping a period during which new ornamentation had been constantly added to original Gothic structures, as though they were infinitely accommodating—but a limit had clearly been reached with the cathedral in Beauvais. Meanwhile, at the church of Saint-Étienne in the same town, the work carried out from 1506 to 1522 was simpler; the chancel was enlarged in order to create a large rectangular space in the apse, and the entire east end was endowed with grandiose stained-glass windows by Engrand Le Prince. Saint-Étienne perhaps represents the finest example of modifications designed to enhance stained glass.

Everywhere, towers had to be completed and churches given a modern aspect. Although Beauvais resulted in failure, at Chartres the task was easier. The wooden steeple on the north bell tower, destroyed in

Church of Saint-Pierre, Caen. View of a pinnacle crowning the apse. 1518–1545.

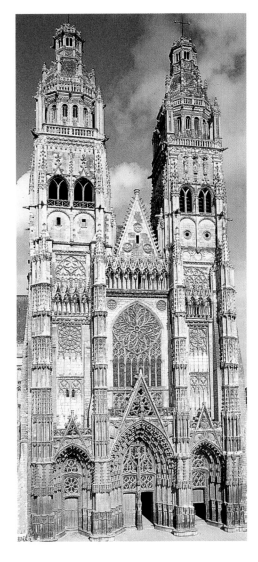

Tours Cathedral (Saint-Gatien). The facade and the two towers, crowned by lanterns in the sixteenth century.

be the work of architect Hector Sohier, provides a superb example of the methodical fusion of two repertoires, one local and one imported, in an effort to animate with embroidery-like panels, the somewhat squat, almost Romanesque masses of the apse. A similar exuberance appears in the elegant wooden porch strangely grafted onto the southern wall of the church in Ry, Normandy. The same thing could be said of the chancel at Tillières-sur-Avre, also in Normandy, where cartouches and arabesques are combined with intricately carved ribbing. These examples date from the middle of the sixteenth century, in contexts where local practices and tastes persisted for a long time, oblivious to the sophisticated trends occurring elsewhere.

At Fécamp, however, it is well known that Antoine Bohier employed Genovese sculptors for the abbey church. The lattice-work in the chapels around the chancel represents a brilliant adaptation of Italian motifs that avoids the fantastic appearance often produced by the clash of two repertoires; the small columns, however, are not truly classical.

In Burgundy, the facade of Saint-Michel in Dijon represents an ingenious translation of Gothic design into a Romanesque ensemble: semicircular arches and two four-storey towers with open bays flanking a small gable. The builders amused themselves by replacing corner piers with supports featuring marked entablatures, thus yielding a "modern" interpretation of earlier projecting buttresses. The porches on Saint-Michel date from 1537, while the rest is from a much later period.

Paris also hosted a long-term construction project, although in this instance an entire church was involved. Begun in 1532, the church of Saint-Eustache offers a good illustration of French architectural goals: retain the overall plan of a model Gothic edifice like Notre-Dame; maintain and even extend the height of the vaulting adorned with decorative ribbing; and finally, give

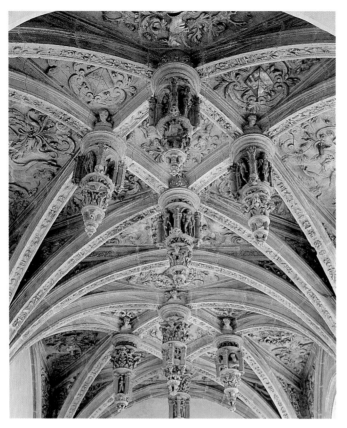

Church of Saint-Hilaire, Tillières-sur-Avre (Eure). The chancel: sculpted
decoration on the vaulted ceiling of the south chapel. 1537–1546.

Church of Saint-Laurent, Arnay-le-Duc (Côte-d'Or). View of
the coffered ceiling in the chapel of the Baptismal Fonts. 1535.

supports a modern look by using fluted
Corinthian pilasters that rise very high,
adorned with carefully executed, classical
consoles and capitals connected to the
springing arch of the vault. The resulting
combination of styles still horrifies purists
unless they attempt to understand the atti-
tude of the builders who worked on this
church throughout an entire century—the
notorious pilasters are not eccentric, they
represent yet another application of the rule
of selective assimilation. Since Gothic archi-
tecture was the French national style, its
masses and statics were retained, though in
modernized form.

Building activity also occurred in the
Pyrenees region. Notre-Dame Cathedral in
Auch was rebuilt starting in 1493, with

Auch Cathedral (Gers). Interior elevation
of the transept. After 1493.

interesting features—the arcading is com-
posed of different types of arches in an
almost experimental mode. Remarkable
attention was paid to the interior, where
everything was transfigured by the use of
beautifully executed stained glass, which
has been miraculously preserved, and the
installation of choir stalls of a scope and
quality of carving unmatched in France (the
somewhat less-inspired facade dates from
the following century).

There are too many similarities in the
handling of these churches, and in many
other minor edifices remodeled during the
first third of the sixteenth century, to refer
simply to incoherent proliferation. True,
there was neither a norm nor a shared doc-
trine, unlike what had perhaps existed in the

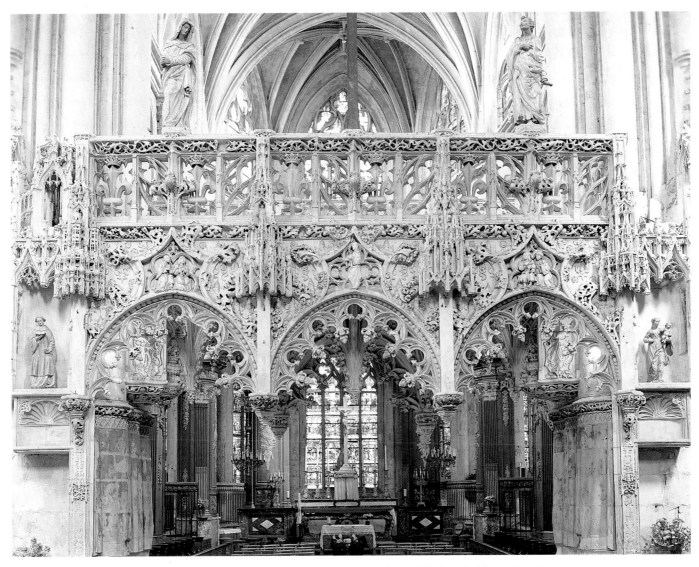

Church of Sainte-Madeleine, Troyes. Rood screen designed by Jean Gailde. 1508–1517.

ecclesiastical architecture of the thirteenth century, then was reconfirmed in the seventeenth, but rather individual action. It is nevertheless striking that in no instance was a previous edifice eliminated; new improvements were introduced which, though far from faithful to the initial design, were rarely out of proportion. There seemed to be a certain pride in having each generation contribute to the enterprise in its own way. The Gothic style had long been abandoned without anyone noticing—it was so flexible and accommodating that it seemed to be compatible with everything. The canon who added a circular, Bramante-style chapel to the side of Vannes Cathedral in 1537 certainly did not consider himself revolutionary. Nor did the designer of the All Saints' Chapel in Toul Cathedral, another central-plan chapel endowed with a faceted dome (1535–1545). The same could be said of the baptismal chapel in Arnay-le-Duc, yet another round shrine grafted onto the main body of a sanctuary. In the early Christian era, the rotunda form was used for funerary chapels. The idea of erecting a large edifice of this type was projected for the Valois Chapel at Saint-Denis around 1560, but was never built.

There was a growing tendency to fragment the interior space of naves by erecting increasingly spectacular rood screens. At the church of Sainte-Madeleine in Troyes, the chancel, rebuilt in 1500, was fronted by a rood screen with three highly flamboyant arcades that was built between 1508 and 1517 by an architect named Jean Gailde. It provided the perfect setting for statuettes and elaborate forms facing a superb, solemn

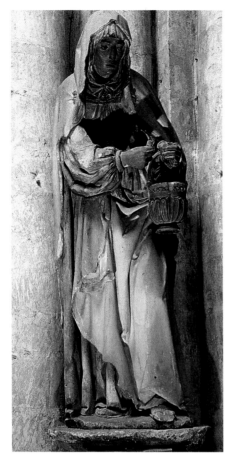

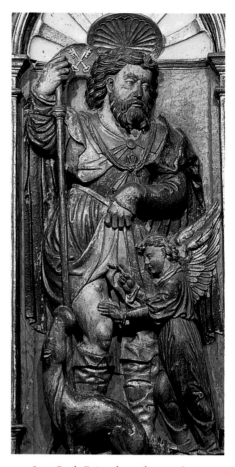

image of Saint Martha. What is curious is that this rood screen is by the same architect as the relatively sober chancel. Gailde apparently wanted to lend new interest to a traditional arrangement, a situation that occurred in many ecclesiastical buildings of the period.

This is the only way to explain—apart from putative liturgical reasons—the wall-like screen that runs along the ambulatory in Chartres Cathedral. Commissioned from Jean de Beauce, it is adorned with carvings executed by sculptors who included Jean Soulas (from 1518 to 1525) and Jean Marchand (after 1542), resulting in two hundred statues that recapitulate all the tactics and traditions of "Hyper Gothic" carving. The ambulatory screen was a complement to the rood screen erected in the mid-thirteenth century (demolished as a hindrance in 1763). Rood screens erected during the sixteenth century, like the one at Troyes, were nevertheless the source of occasionally brilliant aesthetic research—the screen in Limoges, commissioned in 1533–1534 by the enterprising bishop Jean de Langeac

Studio of the Master of Saint Martha, Troyes, *Saint Martha*. Early sixteenth century. Church of Sainte-Madeleine, Troyes.

Saint Roch. Painted wood. 1539. Saint-Bertrand-de-Comminges Cathedral (Haute-Garonne). Rood screen.

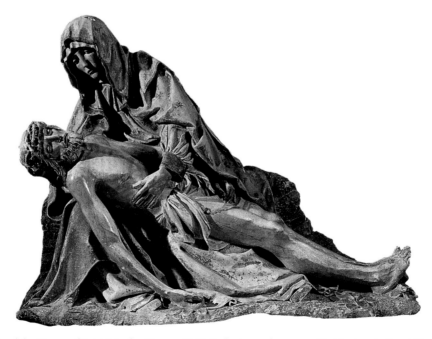

Studio of the Master of Saint Martha, Troyes, *Pietà*. Early sixteenth century. Parish church, Bayel (Aube).

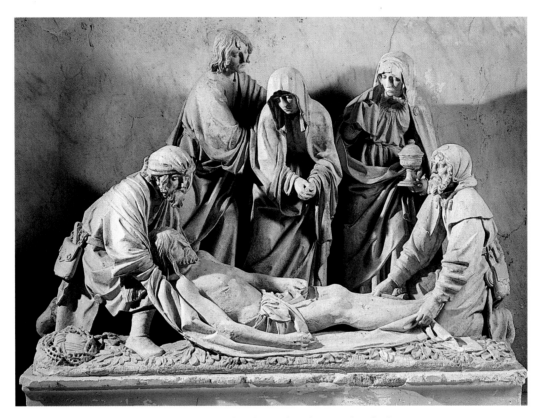

The Entombment. 1528. From the Abbey of Vauluisant. Church of Notre-Dame,
Villeneuve-l'Archevêque (Yonne).

is an ingenious, complicated, bizarre, and
delightful arrangement of *tempietti* (small
temples) perched on top of a canopy.

Such an approach constituted ecclesi-
astical "modernism," as evident at Pagny-le-
Château in Burgundy, where the chapel's
unusually elegant choir screen in alabaster
and black marble featured slim columns
bearing an entablature that formed a frieze
(circa 1540, dismantled in 1881, now in the
Museum of Art, Philadelphia). The opulent
screen contrasted with the arabesques and
dense carving of the chapel.

Similarly, to take a contemporaneous
example from the south, the nave at Saint-
Bertrand-de-Comminges was endowed
with an imposing yet entirely regional deco-
rative ensemble, comprising a set of wooden
stalls and rood screen with four Corinthian
columns supporting a paneled parapet fea-
turing figures of saints.

TOMBS

As mentioned previously, some of the finest
examples of French sculpture depict
Christ's Entombment. It is striking that
these groups of life-size figures, generally
numbering seven, were increasingly com-
missioned by pious confraternities at a time
when tombs honoring the rich and power-
ful also featuring life-size figures became the
norm more or less everywhere. In both
cases, an interest in the virtuosity of emo-
tional expressiveness was combined with a
fascination with death, yielding a rarely
equaled meditative focus on mortality.

The Troyes workshop specialized in
sculpted groups gathered around the dead
Christ. In addition to the elegant statue of
Saint Martha in the church of Sainte-
Madeleine, the workshop perhaps executed
other sculptural groups in the Champagne
region, such as the *Pietá* in Bayel in which

the Virgin leans over the body of Christ to
form a remarkable triangular mass, or the
Entombment in Chaource (1515) with its
seven figures whose draped garments, quiet
solemnity, and weighty gestures are highly
effective. Many other sculptural groups are
admirable for their earnest composition,
artful drapery, and confident definition of
facial features, for example, a group of five
exceptionally well-balanced figures origi-
nally in the abbey of Vauluisant (now in Vil-
leneuve-l'Archevêque, Burgundy). Michel
Colombe sculpted one such mourning
scene for the church of Saint-Sauveur in La
Rochelle (1507–1510, now lost).

Tombs were designed to extend human
glory beyond death, and were meant to con-
vey grandeur. One notable change in mon-
umental tombs occurred in the early
sixteenth century, when the convention of
weeping mourners forming a cortege

Tomb of the Dukes of Orléans, general view and details. Italian, after 1502.
Originally in the Celestine monastery, Paris. Abbey church of Saint-Denis.

around the sarcophagus was abandoned. On the tomb of the dukes of Orléans, executed after 1502 by Italian sculptors at the Celestine monastery in Paris, the arcade harbored apostles, somewhat lacking in style (now at Saint-Denis). It probably represents the first appearance of this feature in France, which was copied in Nantes, at Saint-Denis (tomb of Louis XII), and even later at Montmorency (tomb of Guillaume), yet without ever yielding remarkable results.

Another idea, borrowed from the Neapolitan tombs of the House of Anjou, was to depict the Cardinal Virtues, thereby introducing a religious theme in the glorification of a political personage. The Virtues can be seen in the roundels on the tomb of Charles VIII, executed around 1500 at Saint-Denis, which has a kneeling, rather than recumbent figure on top, as does Louis XI's tomb at Cléry.

The four Virtues played a dominant role for the first time on the tomb that Anne of Brittany commissioned in 1499 for her parents. This new and well-balanced approach was the work of Jean Perréal—the vertical thrust of the Virtues on the corners counterbalances the horizontality of the recumbent figures. The fine, carefully modeled statues themselves were certainly the product of Michel Colombe's workshop. A Tuscan sculptor named Girolamo da Fiesole also collaborated, probably on the decoration of the sarcophagus, which features, along the bottom, a row of roundels containing busts of mourners, above which are positioned statuettes of saints and apostles. Saints Louis and Charlemagne along with Francis, and Margaret, the patron saints of the duke and duchess, adorn the sides of the sarcophagus, which is set in an arcade formed by pilasters whose arabesques betray their Tuscan origin.

It was in the town of Brou (then part of the Holy Roman Empire) that a mausoleum-type chapel was built for Philibert of Savoy, who died in an accident in 1504. This funerary chapel was the object of great attention on the part of his widow, Margaret

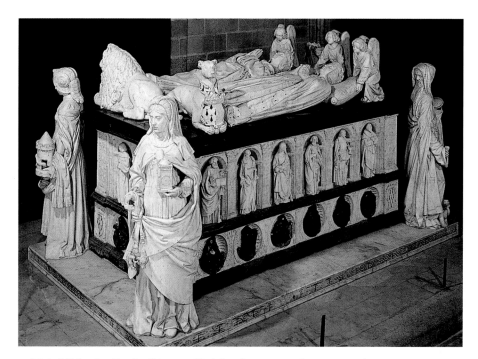

Michel Colombe. Tomb of François II, duke of Brittany, and Marguerite de Foix. 1499–1507. Nantes Cathedral (Saint-Pierre).

of Austria (died 1530), and included three tombs. The poet and chronicler Jean Lemaire de Belges was consulted about the project, as was Jean Perréal, but there was disagreement and the work was ultimately confided to a Flemish artist, Jan van Roome (or Jean of Brussels), the statues being completed later by Conrad Meit. The central tomb was that of Prince Philibert, and it reflects the magnificence associated with Burgundy. Margaret's tomb has a canopy in the form of an aedicule (or small shrine), as does the tomb of the prince's mother, Marguerite of Bourbon, placed opposite. The contract specified one feature, which, although appearing here in a context removed from "French" art properly speaking, would later be copied even in that bastion of French royal art, the abbey church of Saint-Denis. The two levels allow for a "living" image of the individual, richly dressed, to be placed above a representation of death—that is to say, an effigy of the deceased as laid out in the tomb.[15]

Anne of Brittany died in 1514, at the age of thirty-seven. Her confessor's funeral eulogy cleverly listed the thirty-seven virtues composing the chariot that carried Anne to heaven, and also made a point of referring to her Trojan ancestors. Such was the sophistication of official celebrations. Anne's husband, Louis XII, died later that same year—their tomb at Saint-Denis, commissioned in 1515 from Florentine sculptor Jean Juste, was conceived as a monument in the grand style, with complex and original imagery. It apparently represented a desire to assemble all the new motifs in a structure evoking a *tempietto*, not unlike the Visconti tomb in the Carthusian monastery in Pavia. The now-standard figures of the four Virtues sit at the four corners of the base, around which run narrative, lightly carved bas-reliefs. Unfortunately, the Virtues are dull in execution and inappropriate in scale. On the edge of the platform below the twelve arches sit twelve smaller figures of the apostles, in a style reminiscent of Italian

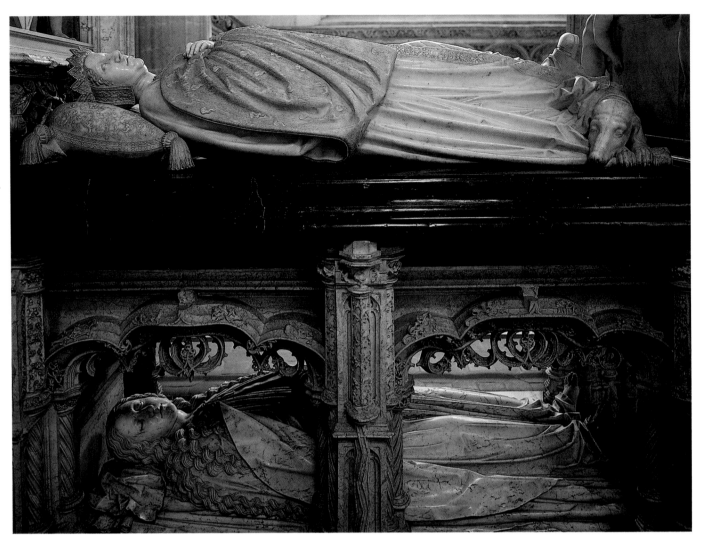

Jan van Roome and Conrad Meit. Tomb of Margaret of Austria (detail). 1516–1531.
Parish church, Brou (Bourg-en-Bresse, Ain).

sculptor Andrea Sansovino. The tomb's originality stems from the fact that it appears to be the first time that a kneeling version of the "living" figures has been placed over the effigies lying inside the arcade. The royal couple are thus given twin existences—as very Christian monarchs nobly pictured above, and as naked corpses below. The impressive effigies are generally ascribed to a French follower of Michel Colombe, while the other, highly conventional, statues are the work of Italian artisans. This unequal collaboration is inter-

esting—the two recumbent figures are sculpted with an accuracy both moving and severe, yet thanks to the remarkable use of marble, the horror of the corpse-like forms gives way to a noble image of striking gravity that fully belongs to that grand period of French art.

The various provinces retained their own idioms. In Normandy, where no facade was complete without a stream of composite decorative details, the same was required for tombs. That, at least, is what can be deduced from the tomb of Cardinal

Georges d'Amboise, begun in 1515 by Roullant Le Roux (the kneeling figure of the great cardinal being later joined by that of his nephew, Georges II). The monument is designed in the form of a recessed wall tomb; above is a carved, overhanging parapet, while below there are niches containing statuettes of the Virtues. The relief carving is determinedly exuberant, and here the influence of Caen would seem to weigh more heavily than that of Gaillon.

These brief comments offer only a glimpse of the overall vitality of sculpture in

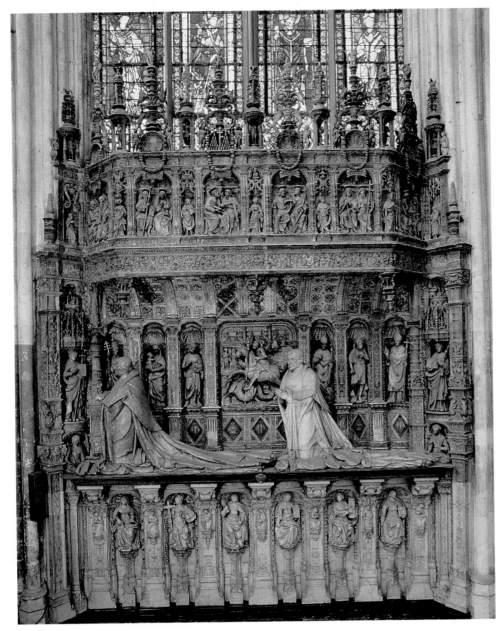

Roullant Le Roux. Tomb of the Cardinals Georges I and Georges II d'Amboise. After 1515.
Rouen Cathedral (Notre-Dame).

the first three or four decades of the sixteenth century. Statues of uncertain date and artist, such as the *Olivet Virgin* (circa 1520–1525, Musée du Louvre), are of distinctive quality in terms of facial features and simplicity of tone. In western France and the Loire Valley, the heritage of Michel Colombe comes to mind, while in Champagne, where such statues abound, Jacques Bachot and Jean Collet have left their mark. Workshops were nevertheless aware that models became dated and were watchful for new innovations—at Saint-Jean in Troyes, figures in a Visitation are artfully draped in garments imitating Dürer's *Life of the Virgin*. German prints were used a great deal as inspiration until the arrival in France in 1541 of Domenico del Barbiere (circa 1506–1565), later known as Dominique Florentin, who brought a touch of the Fontainebleau style to the Champagne region.

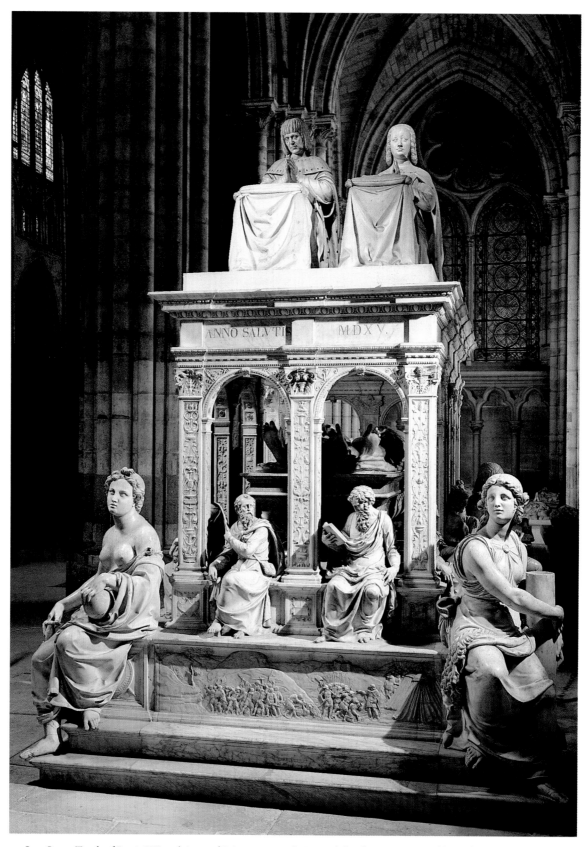

Jean Juste. Tomb of Louis XII and Anne of Brittany, general view and details. 1515–1531. Abbey Church of Saint-Denis.

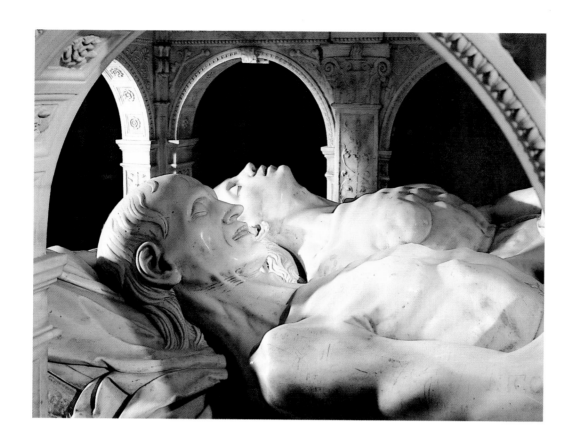

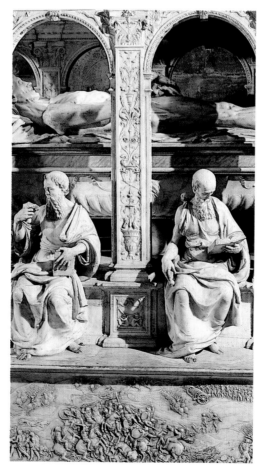

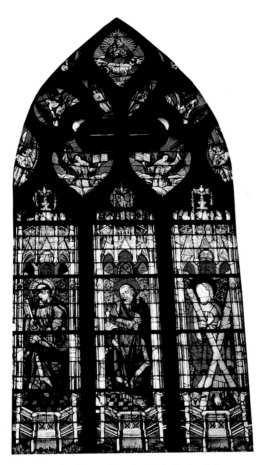

Church of Saint-Séverin, Paris. Stained-glass
window in the nave: *Saint Peter, Saint Paul,
and Saint Andrew.* c. 1470.

Church of Saint-Ouen, Pont-Audemer (Eure).
Stained-glass window in an aisle of the nave:
Dormition of the Virgin. c. 1520.

STAINED GLASS

The same period was highly fertile for stained glass, notably in Normandy and Champagne, with several magnificent examples in the Pyrenean south. The phenomenon might seem surprising unless it is realized that stained glass had always fulfilled the role of painting in French churches. Like the sculpted works just discussed, Renaissance stained-glass windows were the culmination of a traditional practice that was modified to meet new requirements.

In many cases, stained glass benefited from the newly enlarged chancels that replaced partitioned chapels with a unified space featuring large windows. The resulting stream of colored light thus produced a demand for more "painting."

It has been somewhat hastily and repeatedly asserted that stained glass betrayed its true calling by adopting the principles of painterly composition. However working in stained glass had always been a type of painting, subject to the transposition required by transparency, which demanded framing devices to focus the visual effect. Beginning in the fourteenth century, imaginary architectural settings made it possible to handle isolated figures (followed, in the fifteenth century, by groups of figures) with a certain plastic freedom still seen in many examples, such as at Saint-Séverin in Paris (circa 1470). After 1500, these fictional frames evolved into small temples (Saint-Ouen, circa 1520), or arcades (Notre-Dame in Louviers, circa 1520), or

large monumental designs (the east chapel of Auch Cathedral, circa 1510). In France, this compositional tactic was characteristic of stained glass, whereas in Flanders, it was used for wooden retables with small figures.

In the Tullier window in Bourges Cathedral (1532), everything is subordinated to the magnificent architecture— "modern" aedicules and white cherubs crown the arcade, standing out against the blue ground. Even when compositions became more picturesque than pictorial, occupying the entire breadth of the window and incorporating scenes in the distant background (for example, Saint-Vincent in Rouen, circa 1525, or the *Judgment of Solomon* in Saint-Gervais, Paris, 1531), the window frame itself guaranteed an effect of

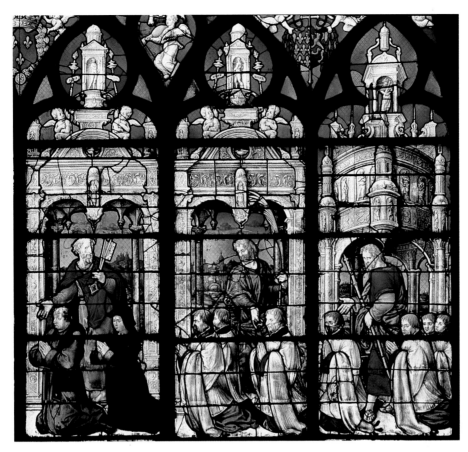

Bourges Cathedral (Saint-Étienne), Sainte-Anne Chapel. Stained-glass window
donated by the Tullier family. 1532.

verticality, while the strips of lead which retained the glass in place lent an ornamental touch, enabling stained-glass windows to retain their specific character.

Stained glass received significant impetus when the range and density of colors were enhanced. This occurred at an early date in Normandy, where a decisive contribution was made by a Dutchman, Arnoult of Nijmegen, who came from Tournai probably at the bidding of Antoine Bohier, abbot of Fécamp. Arnoult's work can be seen in the churches of Saint-Godard (with a dazzling *Tree of Jesse,* 1506), Saint-Ouen, and Saint-Vincent. He left Normandy around 1512, but his influence could be felt throughout the province—not only did Arnoult decorate borders and frames with

details from the modern repertoire, such as vases, garlands, and bucrania (ox skulls), but he also made large drawings directly in red chalk, in imitation of the Flemish masters (his *Three Marys* in Louviers, installed circa 1520, is based on the work of Quentin Metsys). His windows in Saint-Vincent, of remarkable scope and energy, were saved from destruction and reinstalled in the basilica of Sainte-Jeanne-d'Arc. The church of Saint-Vincent was also where Engrand Le Prince, a painter from Beauvais who founded a major workshop, gave an impressive demonstration of the new trend in stained glass with a series of sixteen panels, circa 1520; the pictorial thrust—achieved through blended colors, nuanced effects, and touches of silver stain—can be seen in

the *Triumph of the Virgin*, showing a lively procession in front of the cathedral. His spontaneous, assured handling of such passages avoided potential confusion and successfully yielded a lively and confident type of "transparent painting."

It was in Beauvais itself that this bold master and head of a family of artisans produced his most extraordinary work from 1520 to 1530, seen notably in the church of Saint-Étienne. The technique employed thin glass, sometimes "flashed" (that is, fused with other colors) to produce green and violet hues, with admirably controlled contrasts between the grisaille or reddish outlines and the layers of color. It must be repeated once again that in the sixteenth century such artworks constituted great

Church of Sainte-Jeanne-d'Arc, Rouen.
Stained-glass window by Engrand Le Prince,
The Triumph of the Virgin. Originally
in the Church of Saint-Vincent. c. 1520.

Church of Saint-Étienne, Beauvais, Sainte-Anne Chapel.
Stained-glass window by Engrand Le Prince:
The Tree of Jesse. c. 1520–1530.

French *painting* (occasionally as dazzling as a Matisse). Like Engrand Le Prince, Romain Buron provided Norman churches in Conches-en-Ouches (circa 1535), Les Andelys, and Gisors with windows of wonderful fluidity and charm. Conches-en-Ouches features seven windows on three levels, each having its own register—the relatively straightforward Passion, the more lively legend of Saint Faith, and the hieratic patron saints.

Successful windows required inventiveness on the part of the artists, who relied so little on painted models that they sought inspiration from the prints then circulating everywhere, in particular those by Lucas von Leyden and Dürer. A print was clearly the basis of the cartoon of the Crucifixion seen in the Roucherolles window produced by Engrand Le Prince for Beauvais Cathe-

dral in 1522, as well as for those at Saint-Vincent in Rouen. Engravings were imitated for their acute drawing and lively expressiveness. As proof of the extent to which the enormous output of prints constituted a veritable pictorial phenomenon, one need merely consider the numerous and often surprising versions of the Tree of Jesse.

Among the various biblical subjects, the Tree of Jesse had more difficulty taking root than, say, the family group around Saint Anne, so favored in central Europe. In France, the Tree of Jesse returned to the fore around 1500, as seen at Saint-Godard

in Rouen (circa 1506), where enormous patriarchs in princely robes of remarkably strong colors are arranged among borders of garlands, bucrania, and the like. At Autun Cathedral, around 1515, Canon Celse Morin deployed vertically the branches bearing the royal family, setting the figures against a white ground, as though depicting some kind of fantastic vegetation. Ten years later, at the church of Saint-Étienne in Beauvais, Engrand set his gleaming red and gold figures (resembling the kings from a deck of cards) within a severe yet vibrant blue, in a highly inventive

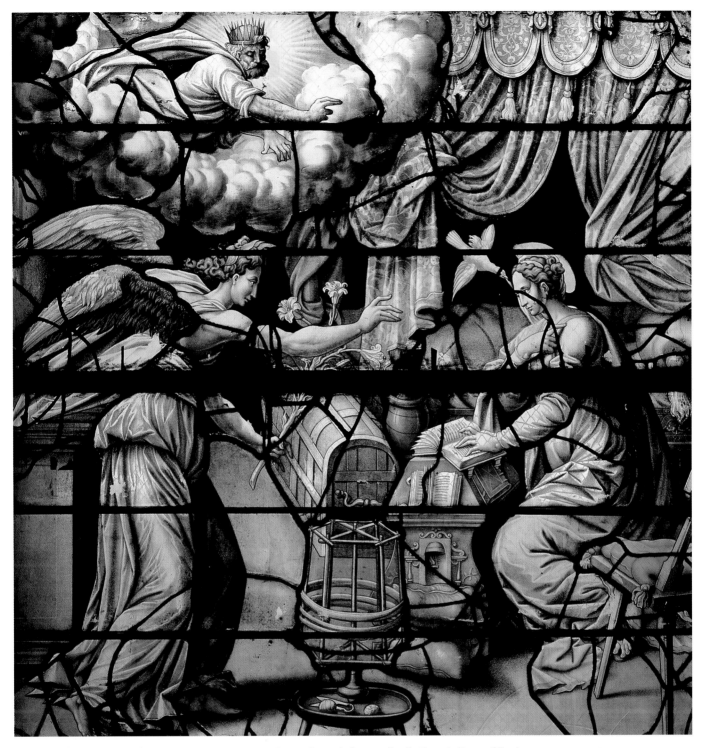

Church of Saint-Gervais-Saint-Protais, Gisors. Stained-glass window by Romain Buron: *The Annunciation*. c. 1535.

arrangement possibly based on a print (or perhaps, for once, completely original). This painting, certainly one of the most dazzling examples of stained glass, represented a continuation of the grand tradition and was itself abundantly imitated throughout western and northern France in—as is unfortunately often the case in such matters—a more mediocre fashion.

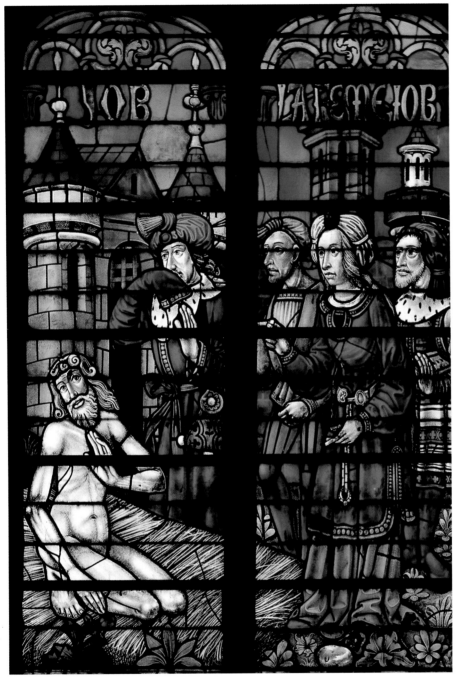

Troyes Cathedral (Saint-Pierre-Saint-Paul). Stained-glass window in the nave:
The Story of Job (detail). 1498–1501.

throughout the entire region. There is an extensive body of local stained glass in churches in Troyes (Saint-Nizier), Châlons-sur-Marne (Notre-Dame-en-Vaux), and Epernay, which remains highly uniform except when a master like Mathieu Bléville added a personal touch (*Life of Saint James*).

New-style stained glass resembled retables, though more spacious, more architecturally inventive, more wedded to light. This is exemplified by the large composition donated to Bourges Cathedral by the Tullier family in 1532 (probably executed by Jean Lécuyer), and by the Popillon Chapel in Moulins (after 1510), featuring extraordinarily refined aedicules harboring majestic figures in flowing white garments. Another superb example is found all the way to the south, near the Pyrenees, where, fortunately, an outstanding set of stained glass has escaped destruction in Auch—eighteen windows by Arnaut de Moles, of great

Auch Cathedral (Notre-Dame), Sainte-Catherine Chapel. Stained-glass window by Arnaut de Moles: *Isaac* (detail). 1513.

The Champagne region also experienced its own "Renaissance," producing a great school centered on the windows at Troyes. The nave of the Troyes Cathedral was endowed with new stained glass from 1498 to 1501, featuring square panels showing Biblical figures such as Job, Daniel, and the prodigal son, set against intense red and blue grounds. It is not known who was behind this ensemble, but a master must have supplied the artisans with cartoons because the same models were reproduced

Former Collegiate Church of Notre-Dame-en-Vaux, Châlons-sur-Marne. Stained-glass window by Mathieu Bléville:
The Life of Saint James (detail): Saint James at Clavijo. 1525.

scope and richness, completed in 1513. His technique is remarkable in its tiered, "Roman-style" decoration, in the damasked garments, and in the finesse of the faces. Arnaut de Moles came from Saint-Sever, but was obviously aware of current styles.

There must have been an enormous amount of stained glass installed in churches throughout France during this period of prosperity and artistic abundance. Vestiges of such work are still being identified today. In Paris, most churches that did not already have stained glass were endowed with narrative-style windows employing an architectural setting that spanned the entire window. The church of Saint-Gervais is a good example, with an *Annuciation* (circa 1520), apparently based on an unknown miniature, and an ambitious *Judgment of Solomon* (dated 1531). The same fervor can be observed throughout the Île-de-France region, particularly in the seven windows of the church of Saint-Martin in Montmorency (circa 1525) with clearly articulated construction—probably of Flemish origin—that stresses outlines with an energy clearly opposed to the more painterly trends.

Blois (Loir-et-Cher). Facade of the Louis XII wing, the entrance portal. 1498–1503.

3. THE FIRST STAGE OF MODERN CHÂTEAUX

The period of construction that ran from the late fifteenth century until the time of Francis I's defeat at Pavia in 1525 was one of the most lively, inventive, and delightful in all of French architecture. Justice cannot be done to it by focusing solely on the extent to which it displayed Italian influence, which at any rate was rather limited. The architectural boom lasted for a quarter of a century and was mainly located in the central part of the country, with the most brilliant results produced in the Loire Valley, where the court usually resided. The resulting transformation could therefore properly be termed the Loire Renaissance.

At Blois, Louis XII added an entrance wing featuring an inner portico, ornamental use of brick, tall gables crowning the arcade, and a somewhat gauche equestrian statue over the entrance portal. This decorative remodeling was far less interesting than the work carried out by Maréchal de Gié at Le Verger, several leagues from Angers, where everything was regular and symmetrical: a vast forecourt framed by towers, a main building of three levels overlooking a *cortile* (arcaded courtyard), a lower side wing, and, according to guests of the day, substantial interior comfort. The château was demolished in 1776 on the orders of Cardinal de Rohan, as were the other two most interesting buildings from this period—Bury and Bonnivet—for the same reasons: they had become decrepit residences that were too costly to maintain. Yet in the sixteenth century, they had been glorious and much admired. The Château de Gaillon, begun a bit later, was less regular but more luxurious. In a certain sense, Gaillon is the edifice that most typifies the early Renaissance, triggering the evolution that culminated in Fontainebleau and Écouen. Ever since the thirteenth century, the archbishops of Rouen had owned a château at Gaillon, a spur of land overlooking the Seine not far from Château-Gaillard, the gateway to

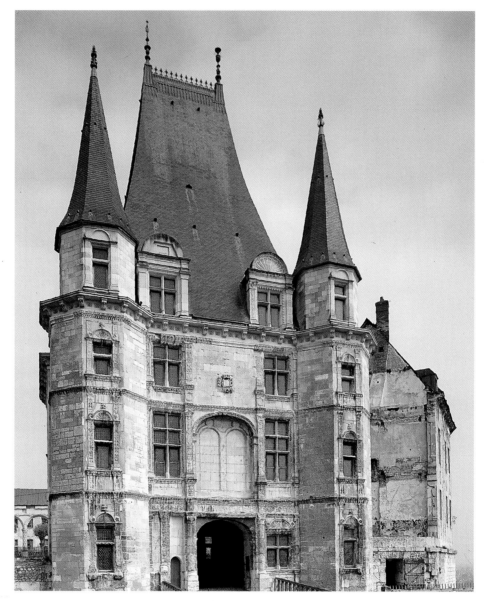

Gaillon (Eure). The gatehouse. 1509–1510.

Normandy. The magnificent stone escarpe (or outer base) of Gaillon recalls the masonry of Charles V's Louvre. The south wing was rebuilt by the wealthy Cardinal d'Estouteville, whose successor, Georges d'Amboise, undertook a complete renovation (a practice that had become increasingly common). The masons recruited from royal work sites were nevertheless replaced in 1506 by Rouen workmen, who were more amenable to new ideas. The main courtyard was separated from the lower entrance yard by a wall that formed a gallery along both sides of the triumphal gateway. A tall spiral staircase, topped by a statue of Saint George, led into the main building, which overlooked the valley. The central terrace was flanked by two projecting elements: to the west was the Mermaid Tower, where the archbishop resided, while to the east was the two-storey chapel. In 1509–1510, the gatehouse was given a new aspect due to the windows framed by Lombard-style pilasters, plus a steep French-style roof (recently restored).

Decorative reliefs covered the walls at Gaillon, first in the eclectic style typical of 1500, then, after 1507, in a more markedly Italian idiom (including the antique-style medallions that quickly became famous).

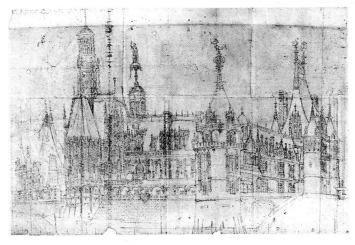

Gaillon (Eure). View of the château from the Seine valley.
Early sixteenth century. Black chalk drawing, 50.6 × 100.8 cm.
Nationalmuseum, Stockholm.

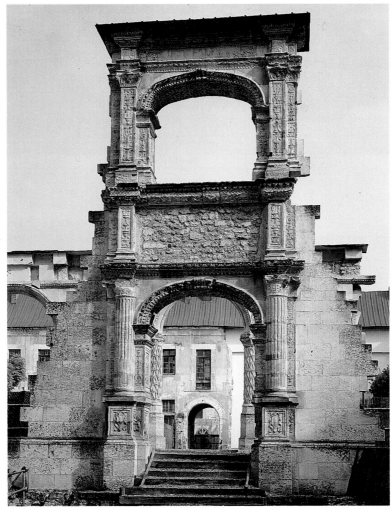

Gaillon (Eure). Gateway to the central wing. Early sixteenth century.

Gaillon (Eure). East facade facing the Seine: interior view
of the gallery. 1502–1506.

Gaillon (Eure). The gatehouse,
detail of the window decoration. 1509-1510.

In the chapel, Michel Colombe's *Saint George* was framed by ovolo molding and scrollwork by Jérôme Pacherot, and the walls over the choir stalls were decorated with portraits of the Amboise family by the Milanese painter Andrea Solario. It is clear that after 1507 Georges d'Amboise, dissatisfied with the way the decoration was progressing, recruited teams of Lombard sculptors and painters, including Solario. Most often mentioned, however, is the unusual scope of the gardens, which boasted terraces complete with galleries and pergolas, and extended into the nearby forest where deer were hunted.

Since the new château at Gaillon was a renovation of an existing building, its plan was not symmetrical. Its decorative elements were nevertheless admired and copied, for example, at Chemazé (in the Loire region), with its large external spiral staircase. France's new ruling elite was beginning to take architectural initiatives. Thomas Bohier, the kingdom's Comptroller of Finances (and the brother of Antoine, who recruited Italian sculptors to work on his abbey at Fécamp), acquired in 1513 a long-coveted estate on the the river Cher, called Chenonceau. Bohier retained the original keep for reasons of historical prestige, but otherwise built anew, between 1515 and 1522, a three-story residence set on piers over the river itself. The vertical thrust is broken by a frieze under the gables, and a modern approach is reflected in numerous details, such as a straight rather than spiral staircase and a coffered ceiling in the study imitating an Italian-style *studiolo*. A taste for the picturesque is evident in the way the chapel and residential tower project over the river. The condensed plan was dictated by the site and the amusing idea (employed again at Azay-le-Rideau) of setting the château over water. Chenonceau was in competition with the construction of Bury—all the wealthy royal officers flaunted their modernity in the residences they built in the Loire Valley.

Another high-administration official, Florimond Robertet, built the so-called Alluye mansion at Blois prior to 1508, with an Italian-style *cortile*. In 1514, Robertet began the château at Bury, based on a rigorous square plan relieved by the standard

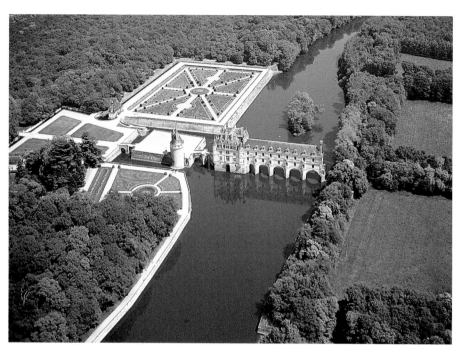

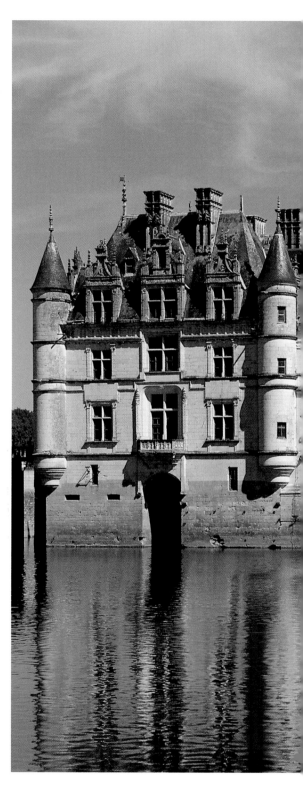

Above and right: Chenonceau (Loir-et-Cher).
View of the château on the river Cher. 1515–1522.

Chenonceau (Loir-et-Cher).
Coffered ceiling in the study. c. 1520.

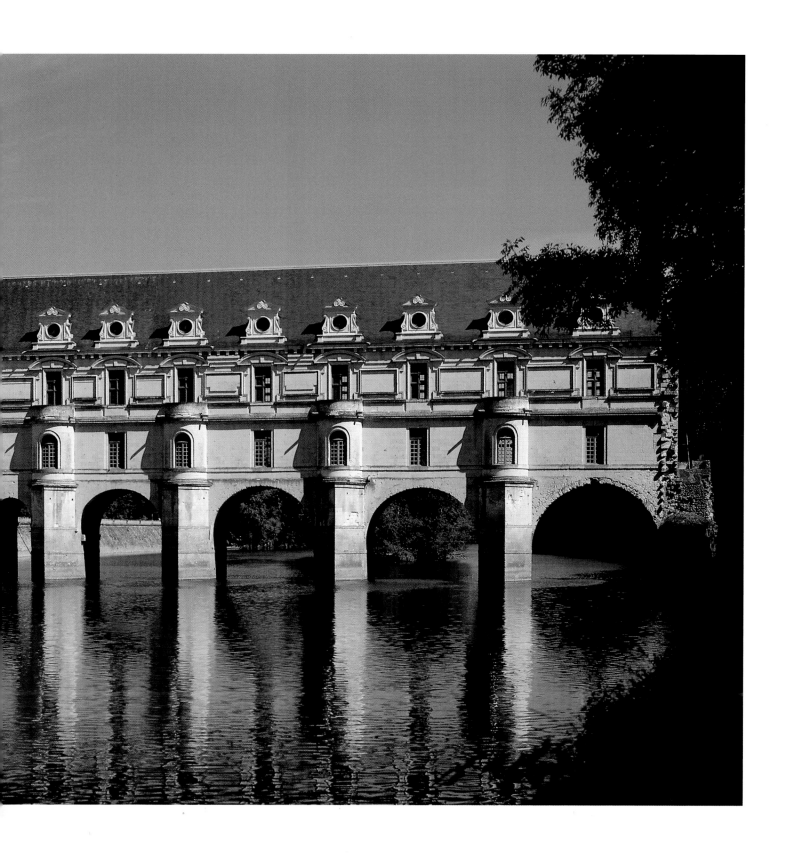

round towers with a low entrance section featuring an interior portico. One of the two wings formed a gallery, the axis being defined by the staircase in the center of the main building. The facade was carefully punctuated by windows, topped by a high, French-style roof. In the middle of the courtyard was a bronze *David* by Michelangelo. Quite different was Bonnivet, in the Poitou region, which Rabelais mentioned when describing Thélème Abbey. This was an enormous building worthy of a lord whom Francis I had appointed Grand Admiral of France (later slain at Pavia, like so many others). Although never completed, Bonnivet was also based on a square plan, its hundred-meter-long facade admirably orchestrated by well-framed bays five storeys high, with a parapet running under the gables and along the towers, which endowed an edifice of this scale with the necessary unity. Finally, the ingenious development of a stairway opening onto both facades inaugurated the typically French motif of transparency.

The château of Azay-le-Rideau (1518–1527) built by the financier Gilles Berthelot, could be considered a small-scale

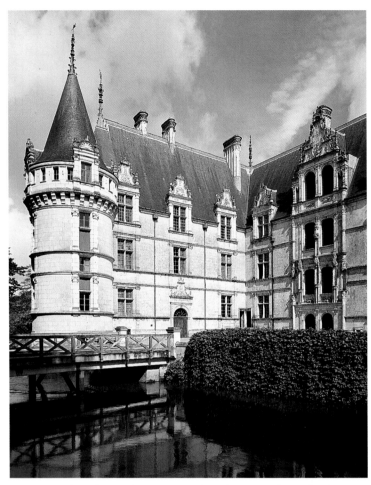

Azay-le-Rideau (Indre-et-Loire). The right wing and main facade overlooking the courtyard. 1518–1527.

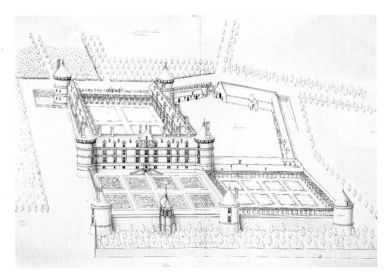

Jacques Androuet du Cerceau. Aerial view of the Château de Bury. 1576–1579. Pen and watercolor. 51 × 74 cm. British Museum, London.

Azay-le-Rideau (Indre-et-Loire). The staircase. 1518–1527.

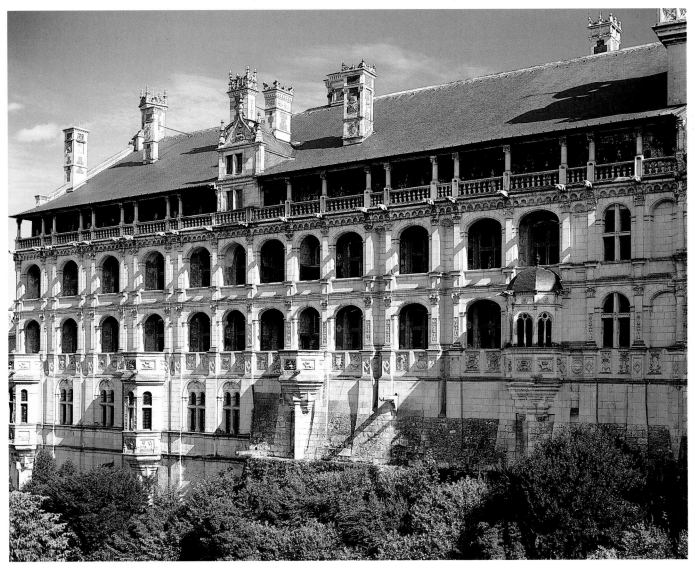

Blois (Loir-et-Cher). The Facade des Loges. c. 1520.

Bonnivet, The inclusion of string courses, a parapet, and a staircase open at both ends of the straight, dog-leg flights is wonderfully coherent with the characteristically French steep roofing. Great charm is exuded by decoration that is not overly capricious; the château is probably unfinished, however, since the L-shaped plan seems to call out for completion.

Meanwhile, King Francis I had taken an interest in Louis XII's château at Blois, which became the young king's realm of experimentation. Francis was initially content to refurbish and boldly modernize the north wing overlooking the courtyard by constructing an enormous, three-storey facade capped by a strong molded cornice of impressive effect. In the center, he added a grandiose external, open-work staircase featuring modern decoration. Several years later, around 1520, the town side was endowed with a double-level loggia manifestly based on Bramante's Vatican model. The four bays on the left adopted a not very successful pattern that was abandoned on the right, where the loggia is devoid of all style; but the idea of *opening* the edifice to the outside seemed timely. This idea became popular more or less everywhere; for instance, at La Rochefoucauld, the three-level arcade on imposts, dating from 1528, displays finer balance than does the one at Blois.

The Italian engineer-architects who went to France, like Fra Giocondo and Domenico da Cortona, worked above all in

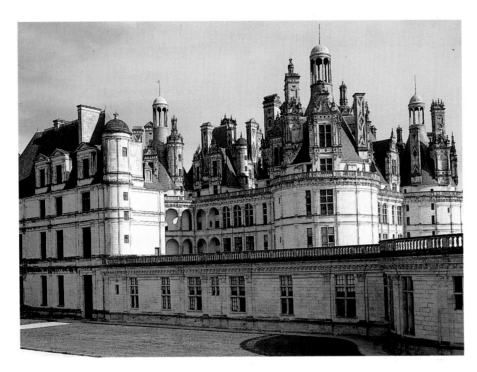

Chambord (Loir-et-Cher). View from the west. 1519–1556.

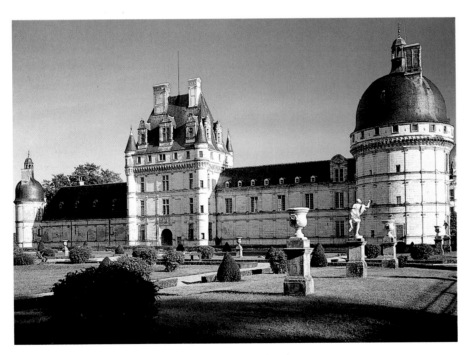

Valençay (Indre). The entrance facade. From 1540.

Paris. Leonardo da Vinci, well-advanced in years when he arrived in 1516, had already supplied the plans for Charles d'Amboise's villa in Milan. To begin with, Francis I had Leonardo work on Louise of Savoy's château at Romorantin. The plans were elaborated and soundings made in 1518—it was to feature a portico set in a large rectangular courtyard flanked by two running streams. However, an epidemic brought work to a halt, and Leonardo himself died in May 1519. Something of his designs for noble residences can certainly be detected in the first château worthy of royal ambitions, namely Chambord, on a site chosen by Francis I around 1518 for hunting and other diversions. Chambord's huge dimensions owe less to Leonardo's ideas than to the extraordinary design of the central section that called for an enormous spiral staircase with two turns, placed at the very heart of the edifice as though it were a demonstration piece in a modernized interpretation of a model that dated back to Charles V's Louvre. The tour de force was the addition of a central lantern that emerges from the roof, like a cupola. As for the rest, the ambitious (and never-completed) château was based on a plan with traditional round towers on the corners; while Italians motifs are used to enliven the surfaces, it is the French aristocratic architectural idiom of the roof, which resembles an enchanted city, that gives the edifice its character. Viollet-le-Duc was only half wrong when he declared, in his renowned nineteenth-century dictionary of architecture, "there is nothing Italian in all that, neither in philosophy nor form."

Finally, it is worth stressing the extraordinary verve of the decorators whose fanciful approach distinctly tilted the composite style toward gaiety and humor. The immense building numbers nearly eight hundred capitals, which alone set the tone for the entire undertaking. French sculptors had too many centuries of freedom behind them to pay even antique capitals excessive respect.[16]

Following events of that scale, nothing could be built as before, except in the most distant provinces that were slow to feel the shockwaves of French modernism as swiftly and ingeniously defined in the Loire Valley. Enterprising nobles and rich royal officers henceforth imitated a new model. This can be seen at residences like Villesavin, circa 1538, a simple one-storey structure with a high roof featuring several original gable windows, as well as at Villegongis, from roughly the same date, where the decorative chimneys were modeled after the above-mentioned châteaux. Valençay is noteworthy for an ambitious north wing that imitated the round tower and decorative approach of Chambord, although the rest of the large edifice was built considerably later. Villandry, meanwhile, probably received its initial form around 1532.

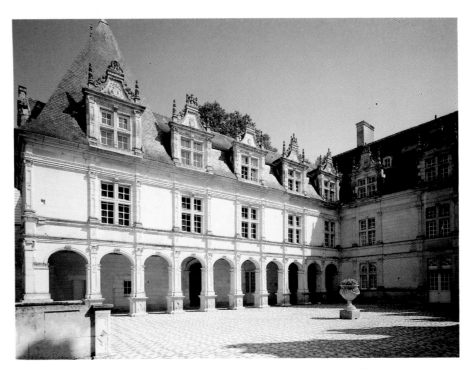

Villandry (Indre-et-Loire). The left wing overlooking the courtyard. From 1532.

Town houses, in general, posed fewer problems than châteaux in terms of siting, implantation, and mass. Thus in Caen, a skillful mason named Blaise Le Prestre endowed the facade of the Escoville mansion (1535–1538) not only with the system of bays and gabled windows evoking a multileveled aedicule (as was becoming standard), but with columns on every storey to underscore the bays. Le Prestre is also credited with one of the most significant Norman châteaux, at Fontaine-Henry. It includes a high-roofed pavilion to the north, which takes the place of an ancient keep; then, after a stylistic break that requires explanation, there is a building with three bays, whose architraves, gable, and turret (perhaps for a staircase) accord with the early sixteenth-century châteaux of Meillant and Chemazé. The two parts of Fontaine-Henry were connected by a system of bays like those in Caen, which suggests that it was Le Prestre who executed that section in 1537, along with a gallery (transformed in the nineteenth century) that terminates the composition to the east.[17]

In the space of just a few years, then, a certain number of conventions were

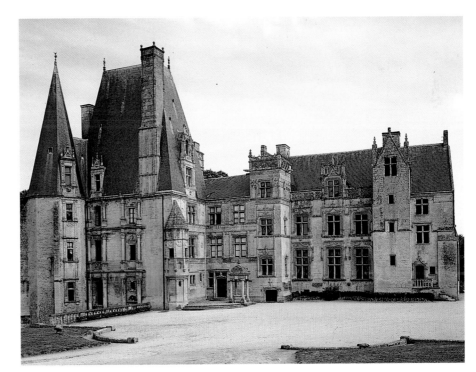

Fontaine-Henry (Calvados): general view. c. 1537–1544.

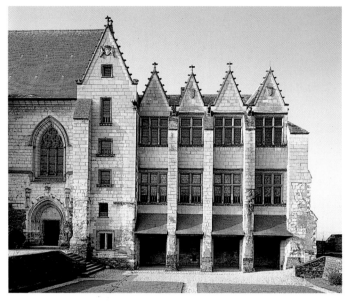

Angers (Maine-et-Loire). View of the gallery added by King René
to the northeast facade of the royal residence. c. 1457.

durably adopted as the mark of noble residences, representing the culmination of an evolution begun in the preceding century. First there was the standardization of the overall plan: a quadrangular design, prefigured as early as 1470 at Plessis-Bourré, employed at Le Verger, and then imitated at Bury and twenty other contemporary châteaux. It is possible that contemplation of the Poggio Reale villa in Naples by Charles VIII's expeditionary companions in 1494 reinforced the taste for a courtyard with portico (Sebastiano Serlio's 1540 treatise, designed to provide prototypes, included this villa). It is also possible that the scale-model château presented to Charles VIII by Giuliano da Sangallo in 1495 led in the same direction. However, such models did not, as was once believed, represent the prime inspiration for French châteaux. They evolved on their own, so to speak, with concerns alien to Italian models. Staircases and chimneys, for instance, were handled in a particular manner.

The long room, or gallery, became an original trait of noble dwellings in France.

It was generally designed as a wide corridor set over an arcade, and was used to store and display works of art. As early as 1457, King René erected a recreational space of this type above a loggia in his château in Angers; it has been suggested that the Tudors in England adapted his pioneering model.[18] In an architecturally precocious château like Bury, the gallery occupied an entire wing; at Fontainebleau, it provided a link between two buildings and was the object of unprecedented decorative attention. A gallery subsequently featured in almost all noble residences. Philibert de l'Orme, the first French architectural theorist, spoke out clearly on the subject in 1567, "Suspending a gallery around a courtyard is suitable for occupying less courtyard space and also for giving more light to the upper floor and for accoutering an old castle that is misshapen." Galleries became a standard part of town residences and so remained throughout the seventeenth century.

It is hard to appreciate the charm and originality of these buildings if their decorative carving is overlooked. The freedom and gaiety displayed by anonymous decorators on the portals, architraves, and consoles were a sign of the unflagging vitality of French stonecutters.

This was also the period when woodcarvers were taking so much delight in producing misericords for choir stalls. Good humor even infiltrated the tapestries (although accurately dated and localized examples are rare) through the vogue for pastoral subjects in the style of Clément Marot's poetry. This can be seen in a tapestry titled *Spinning and Weaving,* which bears the coat of arms of Thomas Bohier and Catherine Briçonnet; in the six *Scenes from Courtly Life* (full of flirtatious encounters, a rich floral repertoire, and a studied elegance of dress); and even in the natural ornamentation of the fleurs-de-lys decorating *The Promenade,* a tapestry certainly destined for a French client but woven in Brussels (circa 1520.

Francis I's captivity after the battle at Pavia led to a halt, or at any rate, to a new phase, in royal undertakings. Architectural

Loire Valley Workshop, *Spinning
and Weaving* (detail). Tapestry. c. 1500.
Musée du Louvre, Paris.

Loire Valley Workshop, *Scenes from Courtly Life:* the promenade. Tapestry. c. 1500. 287 × 265 cm.
Musée national du Moyen Âge, Paris.

experimentation continued, but on different registers—it seemed as though the diversity was deliberate, whether applied to a luxurious villa (Château de Madrid), a residence for long courtly sojourns (Saint-Germain-en-Laye), or a prestigious dynastic château (Fontainebleau).

The capacity for inventiveness, the desire for comfortable interiors, and the elegance of the elevations could hardly be more obvious than in what was known as the Château de Madrid constructed in the Bois de Boulogne just outside Paris. Begun in 1527, its design was based on an original, complex plan: two blocks of apartments (thirty-two in all) flanked four large central halls intended for dances and theatrical entertainment. Chimneys appeared everywhere, and the facade featured a play of decorative arcades adorned with majolica medallions from the workshop of Girolamo della Robbia (1488–1566), who had been specially summoned for the task. The entire complex was framed by turreted staircases providing multiple access. In short, this hunting pavilion in the middle of the woods was a building of unmatched virtuosity designed for receptions rather than residence; but this Renaissance "Trianon" was poorly maintained, hosted only occasional guests, and was demolished at the end of the eighteenth century. The anonymous architect—certainly not the decorator della Robbia nor the master mason, Gadier—was most probably the king himself, who, in consultation with Villeroy, his finance officer, adopted a number of Leonardo's ideas for Charles d'Amboise's villa in Milan (1506).

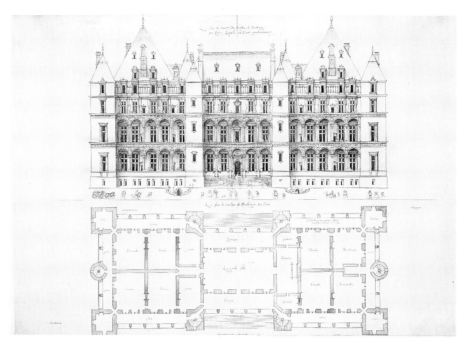

Jacques Androuet du Cerceau, Front elevation and ground plan of the Château de Boulogne, (or Château of Madrid). 1576–1579. Pen and watercolor. 51 × 74 cm. British Museum, London.

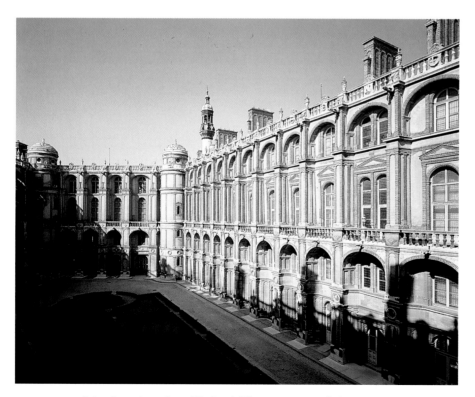

Saint-Germain-en-Laye (Yvelines). The inner courtyard. From 1539.

Altogether different was the former château of Charles V, Saint-Germain-en-Laye, remodeled from 1539 onward by Pierre Chambiges (died 1544): an enormous, flat-roofed, four-level building, it was designed to accommodate a large court and was thereby subject to an interior organization closely linked to court habits and etiquette.[19] This "barracks" continued to be used throughout the ancien régime. It was probably this practical function that explains why the king "was so attentive in building the château [so] that it could almost be said that the architect was none other than himself."[20] Chambiges employed the polychrome effect used in the Cour du Cheval Blanc at Fontainebleau, with recourse to brick for the jambs and shafts. This approach was quite different from that of the Italian models, and was subsequently imitated a great deal, as in the courtyard of Fleury-en-Bière, near Fontainebleau.

4. FONTAINEBLEAU

Francis I's favorite château was also the most disconcerting example of the architectural patchwork typical of his reign. It was decided in 1528 to erect a modern château on the site of a medieval residence that still boasted a sacred and immutable keep from the days of Saint Louis. This decision reflected a shift in royal attention from the Loire Valley to the region aroud Paris. Fontainebleau, set in the midst of an incomparable forest, was an excellent rendezvous for hunting parties, as well as a cool haven in summer. It has become one of the major historical châteaux in France.

The work was entrusted to a master mason, Gilles Le Breton, who remained on the site for nearly a quarter of a century. A monumental entrance known as the La Porte Dorée was erected to the south, between the ponds. Below its traditional steep roofing, there were three levels of open bays that recall the facade of the palace of Urbino, set between two columns of windows with small triangular pediments, underscored by vertical courses of stone. Like Gaillon, Fontainebleau represents a typical statement of the compromise that was reached between imported motifs and French treatment. The buildings were rearranged to form an oval courtyard with rectilinear pilasters and modest pediments as sole ornamentation. A grand, twin-flight staircase, presenting an antique-style version of a type seen in some of the royal palaces in Paris, Montargis, and elsewhere, was set in the middle of the courtyard to provide an air of ceremony; the accurate use of the Corinthian order suggests that it was designed by Giovanni Battista Rosso (known as Rosso Fiorentino, 1494–1540), who arrived from Italy in 1530. But the "bridge" that it established turned out to be cumbersome, and the staircase was moved indoors ten years later.

Further additions followed, such as the chapel of Saint-Saturnin, the ballroom to the south, and above all, a broad extension to the

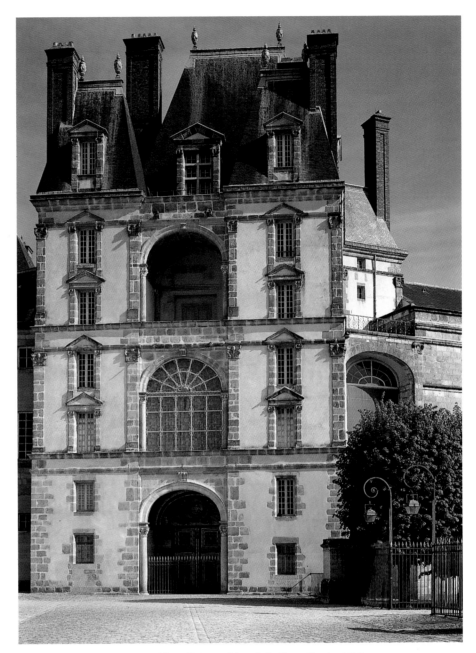

Fontainebleau (Seine-et-Marne). La Porte Dorée. 1528.

west of an arcaded gallery, initiating a link that would be subsequently reinforced by the Mathurin monastery. After 1540, a second courtyard was created between the gallery and the pond, with a building designed by Francesco Primaticcio (1504–1570). Extending from the gallery there was a third courtyard called the Cour du Cheval Blanc,

formed by facades of brick and stone built by Pierre Chambiges after 1540. The southern wing, running along the gardens, contained a new gallery known as the Galerie d'Ulysse due to its decorative interior paintings) and linked the square pavilion at the end of the second courtyard to an artificial grotto (built circa 1540) at the western end.

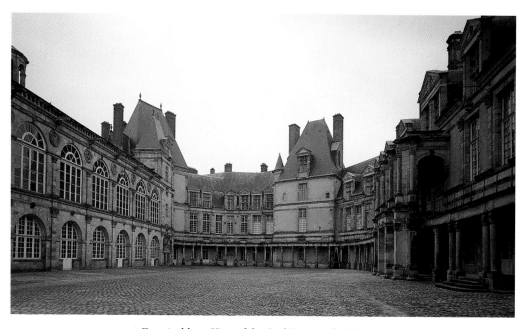

Fontainebleau. View of the Oval Courtyard. 1528.

Fontainebleau. The facade of the ballroom
overlooking the Oval Courtyard. 1548.

Fontainebleau. View of the Galerie François I
in the Fountain Courtyard. 1528.

Fontainebleau. View of the portico of the grand staircase of the Oval Courtyard after the 1882 alterations.

Fontainebleau.
The wing of the Belle Cheminée.
1568.

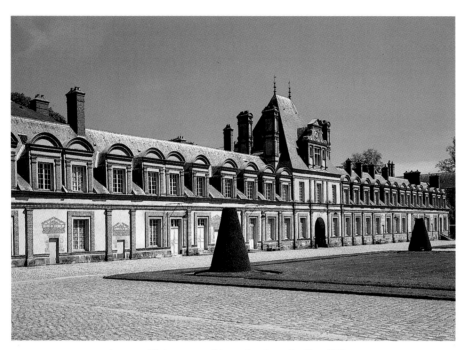

Above and left: Fontainebleau: the Cour du Cheval Blanc:
the north wing and the pavilion of the grand facade. 1540–1565.

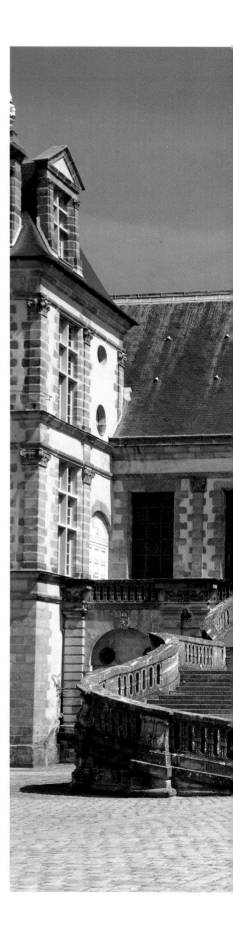

A fourth courtyard was later created to the east, with the Diana wing to the north. The entrance to the château had changed direction at least three times, in a remarkable demonstration of construction by modification and extension. Today, the cluster of successive royal apartments reflects every style of decoration from the reign of King Francis I up to the time of Napoleon III.

The court having established its main place of residence, the town of Fontainebleau blossomed with the mansions of financial advisers who were eager to remain near the monarch. Gilles Le Breton was commissioned to build residences for Jean Duval, Jean Laguette, and, somewhat later, for a financier named Clausse in the nearby town of Fleury-en-Bière.

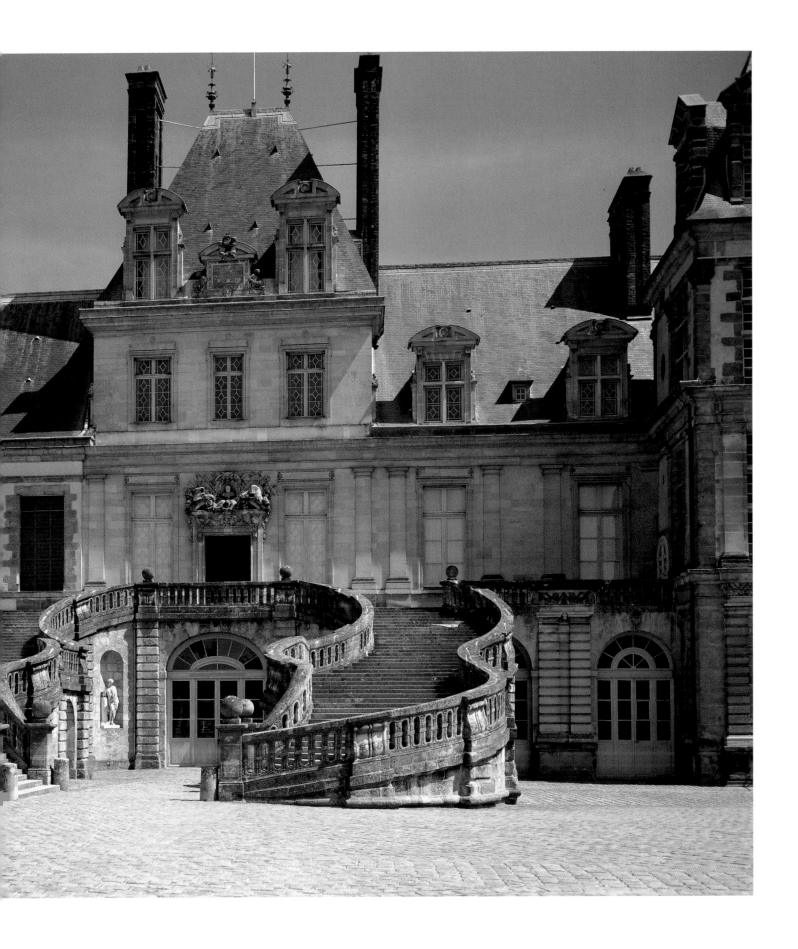

Fontainebleau. Chamber of the duchesse d'Étampes: decoration
by Primaticcio (detail). 1541–1544.

INTERIOR DECORATION

Fontainebleau's relatively uninspiring exteriors were more than compensated for by the sensational interior decoration. In terms of the cost involved, artists recruited, perfection demanded, and originality achieved, this inventive project was one of the key events in the history of French art. Francesco Primaticcio was commissioned to decorate the bedchambers of the king

(1533–1535) and queen (1534–1537), having been summoned in 1532 from Mantua, where he had worked on the Palazzo del Tè with Giulio Romano; but at Fontainebleau he surpassed his master in the elegance with which he arrayed feminine figures along the walls, framed by stucco work of extreme finesse that heralded a new manner. In the chamber of the duchesse d'Étampes (1541–1544, transformed into a stairway in

the eighteenth century), this epoch-making style emerged even more brilliantly in sensual, original motifs. Everything had to be both exceptional and charming.

The Galerie François I, decorated from 1534 to 1539 under the direction of Rosso, presents an unprecedented series of ingenious developments.[21] First there was the lavishness and quality of the decoration: coffered ceilings, wood paneling by Scibec de

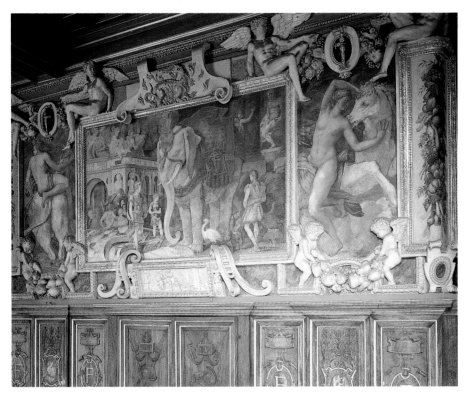

Rosso, *The Fleur-de-Lys Elephant.* 1534–1536.
Fresco. Fontainebleau, Galerie François I.

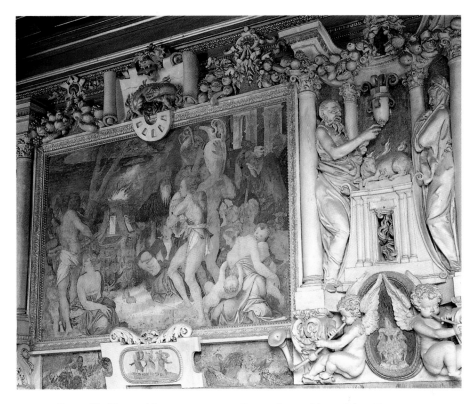

Rosso, *The Twins of Catania.* 1534–1536. Fresco. Fontainebleau, Galerie François I.

Fontainebleau. Galerie François I:
overall view and detail of coffered ceiling.
1534–1539.

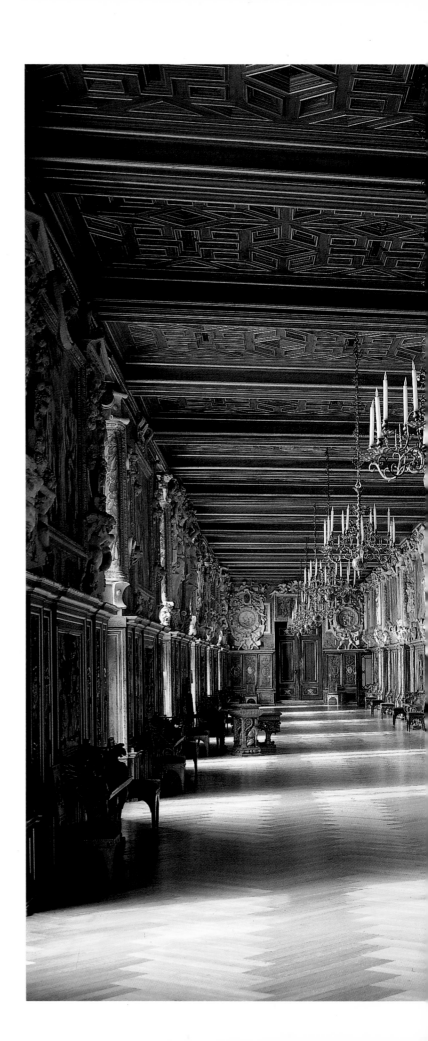

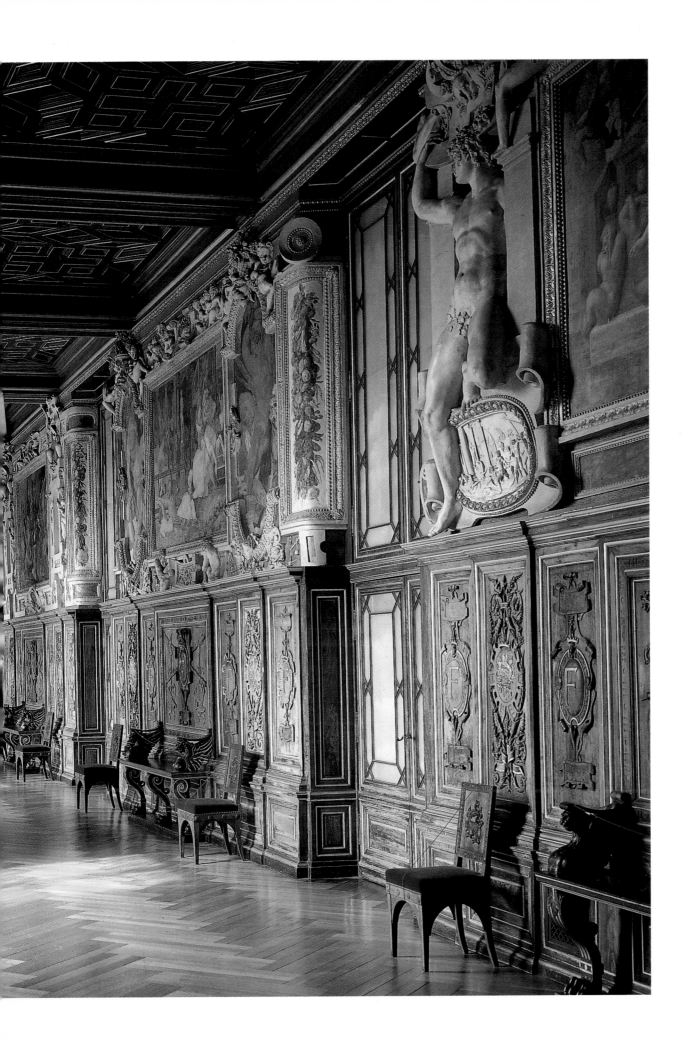

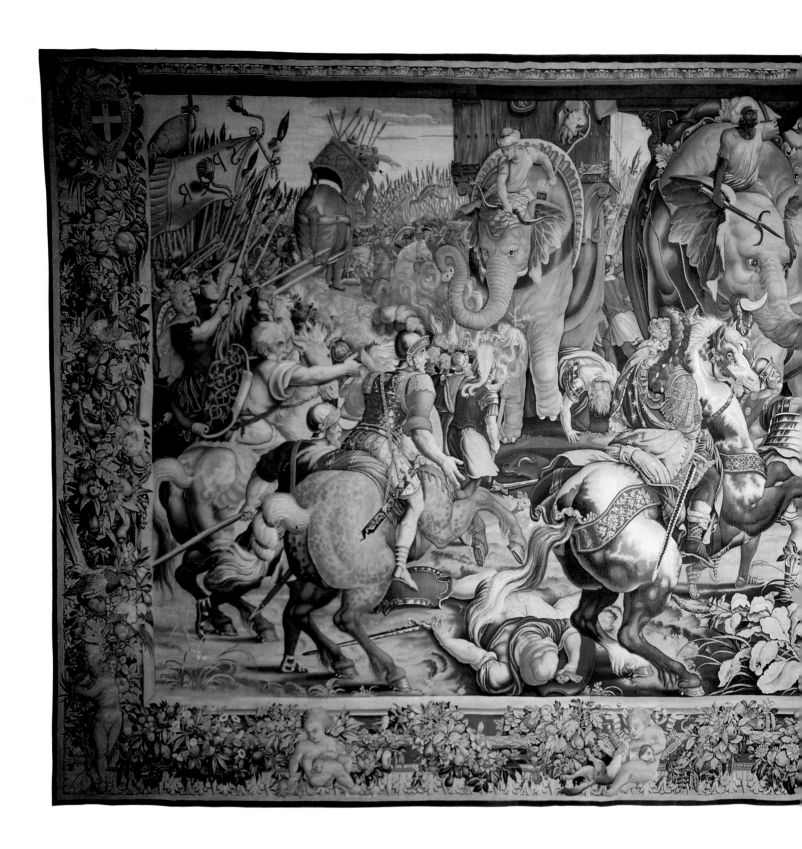

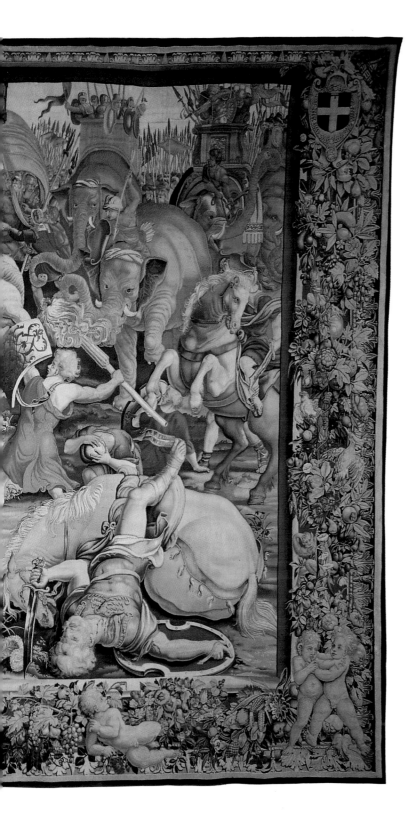

Giulio Romano, *Story of Scipio*: Scipio's chariot. 1532.
Pen and brown ink. 41.4 × 60.2 cm.
Musée du Louvre, Paris.

Left: after Giulio Romano, *Tapestry of the Story of Scipio*:
the battle of Zama. Tapestry woven at the Gobelins
Factory in 1688, copy of the tapestry commissioned in 1532
and destroyed in 1797. Musée du Louvre, Paris.

Carpi, and large stucco figures framing the painted fresco panels (heavily restored by Alaux in 1846, and "de-restored" starting in 1960), all of which formed a continuous path offering a sort of allegorical commentary on the events or guiding principles of the day—*Ignorance Put to Flight* is almost a cultural manifesto, whereas *Fleur-de-Lys Elephant* is a virtuoso play of symbols with a political moral. Secondary motifs, alternately painted and sculpted, provide subtle and witty glosses on the main panels. Nothing of the kind had ever been produced anywhere; the Italian team was able to create a decor adapted to French taste. The gallery provides insight into what the Renaissance aspired—and succeeded—to be.

The decorative repertoire based on garlands, putti, and cascades of fruit was a stunning synthesis of every known motif. A new motif, however, was the strapwork imitating strips of cut leather unrolling before the viewer's eyes; it not only marked a decorative milestone, but became the symbol of

After Primaticcio, *Danaë*. Tapestry. 332 × 625 cm. Kunsthistorisches Museum, Vienna.

Fontainebleau art. All of these elements obviously stemmed from Italian sources, but the manner in which they were adapted and handled, the gaiety that unified them all, produced an original creation whose impact was enormous in France and abroad. Francis I's kingdom was moving into a higher sphere of artistic culture. The convoluted forms of Italian mannerism were suddenly acclimatized, endowed with an original quality that defined the High Renaissance in France.

Everything seemed to take shape during this period of astonishing fecundity. Imitating an initiative launched by Raphael's Roman entourage, the French adopted the brilliant idea of employing engravers to disseminate Fontainebleau's artistic accomplishments. Masterpieces no longer remained confined to inaccessible books, as miniatures once were, but could be appreciated everywhere. A team of etchers working alongside Antonio Fantuzzi, notably Master L.D. (Léon Davent) and Jean Mignon, recorded the special features of Fontainebleau's decor with brio, contributing their own original twists that conveyed the graceful libertinism of the new French manner in a lively and pleasing fashion. Fontainebleau henceforth became a symbol of elegance and pleasure-seeking. The nudity associated with Fontainebleau engendered a heritage that extended—apart from a certain hiatus in the days of Louis XIV—to the seductive painting of the Regency and beyond, making a durable impression on the French imagination.

As an indispensable item of comfort and luxury, tapestries were the object of considerable investment during the sixteenth century, almost always via Flemish imports. This was the case with "the King's fine tapestry," *The History of Scipio*, which was commissioned in 1532 (p. 163). It comprised twenty-two separate pieces, totaling four ells high by 120 ells long (4.76 x 143 meters), making it larger than the famous *Apocalypse* series now in Angers. The grand scenes of battle and celebration were based on cartoons by Giulio Romano; the tapestry was burned in 1797 in order to recover the gold thread, but it is known today from ten pieces of a copy owned by Cardinal Mazarin, woven by the Gobelins factory in 1688–1690 and now at the Louvre (as are the drawings). The tapestry was famous in its own day—the memorialist Brantôme mentioned "the triumph of Scipio that has often been seen hung in great halls on days of grand festivities and assemblies, which cost twenty-two thousand ecus in those days, which was a great deal." In 1539, however, Francis I had looms installed at

Primaticcio, *Danaë*. 1534–1539. Galerie François I, Fontainebleau.

Fontainebleau in order to weave copies of the large allegorical panels in the gallery. The task was only partly completed (six pieces survive in the former Hapsburg collections, now in the Kunsthistorisches Museum in Vienna), but the question of establishing a royal tapestry factory was thus broached.

The impact of Fontainebleau models in every sphere (ceramics, enameling, armor, finery, objets d'art) progressively engendered a typically French decorative style that was soon adopted by Flemish engravers such as the Floris brothers. In the realm of sculp-ture, Domenico del Barbiere, a Tuscan pass-ing through Fontainebleau, carried the new spirit into Burgundy. In Normandy, mean-while, the message was understood by the refined intelligence of Jean Goujon. To pro-vide just one example, the back of the bap-tismal font door (circa 1540) in the church of Saint-Maclou in Rouen includes a panel imitating fairly precisely the framing of sphinxes and figures produced in stucco by Primaticcio for the fireplace in the queen's chamber. However, as can be seen in the organ loft of the same church, which fea-tures two impeccable columns, Jean Goujon was already laying the groundwork for purer, more rigorous developments.

Reactions to the art produced at Fon-tainebleau indicated a determination on the part of French nobles to develop their own style. Publications made practical informa-tion available to designers of decorative programs and devices. The important event yet to come was Francis I's final contribu-tion to French-style construction: the remodeling of the Louvre by Pierre Lescot and Jean Goujon.

III HIGH RENAISSANCE 1540–1570

1. ASSIMILATING ANTIQUITY, ASSERTING A NATIONAL STYLE

By the end of the reign of Francis I (who died in March 1547), many ranking lords, ecclesiastics, and court officials no longer deserved the reproach leveled by Baldassare Castiglione and other Italian critics, since the new generation had acquired a taste for architecture and antiquity. French prelates from prestigious families, having spent time in Italy, set the example for other aristocrats. Cardinal Jean du Bellay (whose secretary in Rome had been none other than Rabelais) became the patron of young Philibert de l'Orme, whom he commissioned in 1540 to build a modern villa at Saint-Maur, on a bend in the Marne River upstream from Paris. The secretary to Cardinal Georges d'Armagnac was the scholar Guillaume Philandrier (1505–1565), an expert on the classical architect Vitruvius— Titian depicted the two men in an admirable double portrait during the cardinal's term as ambassador to Venice (1536 –1539). It was Armagnac who advised Francis I to summon the Italian architect-theorist Sebastiano Serlio (1475–1554) to France and, in his own capacity as bishop of Rodez, invited Philandrier to add a startling *tempietto* to the top of the western facade of Rodez Cathedral. By that time, around 1560, such ornamentation was no longer seen as a radical manifesto, but rather as a profession of faith understood by all.

Little by little there emerged a set of unquestioned guidelines, which attractive publications like Jean Martin's 1546 *Songe de Poliphile* made agreeably accessible. The best minds of the day participated in these

Rodez Cathedral (Aveyron).
The facade crowned by an antique-style *tempietto*. c. 1560.

issues. The problem of the new Louvre occupied the final years of Francis I's reign, and the king's ultimate decision in August 1456 to commission Pierre Lescot to build the residential quarters in the west wing represented a turning point.

It was via architecture that France fully entered the Renaissance—via architecture treated as an intellectual enterprise and a major aspect of the nation's culture. Architecture would retain this special status among all sectors of French society right into the nineteenth century.

This crucial development can be described quite simply. For a good half century, artisans had been playing in a somewhat random and capricious fashion with motifs derived from antiquity—garlands, tabernacles, pilasters—which were grafted onto modified Gothic forms, to the great joy of stone carvers. But there came a point when the architectural system itself, that is to say the logic behind the architectural orders, had to be taken seriously. If a new logic was to be adopted, new ways of organizing facades had to be found, which led to

Francesco Colonna, *Le Songe de Poliphile:* a Roman ruin. Jacques Kerver, Paris, 1546. Bibliothèque Nationale, Paris (Rés. g. Y² 41, fol. 83v).

a progressive rethinking of structure. That is precisely what was done by innovators such as Jean Bullant, Pierre Lescot, and Philibert de l'Orme. French architects' relationship to antiquity had changed—like quattrocento Italians, they henceforth directly confronted the structure of porticoes and arches. They looked antiquity in the face. Which is exactly what the Pléiade poets were doing in literature, claiming the right to address Pindar and Horace without intermediaries, bypassing not only bastard genres of the past, but also Italian writers like Petrarch and Pietro Bembo, however remarkable they may have been.

In the space of just a few years, then, French culture had almost made up for lost time. And, as is typical of France, almost every social group displayed the same attitude. Antiquity was to be seen everywhere, from the facades of bourgeois town houses to chapels and noble châteaux, all sporting busts, medallions, arcades, and columns. The court set the tone through major patrons like Maréchal de Saint-André, and the Montmorency and Guise families. But two points need stressing. Straightforward imitation of

contemporary Italian buildings was very rare; the French wanted to get back to the original sources, and the myth of the *translatio studiorum* (transfer of learning) from Greece to Rome and then from Rome to France circulated again, spurred by local pride. The French even consciously raised issues that had escaped the writings of humanists like Alberti and archaeologists like Fra Giocondo, such as the way architectural design had to be adapted to different social classes. Serlio, once he arrived in France in 1540, realized the importance of such issues and outlined an entire book on the subject; but he did not publish quickly enough, and primacy went to the young Jacques Androuet du Cerceau, who began producing major publications on the issue in 1550. Thus things transpired. By mid-century, great lords and humble gentry who, in the general infatuation, wanted to build, were no longer content with local traditions—even while occasionally remaining attached to them—the trend was toward a uniform period style.

France's specific character was keenly observed. "The nobles of France do not live in cities, but in villages with their châteaux," wrote the Venetian ambassador in his official report for 1558, noting the importance of local estates. Architectural rebuilding and interior decorating were going on everywhere, but the spread of the aristocratic model—swift or slow, depending on the circumstances—did not signify slavish imitation. Models were known from drawings or by reputation, but lessons were followed at one's pleasure. Henri II's Louvre palace was not interpreted in the same way at Vallery as at La Tour d'Aigues. The fusion of new features with regional forms promoted and sustained a simpler, somewhat repetitive style that was admirably adapted to the site, the buildings being replaced, and the modalities of vernacular architecture. The flavor and power of the French Renaissance stems from this ebb and flow. It was nevertheless the moment when a shared French idiom was established by favoring certain forms of

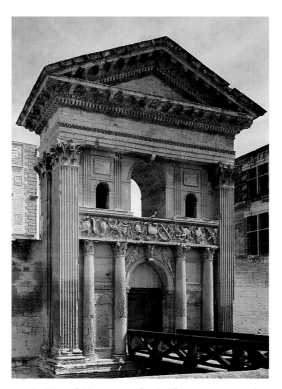

La Tour d'Aigues (Vaucluse). The entrance portal in the form of a triumphal arch. 1571.

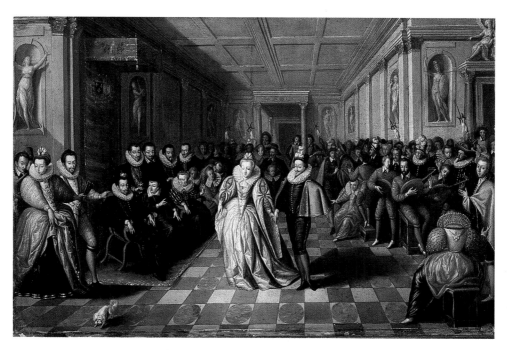

Franco-Flemish school, *Ball Given by the Duc de Joyeuse.*
Oil on copper. c. 1582. 41.5 × 65 cm. Musée du Louvre, Paris.

facades and adopting certain approaches that could survive indefinitely—modest scale, small pilasters on multiple levels, simplified framing of doors and windows. This ornamental approach to bourgeois residences persisted into the seventeenth century and reappeared in the nineteenth and again in the early twentieth centuries in lower-class buildings until concrete arrived on the scene.

Religious and political crises surfaced in France with the famous posting of Protestant broadsheets in 1534. They became worse under Henri II and led to lasting disruption from 1560 onward. As in earlier times, rival bands roamed back and forth, ravaging towns and châteaux. This obviously brought many projects to a halt. Some châteaux that were begun under Charles IX (reigned 1560–1574) were not completed until 1600 or so, underscoring a key historical point: domestic wars and rivalries put a sudden brake on nascent developments. Architectural plans were often put on hold for twenty or thirty years,

until domestic peace returned with Henri IV. A typical example is the Paris bridge known as Pont-Neuf, planned under Charles IX and started in 1578, but not inaugurated until 1603. Numerous painted interiors, whether merely planned or actually begun, were only finally executed around 1600. These facts mean that study of the Renaissance should be extended to the regency of Marie de' Medici following the assassination of Henri IV; his reign, from 1589 to 1610, should properly be regarded as the culmination of an era rather than the start of another.

THE COURT
"Magnificence and gallantry in France never appeared with so much splendor as in the final years of the reign of Henri the Second." This famous opening sentence to Madame de La Fayette's 1678 novel, *La Princesse de Clèves,* conferred—a century after the fact—an unforgettable charm on the court of Henri II. In the seventeenth century, people were apparently con-

vinced that French courtly manners were durably set by Henri's cold and noble style, as well as by his notorious love for Diane de Poitiers. Whereas the revival of arts and letters occurred under Francis I, the veritable birth of courtly society took place under Henri II. Indeed, never were royal receptions and celebrations so brilliant and so successful in terms of finery, damask, gold, and gems. A British observer in 1550 commented that all the jewels in Christendom seemed to be assembled at court, so extensively were the ladies covered with them.

In the early nineteenth century, the label "classical" was applied to two centuries of French architecture based on principles established in the mid-sixteenth century. This implied that antique forms had been understood and assimilated, which is basically true, of course, though in a much less rigid way than has been claimed. The honor traditionally bestowed on the energetic initiatives of the High Renaissance has the merit of underscoring

the fact that certain French construction practices were established at that time.[1] Yet the period must still be understood in all the élan, liveliness, joviality, and, it should be said, attitude of glorious splendor typical of the French when they are enjoying good fortune and well-being. The French always express themselves best in such a climate.

The etiquette and ceremony surrounding the monarch's lifestyle assumed permanent form at that point, as Catherine de' Medici reminded Charles IX in a letter written in September 1563. This did not entail Spanish-style rigidity, but rather a certain protocol that retained the possibility, in principle, of making the king accessible to all. In practice, it implied a specific arrangement of royal apartments, well known from the château at Saint-Germain-en-Laye in the mid-sixteenth century. Rooms were laid out in single file, in the following order: stairway, chamber, bedchamber, dressing room (or washroom,

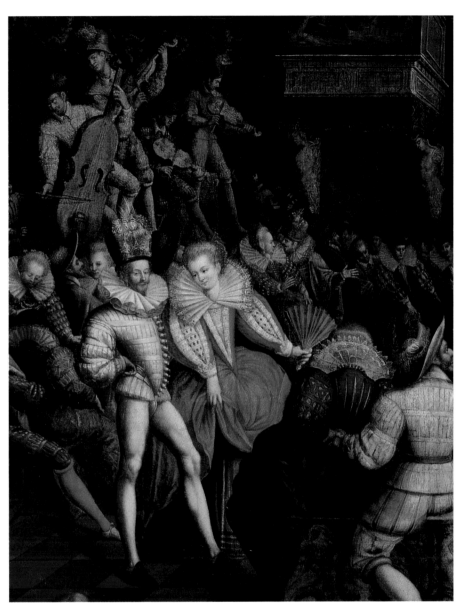

Franco-Flemish school, *Ball at the Valois Court* (detail). Oil on canvas. c. 1580. Musée des Beaux-Arts, Rennes.

Ceremonial entry of Henri II into Paris, June 1549: triumphal arch. J. Roffet, Paris. Bibliothèque Nationale, Paris (Rés. Lb[31] 20c, fol. 4).

with or without private recess). By being present in the king's chamber just when he was leaving for Mass, courtiers could see the monarch cross the room at an angle.[2]

The concept of festivity itself became institutionalized. Royal entries into a given city, which had long been organized on grand occasions, became an official dialogue through the exchange of local petitions and royal promises. Inscriptions and declarations became features of the set decoration—chariots, arches, platforms. Everything was said and shown in allegorical form. Heraldic emblems and devices were more than ever in evidence. Moreover, rival monarchs competed via the organization of such festivals—the royal entries into Paris of Henri II in 1549 and Charles IX in 1571 undoubtedly took into account the preparations carried out in

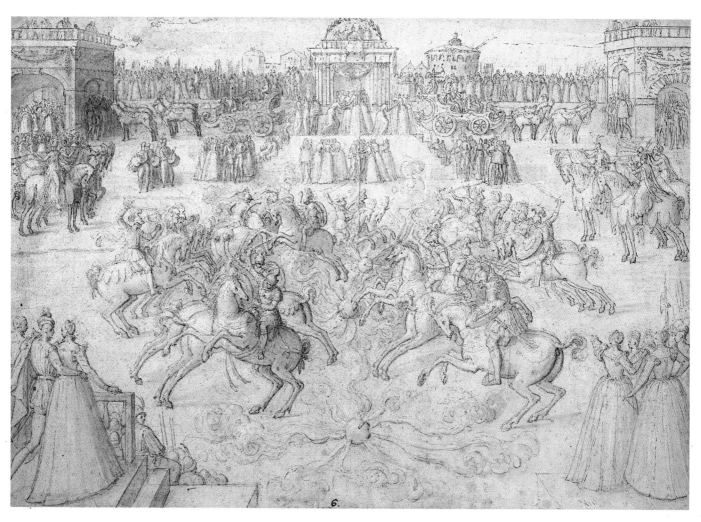

Antoine Caron, *A Tournament* (Valois Festivals). Black chalk, pen, and ink wash.
33.3 × 48.2 cm. Witt Library, Courtauld Institute, London.

Antwerp and elsewhere for the entries of Holy Roman Emperor Charles V and, later, his son King Philip II of Spain. For the entry of Henri II, a triumphal arch was erected at one end of Notre-Dame Bridge, showing Tiphys (Henri II) at the helm of the Argo (Paris) in search of the Golden Fleece—the Hapsburgs were not to be allowed to monopolize the emblem of Burgundy.

The evolution of decorative pomp for entries simultaneously illustrates how political ideas were translated into symbols, how allegorical representations reflected the overwhelming presence of ancient myths, and the way in which architectural struc-

tures became increasingly rich and complex. The anonymous designer of Henri's remarkable entry into Rouen on 1 October 1550 was well aware of all this when he declared that it was simpler to "treat the rules and precepts of architecture [than] to narrate the order and finery of an Entry." Such events functioned to convey and popularize everything. Culture was all the more present insofar as poets and scholars were invited to compose the texts, while famous painters, sculptors, and architects handled the decorative structures and devices.

Ronsard and Dorat, Germain Pilon and Niccolò dell'Abbate collaborated on one of

the most sophisticated of these royal entries in March 1571, at a time when Charles IX put a temporary end to the civil war and married the Hapsburg princess Elizabeth of Austria. The spectacle played on every register simultaneously, representing an extreme example of a complete yet totally ephemeral masterpiece. All too often, this key feature of Renaissance art leaves little more impression than the aftermath of a party.[3]

Thanks to royal "progresses," local practices and variants on such events can nevertheless be appreciated. Catherine de' Medici seized upon the idea of taking the

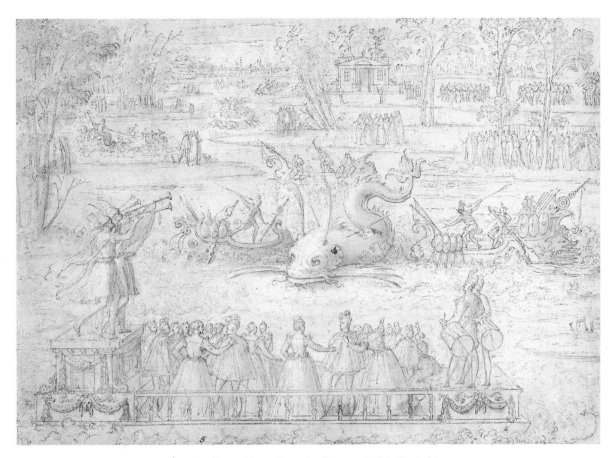

Antoine Caron, *Water Festival at Bayonne* (Valois Festivals).
Black chalk, pen and ink wash. 35 × 49.5 cm. The Pierpont Morgan Library, New York.

Below: *Water Festival at Bayonne* (Valois Festivals) after Antoine Caron.
Tapestry. Brussels, c. 1580–1585. 355 × 394 cm. Uffizi, Florence.

young Charles IX, who became king in 1563 at the age of thirteen, from city to city. The court toured the provinces from March 1564 to May 1566, visiting more than one hundred towns. An anthology of documents on the tour was published by Abel Jouan in 1566.[4] The extraordinary celebrations lasted several days, like the mystery plays of old, but were solely designed for the court. In June 1565 in Bayonne, there were festivities of memorable magnificence, as recorded by Antoine Caron's drawings. There was notably a tournament between knights from Great Britain and Ireland, the young king riding with the former, his brother Henri with the latter. Chariots with *tableaux vivants* of the Virtues accompanied both groups of knights. It was, in fact, a "ballet of

Anjony (Puy-de-Dôme). Mural painting in the room of the
Nine Valiant Knights (detail). c. 1570–1580.

riders" with musical accompaniment, creating a new kind of entertainment. There were also entries featuring mermaids, nymphs, and satyrs, and a parade with Charles dressed as a Trojan in blue and silver, his brother as an Amazon. In short, these were early versions of the court ballets that became popular under Henri III and resurged in the following century.

The general features of these parades, along with certain details of costume and emblem, obviously recall court pomp under Charles VI in France and under Philip the Good in Burgundy. But the style had changed. Figures were more elaborate, with antique-style arrangements of costumes, sets, and platforms. Furthermore, Caron's documentary-like drawings served several years later as inspiration for Lucas de Heere's commemorative tapestries (now in the Uffizi, Florence), which stress the dense swirl of lavish devices and structures. One tapestry even shows peasant dances, in which "Poitou women [dance to] bagpipes, Provençal women to drums." Such details are particularly interesting in a country that lacked a Bruegel to depict village customs. In the stately Paris

residence of the Bourbon family on 20 August 1572, less than a week before the Saint Bartholomew's Day Massacre, the king's troops and those of Henri of Navarre conducted a joust interrupted by a ballet of nymphs, meant to bring harmony. It is difficult to imagine an epoch more unstable, or more picturesque.

The intense stress on public festivities and court games sustained a state of collective excitement and agitation that history must take into account. The parades and ballets given in September 1581 for the marriage of the duc de Joyeuse have gone down in art history, but it might be wondered whether the intimate mix of the theatrical with the social that culminated during the reign of Charles IX was not obscurely related to the climate of violence only too well illustrated by the crowd-pleasing executions, memorable duels, massacres, and public burnings that steadily became more frequent. Passionate reactions and assassinations became commonplace. It was in this context that the Huguenots' iconoclastic ravages took place, spurred by hatred for Catholic ceremonials. Around 1590, the notorious

processions or "mummeries" of partisans of the Catholic League in cities hostile to the Protestant Henri of Navarre became a sort of dreadful theater.

Pagan Stirrings

It should not be forgotten that chivalrous and amorous "gallantry" sprang partly from romances and fictional literature. Even before Italian poet Torquato Tasso's *Gerusalemme Liberata* provided fashionable subjects for painted and woven interior decoration, there had long been a vogue for *Amadis de Gaula,* an interminable if moving Spanish romance brilliantly rendered in French by Nicolas d'Herberay des Essarts, a friend of Ronsard. "Valiant knights" of the day thus paraded in antique dress, and in certain châteaux, special halls were decorated with these heroic figures in traditional costume (as at Anjony in Auvergne, circa 1570–1580).

Alongside this significant trend there existed imaginative versions—highly poetic and free in tone—of ancient mythology, an inexhaustible source of inspiration that colored all poetic output, from pastoral to elegiac. Ronsard's idyllic *Eclogues* (1559) extolled the grotto at Meudon decorated by Primaticcio, "that Charlot had hollowed so well, to be where the nine sisters eternally dwell." Above all, during the reign of Henri II there was a sort of infatuation with Diana as the official goddess of the hunt (a royal pastime more glorified than ever), of nudity (made delightfully fashionable by Fontainebleau), and of every poetic analogy made possible by this extraordinary convergence of sources.

A late anthology collecting "Twelve myths of rivers or fountains with descriptions for painting" (1586), provides descriptions in the manner of the Greek orator Philostratus that are said to have been based on the verses of Pontus de Tyard, one of the most cultivated poets of the Pléiade. These descriptions were supposedly used for the tapestries at the château of Anet. Indeed, five pieces remain from what must have been a

Benvenuto Cellini, *Diana with Stag.* High relief from the entrance pavilion of the Château d'Anet.
Bronze. 203 × 409 cm. Musée du Louvre, Paris.

Below: René Boyvin, ornamental panel: *Diana.* Engraving. Mid-sixteenth century.
Bibliothèque Nationale, Paris (Est. Ed. 3).

complete cycle of tapestries on Diana in the château built for her namesake Diane de Poitiers, the king's favorite. It would be interesting if a poet like Tyard, who wrote anthologies such as *Premier Curieux* and *Second Curieux* ("First Collector" and "Second Collector," published 1557, reprinted in 1578) had contributed to the iconographic program that makes Anet so original. Tyard, or one of the lady's numerous admirers, supplied the bold inscription over the gate: "This vast dwelling of the noble Diana is dedicated to Phoebus; she returns to him what she has received from him" (the royal mistress thereby thanks Henri, her divine guardian, for his magnificent gift). The language was strange, for everything hinged on the myth of Diana alone. Reference to the myth assumed such extraordinary proportions that it broke the barriers dividing the real from the imaginary. Diana pioneered the realm of mythological

portraiture, superbly inaugurated by the startling painting of a nude striding through nature (*Diana the Huntress,* circa 1550). Mythology acquired new validity in the form of a collective cultural imagination that inspired both symbolic fiction and decoration. René Boyvin published a collection of ornamental panels taken from pagan divinities, as though there henceforth existed an essential link between myth and decoration.

Few works celebrated the damsel's beauty as boldly and fully as *Diana with Stag* at Anet. This refined and artful bronze relief, which must be the work of a great artist, established a poetic universe based on classical gods, one that could no longer be erased from the collective memory. The approach adopted at Anet, in which all art was placed at the service of feminine beauty and its privileges, sheds light on a key phenomenon. Following this phase of the

School of Fontainebleau, *Diana the Huntress*.
Oil on canvas. c. 1550–1560. 191 × 132 cm. Musée du Louvre, Paris.

Renaissance, the universe of mythology became a permanent part of culture, providing art with a raison d'être equal to that of religious imagery (itself suffering censorship at that very moment by both the Reformation and the Council of Trent). Plutarch was widely read at this time for his moral lessons (thanks to Jacques Amyot's superb French translation), whereas Livy and Tacitus were less so. Efforts to give history pride of place in general culture failed, so that by the seventeenth century, classical mythology became the basis of education, even for royalty. Its fictions shaped imaginations:

Chaque vertu devient une divinité:
Minerve est la prudence
et Vénus la beauté.
[Every virtue becomes a divinity:
Minerva is prudence
and Venus, beauty.]
(Boileau, *Art poétique,* III)

Studio of Jean Goujon, *Diana with Stag* (also known as the *Diana of Anet*). From a fountain at the Château d'Anet.
Marble. c. 1549. 211 × 258 cm. Musée du Louvre, Paris.

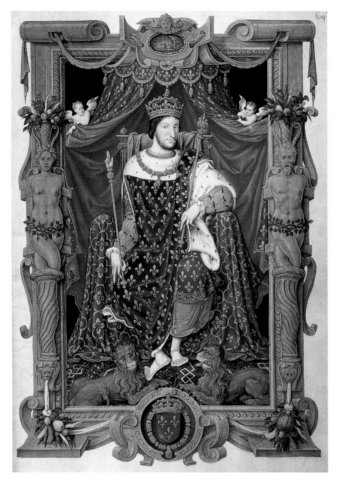

Jean du Tillet, *Recueil des Rois de France:* full-length portrait of Francis I. 1566. Bibliothèque Nationale, Paris (Ms. 2848, fol. 150).

Francis I's son, Henri II, and worsened following Henri's death in 1559 and the succession of his young sons Francis II, Charles IX, and Henri III. No one was more concerned about these divisions than Catherine de' Medici, the Queen Mother. Employing the methods of her day, she spared no effort in attempting to bring the two sides together. In vain, however. By the pivotal year of 1562, many artists and craftsmen who sympathized with the Reformation had already left France, including major figures like Jean Goujon, Pierre Bontemps, and Étienne Delaune.

The critical periods of the Reformation were marked by explosions of violence in which works of art were greatly damaged. Destruction in the year 1562 was catastrophic. Following the absurd massacre of Vassy, French Protestants took revenge on the traditional symbols of the Roman church. As the conflict deepened, sacking of "papist" churches became the rule. Prior to leaving Orléans in 1578 under pressure from his adversaries, the prince de Condé blew up the cathedral; Henri of Navarre, having become King of France as Henri IV and converting to Catholicism, undertook to rebuild the edifice and laid the first stone of the new cathedral in 1601. These events sum up a quarter century of civil disturbance that constituted a pathetic conclusion to the Renaissance.

In many provinces, nothing could compensate for the ravages of iconoclastic rampages. There was nevertheless a rather natural tendency to rebuild altars, tombs, and walls exactly as they were before. The superb domes on Saint-Étienne-de-la-Cité in Périgueux were two-thirds destroyed during the Huguenot occupation of 1577, and it is interesting to see how the main dome over the altar was rebuilt after 1625 in a seventeenth-century version of the Romanesque. A certain obstinacy can thus be observed. As for the châteaux, building assumed a new pace, but with little innovation—a château from 1600 could have been built twenty-five years earlier. Construction simply took up

The only other subject in favor was genealogy. Jean du Tillet's *Recueil des Rois de France* (1566) presents a miniature of every monarch since Merovech. Similarly, there existed "a rich embroidery of gold, set against a huckaback pattern of silver embroidery . . . showing Kings, Queens, princes, and princesses of the blood from Queen Blanche to the present day."[5] Under Henri IV, the duke of Sully would take up this preoccupation once again.

THE REFORMATION

It was not the court's loose morals that sparked the Protestant rebellion in France. Indeed, the idea of "reform" originated in the Erasmus-influenced circles around

Francis I and more especially around his sister Marguerite, where the state of the Church was criticized long before the Calvinist explosion occurred. But following bold moves like the posting of broadsheets criticizing the Mass in 1534, and attacks on pious statues, Francis I could no longer defend freethinkers against the Sorbonne theologians. Once high-ranking nobles openly took a stance in favor of the Reformation, the problem became political. France thus found itself on the fault line of the forces tearing Europe apart—the anti-Roman Catholic element based in the German principalities, and the defenders of Rome loudly led by Spain. This state of affairs continued throughout the reign of

Emblemata by Andrea Alciati: Eloquence is greater
than strength. 1548. Bibliothèque Nationale,
Paris (Est. Te 28, fol. 221).

Thomas de Leu (after Antoine Caron), *Phaethon*. 1614.
Engraving from *Imagines* by Philostratus.
Bibliothèque Nationale, Paris (Est. Ed. 11, rés. fol. 82).

where it had left off. Despite interesting initiatives on the part of the royal government, it was in a weakened state that French art heralded the seventeenth century, which was to be marked by a new and powerful wave of Italianism.

Learning

French nobles at last began to do a little reading, thus building up collections that contained more than romances and religious books. The library at Écouen was decorated with panels of arabesques inspired by Francesco di Pellegrino's anthology. Catherine de' Medici reportedly owned more than four thousand books. Groups that met for literary discussion were soon dubbed "academies." One, formed around poet Jean Antoine de Baïf, acquired official

status in 1570. Another, less famous, was organized at the Louvre in 1576 during the reign of Henri III under the aegis of Guy du Faur de Pibrac, to discuss moral issues. One of its members wrote a treatise in the form of a vision, *Civitas veri sive morum* (circa 1585, published in 1609), with engravings by Thomas de Leu and Jaspar Isac that exemplified the search for a visual translation of moral allegories.[6]

The whole period was marked by a vogue for emblems—*Emblemata* was the title of Andrea Alciati's anthology, first published in 1531 and then reprinted by Tournes in Lyon with illustrations that guaranteed its success (in Latin in 1547, in French in 1548). An incredible number of similar volumes, with more or less inspiring titles, such as *Picta Poesis* or *Pegma*, were

popular for decades, as were anthologies of "Christian devices" by authors including Georgette de Montenay (Lyon, 1571) and Théodore de Bèze (Geneva, 1581). People were enchanted by the idea of a simultaneously figurative and aphoristic idiom combining symbolism with morality. Everything was embellished with emblems, from medals and cartouches to panels and frontispieces, in that mixture of earnestness and levity induced by any cryptic discourse. References to hieroglyphs became more frequent. Moral lessons nevertheless remained simple—a triton holding its tail symbolized the eternal fame of eloquence, while a fly falling into milk evoked the pitfalls of sensual pleasure. There had perhaps never been such an amazing outpouring of images designed to delight.[7]

Bernard Palissy and his studio. Water pitcher. Enameled terra cotta.
Height: 19.2 cm. Musée du Louvre, Paris.

De Vigenère could have compiled a treasure house of information on French art, reflecting the aspirations of the day, if French attitudes had only encouraged it.

Writing in the mid-sixteenth century, Jérôme Cardan did not hesitate to assert that, from an intellectual and scientific standpoint, the French were inferior to others. It would become less and less true, even though France could claim no equals to Vesalius, Gesner, and Aldrovandi in anatomy and the natural sciences. But learning spread thanks to engravings and well-illustrated volumes such as Rondelet's study of saltwater fish (Lyon, 1544), and the great surgeon Ambrois Pare's essay about freaks and prodigies (Paris, 1573). Collections of "curiosities," combining rare objects, moonstones, and fossils became more common in France, as elsewhere. One of the people who sustained interest in nature's curiosities was the master potter Bernard Palissy (1510–1590). In his *Recepte Véritable* of 1563, he described a well-planned garden and orchard, and in *Discours Admirables* of 1570, he offered "scientific" analyses of chemical phenomena and natural history. His proselytizing temperament drove him to share his knowledge via public lectures. Palissy relied on intuition a great deal, and his taxonomy was rather strange, but he nevertheless can be credited with the original development of "rustic pottery" using animal forms cast from life. Indeed, his ceramic artistry has been confirmed by detailed study of the kilns recently discovered in the excavations of the Tuileries courtyard.[9] The quality and naturalism of his molds are astonishing.

The vitality and exuberance of the day can still be detected in furniture, as witnessed by surviving examples as well as drawings in the collections of Jacques Androuet du Cerceau. The wonderful woodwork that covered supports and panels with evocative figures and forms yielded a decorative volubility that bears comparison with the literature of Rabelais and Ronsard.

The vogue for emblems continued throughout the following century, and helps to explain why many compositions were so dense. More generally, it also sheds light on the classical period's penchant for conceits in the form of the reversible phrase *ut pictura poesis,* in which poetry was descriptive and representation discursive. The art of Antoine Caron and his contemporaries cannot be appreciated independently of this context in which every visual work had a subtext, like the librettos behind the operas that would soon become fashionable in France. At the same time, illustrated versions of Philostratus's *Imagines* were beginning to appear; a collection of more or less authentic descriptions of antique painting by Philostratus, already used in Italy (notably by Titian), *Imagines* was translated into French by Blaise de Vigenère around 1570 (though only published in 1614).[8] Blaise de Vigenère (1523–1596) was a man of many talents, the first to write of artists such as Goujon, Pilon, and du Cerceau. He met Michelangelo in Rome and recorded invaluable information concerning him.

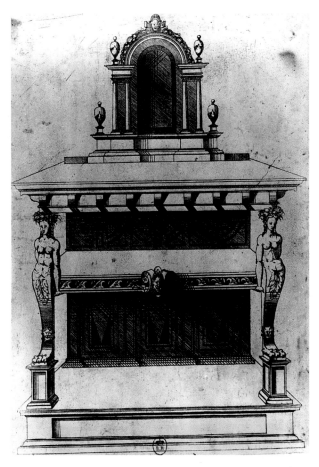

Jacques Androuet du Cerceau. Design for a commode with terminal figures. Engraving. 1550. Bibliothèque Nationale, Paris (Est. Ed. 2e).

Jacques Androuet du Cerceau. Table designs. Engraving. 1550. Bibliothèque Nationale, Paris (Est. Ed. 2e).

That was also the time when the overall plan and distribution of a building was treated in a more methodical, considered way. The ideas that matured around 1540 were, in this respect, of some consequence because the concern to adapt interior layout to function emerged (and would subsequently become a constant subject of reflection). Sebastiano Serlio realized that this was a question to which the French attached a great deal of importance. In Book VI (unpublished) of his treatise on architecture, Serlio presented an outline of various model plans. But it was French authors who durably dominated the subject, and the most brilliant, useful, and successful of them all was du Cerceau.

ANTI-ITALIAN REACTION

Every sphere of French politics, finance, medicine, and art was influenced by Italians, not least among them the boisterous Benvenuto Cellini (1500–1571), who amused the court even though his dealings with the duchesse d'Étampes annoyed Francis I, and who gave brilliant lessons in how to work gold and silver. Teams of artisans almost always included a Florentine or Emilian, though not necessarily in a dominant position. The bank of Lyon, meanwhile, was almost completely in Florentine hands, and had become indispensable to French financial affairs, notably those of the monarchy from Francis I to Henri III. High-ranking nobles turned so often to Italian financiers like Gondi, Gadagne, and others that the Protestant commentator François de La Noue was moved to denounce easy loans made by indulgent bankers to aristocrats infatuated with extravagant expenditure.

Under Henri III, Lombard and Neapolitan secretaries, doctors, chaplains, and valets of all sorts—ripe for intrigue—were even more numerous in the royal households.[10] They often blended comfortably into French society, and certain Italians were able to combine political shrewdness, business acumen, and swift social advancement (not always appreciated by the court) with a remarkable adaptation to everything French. The Gondi

Jacques Androuet du Cerceau, *Livres des Temples.* Engraving. 1550.
Bibliothèque Nationale, Paris (Est. Ed. 2c).

family produced the famous cardinal of Retz, while Ludovic da Diaceto, Henri III's maître d'hôtel, was named count of Châteauvillain, and later, Giulio Mazarini became the extraordinary Cardinal Mazarin.

It is easy to see the relevance of this phenomenon. For a good century or so, there was a relative Italianization of elite French mores and culture, which simultaneously sparked new interest in the comforts of life, domestic luxury, and the arts, in contrast to the Hispanic influence that focused on dress, aristocratic pride (and duels), and romance literature.

The two spheres in which the French nobility effortlessly assimilated Italian resources and skill were the theater—or, more accurately, the new form of court entertainments—and landscape gardening as a mandatory complement to architecture. These twin concerns became definitive aspects of French aristocratic life under the last two Valois kings, with almost incalculable consequences for the ancien régime.

At the same time, the two major poetic works to emerge from Italy, Ariosto's *Orlando Furioso* (1515, translated into

Jacques Androuet du Cerceau. Front elevation of the Château de Verneuil showing drawbridge and gateway. Pen and watercolor. 51 × 74 cm. 1576–1579. British Museum, London.

French in 1543) and Tasso's *Gerusalemme Liberata* (1575, translated into French in 1595) had no French equivalents and became part of a shared culture, especially since their abundance of spectacular episodes supplied subjects for paintings or

cycles of great emotional impact. A novelistic repertoire was thus added to the mythological one (French literature did not mount a defensive counterattack for a long time to come). In the realm of visual arts, subjects based on these almost international

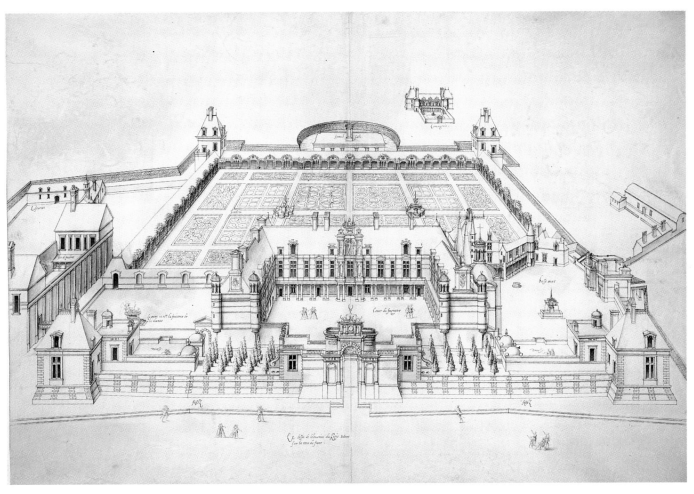

Jacques Androuet du Cerceau. General view of the Château d'Anet viewed from a height, with entrance in the foreground. Pen and watercolor. 1576–1579. 51 × 74 cm. British Museum, London.

themes—which were strengthened by the emergence of opera—continued to be commissioned from artists.

French resistance to Italianization occurred in the spheres of architecture and painting. An inspired draftsman and architect, Jacques Androuet du Cerceau, assessed the situation and decided to become the "illustrator of the art of architecture" by supplying books of architectural models such as the *Livre des temples* (1550) and the *Livre d'architecture* (1559), which contained the following dedication to the king: "In this flourishing kingdom, one sees daily an increase in so many magnificent edifices that henceforth your subjects will have no cause to travel to foreign parts to see finer compositions." The meaning is crystal clear: the Italian model had been surpassed. The most important thing, however, was du Cerceau's initiative of publishing an account of French architecture complete with plans and elevations—that is, in almost scientific form. Two of the three planned volumes of *Les Plus Excellents Bastiments de France* (The Most Excellent Buildings of France) appeared in 1575 and 1579, respectively. Without du Cerceau's effort, which long remained the sole work of its type in any country, the history of French architecture of that period could never have been written.

His chauvinistic reaction was not an isolated one. In the spheres of furniture, precious metalworking, and weaving, numerous local artisans sought to win orders. However, in many cases, such orders were much longer in coming than had been hoped. The irony of the situation was that the period of 1600–1610 ended with the regency of another Medici queen, so that court and city were once again exposed— Marie being less attuned to the French mentality than Catherine—to an invasion of Italian fashion, models, and personnel.

Around 1540, the circulation of modern ideas in architecture suddenly accelerated with the arrival in France of major Italian artists. The ever-exuberant Cellini was casting statues and giving advice on more or less everything. The already aged scholar Sebastiano Serlio, who dedicated Book III of his work on Roman antiquities to Francis I, was invited to come work in France; the letters patent of 1541 assign Serlio building tasks at Fontainebleau, but it was in Paris in 1545 that he published Jean Martin's translations of his Books I and II, devoted to the principles of geometry and perspective. Over a ten-year period, Serlio formulated numerous proposals and projects.

Jean Goujon, in an introduction to Martin's 1547 translation of Vitruvius, hailed Serlio as a master, and in 1567, Philibert de l'Orme described him as the mentor of French architects. But the Bolognese architect actually built little more than the Grand Ferrare residence for Cardinal d'Este in Fontainebleau itself, plus Ancy-le-Franc for Antoine III of Clermont-Tonnerre. He supplied plans for a southern site called Rosmarino (in fact, Lourmarin in the Vaucluse region) and responded, regardless of what has been asserted, to the king's request for competing ideas for the "new Louvre." Serlio was not alone in that, for Primaticcio, on mission in Rome, brought architect Giacomo da Vignola back to France to help him cast antique molds; Vignola, whose publication of *L'Architettura* in 1562 formally established the five antique orders, also had his own ideas on the matter.

The Grand Ferrare residence, commissioned in April 1544, was completed in record time by May 1546. Located at the gates of the new western entrance to the château, it represented the most explicit and elegant example of an aristocratic dwelling, being a transposition of Bury's overall plan to an urban setting—two levels with large

Ancy-le-Franc (Yonne). Facade overlooking the courtyard (detail). 1544–1550.

windows and a stairway forming a porch. The cardinal was pleased to note that Serlio had "observed the measures and orders of architecture in what was done in the French style as well as in the Italian parts." The residence was thus a synthesis. The left wing, comprising a gallery, lead to the chapel, while on the entrance wall fine niches with alternating pediments flanked an enormous, rustic-style portal (still extant). It constituted a model for the noble residences to come.

Serlio appreciated the consistency and persistence of certain design features typical of French vernacular architecture: roofs high and steep instead of flat; casement or mullioned windows that exclude aedicule windows; gables (or attics) that interrupt the cornice and preclude a balustrade; galleries that discourage development of a *cortile;* and, above all, a sense of interior arrangement or *commoditas* (convenience) that was already—and would remain, according to classic theorists—a sphere in which French architecture was superior.

Meanwhile, work in Fontainebleau continued on the château itself: baths under the gallery (1541–1547), ballroom overlooking the oval courtyard, and the Galerie d'Ulysse along the gardens to the south of the new courtyard with, at the far end, the Pine Grotto (1543–1544). This construction was carried out under the supervision of Primaticcio, who was simultaneously painting frescoes in the new gallery. Major initiatives were also undertaken more or less everywhere. Philibert de l'Orme, arriving from Rome, built a château on a square plan at Saint-Maur-des-Fossés for Cardinal du Bellay; in the eyes of the young architect, the château (completed in 1544) constituted something of a manifesto. The main facade was endowed with an impeccable orchestration of bays featuring a projecting frontispiece (entrance bay) and pediment. Purchased by Catherine de' Medici in 1563, the château was extended by the addition of high pavilions that were later doubled, but the entire edifice was demolished in 1796. In the provinces, skillful compositions

Sebastiano Serlio. Facade overlooking the courtyard of the Château d'Ancy-le-Franc. Lead point. 1547–1550. 12.5 × 28.5 cm. Bayerische Staatsbibliothek, Munich (Cod. 189, Book VI, fol. 18).

Jacques Androuet du Cerceau. Drawing of the Château de Saint-Maur. Pen and watercolor. 1576–1579. 51 × 74 cm. British Museum, London.

based on antique elements attested to a desire to reflect the new spirit. One example of this is the chapel of La Fierté-Saint-Romain in Rouen (1543), an enlarged version of the multileveled decoration of certain windows resembling *tempietti*, while another is the Saint-Lazare fountain in Autun (1543), also a variation on an Ionic *tempietto* set on a stylobate and topped by a Corinthian upper level. Both structures

give the impression of models playing on antique-style forms.

There was also a strong increase in activity in southern France, particularly in Toulouse. Nicolas Bachelier typified the work of sculptor-architect in the numerous residences he built: Bagis (1538), the entrance to Assézat (1555), Beringuier-Maynier (circa 1550). Telamones —carved figures—rose at the portal in the place of

columns, while pediments began to undulate. Decoration triumphed everywhere, as at the château of Saint-Jory (1545). The designer of the Assézat residence reacted against this somewhat empty proliferation by eliminating the carved reliefs and by orchestrating facades uniquely through the use of classical orders and the design of arcades. The projecting staircase in the corner of the courtyard, although harking back to tradition, produces an animated effect (circa 1550–1562).

ÉCOUEN

The nobleman Anne de Montmorency (1493–1567) was a glorious yet disappointing figure. He was named Connétable of France, the highest-ranking

Écouen (Val-d'Oise).
Gable window on the north wing
of the courtyard. 1545.

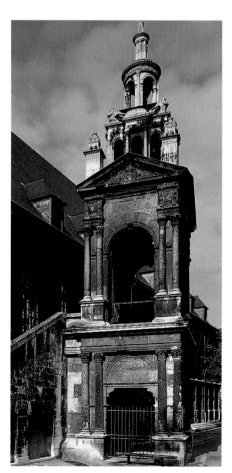

Chapel of La Fierté-Saint-Romain, Rouen
(Seine-Maritime). General view
from the northeast. 1543.

military title, in 1538, after a brilliant campaign in Italy, but as an influential politician he lacked foresight, having taken at face value Holy Roman Emperor Charles V's pronouncements on the duchy of Milan. Montmorency's activity as art patron was equally confused, as his vast property continued to grow through dowries and gifts.

Starting in 1538, Montmorency placed particular emphasis on his château in Écouen, the initial architect of which has now been identified—a certain mason named Pierre Tâcheron. It is unfortunate that Tâcheron's career cannot be retraced, since in erecting the main section and south wing of Écouen he already employed the remarkable plan with square pavilions at the corners that constituted a decisive novelty over the designs of Plessis-Bourré and Le Verger. True enough, this approach was anticipated by the plan of the somewhat earlier Château de Madrid; Tâcheron's arrangement, however, adopted ten years later at Henri II's Louvre, led to a new and much

more effective handling of exterior elements. The upper storey of this first version of Écouen included gable windows with tabernacle pediments, and tall decorative chimneys typical of the Loire Valley.

Around 1545, a different approach was taken with the north wing, where Doric architraves suddenly gave the gable windows an antique appearance. Since Jean Goujon was mentioned as being in Montmorency's service at this date, he has been credited with this moment of purism, also evident in the chapel in the southwest pavilion with its handsome entrance portal. However there was a third stage of construction that indicated dissatisfaction with the state of the château after 1550. Jean Bullant added a projecting section

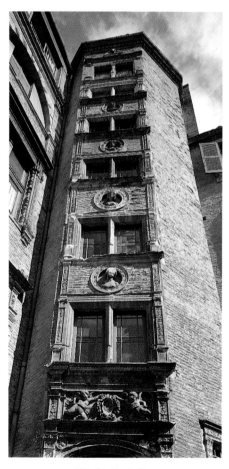

Nicolas Bachelier,
Hôtel Beringuier-Maynier, Toulouse.
The staircase tower. c. 1550.

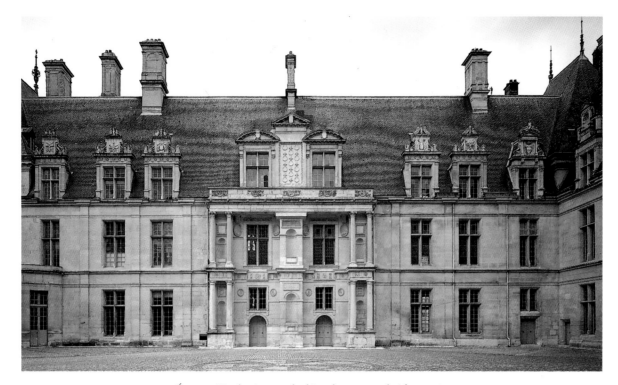

Écouen. North wing overlooking the courtyard. After 1550.

Below: Écouen. Portico of the south wing overlooking the courtyard. After 1550.

and portico to the exterior of the north wing bearing the arms of Henri II and organized around two levels of detached columns. He then added an impressive entrance wing with a three-level frontispiece, similar to the one on the main building at Anet, but with a planned upper arcade for an equestrian statue (now lost).

In a final addition, which was both an enhancement and a correction, Bullant placed another portico on the south wing; reflecting greater ease than the north portico, it features colossal order columns rising two storeys high and bearing an enormous entablature. Borrowed directly from the Pantheon in Rome, the use of such a portico on a palace facade was nevertheless completely new for France, having been employed in Italy only by Palladio.[11] It is not certain that this sensational innovation was truly appreciated, for it was a long time before a colossal order of this type was used

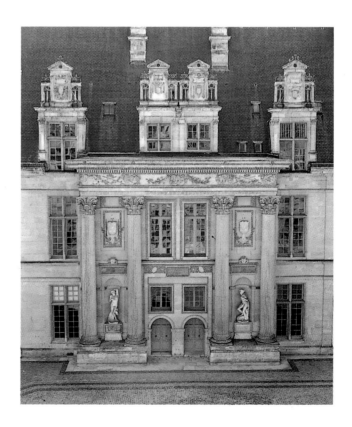

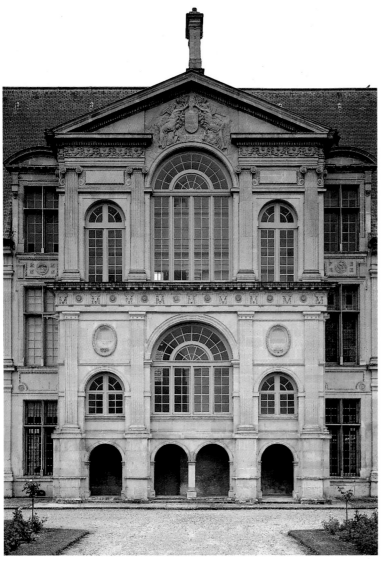

Écouen. Rear facade of the north wing:
the loggia of the King's Staircase. 1552–1553.

again in France (excluding pilasters as employed, for example, at the Lamoignon residence). But this effort is revealing of the fact that for more than a twenty-year period there was a search for a certain style.

That style was finally found at Chantilly around 1560 with the Petit Château, in which all the elements, like so many pieces of a puzzle, elegantly fell into place: tall windows with crossed mullions and transoms which intersected the cornice for the first

time in a way that animated the composition, obviating the need for other ornamentation in a classical adaptation of linear penetration as practiced in Gothic art. No less original are the side pavilions and the facade that employ, perhaps prior to Écouen, the colossal order. The capacity for inventiveness is also demonstrated by the viaduct with double gallery that Bullant built over a valley to provide access to the château at Fère-en-Tardenois in Picardy;

parallels between the work of Bullant and Philibert de l'Orme will be discussed later.

A tendency toward classical rigor appeared on the facades of churches in the Île-de-France region. This could be seen at Othis as early as 1555 with a pediment over Ionic columns, and friezes on the upper levels, as well as at Montjavoult around 1565. An idea of the originality of juxtapositions and of the charm and gaiety of certain arrangements can be gleaned from the west portal of a church in Gisors executed in 1550, where paterae and bucrania are topped by plumed lion heads rising to the cornice. The same droll forms appeared on the facade of Belloy-en-France around 1545, and on the church of Saints-Côme-et-Damien in Luzarches where Nicolas de Saint-Michel's facade (circa 1551) included columns even alongside the rose window.

THE LOUVRE

The first specifically and identifiably French architecture was Pierre Lescot's facade for the Louvre. Renovation of the château had become indispensable. The 1540 visit to Paris by Holy Roman Emperor Charles V made it apparent how archaic and uncomfortable the old castle had become. Francis I solicited competing designs from all the specialists—Serlio, Vignola (who arrived in France in 1542), Cellini (who must have made suggestions)—only to select in 1546 the proposal of a highly cultivated gentlemen about whom little, alas, is known: Pierre Lescot (circa 1515–1578). The project was underway when Francis I died, and work continued under Henri II after 1547. Around 1550, however, a notable change was made: the staircase, which had been planned for the center, was shifted to the far right so that two large rooms could occupy the ground and upper floors. Furthermore, a square pavilion was begun on the northwest corner facing the Seine. This decision was coherent with a transformation of the château that permanently eliminated round medieval towers.

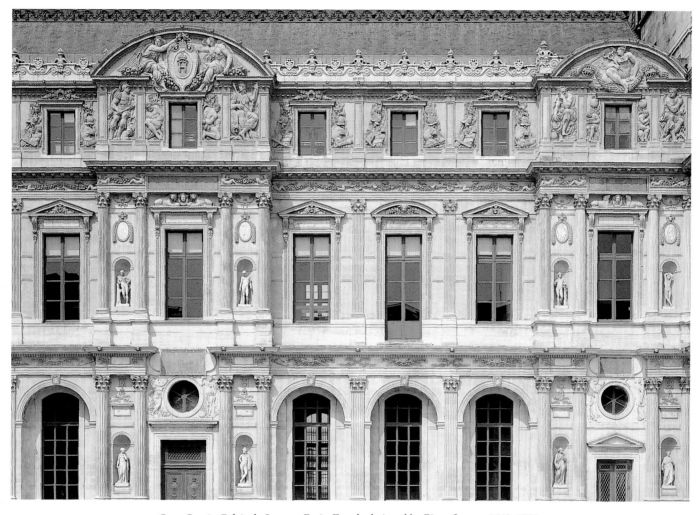

Cour Carrée, Palais du Louvre, Paris. Facade designed by Pierre Lescot. 1549–1555.

From there, the overall design had to be established. The wing at right angles to the new pavilion was not developed beyond three bays, and the walls of the old Louvre carried on from there until late in the seventeenth century. It probably became quickly apparent that simply forming a square with the Lescot wing as the main body was not sufficient. One of the plans submitted by Serlio (known from his Book VI, not published in the sixteenth century, and from an engraving) doubled the overall dimensions, so it is plausible to suggest that the definition of a larger square through the repetition of

the Lescot facade to the north was considered at an early date.

Lescot composed his facade with startling virtuosity. Three avant-corps (projecting pavilions), topped by curved pediments, frame two groups of three bays separated by antique pilasters. This arrangement provides a balance and serene harmony that invite close scrutiny of detail. Everything is ingenious yet vigorous, with a rare quality of execution in the proportions, niches, and reliefs. The avant-corps are based on a model of rhythmically orchestrated bays, with an entablature and oculus above the door that break with Bramante's idiom. The windows

are handled differently on each of the three levels: recessed windows in semicircular arches on the ground floor, tall windows topped by pediments above, and smaller windows surmounted by crossed torches on the top floor. All the resources of the antique repertoire were brought into play, yet adapted to a subtle overall organization. It cannot be said that horizontal lines predominate, as they would in the Italian manner; although they are underscored by cornices, the one running above the ground floor is broken in the middle of the avant-corps. The horizontals are thus intersected by the vertical thrust of the bays, which draw the eye upward.

Lescot's facade represents a new type of grid rendered lively and dynamic through the intersection of horizontal and vertical lines.

The elegant distribution of decorative features is no less effective. They are concentrated in the upper levels, as befits French tradition. Slabs of pink and gray marble add a touch of color. The sculpture also merits attention for the regular progression, symmetry, and grace that Goujon and his workshop imparted to it. Taken together, the

Gabriel Pérelle, View and perspective of the Louvre. Engraving. Musée Carnavalet, Paris.

Below: Palais du Louvre, Paris. Sculpted ceiling in the king's bedchamber executed by Scibec de Carpi. 1556.

elements of the superb bas-reliefs form a political program, announcing France's absolute monarchy. Such ideas could even be read in 1551 in a treatise titled *Raisons de la Monarchie* by the impassioned philosopher Guillaume Postel.[12]

The square pavilion, called the Pavillon du Roi, must have seemed equally sensational with its four storeys, the fourth one graced with statues and somewhat recessed above a mezzanine with an emphatic cornice. The sets of triple windows facing the river were designed to present the typical image of a royal residence: vermiculated rustication, absence of antique orders, double-transom windows that varied from one floor to another, topped by triangular pediments on the *piano nobile*, but by round-headed arches on the ground floor.

The external appearance in no way echoed the charm of the facade facing the courtyard (in any case, the pavilion was enveloped by the extension that Le Vau added to the south wing). Great attention was paid to the apartments. The ceiling of the king's bedroom, executed by Scibec de Carpi according to a program devised by Lescot in 1556, revealed Lescot to be a first-rate decorative designer. The reliefs and motifs obey a clean and elegant organization that was fully appreciated a century later (the ceiling was subsequently moved behind the colonnade).

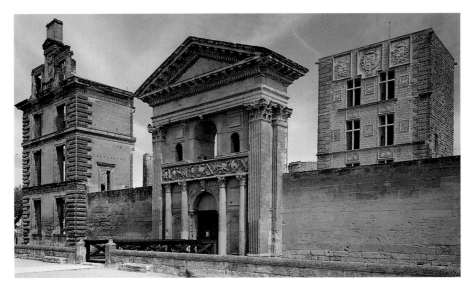

The Tour d'Aigues (Vaucluse). Entrance facade. 1566–1579.

It is worth mentioning the surprise generated by Lescot and Goujon's work, even though it remained trapped between the buildings of the old Louvre until the following century. Foreign ambassadors admired it, and French nobles realized that there was once again a "royal" style. The first imitation of the Louvre could be seen at Vallery in Burgundy, where Jacques d'Albon, maréchal de Saint-André, received the king in March 1550. Strangely, only the corner section corresponding to the Louvre was executed—the elevation is similar and the corner pavilion, despite its steep roof, has the same general appearance, being "based in part on that of the Louvre," according to du Cerceau. Work was halted in 1559, however, when the maréchal fell from favor.

Another echo was the château of the Bouliers family at La Tour d'Aigues in Provence. This large rectangular residence was rebuilt and modernized after 1560; four pavilions surround a piously preserved keep (unlike the Louvre, where the central keep was razed). The northeast pavilion repeats the moldings, rustication, and structure of the Parisian model, representing an obvious political and feudal homage at a time when emblematic signals had become increasingly significant. According to the documents, a certain Piedmontese architect, Ercole Nigra, was commissioned to execute the chapel. In the middle of the entrance wall, an enormous antique-style portal was erected in 1571 that reflects the presence of vestiges of ancient portals in Provence. Also worth mentioning, although built somewhat later, is the château of Lanquais (Dordogne), the only example of its kind in the region, with two uncompleted wings flanking at right angles a pavilion notable for its height, vermiculated bosses, and rounded architraves. The pavilion replaced one of the original castle's two round towers; the somewhat gauche and temporary effect is itself not unlike the one created by the Louvre until it was completed. Lanquais has been dated to the reign of Charles IX (1560–1574).

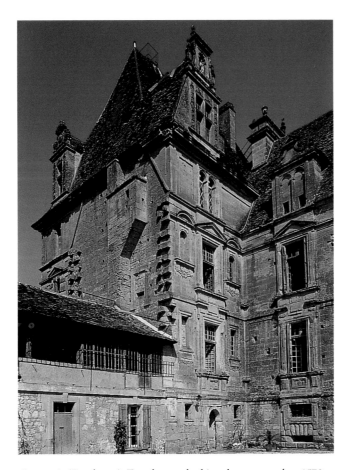

Lanquais (Dordogne). Facades overlooking the courtyard. c. 1570.

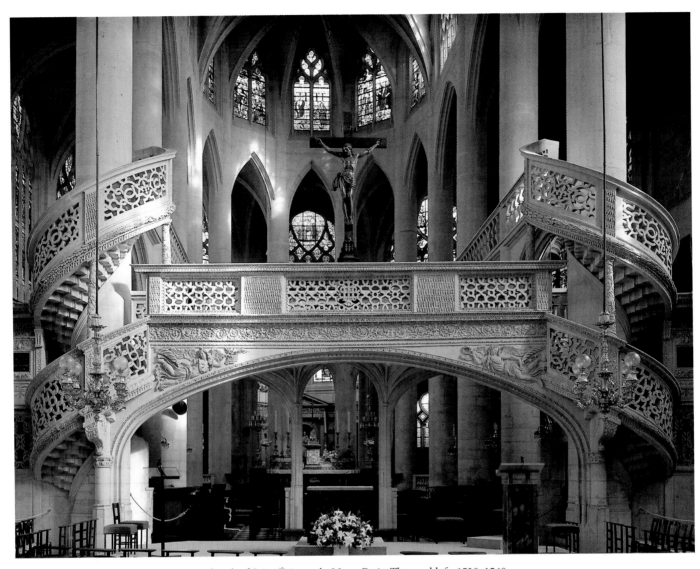

Church of Saint-Étienne-du-Mont, Paris. The rood loft. 1530–1540.

PHILIBERT DE L'ORME AND ANET

It was during this period that French society came to consider the château as the most lofty of projects, an "ideal form" incarnating all the aspirations of the day—the very role cathedrals had played in the thirteenth century. This is evident in the wealth of inventiveness that made every building interesting; innovation generally entailed transforming certain traditional features, all the while retaining signs of nobility such as corner turrets, gatehouse, and even crenellation, once it had been stripped of its military function to become a sawtooth decorative pattern (an amusing example is furnished by the alternating pediments on Grand Ferrare). It took other forms at Chantilly and the Tuileries. Lescot taught the nobility to use rusticated stonework to stress vertical lines, while Philibert de l'Orme developed all sorts of innovations at Saint-Maur and especially at Diane de Poitiers's château at Anet.

This decisive period was dominated by the figure of Philibert de l'Orme, and the disappearance of three-quarters of his œuvre is an irreparable loss. Unlike Lescot, who was a brilliant and inspired connoisseur, Philibert was the son of a mason—a craftsman—and was able profoundly and permanently to wed French stonecutting technique—*l'art du trait*—to a fully assimilated antique repertoire. He thus played a role similar to that of Palladio in Italy. Like Palladio, de l'Orme felt the need to explain his work in two books. One, titled *Nouvelles Inventions pour bien bastir à petits frais* (New Inventions for Building Well at Little Expense, 1561)

described his new way of constructing vaults and roofs, of which he was very proud and which he demonstrated at Montceaux. His second treatise, crucial for France, was the *Livre d'architecture* (1567), a vast doctrinal exposition in which he presented a methodical defense of his œuvre. These two volumes were written during de l'Orme's forced retirement—almost political disgrace—from 1559 to 1564.

Upon his return from Rome to his home town of Lyon, he had a fine gallery on pendentives with Ionic pilasters built for a financier named Bullioud. De l'Orme liked the inward curve of the pendentive, which relied on a delicate line to unite two distinct levels, and he would use one in a corner of the main building at Anet.

There are good reasons to think that de l'Orme contributed to the designs for the rood loft in the Paris church of Saint-Étienne-du-Mont. Although the main arch was erected along with the church's chancel between 1500 and 1535, the two symmetrical and wonderfully mannerist stairways on the sides exhibit openwork and decorative details very similar to Philibert de l'Orme's work. Who else could have displayed such a capacity for invention around 1540? The lateral doors may also have been based on his designs, but they were only installed at the end of the century. The date of 1600 on the frame of the vault refers to the erection of a crucifix (now lost) by Pierre Biard.

Henri II made Philibert de l'Orme both an abbot and the director of all official construction. This included designing the tomb of Francis I, an enormous triumphal structure featuring fluted Corinthian columns of innovative arrangement and proportions, for which Pierre Bontemps sculpted the figures and probably part of the decoration. He was also responsible for the royal chapel at Vincennes; another chapel at Villers-Cotterêts (1550) based on a trefoil plan that exploited a new order, the so-called French order; and the new château

Anet (Eure-et-Loir). The chapel:
detail of the interior decoration. 1549–1552.

at Saint-Germain-en-Laye (after 1557), which featured the brilliant idea of a quatre-foil courtyard allowing for symmetrical apartments (demolished in the eighteenth century). In the midst of all this, de l'Orme also managed to design and build the château at Anet for Diane de Poitiers in record time (1547–1552). Following the death of Henri II and Diane's removal from power, de l'Orme fell out of favor for several years. Construction of an elegant château that he had begun in 1547 at Saint-Léger-en-Yvelines (en route, so to speak, to Anet) was suddenly brought to a halt, as recent excavations on the site have confirmed. But Catherine de' Medici, as Queen Mother, had the good sense to put de l'Orme to work again after 1564, notably on the key edifice of the Tuileries Palace

(since destroyed), to be discussed below.

Poetic literature of the day demonstrates the extent to which the building of the château at Anet interested intellectuals and courtiers. The originality of the overall design revealed a desire to make the Écouen idiom more supple. Everything flows together: a three-storey frontispiece is aligned with the main building to the rear; on the right, a wing bordered by a gallery opens onto a chapel projecting into the right-hand courtyard; on the left, a wing with tall casement windows runs below alternating pediments (altered in the eighteenth century). The north side of the main building gave onto a cryptoporticus (enclosed gallery) leading straight to the garden and the canal. The surviving frontispiece, now in the École des Beaux-Arts in

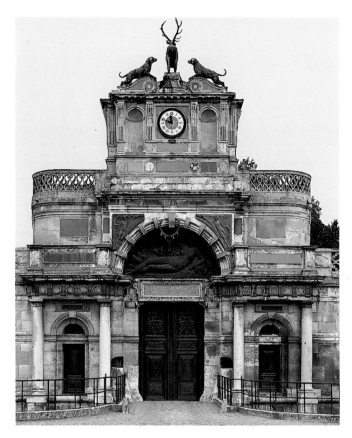

Anet (Eure-et-Loir). The entrance pavilion. 1552

Right: Anet. The chapel:
interior of the cupola. 1549–1552.

Paris, is a magnificent demonstration of the proper use of orders. De l'Orme employed stylobates to adjust its proportions, skillfully adorned the shafts on the third level, and achieved a refined handling of surfaces, which suddenly rendered effete all previous formulations, including Lescot's distinguished avant-corps.

De l'Orme was not advocating purism, however. Anet's entrance pavilion skillfully combines bastion-like forms (in honor of the seneschal who was Diane's late husband) with elements of a triumphal arch and Doric frieze, plus allusions to the namesake goddess (notably Cellini's bronze nymph, transported from Fontainebleau, now in the Louvre). Here, de l'Orme wanted to produce a picturesque model of the traditional profile of a château, as reflected by the sarcophagi and

chimney shafts. The admirable chapel constitutes another work of personal virtuosity—it is set in a circle traced by the curved projection of the side chapels, while the central space is composed of a cylinder topped by a dome and lantern featuring extremely elegant arches. The intersecting lines of the ceiling correspond to those of the flooring; everything is admirably finished, from the fluting of the pilasters to the pattern of the niches to the silhouettes of the double arcades. Two pyramidal pinnacles (an original variant on a familiar element) flank the gallery entrance to the chapel.

The quality of the ornamental sarcophagi and the skillful deployment of mythological symbols of the goddess Diana (the bow and the crescent) indicate that the architect closely monitored decorative

details. The base of the sculpture of *Diana with the Stag* (today in the Louvre) fully reflects his style. De l'Orme also designed architraves and gable windows, published in his *Livre d'architecture,* which serve as examples of emblematic ornamentation. The "stream" or "fountain" tapestries woven for the apartments have been mentioned previously; everything was coordinated to reflect an ancient myth and the cool, charming reality of the king's mistress who incarnated that myth. According to one observer the gallery was "all filled with representations of the aforementioned Diane de Poitiers sometimes painted as a huntress, naked in form like the Diana of the ancients, sometimes richly dressed with grand pomp in the fashion of the day ." (Denis Godefroy, *Description de la Maison d'Anet,* 1640).

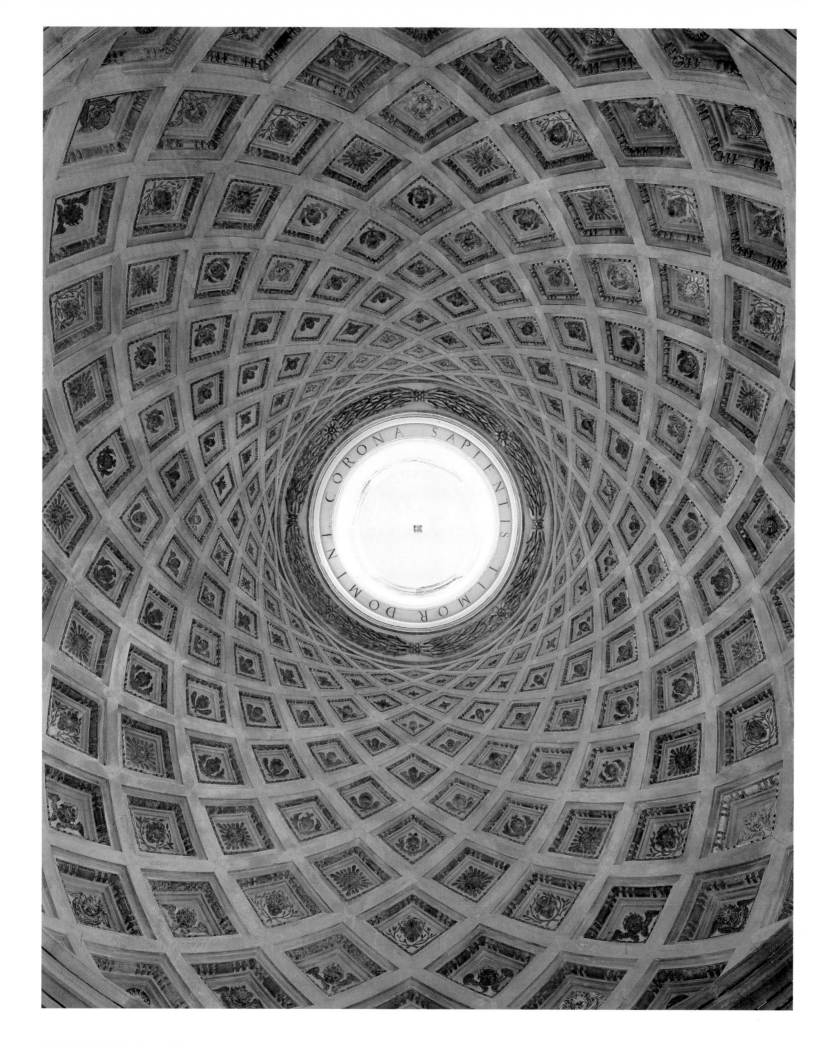

Church of Saint-Nicolas des Champs,
Paris. South portal. 1576–1587.

Church of Saint-Germain-l'Auxerrois,
Paris. Apse portal. 1570.

Philibert de l'Orme soon became an important personage. The ecclesiastical benefices he was awarded (three abbeys, including Ivry) gave him the status of a courtier—to the exasperation of Ronsard, who was jealous of the favors bestowed on this "crosiered trowel." Above all, his post as Commissioner of the King's Buildings endowed him with exceptional authority. With de l'Orme, the status of architect was transformed and once again elevated to the high social rank that it had held during the thirteenth century.

His doctrine was extremely practical and lucid. He intended to define the modern approach, based on the assimilation of antique forms elaborated on blueprints, because they were the most reasonable and best adapted to modern programs. De l'Orme rejected Vitruvius-like dogmatism—blindly copying Roman models would only be ridiculous. Marble would have to give way to stone, which was of such high quality in France. A sixth order was added to the traditional Greek and Roman orders, using rings to cover the joins of shafts, since in France it was impossible to have monolithic columns. De l'Orme was convinced that the time had come for French architecture to free itself completely from the Italian model, relying on antique forms only when he judged useful. He himself gave an example of what it was possible to produce with the chapel at Anet (miraculously preserved) and the Tuileries staircase (destroyed in 1664). Philibert de l'Orme's inspired initiatives inaugurated French classical architecture.

A good example of general developments is supplied by de l'Orme's drawing for a triumphal-style gate for the tournament of 1559 at the Hôtel des Tournelles (a tournament that "was transformed into the greatest disaster and desolation" due to the accidental but ultimately mortal wounding of Henri II). The gate was one of the plans that became a lasting model—"it must be a perfect square"—with a pair of fluted pilasters, separated by a niche, flanking a high porch topped by an entablature. Above that was a pediment broken, in this instance, by statues and floral motifs, but which was usually reduced to the classical form of a triangle. This general design was used some twelve years later for portals on Saint-Nicolas-des-Champs and Saint-Germain-l'Auxerrois, where they can still be seen.[13] The interesting point is that this interpretation of Bramante's rhythmic bay was more or less used as a recurring motif by Henri IV's architects for the Long Gallery of the Louvre and for the wing linking the Flora Pavilion to the Tuileries.

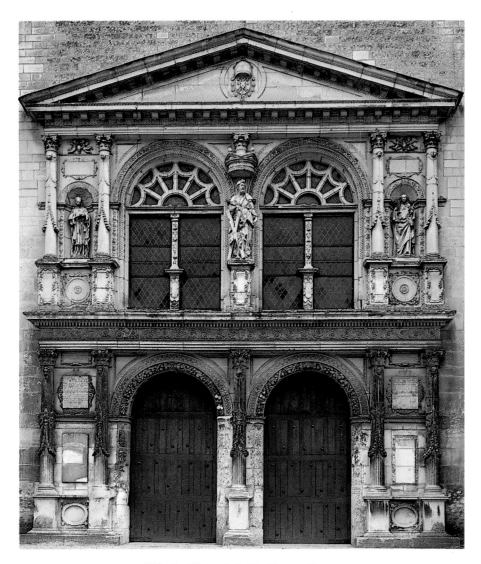

Church of Saint-André-les-Vergers, Troyes.
Facade with double portal. 1549.

In this way a lasting system emerged. French national architecture was promoted by Jacques Androuet du Cerceau who, with the exception of some practical construction at Montargis, devoted himself to the publication of models, a task of enormous importance. After publishing volumes on arches (1549) and temples (1550), his *Premier Livre d'architecture* (1559) supplied models of domestic residences for various classes of society. It conveyed an original sense of interior arrangement around the living quarters, as well as providing compositional models for avant-corps, pavilions, wings, roofs, and so forth. By the calculated grading of plans as a function of social status or condition, his volume was a model of sociological adaptation which architect Pierre Le Muet would exploit in the following century. The clarity of the presentation, which combined a conventional aerial view with upturned facades, gave it unique didactic value. Finally, it should be stressed that none of the models followed Italian examples. Although a few portals and gable windows convey an antique flavor, the remarkable thing is that the new architecture featured volumes, steep "French-style" roofs, and decorative elements like rustication and modillions (small brackets) that were completely alien to Vitruvian classicism.

In the same spirit, but with a larger number of distinguished references to antiquity, du Cerceau's *Second Livre*

La Bastie d'Urfé (Rhône-Alpes). Ramp leading to the gallery. 1532–1536.

d'architecture (1561) dealt with chimneys and decorative elements, whereas the *Troisième Livre* (1582) concerned country homes. In the meantime, he published the two crucial volumes of *Les Plus Excellents Bastiments de France*.

All this information spurred innovation. The idea of a temple facade or of a frontispiece forming a portico emerged swiftly. A two-storey structure, one level Corinthian, the other Ionic, could frame an entrance topped by a window; a double portal might also be topped by two windows, as seen at the church of Saint-André-les-Vergers in Troyes, dating from 1459, where the niches between the side columns host the customary statues and a large pediment modernizes the facade. To give an example of secular architecture in the same town, the Vauluisant residence, dating from the mid-sixteenth century, has

a four-storey, rhythmic facade in the new spirit, flanked by two round turrets and preceded by a two-flight staircase, which lends it an original and especially practical air.[14] A vestige or two of such lively and attractively decorated compositions can still be seen today in almost every city or town throughout France.

GROTTOES

Noble residences had their own special character, tinged with magic. Chambord was said to be the château of romance hero Amadis, while Anet assumed the aura of a mythological temple, and the Louvre came to be perceived as the French monarchy's sacrarium. Other châteaux adopted different hues—La Bastie d'Urfé (Auvergne), for example, evoked initiatory rites. La Bastie was a stronghold modernized by Claude d'Urfé (1501–1558), who not only

hosted a visit from the king of France in 1536, but was governor of the royal children from 1541 onward and was the monarchy's representative to the Council of Trent in 1546. Initially, La Bastie's modernization entailed a wing forming a porch-like open gallery, with an entrance ramp featuring a sphinx and a projecting roof with a statue of Mercury. In a second phase of improvements, a remarkable ensemble was formed by endowing the main building with a grotto-cum-chapel, which boasted a cycle of inlaid woodwork imported from Verona that was unusual for France, (now in the Metropolitan Museum of Art, New York), and another cycle of paintings on Biblical subjects by the Emilian artist Girolamo Siciolante with inscriptions from the Scriptures in both Latin and Hebrew (still at La Bastie d'Urfé). By placing everywhere the symbol

Fontainebleau. Entrance to the Pine Garden grotto. 1543–1544.

of the paschal sacrifice (a lamb on the altar), along with the trinitarian emblem UNI, Claude d'Urfé hoped to create a unique atmosphere.

Grottoes were very much in fashion around 1450–1550, so it is hardly surprising that Fontainebleau was extended to include not only baths but a pavilion of grottoes, following the example given by the Italians in Rome and Tuscany. Grottoes established a link between nature and art. The outer envelope was an enormous rock, inside of which there was a temple or sophisticated arrangement, but through the use of stalactites, shells, fountains, and so forth visitors were placed in the presence of telluric forces.

Grottoes were sometimes designed as cool retreats (for example the raised grotto at the end of the Galerie d'Ulysse in

Fontainebleau), sometimes as baths, and sometimes as naturalistic settings with a more or less symbolic atmosphere of antique mysteries (the extraordinary example of La Bastie d'Urfé combines grotto and chapel). The grounds at Gaillon also featured the "White House" (now destroyed), while Meudon boasted a notoriously monumental, allegorical, and delightful grotto that Primaticcio[15] (who, it seemed, had already built the one at Fontainebleau) executed for Charles of Guise, cardinal of Lorraine, in 1556–1559. The purpose of this magnificent underground lair beneath a tall pavilion is clear—the interior was covered with faience, stucco, and mosaics in a deliberate attempt to dazzle visitors. An ingenious artist then set about perfecting this type of decoration, namely Bernard

Palissy. A great deal of importance must have been placed on the extraordinary Tuileries grotto if Palissy was invited to decorate it despite his Huguenot affiliations. Excavations carried out in the Tuileries in 1984–1985 uncovered the potter's kilns in the courtyard, along with a number of molds featuring antique-style medallions and other items.[16]

The vogue for naturalistic architecture was far from negligible. For two hundred years France was dotted with many such grottoes. The fashion was not only long lived, it actually culminated in the extraordinary development of cascades and gushing fountains, of which the finest example, by all accounts, was the new château at Saint-Germain-en-Laye. At Versailles, one of the first major projects to be undertaken was the grotto of Thetis.

La Bastie d'Urfé (Rhône-Alpes). View of the interior of the grotto. 1551–1558.

Fontainebleau. View of the interior of the Pine Garden grotto after restoration. 1543–1544.

3. The Height of Sculpture: Jean Goujon, Germain Pilon

The sophisticated celebration organized by the city of Paris for Henri II's ceremonial entry in 1549 is generally considered to be a manifesto of neoclassicism. Although not entirely true concerning the texts contributed by Thomas Sébillet (the writer who would be properly vilified the following year by the spokesman for the Pléiade poets, Joachim du Bellay, in his treatise *Deffence et Illustration de la langue françoyse*), it is accurate in terms of the panels painted by Jean Cousin and Charles Dorigny, of the program of allegories prepared by Jean Martin, and above all of the architectural structures and sculpted elements executed under the direction of Jean Goujon and Philibert de l'Orme.

The fountain on the corner of rue Saint-Denis and rue aux Fers (now rue Berger), known as the Fontaine des Innocents, was completed for those festivities and became the main attraction. Arches opened on three sides (the fourth side was added when Pajou transformed the fountain into a freestanding monument in 1787), each with twinned, fluted pilasters flanking exquisite figures of bas-relief nymphs pouring forth water. Other fine relief works covered the entablature and the bronze balusters. Nothing so elegant existed at that time in France, or anywhere else for that matter. This demonstration of new savoir faire, based on a thoughtful consideration of antique art, won instant acclaim.

Goujon began his career in Rouen, notably working on the organ loft at Saint-Maclou where he revealed himself to be a disciple of the Fontainebleau masters. His rigorous yet increasingly fluid and pure interpretation of antique style can be seen on the rood screen at Saint-Germain-l'Auxerrois (1544, fragments now in the Louvre), where he had been summoned by Pierre Lescot. Goujon subsequently

Jean Goujon, *Nymph*. Bas-relief on the Fontaine des Innocents, Paris. 1547–1550.

Jean Goujon, *Nymph*. Bas-relief on the Fontaine des Innocents, Paris. 1547–1550.

Jean Goujon, *Nymph and Spirit*. Bas-relief originally from the stylobate of the Fontaine des Innocents.
Stone. 1547–1550. 73 × 195 cm. Musée du Louvre, Paris.

collaborated so closely with Lescot that it is sometimes difficult to know whether to ascribe certain works to the architect or to the sculptor. It was a time of bold statements, and Goujon publicized the new style by illustrating Jean Martin's translation of Vitruvius. He was in the service of the Montmorency family for a while, then was named sculptor to the king, and also executed the magnificent *Four Seasons* decoration for the private residence of Jacques de Ligneris, head of the Paris *parlement*, (today the Musée Carnavalet). For the Paris Hôtel de Ville (town hall), Goujon carved wooden reliefs of the *Months* (destroyed in 1871, molds at the Musée des Monuments Français)—the sharpness of the silhouettes and charm of the execution earned this work the epithet Hellenistic, as did the nymphs on the Fontaine des Innocents. Indeed, it was a question of selective antiquity.

The Goujon–Lescot team created miraculous transformations at the Louvre. By 1548, *War* and *Peace* were carved on both sides of the central oculus, while similar figures took up position on the two avant-corps of 1549. The commissioning of

Fontaine des Innocents, Paris. 1547–1550.

Jean Goujon, *Saint Luke and Saint Mark*. Bas-reliefs from the rood screen of the Church of Saint-Germain-l'Auxerrois, Paris. Marble. 1544. 79 × 56 cm. Musée du Louvre, Paris.

large caryatids for the gallery of the hall of the same name dates from September 1550. Whether or not they were based on molds of the Erechtheum in Athens, the caryatids represented a bold and unprecedented demonstration of the restitution of a Greek work. Here, long narrow folds replace the fluting of columns, while the caryatids' heads are "capped" by traditional capitals.

Among other work at the Louvre, the coffering of the Henri II staircase, the ceiling of the ceremonial bedchamber, and the doors are without doubt based on designs by Goujon—the wealth of elements (garlands, Greek borders, rosettes,

trophies) and their distribution in a rich setting attest to a perfect assimilation of Italian examples. Scibec de Carpi, the carpenter at Fontainebleau, installed these new models of luxurious woodwork.

In 1562, Goujon left France for religious reasons, but not before profoundly altering the course of French art by advocating a specific approach: the borrowing of forms from antiquity that could be adapted either to sensuous or noble compositions, as though it were possible to recover and decant at will this precious, long-lost heritage. Imitations flourished as Goujon-influenced silhouettes invaded the decorative arts, especially furniture,

when applied to models disseminated by Fontainebleau's engravers. Although Goujon was never completely forgotten, taste did eventually shift away from the sharply precise chiseling of marble reliefs. Two centuries later, during the return of a certain neoclassic purism, Goujon's fame once again inspired imitators. His art periodically resurfaces as a model to follow, having become one of the permanent features of French taste, with its attachment to clean, pure marble endowed with an unforgettable note of elegance. This can be seen not only in the silhouettes of the fountain nymphs but also in the beautifully executed moldings of the door to the

Jean Goujon,
Caryatid.
1550–1551.
Musée du Louvre, Paris.

Above: Jean Goujon, *The Four Seasons:*
Spring and Summer. Bas-reliefs decorating
the main facade of the Hôtel Carnavalet,
Paris. Second half of sixteenth century.

Left: Palais du Louvre, Paris.
Vaulted ceiling of the Henri II staircase
sculpted by the studio of Jean Goujon.
c. 1550.

chapel at Écouen (circa 1540, certainly
by Goujon).

Goujon headed a major workshop.
The names of Étienne Carmoy and Martin
Lefort appear in the accounts, and they
may have worked on the reliefs in the
south wing of the Louvre, on the Attic tro-
phies, and elsewhere. Perhaps one of them
was responsible for the strong, dense dec-
oration of the Du Faur residence (to be
discussed in the next chapter). There were

also other sculptors about whom little is known. A certain Ponce Jacquio, who had passed through Rome and also worked for Germain Pilon, was important enough in 1560 to be commissioned to execute forty statues, sixteen of them "in the form of Persian columns," destined for the niches in the courtyard at the château of Verneuil (Picardy).

An unresolved mystery still surrounds the most justly popular work of the Renaissance, namely the Anet *Diana* (p. 175). The points of departure were an often-engraved drawing by Rosso, another by Primaticcio, and the bronze lunette that Cellini cast in 1543–1544 for the Porte Dorée at Fontainebleau, showing the goddess of the hunt as a nymph lying beside a stag. Ten years later, the bronze lunette (today in the Louvre) was reinstalled over the portal at Anet. The subject inspired several other reliefs, but nothing equaled the large sculpture decorating the fountain at Anet: on a curved base of remarkably skillful and elegant execution, the composition is admirably calculated to favor multiple viewpoints of the nude goddess and the tame stag, at the same time introducing delightful gracefulness through studied contrasts such as a juxtaposition of the animal's horns and the huntress's sophisticated coiffure. This hyperbolic glorification of the mistress of the château was in place by 1554.

Nothing in Goujon's own work corresponds to this robust sculpture in-the-round. Another artist must be behind the strong, brilliant composition drawn from the Fontainebleau repertoire—perhaps the mysterious Ponce Jacquio, or one of the two sculptors who worked with Philibert de l'Orme on the tomb of Francis I from 1548 to 1559, namely Pierre Bontemps (1505/1510–after 1562) and Germain Pilon (1528–1590). The former, who trained under Primaticcio at Fontainebleau, sculpted some of the decorative elements for the tomb including, it would seem, the recumbent figure and the admirable monument designed to hold the

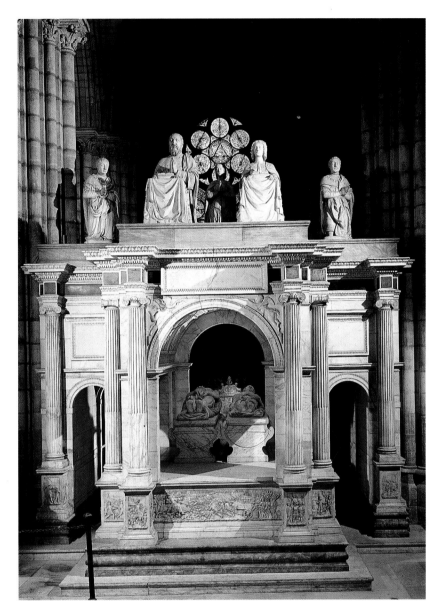

Philibert de L'Orme and Pierre Bontemps. Tomb of Francis I and Claude of France. 1548–1559. Abbey Church of Saint-Denis.

king's heart (1550, Saint-Denis)—an oval urn decorated with skillfully executed cartouches. Bontemps has also been credited with the tombs of Guillaume du Bellay (after 1557, Le Mans Cathedral) and of Admiral Chabot (died 1543, Musée du Louvre). The sober, virile style of Chabot's tomb, like that of Charles de Magny (Musée du Louvre) indicates an evolution toward a more powerful style. Bontemps

vanished from France, for the same religious reasons as Goujon, in 1562.

However, the Anet masterpiece has also been credited to the youthful Pilon. That would make it an early masterstroke, rendered possible by Pilon's rectified date of birth of 1528. He seems to have emerged from the Fontainebleau milieu and, like Domenico del Barbiere, was initially close to Primaticcio. For the monument containing

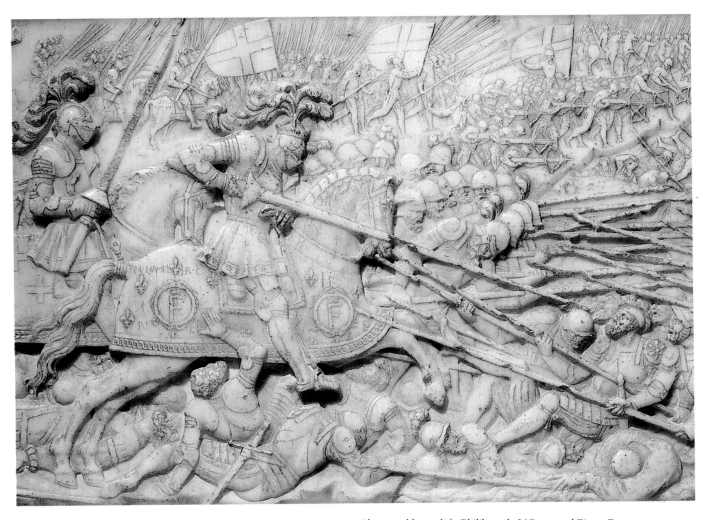

Above and lower left: Philibert de L'Orme and Pierre Bontemps.
Tomb of Francis I and Claude of France. Details of bas-relief on the stylobate:
The Battle of Marignano. 1548–1559. Abbey Church of Saint-Denis.

Below and right: Pierre Bontemps. Urn containing the heart of Francis I:
full view and detail. Marble. 1550. Originally in the Abbey of Hautes-Bruyères
(Yvelines). Abbey Church of Saint-Denis.

Germain Pilon and Domenico del Barbiere. Monument containing the heart of Henri II. 1561–1562. Musée du Louvre, Paris.

the heart of Henri II, which was in the form of a giant tripod imitating the royal incense holder, Domenico executed the triangular pedestal while Pilon was responsible for the Three Graces who display remarkable elegance and finesse. As distinct from Goujon and his linear art, Pilon—son of a traditional sculptor—was destined to reintegrate the practices of French stonecutters into the new manner, which ensured him a crucial role consolidated by a long career. Pilon worked on small marble statues for the tomb of Francis I as early as 1558, and his many years in royal service included work on all the major funerary monuments. On the tomb of Henri II, supervised by Primaticcio as Commissioner of the King's Buildings, the kneeling bronze figures on top and the recumbent figures inside represent the highest affirmation of Pilon's art. The contrast with Primaticcio's four Virtues on the corners is interesting—the latter are merely elegant and graceful, while the royal figures possess the straightforward authority that constituted one of the strengths of French sculpture for two hundred years. As to the recumbent figures, which are even more poignant than those of Francis I and Claude of France, Pilon was able to combine the rigidity of death with a moving sense of fate fulfilled, yielding one of the finest demonstrations of the ability of French sculptors to magnify the passage into the next world.

A small terra-cotta maquette of the recumbent figure of Henri II exists, as does another of the body of Christ (both in the Musée du Louvre), produced in connection with the never completed mausoleum for the House of Valois planned for Saint-Denis. Pilon's work displayed an increasingly free and emotion-charged tone during the dark days of civil war—this late work will nevertheless be discussed here in order to convey the unity of his œuvre.

In the tombs of the two Biragues (Musée du Louvre), the heavily decorated black and white marble framework has been eliminated, allowing the figures to assume their full value. The Biragues were a

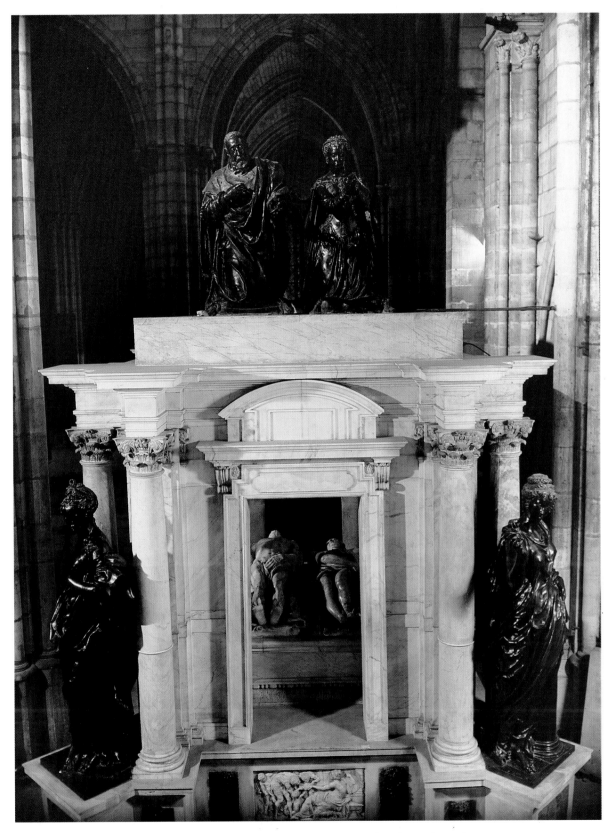

Primaticcio and Germain Pilon. Tomb of Henri II and Catherine de' Medici.
1561–1573. Abbey Church of Saint-Denis.

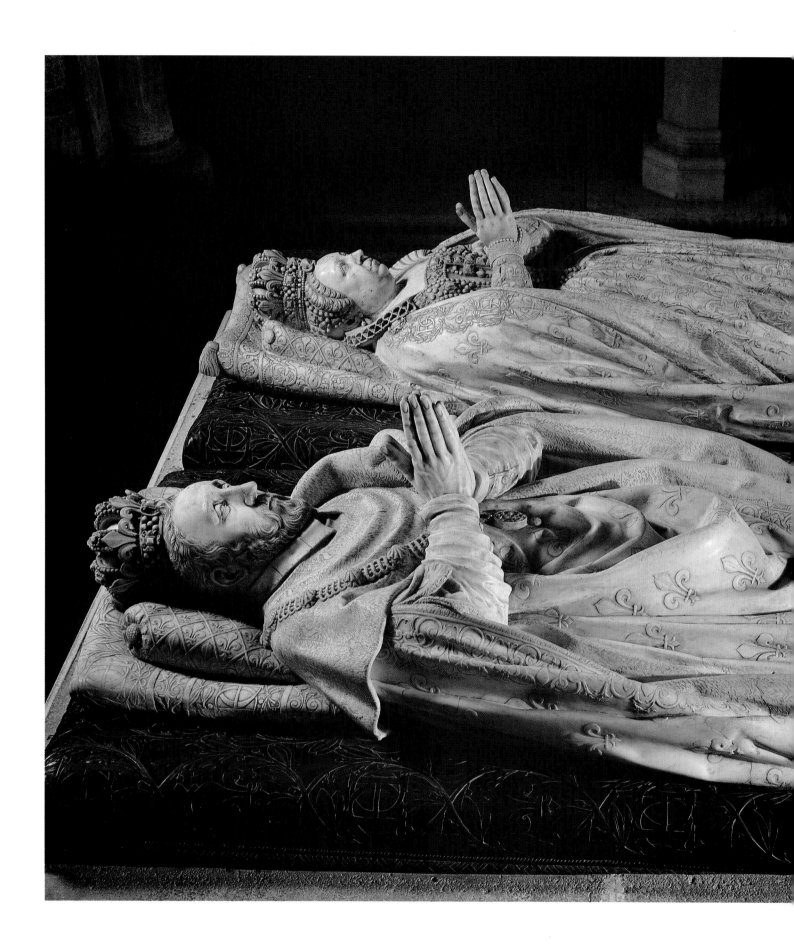

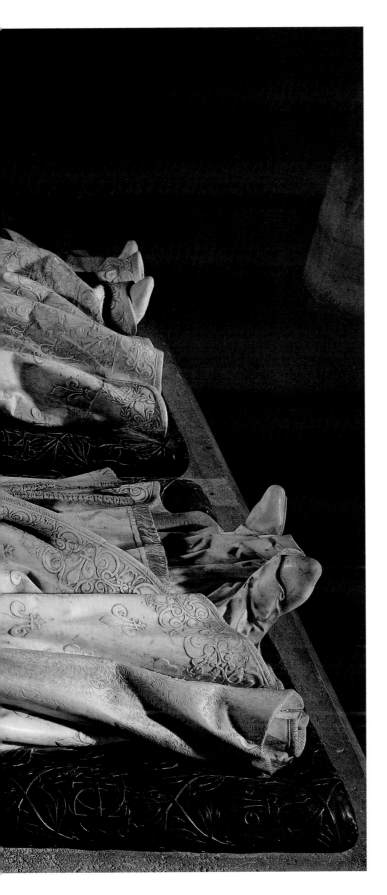

Primaticcio. Tomb of Henri II and Catherine de' Medici.
Detail of a Virtue. 1561–1573. Abbey Church of Saint-Denis.

Left: Germain Pilon. Effigies of Henri II and Catherine de' Medici in
Coronation dress. Marble. 1583. Abbey Church of Saint-Denis.

family from Italy's Piedmont region who rallied to the French cause. After he became chancellor of France, René de Birague (1506–1583) founded the chapel of Saint-Catherine-du-Val-des-Écoliers in Paris, and commissioned Pilon in 1574 to execute a tomb in the grand style for his wife, Valentine Balbiani (1518–1572). His heir later commissioned Pilon to do the same for the chancellor. The presentation of the two wall tombs (removed in 1793) is known from drawings by François Roger de Gaignières. The chancellor, endowed with a long train, was shown praying, whereas his wife was not presented kneeling in prayer but stretched out in a dreamy pose, leaning on

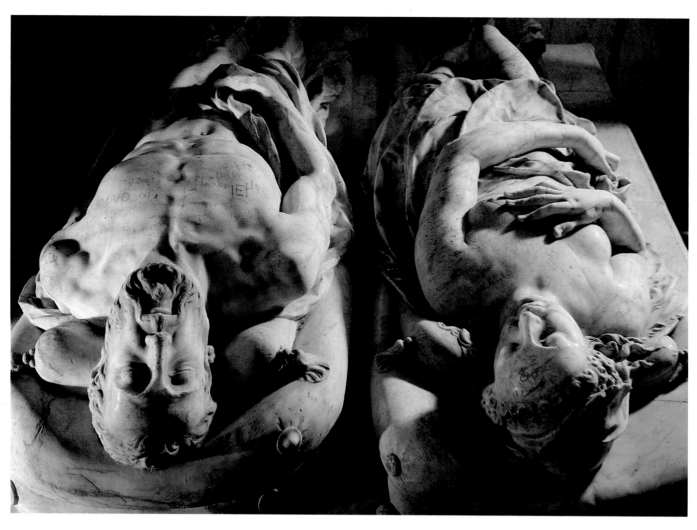

Germain Pilon. Tomb of Henri II and Catherine de' Medici, detail of the effigies.
1561–1573. Abbey Church of Saint-Denis.

Below: Germain Pilon. Study for the effigy of Henri II.
Terra cotta. 19.5 × 57 cm. Musée du Louvre, Paris.

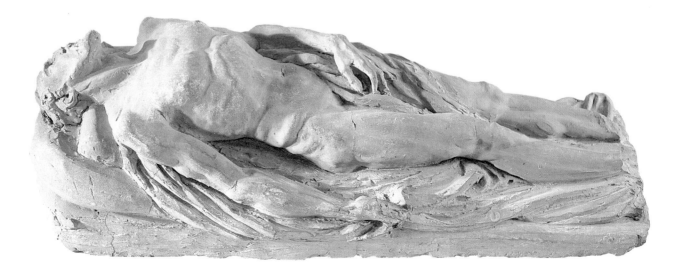

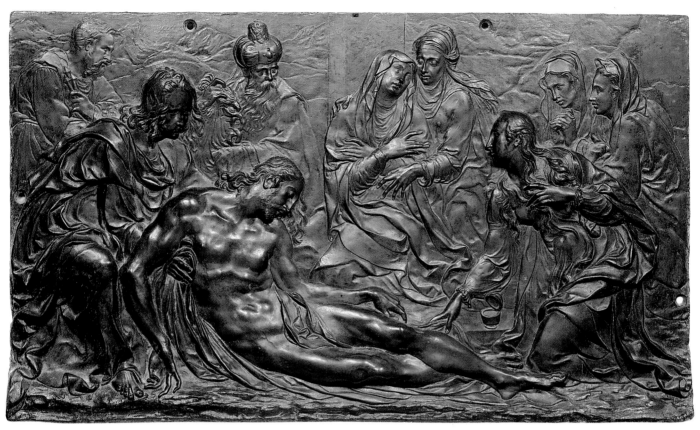

Germain Pilon, *Descent from the Cross.* Bronze bas-relief.
1580–1585. 48 × 81 cm. Musée du Louvre, Paris.

Left and below: Germain Pilon, *The Resurrection*.
Details: the soldiers sleeping.
Marble. 1583–1585. 64.5 × 146 and 61 × 163 cm.
Musée du Louvre, Paris.

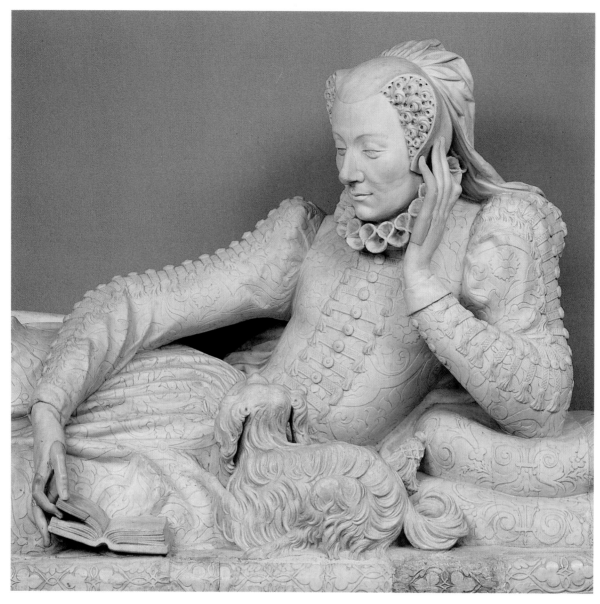

Germain Pilon. Tomb of Valentine Balbiani (detail). Marble. 1574.
Musée du Louvre, Paris.

an elbow, with one hand supporting her head, a book in the other hand, a lapdog beside her. The garments were handled with extreme finesse and the whole composition assumes an intense and startling air for a funerary subject. There were precedents for recumbent figures propped on an elbow (for example, the tomb of Guillaume du Bellay in Le Mans, executed in 1557 by Bontemps), but Pilon's work is of a rare

refinement that is further underscored on the sarcophagus by a bas-relief effigy of the deceased with rotting flesh and wispy hair. This represents a return to the harsh motif of the previous century, though handled with an extremely agile chisel. The same fluidity can be seen in a bronze relief of the same provenance, a Descent from the Cross (circa 1580, Musée du Louvre) perhaps a shade too elegant for the subject matter.

THE VALOIS CHAPEL

The Valois Chapel, intended for the north flank of the basilica of Saint-Denis, was one of the most dazzling projects of the day. Dynastic chapels, as an updated version of the mausoleum, interested all royal families during the Renaissance, from Philip II of Spain (the Escorial) to the Medicis (the chapel at San Lorenzo in Florence). As regards the Valois family, the

Germain Pilon, *Virgin of Pity.* c. 1585. Terra cotta.
Height: 178 cm. Musée du Louvre, Paris.

tomb of Henri II and Catherine de' Medici, begun in 1561, designed by Primaticcio to house sculpture by Pilon, was meant to have been an open *tempietto*, more elegant than Philibert de l'Orme's triumphal arch for Francis I. The tomb was to have been set in the center of an impressive circular chapel planned by Primaticcio after a design which in fact went back to Leonardo da Vinci. Responsibility for the actual construction passed to Jean Bullant and then to Baptiste du Cerceau, and the chapel was never completed; it was demolished under Louis XIV when François Mansart devised a plan for an enormous Bourbon chapel to be aligned with the basilica (although never built, this chapel inspired the design of the royal chapel at the Hôtel des Invalides, Paris).

Pilon's strongest work would probably have been the ensemble destined for the uncompleted rotunda at Saint-Denis, on which he worked sometime around 1583–1585. A marble resurrected Christ, hand outstretched in a gesture of benediction (acquired by the Musée du Louvre in 1933), would have conspicuously occupied the back of the main chapel. A side chapel would have featured a Virgin, wrapped in deep folds of drapery, conveying a striking image of sorrow (circa 1585, maquette at

Germain Pilon. Medallion of Chancellor
René de Birague. 1577. Bronze.
Diameter: 16.4 cm. Cabinet des Médailles,
Bibliothèque Nationale, Paris.

Bas-reliefs displaying the venerable master's remarkable sensitivity and finesse have also been found in Saint-Étienne-du-Mont and in a number of now-demolished Paris churches (circa 1588, Musée du Louvre). Playing on all the registers of his art, Pilon also sculpted royal busts on small pedestals (Musée du Louvre). As controller general of the mint in 1572, he produced chased and gilded bronze medallions that constituted a metallic version of the chalk drawings then in vogue, a remarkable example of which is the incisive medallion showing a bust of René de Birague (1577, Bibliothèque Nationale).

The active participation of a figure as important as the sculptor Pilon reveals the value attached to commemorative medals not only by rulers but by nearly all social figures, including "pedants" (as poets were called). There were few celebrities who did not have their effigy thus recorded, from Catherine de' Medici to members of the Guise family and Jeanne d'Albret, Queen

Germain Pilon. Medal of the Order of the
Holy Ghost. 1579. Cabinet des Médailles,
Bibliothèque Nationale, Paris.

the Louvre). These statues, along with the royal tombs, would have undoubtedly constituted a major affirmation of the Catholic tradition with an intensity alien to the serenity of the High Renaissance.

of Navarre (mother of Henri IV). The medal of the Order of the Holy Ghost, (cast in 1579, Bibliothèque Nationale) showed King Henri III enthroned below the motto *In Te Vere Christus* (an anagram for

Barthélemy Prieur, *La Paix, la Justice et l'Abondance*. Figures provenant du monument du cœur d'Anne de Montmorency.
1571-1573. Bronze. H : 134 cm. Paris, musée du Louvre.

Domenico del Barbiere, *Charity*. Statue originally from the rood
screen of the Church of Saint-Étienne, Troyes (destroyed).
c. 1550–1551. Church of Saint-Pantaléon, Troyes.

Henricus Tertius). Medals were cast for
every purpose—gifts, festivities, portraits.
The invention and installation of mechan-
ical die-stamping equipment at the end of
the palace garden (called the mint at the
mill) met with some resistance, but Éti-
enne Delaune supervised the works after
1552 with great fertility of imagination,
directing numerous engravers whose exact
contributions are far from clear.

Henri II expressed the desire that the
funerary monument holding his heart—
distinct, in accordance with tradition,
from the main tomb—be united with the
one containing the heart of the great *con-
nétable*, Anne de Montmorency. Upon
Montmorency's death in 1567, the requi-
site monument, destined for the Celestine
monastery, was commissioned from Jean
Bullant and executed by Bullant's nephew

Barthélemy Prieur (circa 1540–1611) in a
spirit close to Pilon, yet without Pilon's
charm—three bronze figures perched on
high pedestals were placed around a finely
engraved, twisted column, topped by the
urn (now in the Musée du Louvre, having
escaped the 1792 sack of the monastery).
Inscriptions on black tablets honored the
great commander in chief, yielding a man-
nerist variation on Pilon's masterwork.

Ligier Richier. Tomb of René de Chalon. From the collegiate church of Saint-Maxe, Bar-le-Duc (destroyed). 1547. Church of Saint-Étienne, Bar-le-Duc.

for Saint-Étienne in Troyes, from which there survive figures of Charity and Faith that betray a certain Michelangelesque inflection. Del Barbiere also worked on the tomb of Claude, duke of Guise, in Joinville in 1550–1552—this tomb of black and white marble, jasper, alabaster, and porphyry featured numerous reliefs glorifying the duke. It was dismantled in 1792, but there remain fragments revealing a certain Primaticcio-like quality plus four Virtues and two somewhat Goujon-like caryatids. Del Barbiere's assistant, Jean Picart (called Le Roux), also contributed to the work. As already mentioned, the esteemed master Domenico was commissioned to execute the base of the monument for Henri II's heart; had his own death not prevented it, he would have worked with Primaticcio and Pilon on the tomb at Saint-Denis. His presence in Troyes is probably responsible for a stylistic change in neighboring Burgundy, a province traditionally rich in sculptors. The emergence of a grandiloquent style has been noted (and sometimes deplored), including giant nudes such as Del Barbiere's Christ, manifestly inspired by Italian models, especially those of Michelangelo.

The case of Lorraine sculptor Ligier Richier (1500–1567) is fairly typical. The tomb of the duchess of Lorraine in the Franciscan monastery in Nancy seems to be one of his early works, displaying fine artistry, whereas another tomb at Saint-Étienne in Saint-Mihiel is noteworthy for its dynamic figures (circa 1560). Meanwhile, at the collegiate church of Saint-Maxe in Bar-le-Duc (demolished), the Princes' Chapel included rich decoration (circa 1555), of which vestiges, such as a head of Saint Jerome, bear the stamp of Italianism. The same church housed Richier's tomb for René de Chalon (died 1544), who asked to be depicted "as he would be three years after his death." His wish yielded the astonishing and dynamic "living skeleton" that is far less Gothic than has been claimed (now at the church of Saint-Étienne, Bar-le-Duc). In fact, it is an excellent example of "oratory" sculpture.

The influence of the new models coming out of Fontainebleau and Paris was particularly strong during the third quarter of the sixteenth century. Domenico del Barbi-ere had worked under Primaticcio; when named abbot of Saint-Martin in Troyes, he moved permanently to the Champagne region. There he designed the rood screen

Jean Cousin the Elder, *Eva Prima Pandora*. Before 1550. Oil on panel. 97.5 × 150 cm. Musée du Louvre, Paris.

4. Decorative Qualities

The *Eva Prima Pandora* by Jean Cousin the Elder (circa 1490–circa 1560) is perhaps the best introduction to a new trend in painting that emerged after 1540 along the lines—one might even say the grid—that may be described as Franco-Italian. When Henri II made his ceremonial entry into Paris in 1549, a platform bore the inscription *Lutecia nova Pandora* (Paris New Pandora), establishing a frame of reference—the allegorical figure presented a munificent urn (or box) that she was going to open for the king. This was a visual translation of the allusion to "Pandora's good urn" made by such poets as Joachim

du Bellay. Cousin, however, gave this emblematic image a moral twist aimed at another audience. Two motifs are combined in his painting, a nude with a city in the background (Jan van Scorel depicted Antwerp in a similar fashion, and other examples abound), and a moralized allegory containing *both* of Pandora's urns and a skull (symbol of mortality). In this respect, the painting is typical of modern sophistication; the gray-green landscape is northern, the superb reclining nymph reflects the canon of proportions imported by Primaticcio and his associates. It is difficult to imagine that this painting could predate Cousin's arrival in Paris in 1538. Although the exact details of the commis-

sion are unknown, it should be dated around 1550, just before or just after the king's ceremonial entry.

Jean Cousin's rich technical scope is representative of the new direction in painting. In his depiction of *Charity,* the group is framed by ennobling red drapery, a device which was appearing increasingly, especially in portraits, while the blue garment on Charity's lap plays delightfully on the Flemish-style landscape in the background (circa 1543, Musée Fabre, Montpellier). In good French tradition, Jean Cousin was highly versatile, drawing cartoons for stained-glass windows in his home town of Sens (circa 1535) as well as designing tapestries. A contract dated 1543 documents his role in

Jean Cousin the Elder,
Charity. c. 1543.
Oil on panel. 98 × 77 cm.
Musée Fabre, Montpellier.

Below: Jean Cousin the Elder,
Livre de perspective: perspective
drawing of a landscape with
architectural elements.
Jean Le Royer, Paris, 1560.
Bibliothèque Nationale, Paris
(Rés. g.v. 246, fol. Mij.).

designing a cycle of tapestries on the life of
a local saint, Mammès, for the cathedral in
Langres (three segments have survived).
The borders include splendid strapwork
that presupposes direct contact with the
work of Rosso at Fontainebleau, while
strong architectural elements provide a
striking antique-style anchor for the lively
landscape. Jean Cousin the Elder, in short,
was a solid artisan whose precise impor-
tance remains to be determined; he was also
a theorist, having published a book on per-
spective (1560) as well as a sort of manual
on portraiture (1571), which was complet-
ed by his son, Jean Cousin the Younger,
whose work will be discussed later.

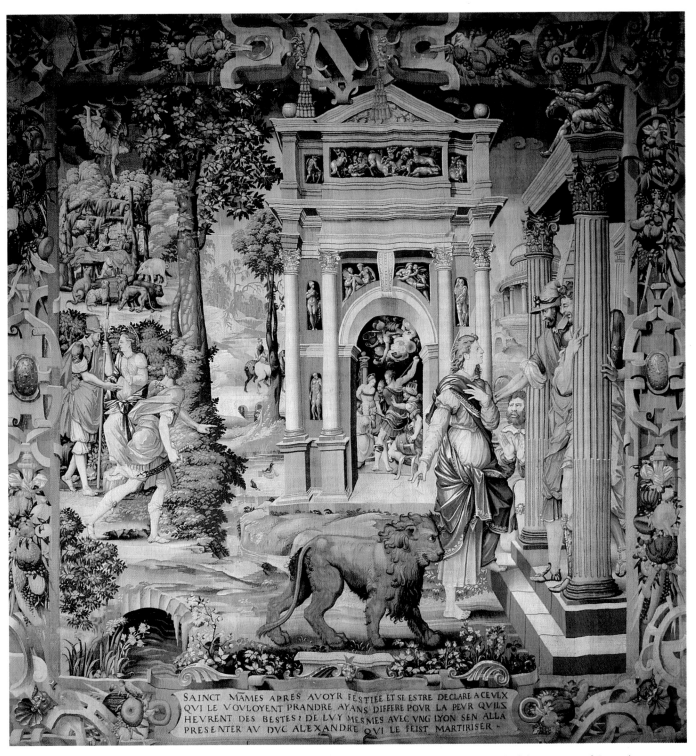

After Jean Cousin the Elder, *The Story of Saint Mammès:* Saint Mammès presents himself to the tribunal of the governor of Cappadocia.
Tapestry. French, 1544. 435 × 475 cm. Musée du Louvre, Paris.

PRIMATICCIO

Francesco Primaticcio (1504–1570) was sent to King Francis I by Giulio Romano in 1531. His stucco work alongside Rosso's painted panels in the king's bedchamber and Galerie François I at Fontainebleau was stunning, for it displayed a linear elegance that Primaticcio would always retain. Named Commissioner of the King's Buildings after Rosso's death, Primaticcio played an eminent role in French art for thirty years, if somewhat diminished under Henri II, who nevertheless made him an abbot. A Gallicized Italian from Emilia, Primaticcio dominated his epoch through his imposing appearance and remarkable skills. But the seductiveness of his style can be only imperfectly assessed today due to the unfortunate gaps in his Fontainebleau œuvre. Nothing remains of the Pavillon des Poêles (1539–1542), of the vestibule to the Porte Dorée (1543–1544), or of the baths (1541–1547). Nor, alas, does anything remain of the Galerie d'Ulysse (1541–1570), the longest and best-orchestrated gallery of the sixteenth century. Loosely modeled on the Vatican loggia, the decoration was drawn by Primaticcio but then executed by Niccolò dell'Abbate, summoned to Fontainebleau in 1552 to assist on the ballroom. This aspect of Primaticcio's work is known through delightful drawings in his own hand or copied in the seventeenth century, especially those by Theodor van Thulden, which provide a somewhat less vague idea of these decorative ensembles.[17]

The paintings ascribed to Primaticcio—the *Danaë* in the central panel of the Galerie François I (p. 165), *Helen* (or *Andromache*) *Swooning* (Rhode Island School of Design, Providence), and *Ulysses and Penelope* (Museum of Art, Toledo)—reveal the ease and fluidity of a style that employs flaxen highlights and seeks elegance above all. These delicate accents can also be noted in variations by Niccolò dell'Abbate. The portrait of Dinteville ascribed to Primaticcio is stronger and more ornate, as the genre required (circa 1545, private collection).

Primaticcio, *Diana Bathing*. Study for the decoration of the Appartement des Bains at Fontainebleau. 1541–1547. Pen, brown ink, brown wash, and white highlights on beige paper. 21.5 × 34.5 cm. Département des Arts graphiques, Musée du Louvre, Paris.

Primaticcio, *Olympia*. Study for the decoration of the Galerie d'Ulysse at Fontainebleau. Pen, brown ink, brown wash, white highlights, and chalk on beige paper. 38.2 × 33.7 cm. Département des Arts graphiques, Musée du Louvre, Paris.

Primaticcio, *Ulysses and Penelope*. Oil on canvas. 114 × 124 cm. The Toledo Museum of Art.

It is important to appreciate the handsome appearance of his compositions, a certain Italian elegance in the refined, elongated feminine figures, thanks to a draftsmanship that could be compared to Perino del Vaga, complemented by a measured use of ornamentation. For the ceiling of the Galerie d'Ulysse Primaticcio mainly developed lively networks of grotesques stemming from the Roman school. This scheme produced a sense of wonder that made a lasting impact. A broad and diffuse movement grew up around Primaticcio, characterized by a search for gracefulness and a crystallization of a specifically French taste, similar to the

Niccolò dell'Abbate, *Landscape with Wheat Threshers.* Oil on canvas.
85 × 112 cm. c. 1560–1565. Musée national du château, Fontainebleau.

Right: Niccolò dell'Abbate, *The Rape of Persephone.* Oil on canvas.
196 × 215 cm. c. 1558. Musée du Louvre, Paris.

one that coalesced around Goujon's sculpture. A substantial measure of Italian graphic sensuality and subtle tension was required for this crucial phenomenon to occur. As was customary, given the express wishes of a royal patron, the artist developed his œuvre in the desired direction.

Primaticcio worked with numerous assistants, but the most remarkable and best known was Niccolò dell'Abbate (circa 1509–1571). Dell'Abbate executed and occasionally augmented his master's designs, as in the ballroom. He also painted frescoes (the chapel in Fleury-en-Bière), and his landscapes display familiarity with Dosso Dossi and Correggio—delightful compositions with high horizons and distant cities that feature lively foliage and mythological nudes, as seen in his admirably orchestrated *Rape of Persephone* (circa 1558, Musée du Louvre) and *Eurydice and Aristaeus* (circa 1560, National Gallery, London). His purely rustic scenes—like

Landscape with Wheat Threshers (circa 1560-1565, Fontainebleau)—perhaps also betray the hand of his son, Giulio Camillo.

Finally, it is worth mentioning a delightful painter conventionally known as the Master of Flora, after a fresh and graceful painting of a female nude amid flowers and putti. The *Birth of Cupid* (circa 1560, Metropolitan Museum of Art, New York) shows a fair-skinned, long-limbed Venus reclining elegantly among the Graces on a magnificent gilded bed covered with a blue-hued spread strewn with flowers. Perhaps the master was Ruggiero de Ruggieri, a colleague of the two preceding painters, also from Emilia.

Luca Penni (1500/1504–1556) also merits discussion in this context. If, as has been suggested, he painted the nude *Diana the Huntress* (circa 1550–1560, Musée du Louvre, p. 174), he succeeded in producing a remarkable model. But the attribution is not certain and Penni's case reveals the

Master of Flora, *The Birth of Cupid*. Oil on panel. 108 × 130.5 cm. c. 1560.
The Metropolitan Museum of Art, New York. Rogers Fund.

multifaceted activities of these artists—an inventory taken after his death suggests that he was less a painter than a supplier of models to engravers, costumiers, tapestry weavers, and armorers. He played a fairly considerable role in Fontainebleau in the sphere of engraving, since Léon Davent, Jean Mignon, and Étienne Delaune worked from Penni's drawings. He quarreled with Primaticcio around 1547–1548 and went to Paris, where he established himself on rue de la Cerisaie, in a neighborhood that from

1543 onward harbored a small colony of artisans and sculptors when the former Étampes property was divided into lots.[18] In conjunction with René Boyvin, Penni actively participated around 1550 in the dissemination of Fontainebleau-school prints. But he was henceforth based in Paris, and his success was on a European scale.

Other painters active at this time include Rosso, who executed a luminous *Pietà* for the château at Écouen, notable for its almost gilded quality (prior to 1540), and

Charles Dorigny, a little-known French artist, who painted a *Descent from the Cross* (1548, Sainte-Marguerite, Paris) in a completely different spirit characterized by a dense cluster of figures rendered in steely hues. Dorigny collaborated with Cousin the Elder on the decorations for Henri II's entry into Paris. There are references to dozens of other works that have either disappeared or been heavily repainted, such as the unusual cycle on the Trojan war (circa 1549) in the gallery at the château d'Oiron in the

Above: Rosso, *Pietà*.
Oil on canvas. 127 × 163 cm.
c. 1530–1535.
Musée du Louvre, Paris.

Left: Charles Dorigny,
Descent from the Cross. Oil on panel.
208 × 217 cm. 1548.
Church of Sainte-Marguerite, Paris.

Above: Noël Jallier,
The Trojan War. Mural painting.
270 × 570 cm. 1545–1549.
Chateau d'Oiron (Deux-Sèvres),
upper gallery.

Left and right: Ancy-le-Franc
(Yonne). The Chambre des Arts,
general view and detail.
c. 1565–1570.

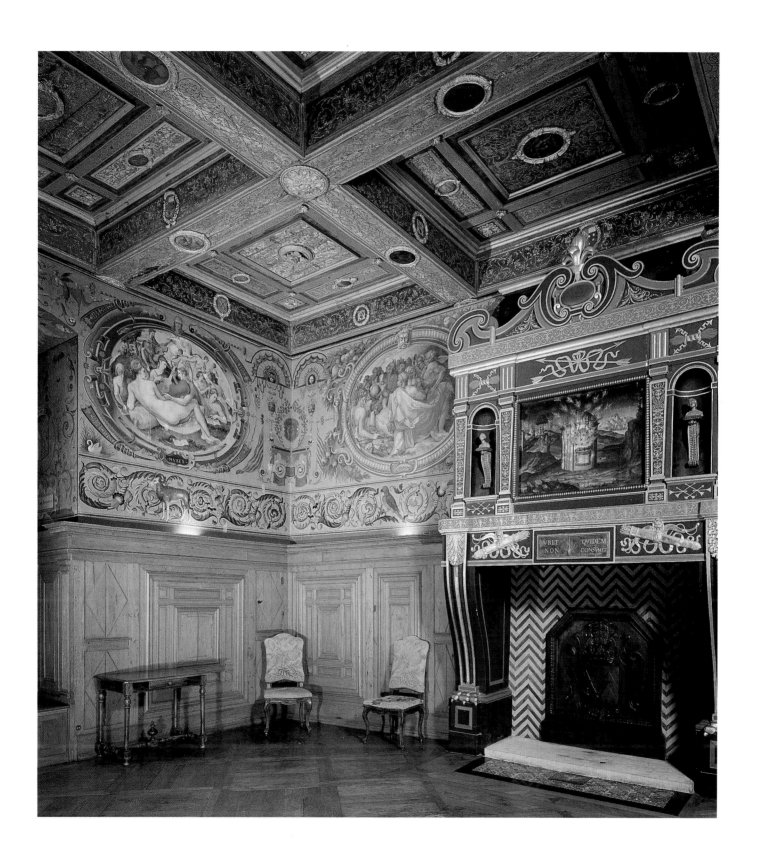

Ancy-le-Franc (Yonne). The Chambre des Arts,
details: *the Liberal Arts*. c. 1565–1570.

François Clouet, *Lady in her Bath*. Oil on panel. 92 × 81.5 cm. c. 1570.
The National Gallery of Art, Washington. Kress Collection.

Poitou region, by another almost-unknown French artist, Noël Jallier, in a depiction of battle scenes that draws on every possible source.[19] At Ancy-le-Franc a decorative scheme illustrating the Liberal Arts contains elements clearly derived from Primaticcio, and applied in an ornamental approach that ultimately stems from Fontainebleau.

French artistic circles had become dynamic once again; the conjunction of Italian and Flemish forms yielded some of the greatest developments of the day. The most striking and famous example is that of the *Lady in her Bath* by François Clouet (circa 1570, National Gallery of Art, Washington). The depiction of a female nude from the waist up already existed in Italian art (Giulio Romano's *Woman at her Bath*, circa 1520–1525, Pushkin Museum, Moscow), and Titian had painted glimpses of a distant interior with a busy maidservant. But all of

School of Fontainebleau, *Lady at her Toilet.* Oil on canvas. 105 × 76 cm. 1585–1595.
Musée des Beaux-Arts, Dijon.

that was composed here under stately, half-drawn drapery, with the unexplained presence of a wet-nurse and a little boy behind the woman in her tub. These are probably allusions to royal bastards, the woman holding in her left hand the traditional carnation of affection. The still life of fruit is notable for its very Flemish precision. But the exact meaning of the composition is unclear, apart from its cool, serious glorification of a beauty glimpsed during a moment of intimacy—very probably Diane de Poitiers. She was already forty years old by mid-century, but Brantôme, like other witnesses, stressed the imperishable youthfulness of her figure and complexion.

Other interior scenes featuring a half-length portrait of a nude woman at her toilet followed, usually including a mirror with gilded frame. In at least three of them, the woman, always with an earnest expression, delicately takes a ring from a jewel box, a

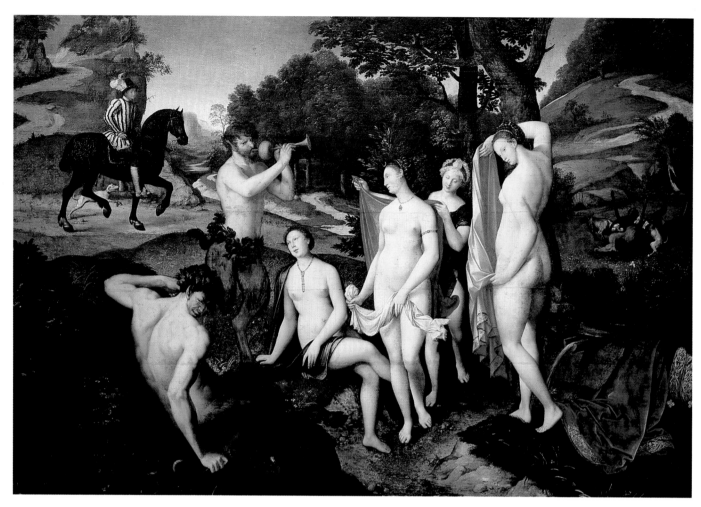

François Clouet, *Diana Bathing*. Oil on panel. 133 × 192 cm. c. 1550–1560. Musée des Beaux-Arts, Rouen.

symbol dispersing all mystery except for the name and date. This sensual subject inspired numerous imitations throughout the remainder of the century (although during the following century, it was thought wise to dispose of them, as Anne of Austria proceeded to do). Thirty years after Clouet and his emulators, such portraits were still being painted as tokens of love. They always conveyed a certain boldness, as in the remarkable couple of Gabrielle d'Estrées in the bathtub with the duchesse de Villars, framed by ceremonial drapery (circa 1594), even though there was nothing scandalous about sharing a bath. The notorious fair-haired lady earnestly displays the ring she holds in her left hand, while her companion verifies the signs of pregnancy and a servant bends over her needlework in the background, in an excellent demonstration of the original clarity of the visual message.

The flirtatious models developed during the reign of Henri II were elaborated on for another fifty years, employing new faces in order to update the imagery. This can be seen in the many paintings of *Diana Bathing* that feature a rider (often Charles IX, or, later, Henri IV) glimpsing—through conveniently sparse foliage—the nude goddess and her fair nymphs at the fountain.

INTERIOR DECORATION

Interior decoration took on a new character, as can be gleaned from visual documents (there being very few surviving interiors apart from Écouen and Fontainebleau). Floors were almost always tiled in an alternating pattern, with figurative emblems. One example at Écouen, by Masséot Abaquesne, has been partly reconstructed. Ceilings featured either Italian-style coffers or a framework of beams with painted panels separating the tie-beams. Walls were covered with patterned tapestries or, in smaller retiring rooms, with wood wainscoting that rose

School of Fontainebleau, *Gabrielle d'Estrées and One of Her Sisters.* Panel. 96 × 125 cm. 1594. Musée du Louvre, Paris.

up to seven feet (including carved panel or wood inlay), topped by paintings. Walls of this type can still be seen in the châteaux at Pibrac and Beauregard, as well as in the chapel at La Bastie d'Urfé. The most pronounced feature was usually the fireplace. Of large dimensions due to its function, its masonry formed part of the wall. It included a monumental hood (specific to France) the evolution of which provides a remarkable indication of increasingly eloquent decorative approaches. The mantel

sat on jambs in the form of columns or caryatids, while the hood itself might be carved with a coat of arms and sport an enormous composition of stucco and painted motifs. The fireplace executed by Primaticcio for Francis I's bedroom at Fontainebleau (circa 1532, now destroyed) served as a basic model.

Printed anthologies of ornamentation made it possible to disseminate widely examples of grandly heroic or symbolic interiors (such as stags or tro-

phies), usually in stucco, although sometimes painted. Examples of fireplaces being completely covered in painted decoration, as at Écouen in imitation of Fontainebleau, are relatively rare. What often did occur was the extension of the fireplace motif to the entire partition wall and lateral passages, which yielded an unbroken decorative pattern. This was the case at Clairvaux and Fontevrault, and examples still exist in southwestern France at Lanquais and Cadillac (Gironde).

Masséot Abasquesne, tiles from the Château d'Écouen: *The Story of Noah*.
High-temperature colors on earthenware. 1557. Musée national de la Renaissance, Écouen.

Lanquais (Dordogne).
Fireplace in the main hall.
c. 1570.

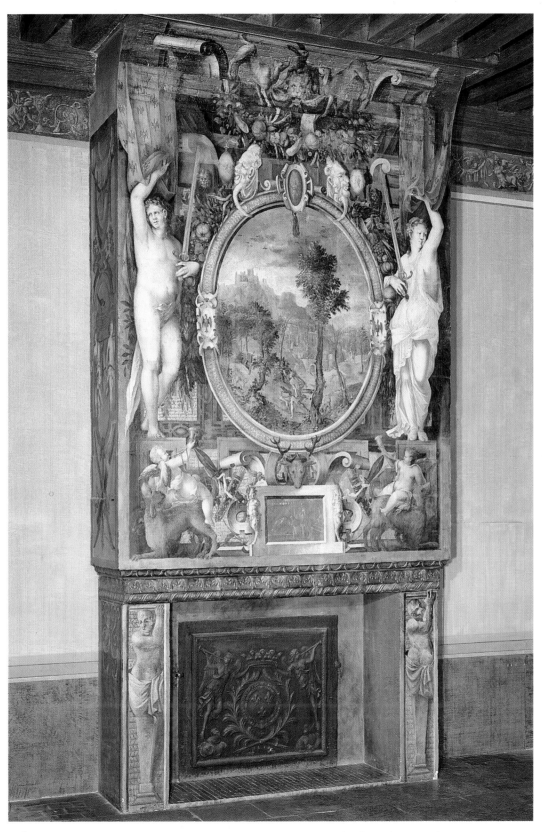

Écouen (Val-d'Oise). Fireplace in the Connétable de Montmorency's chamber: *The Hunt of Esau*. 1555–1560.

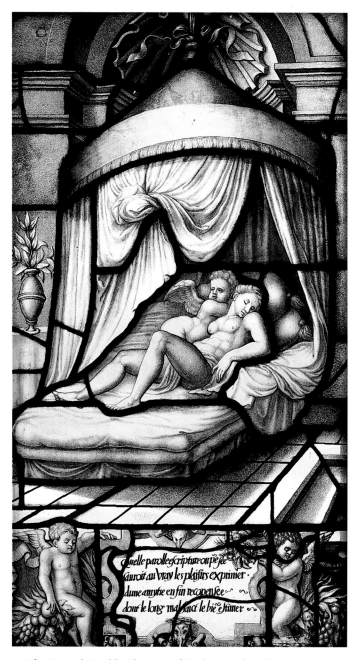

After Bernado Daddi, *The Story of Psyche*: Cupid and Psyche asleep.
Stained-glass window from the Château d'Écouen.
1542–1544. Musée Condé, Chantilly.

Distinguished interiors also included stained glass. Engravings were still a source of inspiration, but now there were original responses to Roman and Rhenish models. The forty-four panels depicting the story of Psyche, in pale glass adorned with light arabesques for the gallery in Écouen (1542) were based on a set of engravings by Bernardo Daddi. Daddi himself was strongly influenced by Marcantonio Raimondi's "portable Raphael." A little later, the stained-glass windows in the chapel at Vincennes were based on Jean de Tournes's vignettes for the Old Testament (1554, Lyon). Thanks to engraver Antonio Fantuzzi and his French competitors, the Fontainebleau artists began to disseminate new models on a wide scale, leading to compositions with understated color, adorned with emblematic medallions framed by grotesques, as at the chapel of La Bastie d'Urfé (circa 1550).

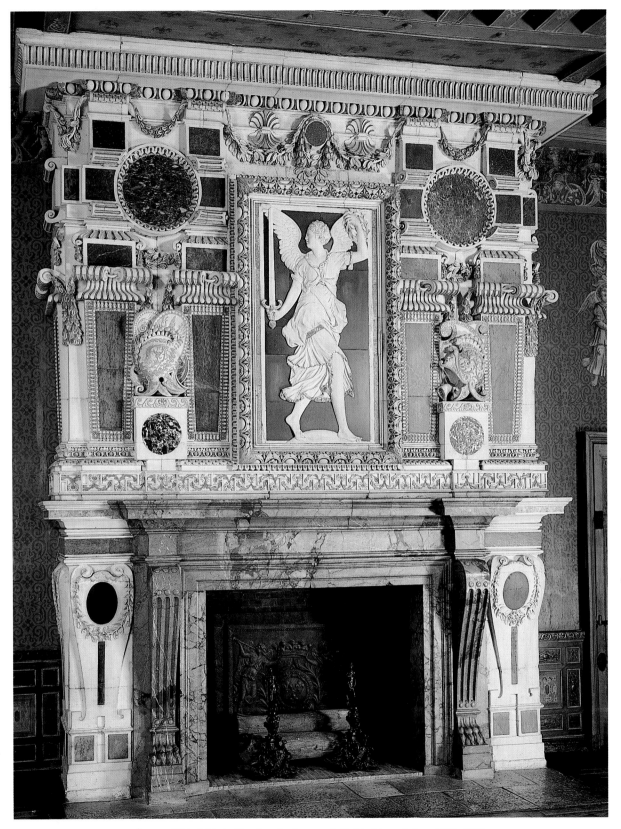

Écouen (Val-d'Oise). Fireplace in the great hall. Marble and slate. 1555–1560.

Jacques Androuet du Cerceau. Design for a bed. Engraving. 1550. Bibliothèque Nationale, Paris (Est. Ed. 2e).

Jacques Androuet du Cerceau. Design for a table. Engraving. 1550. Bibliothèque Nationale, Paris (Est. Ed. 2e).

Étienne Delaune. Design for a mirror. Engraving. 1561–1572. Bibliothèque Nationale, Paris (Est. Ed. 4a).

FURNISHINGS

The liveliness and vitality of the period find some of their best expression in domestic furnishings. Almost all surviving examples have been subsequently altered or recast, but an extraordinary set of extant engravings demonstrates the attention given to these items of decoration and lifestyle: sculpted wooden beds with whimsical columns as bedposts; tables with carved trestles in the form of distaffs or female sphinxes; dressers designed in two rigorously architectural tiers with pediments and pilasters framing a swarm of medallions and panels. Superb tables hewn from walnut, with enormous scrolls and masques for bases, testify to the lively penchant for burlesque copiousness. There was a marked taste for double forms produced by placing a figurative motif above a gaine (or lower shaft); this allowed for two registers of ornamentation—a virile bust or sensuous feminine torso topped a gaine of foliage or guilloche-work, with feet perhaps humorously poking out below the lacy lower edge.

Visitors were struck by such luxurious interiors—the velvet and satin drapes, the damasked door curtains and abundant tapestries (inventories are enlightening in this regard). Du Cerceau's drawings of furniture were complemented by Étienne Delaune's model for a mirror; by Pierre Woëriot's finery, rings, and sword hilts; by vases and chandeliers; and by the rage for enamel work. All that had been done before suddenly seemed almost timid. This reinvigoration, however, did not occur in 1500, as has often been asserted, but around 1540. That was when the somewhat heavy dressers and sideboards went out of fashion and the so-called Île-de-France style first appeared, characterized by two-tiered cabinets and triptych cupboards that resembled small temples with carefully studied proportions and well-orchestrated architectural elements (sometimes including Goujon-inspired silhouettes or, increasingly often, fashionably ambiguous, paradoxical, and comic forms such as figures poking out of gaines or drapery, caryatids, or scrolls with putti). In Burgundy, this

Two-tiered cupboard. Walnut. French, second half of the sixteenth century.
Musée national de la Renaissance, Écouen.

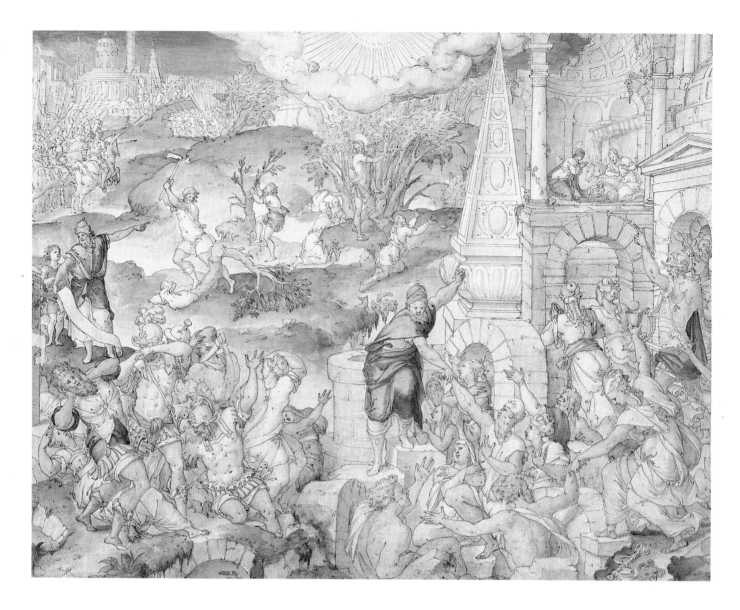

Above: Étienne Delaune,
Allegory of Religion. Watercolor.
c. 1540–1545. 33.5 × 43.5 cm.
Département des Arts graphiques,
Musée du Louvre, Paris.

Left: Étienne Delaune. Design for a platter.
Pen, brown ink, and brown wash on vellum.
Between 1561 and 1572. Diameter: 27.2 cm.
Département des Arts graphiques,
Musée du Louvre, Paris.

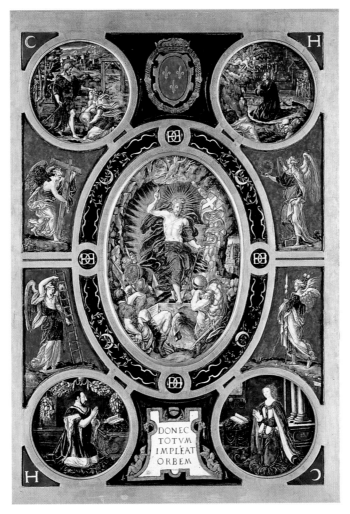

Léonard Limosin, *The Resurrection*. Altar decoration originally
at the Sainte-Chapelle, Paris. Enameled copper plate.
107 × 75 cm. 1553. Musée du Louvre, Paris.

dense, teeming repertoire came to dominate interior decoration and furnishings once Hugues Sambin published his anthology of ornamental designs in 1572.

Enamels were also more fashionable than ever, as were glazed ceramics. One of Léonard Limosin's original contributions was to have promoted—if not invented—the fashion for portraits in enamel. More than one hundred of his portraits survive, and that of Anne de Montmorency (1556, Musée du Louvre) with its Fontainebleau-style borders is typical of the simultaneously precious and lively taste of the French Renaissance. These colored enamel plaques could be found everywhere, for Limosin's workshop produced at least a thousand vases, inkwells, mirrors, dishes, and casks decorated with mythological figures framed by strapwork and grotesques. Pierre Reymond and Pierre Courteys, who remained in Limoges but were equally prolific, tended to favor the grisaille technique but also produced veritable decorative panels such as the plaque with allegories and planets that Courteys executed in 1559 for the Château de Madrid. The costliness of these items explains the 1547 commissioning of twelve plaques of the Apostles, based on drawings by Primaticcio, for the château at Anet (now at the Musée des Beaux-Arts, Chartres). When a new screen of lacy woodwork was installed in the Sainte-Chapelle in Paris, it included two retables of enameled copper for the side chapels. The two pieces, dated 1553, employed the traditional motifs of the Crucifixion and the Resurrection based on drawings by Niccolò dell'Abbate (École des Beaux-Arts, Paris).

One of the most active producers of models of all kinds was Étienne Delaune (1518–1583), a highly refined engraver and decorator whose designs were used by all goldsmiths and armorers. He also drew

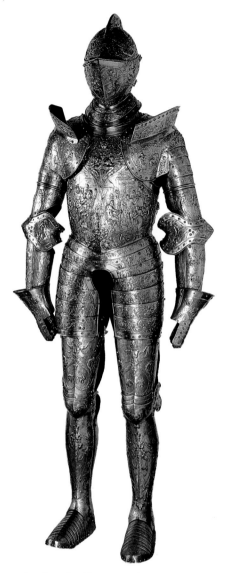

Attributed to Étienne Delaune. Armor
belonging to Henri II. Iron. Before 1559.
Height: 184 cm. Musée du Louvre, Paris.

cartoons for tapestries, and is even known
to have painted a watercolor landscape
exhibiting lively draftsmanship in limpid
colors (Musée du Louvre). Delaune's book
illustrations were always carefully and
attractively executed. His designs for table-
ware—ewers, dishes, and platters with
patterns of medallions—testify to an extra-
ordinary ability to combine figures and
abstract shapes, with a surer sense of taste
than Cellini. The shield and armor of dama-
scened iron made for Henri II, entirely
covered with decorative patterning, have
justifiably been linked to the inventive
Delaune. In 1572, the Protestant Delaune
fled France, and the twilight of his career in
Augsburg (Germany) helped to disseminate
Fontainebleau-style models.

An atypical case arises with goldsmith
and engraver Jean Duvet (circa 1485–circa
1570), who worked at the Dijon mint, then
went to Langres, and finally took refuge in
Geneva from 1540 to 1556. His twenty-five
line engravings of the *Apocalypse* (circa
1550, published in 1561) are extremely
dense yet striking—the frontispiece to the
collection shows him working amid allegori-
cal figures, symbols, and inscriptions. His
Unicorn series, more difficult to date, is no
less striking. Drapery and foliage are tightly
packed with detail, and the exaggerated den-
sity of the composition indicates a profound
taste for the enigmatic, or at least the
emblematic—he was obviously familiar with
Dürer and Lucas van Leyden. Roughly sixty
engravings by Duvet have survived.[20]

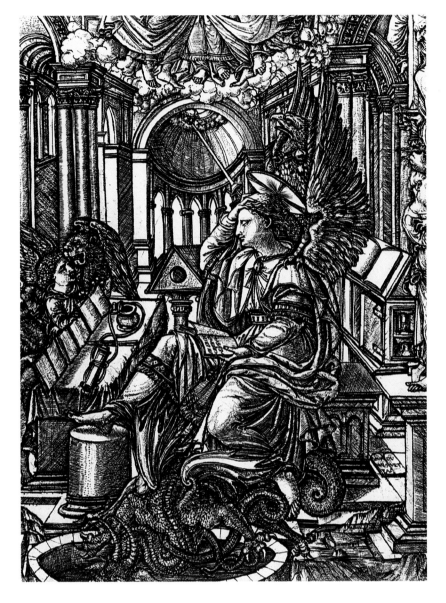

Jean Duvet, *Apocalypse.*
Engraving. 1561.
Bibliothèque Nationale,
Paris (Rés. A.1587).

Below: Jean Duvet,
The Unicorn Led in Triumph.
Engraving. 1540–1550.
Bibliothèque Nationale,
Paris (Est. Ed. 1b Rés. 65).

IV A Time of Crisis 1570–1620

1. The Valois Court and Civil Strife

When King Philip IV the Fair died in 1314, he was followed by his three sons—Louis X, Charles IV, and Philip V—all of whom died in quick succession without leaving a male heir. The throne passed to a cousin, Philip VI of Valois, lauching the Hundred Years' War. A similar crisis of succession arose after the accidental death of Henri II in the ill-fated tournament at the Hôtel des Tournelles. His three sons also ascended to the throne one after another, none producing an heir: Francis II, reigned 1559–1560; Charles IX, 1560–1574; and Henri III, 1574–1589. Not only was the line dying out, but the religious crisis took a nasty turn during Charles IX's reign, when the Huguenot revolt and the iconoclastic excesses of 1562, were followed—despite attempts at pacification—by the bloody Saint Bartholomew's Day Massacre in August 1572. Yet nothing was resolved, and the killing continued. Following Henri III's assasination in 1589, the full recognition of his cousin and designated successor, Henri of Navarre, required nearly ten years of struggle. By the time Henri IV renounced the Protestant faith in 1593 and issued the Edict of Nantes in 1598, bringing a measure of civil peace, the country had been torn by religious war for more than thirty-five years.

Torquato Tasso, Italian author of the poem *Gerusalemme Liberata* (Jerusalem Liberated), which remained popular and influential for nearly a century, was charged with a mission by the court of Ferrara and went to Paris in 1570–1571. His description of France was unfortunately the product of a wary, narrow-minded attitude—it is not

Franco-Flemish school, *Ball at the Court of Henri III* (detail).
Oil on canvas. c. 1582. Musée du Louvre, Paris.

even certain that he met poets like Ronsard or his future translator, Vigenère. Nevertheless, Tasso's account stressed the depth of popular piety in France, as evidenced by the importance of churches and the people's devotion to the monarchy. It would seem that the religious and political upheavals—extremely intense just prior to the events of Saint Bartholomew's Day—remained secondary in his eyes. For Tasso, churches were

large and numerous, although inferior to those in Italy in terms of architecture, paintings, and statuary. This suggests that he was not particularly struck by the Italianization of French art. Furthermore, he found the monarchy powerful and the court brilliant, but the provincial nobility still appeared brutal and uncouth, committing the error of leaving the sphere of learning and technology to "plebeians." Judging solely from

Tasso's harsh comments, nothing seemed to have changed since similar criticism was leveled earlier in the century by other Italian observers. But Tasso tended to notice only what confirmed the old accusation of French ignorance and flippancy. True enough, he arrived in the country at a time when the general destabilization brought French weaknesses to the fore. In an easily explained contradiction, the royal court under Catherine de' Medici and later under Henri III maintained an opulent lifestyle at all costs. Dress had always been a major preoccupation, but now luxurious display was pushed to an extreme. Despite the general poverty of the day, such lavishness constituted a prodigious spur to the ornamental arts. On the Epiphany in 1586 (the feast of the Three Kings), Henri IV appeared dressed in violet and silver, and awarded a matching silk gown to the "queen" (she who found a bean hidden in the traditional cake).

Royal portraits during this period were first and foremost portraits of costume, a development that can been seen in the works of Jean Clouet, his son François, and a range of tapestries and stained glass. The male wardrobe featured puffed breeches, temporarily replaced under Henri III by tight, colorful, clinging breeches. At the same time, around 1580, ruffed collars appeared, transforming both the male and female silhouette.

All these refinements were highlighted by court festivities that had become a sort of rule of government under Catherine, along with spectacular demonstrations of artistic pretensions. A classic example from 1581 underscores their importance. The marriage of Henri III's friend, the duc de Joyeuse, to the queen's half-sister, Marguerite de Vaudémont, took place on 24 September and was followed by several days of celebrations. Besides the usual pageants, equestrian games, and fireworks there was something more: *The Court Ballet of the Queen* presented on 15 October by Balthazar de Beaujoyeulx. This first of the court ballets had a plot inspired by classical mythology, hinged

Jacques Patin, *The Court Ballet of the Queen:* the theater.
Court ballet by Balthazar de Beaujoyeulx. Engraving. 1582.
Bibliothèque Nationale, Paris (Est. Pd. 68).

Jacques Patin, *The Court Ballet of the Queen:* the mermaids.
Court ballet by Balthazar de Beaujoyeulx. Engraving. 1582.
Bibliothèque Nationale, Paris (Est. Pd. 68).

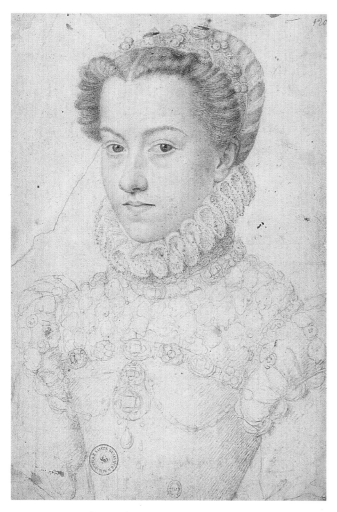

François Clouet, *Elizabeth of Austria*. Pencil drawing. 1571.
Bibliothèque Nationale, Paris (Est. Na 22 rés.).

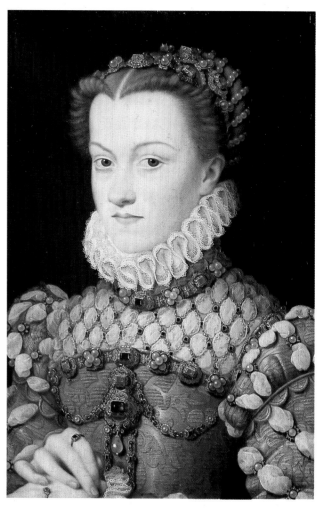

François Clouet, *Elizabeth of Austria*. Oil on panel.
36 × 26.2 cm. c. 1571. Musée du Louvre, Paris.

on the struggle of the luminous powers of Harmony and Reason against the madness of Passion and Violence. Particular emphasis was placed on the story of Circe, whom Minerva would subjugate, for the greater glory of Henri. The moral message was conveyed through costumes and spectacle—mermaids and wood nymphs burst forth among the glitter of finery and sets, a dragon-drawn chariot crossed the stage, and unfamiliar music seduced the audience. The composer Beaujoyeulx was Italian; opera was being invented. The monarchy later carefully cultivated this medium, making it a major musical form during the seventeenth century, for it successfully combined propaganda with entertainment.

Such festivities were recorded in several paintings, such as the *Ball of the duc de Joyeuse* (1582, Louvre) commemorating the event which took place in the presence of the court in the upper hall of the palace. This formal, minor work was probably painted by a Flemish artist. Similarly stiff in style is a large painting of a ball showing female dancers wearing extraordinary bodices sleeves studded with gems and braiding (*Ball at the Court of Henri III,* Louvre). These cold, stilted scenes betray not a hint of a smile.

It is debatable whether the many court portraits painted in the manner of Corneille de Lyon (1500/1510–circa 1574), a Dutch artist who went to Lyon and was naturalized in 1547, should be considered as belonging to the French school. Corneille's speciality was small-scale, mirror-sized portraits of courtiers. These images are charming in their sharp naturalism. Sometimes painted portraits were based on chalk drawings, which were executed with increasing frequency by François Clouet and others. One example is the portrait of Catherine de' Medici in a small, white, turn-down collar of great simplicity—the dignified widow

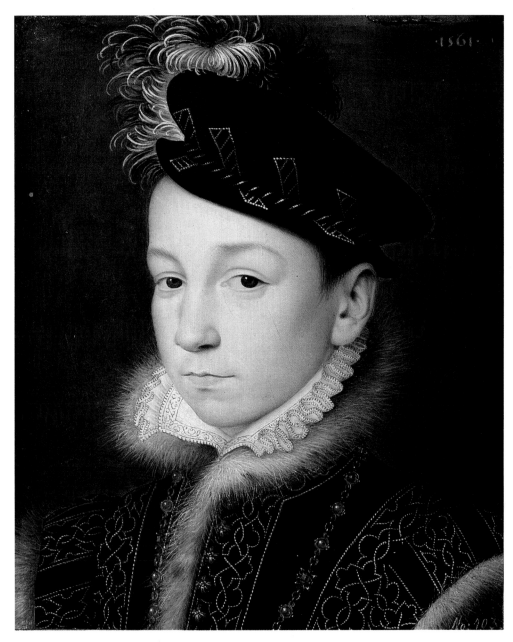

François Clouet, *Charles IX*. Oil on panel. 292 × 113 cm. 1561.
Kunsthistorisches Museum, Vienna.

remained aloof from sartorial follies (circa 1580, Louvre). The Queen Mother, moreover, collected entire portfolios of these remarkable chalk drawings. In principle, authorization was required to execute or acquire a royal portrait. Jean Rabel, François Quesnel, and Pierre Dumoustier were the principal portraitists commissioned, but attributions are difficult to determine since there was so much repetition. Thanks to the Valois interest in physiognomy, few courts seem as physically present today as the French court, with its intrigues and suspicions. An incipient smile and lively eyes convey the charm of Francis II's young wife Mary Stuart, in white mourning dress for the death of her father-in-law, Henri II. Jean Decourt's *Henri III,* circa 1574, is strangely devoid of expression, as is François Clouet's *Marguerite de Valois,* executed around 1572, although her clothing—collar, embroidery, and even each wave of her hair is highly detailed (Bibliothèque Nationale).

The Consequences of Civil War

Attitudes concerning superstition and the religious orders varied greatly between the humanist irony of Erasmus (even when taken as far as Rabelaisian mockery) and the profound indignation of Calvin's followers. Detestation of Catholic traditions led the Huguenots to destroy all the monumental, artistic, and ritual trappings of religion—iconoclasm was their reaction to persecution. Although iconoclasm in France was not as radical as in the Netherlands, on several occasions it took the form of organized campaigns that roused the local populace to indulge in a sacrilegious carnival. The movement's leaders did not approve of such excesses, but in the heat of conflict a Flemish scholar named Marnix de Sainte-Aldegonde went so far as to openly praise such destruction in a 1566 treatise.

Naturally, once the crisis had passed, tradition often reasserted itself. It has been argued that "the reestablishment of feasts and processions in all their accustomed pomp, so soon after the Protestant wave receded, took on the aspect of a manifesto everywhere."[1] But it was impossible to rebuild every ruin or replace all the broken statues. Ultimately, the loss to French art was greater than is usually acknowledged. Not only did the fleeing Huguenots include many great artists, such as Goujon, Bontemps, and Delaune, but major projects like the Valois mausoleum were halted due to insecurity or lack of funds. In general, an artistic hiatus of twenty or thirty years occurred nearly everywhere.

The colossal list of churches ravaged, burned, and ruined in 1562 by Calvinist troops (swelled by pillagers and, apparently, foreign elements) leaves a painful impression. The blame should be placed partly on religious fanaticism and the passion for demolishing the artificial rampart of sacred rituals in order to expose the purity of inner faith. The importance placed on congregational singing in reformed

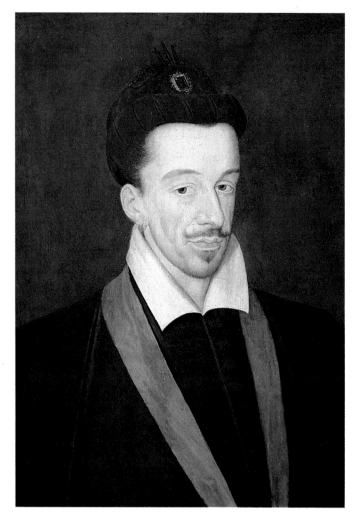

François Quesnel, *Henri III*. c. 1582–1586. Oil on panel. 66 × 52 cm. Musée du Louvre, Paris.

gatherings was significant. Another element should be added: hatred for the established orders, which swiftly included the Catholic monarchy. The thrill associated with "wiping the slate clean" reflects a negative tendency lodged somewhere in the French mentality, where it has loomed larger than elsewhere.

Claude de Sainctes's inventory of "the sack of Catholic churches by Calvinist heretics in the year 1562" provides the basis for a calamitous reckoning that includes Saint-Ouen, Jumièges, Caen, and Bayeux in Normandy; Soissons and the abbey of Longpoint in Burgundy; Saint-Étienne in

Auxerre (which lost bells, choir stalls, stained-glass windows, and statues); La Charité-sur-Loire (ravaged in 1559); and Vézelay, transformed into stables in 1569. In Orléans, the monument to Joan of Arc erected in 1458 was knocked down in 1567. Along the Loire, Notre-Dame-de-Cléry (the site of Louis XI's tomb) and the nave of Germigny-des-Prés were sacked. At Saint-Benoît-sur-Loire, the gold reliquary of Saint Benedict was destroyed. In Tours, the stained-glass in Notre-Dame-la-Riche was gutted. The list goes on and on and includes reliquaries, holy urns, statues. All Christian imagery was spurned. Entire provinces were

François Clouet, *Mary Stuart in White Mourning Dress*. Chalk drawing. c. 1560. Bibliothèque Nationale, Paris (Est. Na 22 rés.).

Jean Decourt, *Henri III*. Pencil drawing. c. 1574. Bibliothèque Nationale, Paris (Est. Na 22 rés.).

"purified." The "destruction of images"—tombs, statues of the Virgin, and so on[2]—intensified as early as 1550 in the Lot region as Calvinism spread throughout the south, where subsequent replacement of the "idols" was out of the question.

Naturally, venerated works and sanctuaries were defended and protected. Yet it is hard not to be surprised at the extent of the destruction seen everywhere that religious strife occurred. Saint-Savin was ravaged in 1562 and 1568; the rotunda and nave at Charroux were damaged; abbeys in the Saintonge region suffered badly. In Périgueux, the tomb of Saint-Front was destroyed in 1577 and three of the domes on the church of Saint-Étienne-de-la-Cité were demolished. At Montpellier and throughout the south, more than sixty churches were targeted, notably the three bell towers of Saint-Pons-de-Thomières; Saint-Gilles-du-Gard was occupied in 1563 and would remain so for a long time. The cathedral in Lyon lost much of its decoration and many of its valuable liturgical treasures.

Thus the Renaissance ended in France with a brutal, occasionally bestial, outburst that had far-reaching consequences. In a reaction typical of the French during certain states of excitement, the mob attacked "things" for the sake of destroying symbols of what it hated. The same highly emotional reaction—though with different motives—might be attributed to the destruction of religious symbols by the Jacobins during the French Revolution.

This dismaying picture explains why, after thirty years of disorder, ruin, and inertia, a long period of recovery and reparation was required. The country stumbled along for another twenty years as old models were revived and aborted projects were more or less completed. The France of 1600 had fallen far behind European culture, the source of which was Rome.

Jean Cousin the Younger, *The Last Judgment*. Oil on canvas.
145 × 142 cm. c. 1585. Musée du Louvre, Paris.

2. Contrasts

Painting: Festivities and Buffoonery

Apart from Fontainebleau's treasure-trove of allegorical and mythological models, painting was essentially found in galleries and already, it seems, decorated small rooms, or "cabinets," as an accompaniment to the architecture. The large religious paintings typical elsewere in late sixteenth-century Europe were rare in France, and there are only scattered references to easel painting. Obviously, civil strife and destruction led to the loss of many works. It is difficult, for instance, to get a clear idea of the activity of Jean Cousin the Younger (1522–circa 1594), though a book of his models has survived, as has a painting of the *The Last Judgment* (Louvre) in an urban setting where ruined buildings retreat into the gray distance and a crowd of tiny figures betrays a typically mannerist penchant for miniaturization.

More original was the role played by Antoine Caron (1520–1594), insofar as his compositions clearly evoke the artificial settings and processions organized for festivities—his painting of *Augustus and the Sibyl* (Louvre), for instance, includes a variety of picturesque altars and temples. Historical deeds, on the other hand, are presented in a purely stylized fashion, and

Antoine Caron, *Augustus and the Sibyl.* Oil on canvas. 125 × 170 cm. c. 1580. Musée du Louvre, Paris.

Following pages: Antoine Caron, *The Massacres under the Triumvirate.* Oil on canvas. 116 × 195 cm. 1566. Musée du Louvre, Paris.

his œuvre illustrates the contrived heroics typical of European mannerism. In addition, Caron was one of the last truly versatile artists whose work is available for study. Except for Charles Lebrun in the days of Louis XIV, no other artist was so active in fulfilling every sort of commission. Caron organized festivities, devised the decor for the duc de Joyeuse's wedding celebrations, provided cartoons for stained-glass windows during his youth in Beauvais, and

painted portraits (now lost). Of his procession-like compositions, there remains the *Triumph of Summer* (private collection) in which the dancing parade is more drawn than painted. As mentioned above, he also prepared the cartoons for the tapestries executed by Lucas de Heere to commemorate the Valois festivities (p. 171).

Reacting to current events, Caron also signed and dated a horrifying and original painting, *The Massacres under the Tri-*

umvirate (1566, Louvre). It is set before the Colosseum (cut away like a gutted palace), and features gray architecture, small figures, light brushwork, and cool tones. The composition is unconvincing, however, and another version, perhaps from 1562, displays better pictorial and compositional control (Musée des Beaux-Arts, Dijon). Caron's originality would have been all the greater if the subject of massacres had not already been treated by

Antoine Caron, *Story of Queen Artemis: The Chariot of the Golden Throne.* Pen, brown and black ink, wash, white highlights over chalk. 40 × 55 cm. Bibliothèque Nationale, Paris (Est. Ad. 105 rés.).

Antoine Caron, *Story of Queen Artemis: The Monument.* Pen, brown and black ink, wash, white highlights over chalk. 40 × 55 cm. Bibliothèque Nationale, Paris (Est. Ad. 105 rés.).

Antoine Caron, *L'Histoire françoyse de nostre temps: The Battle of Cerisole Alba.* Pen, brown and black ink, wash, white highlights over chalk. 40.3 × 55.6 cm. Département des Arts graphiques, Musée du Louvre, Paris.

Niccolò dell'Abbate in Modena, and repeated throughout Central Europe in numerous paintings.

Caron has been somewhat uncritically credited with a number of mythological paintings, such as *The Eagle and the Demoiselle of Sestos,* as well as depictions of festivities like the *Parade with Elephant* (private collection, Paris). The decorative architecture, fantastic colors of the sky, and elongated figures of *Astronomers* interrogating a blood-red sky, on the other hand, are unmistakably the work of Caron (circa 1570, J. Paul Getty Museum,

Malibu), who handled visionary themes well. There is greater hesitation over a *Resurrected Christ* (Musée Départemental de l'Oise, Beauvais) which, if it is truly by Caron, represents his masterwork—Christ is handled with unexpected elegance, while luminous contrasts and movement are effectively imparted to the scene.

Caron drew stereotypical ornamentation and possessed a fluid narrative style. In his finest vein he illustrated most of the plates in the *Story of Queen Artemis* (an allusion and homage to Catherine de' Medici, the inconsolable widow), a tale

presented to the Queen Mother in 1562 by the apothecary Nicolas Houel. Caron's drawings were also intended to serve as cartoons for an enormous tapestry, but only a few pieces were woven in the early seventeenth century. There nevertheless survive fifty-nine drawings, executed in India ink with chalk highlights and flat washes, full of architectural details and crowded processions, battles, and hunts, all portraying standardized figures designed to be interpreted in terms of current events. The series concludes with the construction of a circular mausoleum,

Toussaint Dubreuil, *Hyanthe and Climène at their Morning Toilet.* Scene
from Ronsard's *Franciade* originally from Saint-Germain-en-Laye.
Oil on canvas. 107 × 96.5 cm. c. 1602. Musée du Louvre, Paris.

prefiguring the Saint-Denis rotunda. Another series, on French history, includes twenty-seven drawings in triptychs modeled after the Galerie François I: lateral scenes in oval medallions, flanked by caryatids, frame the main scene, which depicts a major event from recent history, in particular those relating to Henri II and Catherine de' Medici. These drawings demonstrate a certain vigor and, though they lack true distinction, reveal the extent to which the Valois court sought to glamorize its own image.

In the nationalist and monarchist effervescence of succeeding reigns, the legend of the Trojan origins of France (first articulated during the tenth century and revived in the fourteenth) enjoyed a final incarnation through Ronsard's never-completed epic in decasyllables, the *Franciade,* of which four books were published in 1572. They met with only limited success, but the legend of France's Trojan past retained its appeal longer than is generally appreciated, inspiring an iconography that can only be deciphered with text in hand. Such is the case of Toussaint Dubreuil's painting for one of the galleries of the new château at Saint-Germain-en-Laye.[3]

Research into the taste of the Paris bourgeoisie, based on late sixteenth-century death inventories, reveals a penchant either for small pious paintings (of which almost no trace remains) or for genre scenes that were far more down to earth— even coarse—than anything discussed so far. Indeed, there survive paintings based on commedia dell'arte figures or on moralizing themes—bawds, young woman with old lecher, etc.—that permitted the depiction of certain lewd charms (*The Middle-aged Woman,* Musée des Beaux-Arts, Rennes). These often-copied scenes are difficult to date and, though they reflect an awareness of Fontainebleau forms and Niccolò dell'Abbate's figures, they may well be the work of northern artists.

The bourgeois inventories that have been studied suggest that average homes possessed a number of comic paintings (or, more commonly, prints) known as "drolleries." A painting by Rabel, for example, titled *Drollery from Flanders,* typifies the genre: clownish caricatures of beggars and pullers of teeth.

François Rabelais, *The Comic Dreams of Pantagruel*. Richard Breton, Paris, 1565. Bibliothèque Nationale, Paris (Rés. Y² 2173).

As far as we know, the overtly knavish and satirical attitude of the day was expressed only in prints, rather than in paintings. Several surviving prints are extravagantly bizarre, such as a long, grotesque frieze depicting the festivities of *The Marriage of Michaud Crouppière* (circa 1570, Bibliothèque Nationale). In 1565, an apparently unclassifiable work was published in Paris, recounting Pantagruel's "comic dreams"—a series of freaks based on animals and kitchen utensils in the manner of Hieronymous Bosch, adapted from decorative grotesques and placed under the high patronage of that prince of buffoonery, Rabelais.

There was an explosion of illustrated broadsheets, popular prints, and satiric publications ridiculing groups and individuals, all fated to vanish and be forgotten. It is only by chance that a collection of forty-six items from the year 1589 has been preserved, titled *Les Belles Figures et Drôleries de la Ligue.* The chronicler Pierre de l'Estoile thought it interesting to collect these unrelenting caricatures with their often complicated symbols. Although only one of his four volumes has survived, it documents the beginning of a technique of willful exaggeration and caustic political message, which would assume full scope with the satires aimed at Louis XIII's minister Cardinal Mazarin.[4]

The Marriage of Michaud Crouppière. Engraving. c. 1570. Bibliothèque Nationale, Paris.

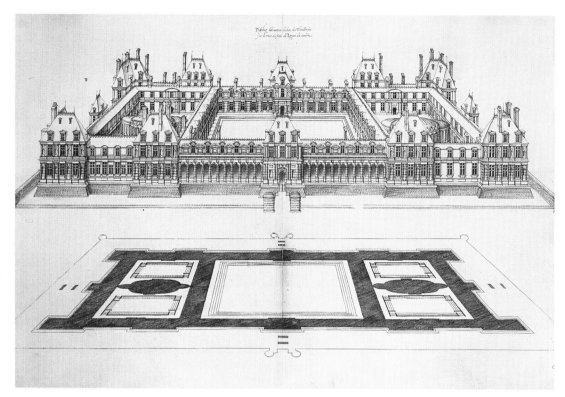

Jacques Androuet du Cerceau. Aerial view and plan in perspective of the Palais des Tuileries.
Pen and watercolor. 51 × 74 cm. 1576–1579. British Museum, London.

View of the Tuileries before the construction of the Marsan pavilion and the modifications made to the domes by Le Vau.
Watercolor. Bibliothèque Nationale, Paris (Est. Ve 53h.).

ARCHITECTURE: PRESTIGE AND EXTRAVAGANCE

Architecture became the art par excellence of a society aware of the demands and political significance of culture. European courts vied for the construction of increasingly sophisticated architectural monuments, as typified in Spain by Philip II's Escorial. In France, rivalry between branches of the royal family was expressed in the same fashion, while in the provinces, ambitious nobles tried to flaunt their status by constructing remarkable buildings. Philibert de l'Orme, Jean Bullant, and Jacques Androuet du Cerceau responded to this demand, and their proposals were duly appreciated.

As initially projected around 1563–1564, the Tuileries Palace was to have been a villa "outside the city walls." De l'Orme proposed a plan and attached great importance to the project, as his 1567 treatise attests. But the project lost momentum—in 1572, Catherine de' Medici abandoned it in favor of other undertakings like Chenonceau and the Soissons residence in Paris. The original design of the Tuileries remains unknown, though it would appear that the one-storey section of the west facade, built by de l'Orme, included a superb arrangement of banded columns (the "French" order) and aedicule gables dense with ornamentation. In the center, an original stairway devoid of central support had been

begun, and quickly became famous. In 1579, du Cerceau published a vast plan comprising side courts and secondary buildings, which is hard to credit to de l'Orme; it probably represents du Cerceau's own proposal for a gigantic complex that would have practically replaced the Louvre, and which would have included oval courtyards conducive to the staging of antique-style spectacles.[5]

Indeed, the real problem was the relationship between the new palace and the Louvre, for which a complete extension had been planned beyond the Lescot facade. It is not known at what point the idea of a long gallery was proposed to link the two, running along the river and straddling the city walls. Whatever the case, the project seems to have been launched by the building of a gallery extending from the Henri II pavilion to the Seine, commissioned by Catherine around 1566; Henri IV pursued the idea and, forty years later, the gallery was topped with another storey called the Galerie des Rois.

De l'Orme died in 1570. Bullant, no longer in the service of Montmorency (who died in 1567), was free to do the Queen Mother's bidding. He was the architect appointed to take charge of ongoing construction projects—probably the Tuileries, certainly Saint-Maur (where he was instructed to enlarge de l'Orme's original building), and Chenonceau (where a delightful and highly mannerist gallery was set on the bridge over the river Cher). The extreme fancifulness of the semicylindrical projections above the triangular piers of the bridge at Chenonceau has often been noted (pp. 142–143). A vast extension project, published by du Cerceau, was designed for Catherine de' Medici around 1576, and one of the new wings was started. Ambitious designs bordered on megalomania. In Paris, Bullant also built the Soissons residence for the Queen Mother (of which only the tall, so-called "astrologer's" column remains); the mansion occupied a vast area to the northwest of Paris and featured diverse

Frans Ertinger (after a drawing attributed to Theodoor Van Thulden). Pastoral scene decorating the gallery of the Hôtel du Faur, Paris (destroyed). Engraving. Bibliothèque Nationale, Paris.

elements known today only from engravings executed by Israël Sylvestre around 1650. The opulent interior housed the famous Valois tapestries, and there was a hall of mirrors set in elaborate wood paneling (destroyed in the mid-eighteenth century).

PARIS

Toward the middle of the sixteenth century, a major property division took place in the Marais district of Paris, in a neighborhood called Culture-Sainte-Catherine, where Montmorency, Ligneris (who built what is now the Hôtel de Carnavalet), and others built their magnificent *hôtels particuliers*. A little farther along, on rue de la Cerisaie, in an allotment carved out of the Saint-Pol property, de l'Orme erected his own residence, which he described in his treatise of 1567—its two facades, twin galleries over a portico, courtyard, and garden used the narrow dimensions of the plot to best advantage.

The number of noble residences in Paris began to grow. Naturally, they adopted certain features from châteaux, such as the framing of the main building by two wings projecting from pavilions.

The intermediate courtyard separating this ensemble from the street was already a common feature, so the novelty lay in the standardization and symmetry of the forms, as defined by models provided in repertoires such as du Cerceau's *Livre d'architecture* (1559).

In fact, symmetry only came to predominate slowly, whereas around 1570 it was above all decorative features that were stressed. Typical of this tendency was the remarkable residence of a great magistrate, Jacques du Faur, a nobleman from Saint-Jory in the south, who built his mansion (demolished) on the rue des Bernardins with a right-angled gallery, all the more interesting for the wealth of sculpture on the ground-floor arcade (vestiges of which can be seen at the École des Beaux-Arts, Paris). Also notable were the enormous consoles and figures echoing Goujon's work at the Louvre, although these were executed with a mannerist density perhaps attributable to assistants left in charge after the departure of the main sculptor, Étienne Carmoy or Martin Lefort. Another example is a cycle of paintings illustrating a pastoral romance in the finest tradition of Niccolò dell'Abbate (lost, known through drawings in the Bibliothèque Royale, Brussels).[6]

To paraphrase the sixteenth-century memorialist François de La Noue, the fate of most of these interesting buildings was as follows: an existence begun with pleasure, pursued with difficulty, and concluded with woe.[7] The Nevers mansion was begun by Louis de Nevers-Gonzaga on the Left Bank opposite the Louvre; its grand north pavilion had four storeys and was the first of that size to use brick and stone. It long served as a landmark, but was sold in 1642 and later demolished. Another example, still extant, was the abbatial residence of Saint-Germain-des-Prés, built for Charles of Bourbon by Guillaume Marchant in 1586. Architraves of rusticated stone contrasting with brick and the play of alternating pediments that

The Abbot's Residence of Saint-Germain-des-Prés, Paris. 1586.

MARVELOUS CHÂTEAUX

The story of the château at Verneuil in Picardy reads like a novel. Philippe de Boulainvilliers and his friend the poet Jodelle, also a connoisseur of architecture, became highly attached to this country residence. A first plan dating from roughly 1560—the work of du Cerceau—called for a square-plan château on a bastioned terrace. It was to have projecting corner pavilions and curved roofing forming a dome. The most unusual feature was the number of staircases—perhaps designed to rival Philibert de l'Orme—and the magnificent decoration for the inner facades that was to feature giant statues of "Assyrian kings." The historical statuary was commissioned from Ponce Jacquio and Pierre Bontemps.

The north wing, with gallery, was set on a portico featuring fluted pilasters, adorned with a rich array of niches and entablatures. It was completed in 1576, the same year that a thoroughly remarkable overall plan for the site, with a series of terraces and stairways leading to the gardens, was published by

pierce the cornice, constituted a specific and original interpretation of modernity.

An outstanding example is the Hôtel d'Angoulême (later Lamoignon, now the Bibliothèque Historique de la Ville de Paris), built for Henri II's illegitimate daughter, Diane of France, around 1584. The architect is thought to be Louis Métezeau. The building at any rate derives from Bullant's style, as recognizable by two traits: the colossal order pilasters rising two storeys high, and the break in the entablature created by the gable windows, endowing the facade with powerful thrust and even a certain grandiloquence appropriate to the rank of the owner. The colossal order, first used by Bullant on the portico at Écouen, was one of the marks of prestige most enthusiastically retained during this period of experimentation.

Hôtel Angoulême, later Lamoignon
(Bibliothèque historique de la Ville de Paris).
Facade overlooking the courtyard. c. 1584.

Jacques Androuet du Cerceau. Château de Verneuil, elevation of gallery in the courtyard.
Pen and watercolor. 51 × 74 cm. 1576–1579. British Museum, London.

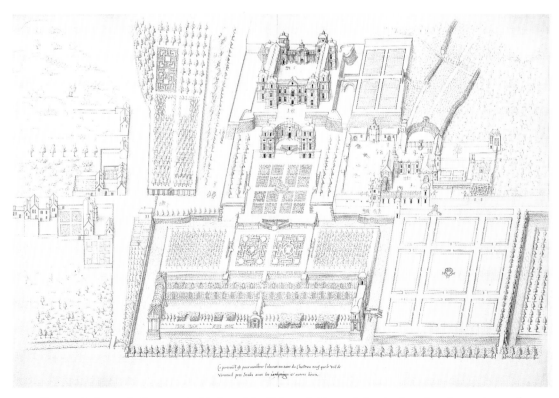

Jacques Androuet du Cerceau. Aerial view of the Château de Verneuil showing formal gardens and grounds.
Pen and watercolor. 1576–1579. 51 × 74 cm. British Museum, London.

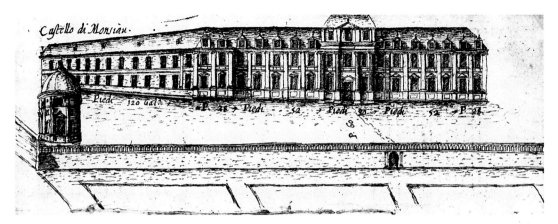

Vincenzo Scamozzi. Facade of the Château de Montceaux-en-Brie. Drawing. c. 1600. Museo Civico, Vicenza.

du Cerceau. His proposals represented an important initiative. The gardens went further than those landscaped at Meudon for the cardinal of Lorraine, prior to 1560—the gradually descending levels with ponds and pools planned by du Cerceau evoked the Villa d'Este. Indeed, in 1575, the duc de Nemours and his wife, Anne d'Este, bought the Verneuil site; but little work was achieved on the château. In 1600 it was sold to Henri IV, who gave it to Henriette d'Entraigues; Salomon de Brosse then completed the entrance wall (demolished in 1731). The immense fairyland of Verneuil, with its marvelous sculpture and space, thus remained limited to du Cerceau's engravings.

Although more modest, Montceaux-en-Brie to the east of Paris was not very different. A first residence was built between 1547 and 1559 based on the designs of an architect who might have been Philibert de l'Orme, at least as far as the annexes were concerned. A rather straightforward plan was chosen for this lovely site. The long facade with colossal Ionic columns was sketched by the Italian Vincenzo Scamozzi during his voyage through France in 1600. But the château really only began to take form at the end of the century, when Henri IV granted the land to Gabrielle d'Estrées in 1597 and, after her death, to his wife Marie de' Medici in 1599. Du Cerceau, followed by Salomon de Brosse after 1609, was responsible for the porticoes in the courtyard. The château was abandoned in the course of the

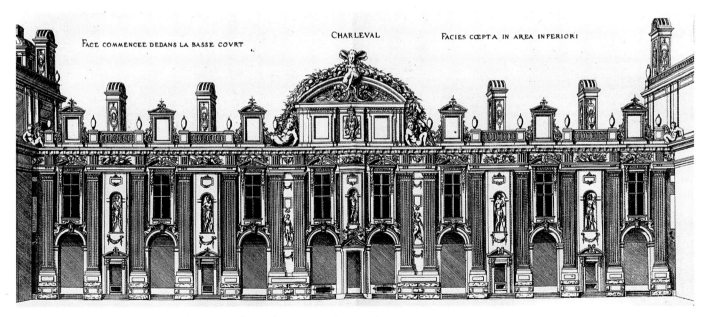

Jacques Androuet du Cerceau. Charleval, facade overlooking the rear court.
Engraving from *Les Plus Excellents Bastiments de France*, vol. 2. 1579. Bibliothèque Nationale, Paris.

Maulnes-en-Tonnerois (Yonne). General view and cylindrical stairwell. c. 1575.

seventeenth century and demolished in 1799.

Designed around 1570 for the valley of Andelle, near Lyons-la-Fôret in Normandy, the château of Charleval might have immortalized the reign of Charles IX, had the king's death in 1574 not brought the barely commenced work to a halt. Du Cerceau's superb documentation of the plans suggests that he himself was the architect. The vast project, more immense than all of Fontainebleau, featured a moat-like canal surrounding a square central courtyard and two lateral, double courtyards slightly offset to the rear, as well as a large garden. Another remarkable feature would have been the particularly lively play of decorative rustication and quoins on every facade. The windows were framed between fluted pilasters and seemed to flow downward toward the arcade, held up only by the

bracing figures of atlantes; it is hard to conceive of a more mannerist program. An archival document indicates that an engineer of Italian origin had supplied a "lifelike picture" of the design in April 1572, as well as a wooden model that August. The colossal undertaking was also slated to feature impressive woodwork.

Demonstrations of architectural bombast were plentiful. Around 1563, at Pailly in the upper Marne Valley, Gaspard de Saulx-Tavannes rebuilt a three-storey facade with a domed entrance pavilion featuring an equestrian statue (destroyed in 1759). Examples of experimentation were also very much in evidence. Antoine de Crussol (1528–1572) married Louise of Clermont-Tonnerre in 1556 and built a château that aroused interest for its very structure—the contract makes explicit the nobleman's wish

to have the residence built "in his forest of Maulnes, over the fountain of said site." Pentagonal in shape, the château rose four storeys high around a sort of well framed by stairways that descended toward a spring that formed a nymphaeum or nymph's grotto. This caprice reflects the importance attached to sources of running water.

The appearance of the château is perhaps surprising, since it bears a closer resemblance to a fortress like La Force (Dordogne) than to a hunting pavilion. Completed around 1575, it overlooked grounds enclosed by a wall, according to the plan published by du Cerceau, who thought it merited that honor. Meanwhile, the brick-and-stone château de Neuville at Gambais to the west of Paris follows a similar plan, based on the 1582 rebuilding of a prior manor.

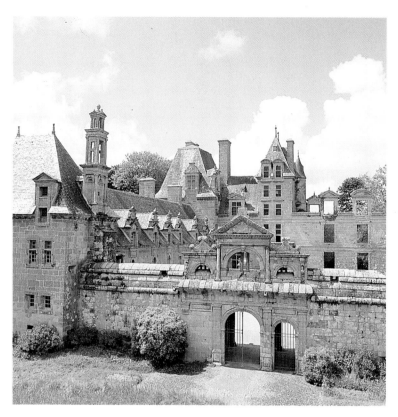

Kerjean (Finistère). General view. After 1553.

ARCHITECTURAL GLORY

Oblivious to criticism and discredit, the court tried to sustain a grand monarchic lifestyle. Many intelligent minds raised questions—*Recherches de la France* was the title given in 1560 to the first volume of lengthy research into French institutions by Étienne Pasquier, a jurist and historian (1529–1615). He believed that the quarrelsome and divisive nature of the French made it necessary to explore "the French identity" by studying its institutions and customs (the 1621 edition numbered ten volumes).

At the same time, in what might be called escapist literature, the nationalist myth resurfaced in works like *La Galliade ou la Révolution des arts et sciences* by Guy Le Fèvre de La Boderie. This didactic poem, published in 1576, uncritically celebrated the grandeur of the Gauls who, thanks to the Druids, possessed universal knowledge. It was the Druids who taught the Greeks, and who were therefore the true originators of "that useful art of building called architecture." The modern resurgence due to Francis I and Henri II was thus perceived as a rightful return to French preeminence, especially in the realm of architecture. The same tone emerged from *Antiquités gauloises et françaises,* the somewhat less emphatic anthology of Gallic and French antiquities published by Claude Fauchet in 1574.

But the key architectural publication of the day, revealing the extent to which successful accomplishments in the art of building were widely advertised, was du Cerceau's *Les Plus Excellents Bastiments de France.* The first two volumes appeared in 1576 and 1579 (republished 1607), while the third volume was never completed. This anthology was nevertheless the best of its kind, for nowhere else was a collection of this scope conceived and executed so authoritatively. It clearly fulfilled the need and desire of the last Valois monarchs not only to glorify the architectural accomplishments of their reigns, but also to highlight the enduring role of the Renaissance.

A "refortification" of many noble residences took place between 1560 and 1570 in several provinces. Fontainebleau was given new moats; bastioned structures and defensive windows appeared on many châteaux, and walls were reinforced. At Kerjean in Haut-Léon (Brittany), a château with a double enclosure was built by the powerful Barbier family. The first enclosure comprised moats and walls with bastions and casements according to the now traditional design of central building with four pavilions. The entrance wing had a gallery over arcade, linking the archive tower to the chapel tower. The upper parts of the main building were adorned with decorative gables of gray stone.

In Languedoc in southern France, François de Rougier (died 1575) built a "new château" in Ferrals to the east of a ruined castle. Never completed, the château was a typical compromise between a fortified castle and an aristocratic château, with bastioned corner towers, rustication, and decorative niches and entablatures. The residence was begun in 1565, and the unstable political situation made this new arrangement necessary.[8] It was probably at this time that La Bastie d'Urfé, in another politically tense area, was endowed with protective bastions on its south wall.

Châteaux retained a modest military value when it came to resisting assault by religious rivals. Recollection of such defiance, along with concern to knock feudal pride down a notch, explains why Henri IV dismantled so many noble dwellings, even prior to the end of the conflict, as well as after 1598. Many other châteaux underwent similar humiliation thirty years later at the hands of Cardinal Richelieu.

Remarkable care was taken in preparing the copper engravings for the thirty châteaux presented in the two volumes, and 116 original drawings on vellum have survived (British Museum, London). The manner of presentation involved an original approach to contemporary systems of projection—aerial views were combined with overall plans and, on occasion, facades. The whole project reflects a surprisingly modern attitude in that du Cerceau, author of manuals and anthologies of models, marshaled a wealth of French examples (some of which never advanced beyond the planning stage) as proof of national virtues. As was the custom, each building was presented in reference to the royal or noble patron who commissioned it. The names of the architects were mentioned only in passing; the lord of Clagny (Lescot) received one mention for the Louvre, and Philibert de l'Orme was cited in relation to La Muette, near Saint-Germain-en-Laye. The idea was not to supply documentation on artists, as the Italians might have done, but to display the wonders of France's national art.

Fleury-en-Bière (Seine-et-Marne). The wing built in 1552.

BRICK AND STONE

Construction employing brick surfaces outlined by stone quoins was frequent in the Loire Valley, Normandy, Picardy, and Flanders. In certain areas around Brie and Beauvais, brick was used for the structural framework, which would be filled with stone rubble that was then plastered, a practice used at the château of Fleury-en-Bière to the south of Paris, in the Cour du Cheval Blanc at Fontainebleau, and at Saint-Germain-en-Laye. Picturesque masonry was thus standardized and adapted to royal residences. The two types—stone on brick, and brick on stone—coexisted side by side.

With a few elements taken from the modern repertoire—cornices and moldings—this approach evolved into France's distinctive "three-color" construction (stone, brick, slate). The royal innovation slowly filtered down to the aristocracy and then the

bourgeoisie (as noted by historian Henri Sauval), becoming a characteristic feature of French vernacular architecture. The charm of slate roofing, which lent French towns their highly original appearance, had been noted by Serlio: "In France, sheets of bluish stone or slate are used, to very pleasant and distinguished effect [*molto piacevole e nobile*]" (Book VII, written circa 1550, published in 1584).

It is worth dwelling on this interesting phenomenon. During the troubled decades of the late sixteenth century, a taste for simplified, three-color architecture was reinforced in provinces where it already existed, and took hold in many others. Famous examples abound, such as Saint-Germain-de-Livet (1584, Normandy), and Wideville (1580–1584, Île-de-France). The latter was modest in

layout but was later endowed with a famous grotto (1635). During the days when France turned inward, around 1600, this construction technique played a key role at all levels of architecture.

A sort of maturation occurred throughout this long period marked by powerful passions, leading to a split between admirers of the new building style and people annoyed by the lavish expenditure or haughtiness of architects. In the frontispiece of his 1567 treatise, Philibert de l'Orme depicted a good architect—calm, methodical, enlightened—opposite a groping, confused master builder, thus triggering the quarrel between the "ancients" (more or less Gothic) and the "moderns" (aware of Italian developments and above all of antiquity), a distinction of little import until that time.

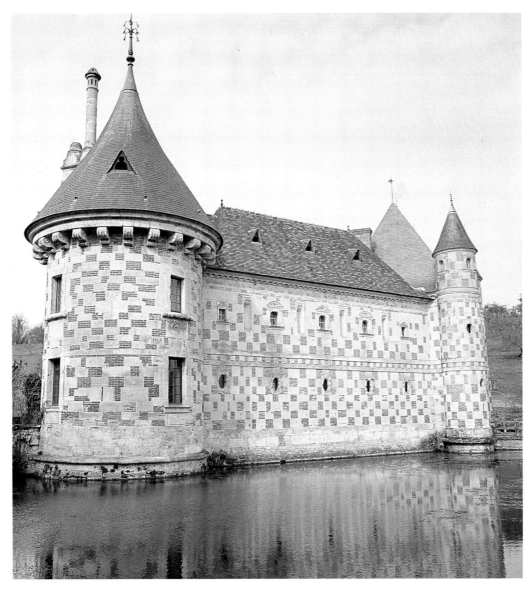

Saint-Germain-de-Livet (Calvados). The wing built in 1584–1588.

The rural nobility still formed the social backbone of the provinces. "French nobles live not in cities but in villages and their châteaux," noted the ambassador from Venice in 1558. Their dispersion benefited architecture at a time of expansion—provinces like Burgundy, the Loire Valley, and Dordogne are surprisingly dense with châteaux, and Provence with fortified manor houses. Vanity also influenced new construction; people imitated the lifestyle of the great nobles by building dining rooms, although Olivier de Serres later claimed that they actually ate better when they simply dined in the kitchen. The gentry, like the peasants, complained about the general social upheaval.

The Huguenot moralist François de La Noue, in his *Discours politiques et militaires* (1580, published in 1587), boasted that there were more magnificent buildings in France than anywhere else, yet he went on to ask how many of their owners had gone bankrupt. The aristocracy found itself in an increasingly absurd situation, especially since all social classes were adopting the new styles, leading to a period of inflation. A Paris-based noble, Bernard Gérard, lord of Haillan, who was historian to Charles IX and also served under Henri

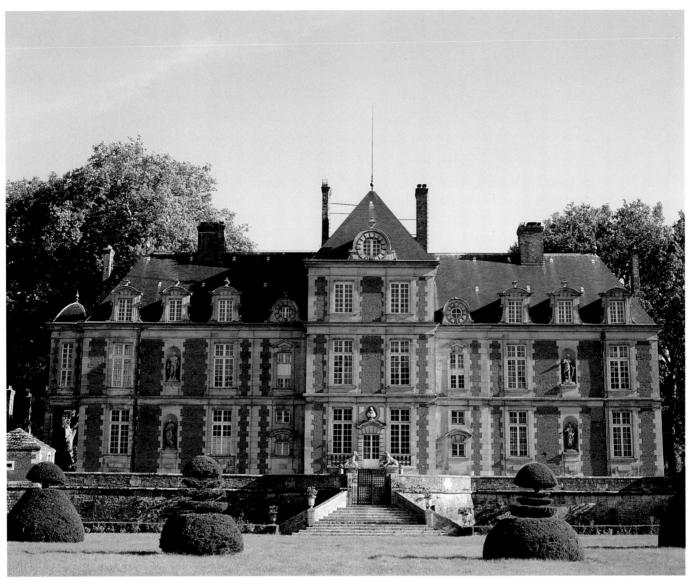

Wideville (Yvelines). Garden facade. 1580–1584.

III, published a pamphlet in 1586 explaining why things "had become so dear" in France. Every architectural historian cites this document on inflation, in which Gérard denounces the excessive opulence of construction methods employed throughout France during the previous thirty or forty years. "Formerly our fathers were content to build a good dwelling, with pavilion or round tower." Modern taste, however, required "large residences . . . galleries, halls, porticoes," and demanded "all these antique methods of architecture that cost too much money and most often make the inside ugly by overembellishing the outside."

Montaigne, in his *Essais* (vol. 2, chap. 5), admits his aversion to the jargon used by fashionable architects; little concerned with appearances, he resisted the suggestion that he update his old family manor by adding a gallery. Troubled times and financial crisis were not the only causes of a slowdown in construction. Even though lavish (and never-executed) plans circulated at court with increasing frequency, the real trend favored relatively simple, less costly buildings that retained regional hallmarks. In short, the time had come for a certain return to local architecture.

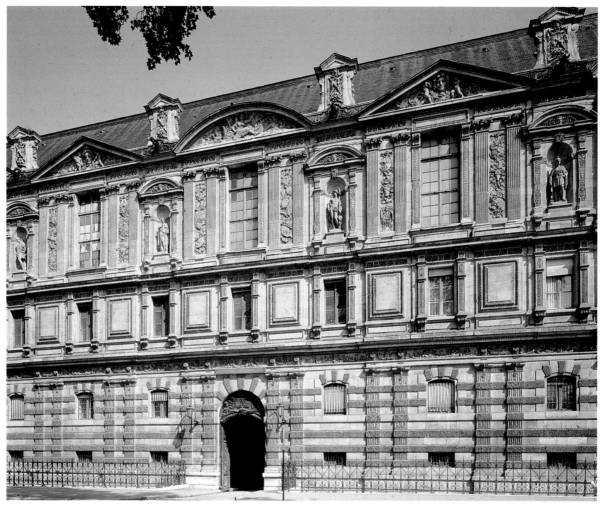

Grand Gallery of the Palais du Louvre, Paris. 1595–1656.

3. RECONSTRUCTION

After several years of fighting to secure his kingdom, Henri of Navarre finally entered Paris as King Henri IV in 1595, inaugurating a reign that would last only fifteen years. A realistic and decisive monarch—unlike the last Valois kings who, though refined, were unstable and inept—the first king of the Bourbon Dynasty not only undertook the reconstruction of buildings to which he immediately took a fancy, but also carried out urban improvements. He innovated, significantly, by treating the city of Paris like an organism in need of repair. Development

was conducted in the name of usefulness, since the king cared little for the art of pomp. One monumental project illustrates this well: the Cordouan lighthouse, the first of its kind to be built since antiquity. The decision to erect the huge "telescopic" edifice had been taken under Henri III in 1584, but was only developed in 1594 by the engineer Louis de Foix at Henri IV's request. The much-needed lighthouse was erected on the rocky islet of Cordouan at the mouth of the Gironde estuary in Aquitaine. The lower part was handled in a strict classical style with columns and pediment, while the interior contained a chapel

and a range of emblematic descriptions of royal power, which was likened to a beacon that provided guidance in a storm.[9]

Henri's adviser and finance minister, the duke of Sully, strived intelligently to revive agriculture—France's key source of wealth—and to stimulate industry where French initiatives were lacking. His efforts produced important results, in the former sphere by encouraging improvements in dwellings and farms, in the latter by importing labor and technology, especially in the decorative arts. During this all-too-brief reign, there was a fresh approach to the issues and activities that would mark the

seventeenth century. But the vast revival nearly came to a halt due to agitation not only by the nobility (incapable of submitting to authoritarian directives) but also by the Huguenots, whose confidence in the regime was sorely tested by Marie de' Medici (1573–1642), named regent for the young Louis XII following Henri's assassination in 1610. Marie lacked the political savvy displayed earlier by her distant cousin Catherine. Reconstruction of the kingdom remained shaky, as demonstrated by the general dissention within the Estates General, summoned by the queen in 1614. It was not until Richelieu came to power in 1624 that public affairs moved forward.

For fifteen or twenty years France marked time, with ideas and plans put on hold. The numerous projects that were resumed or launched during that period were either additions to earlier grand designs or new examples of the standard, common style employed during the first quarter of the

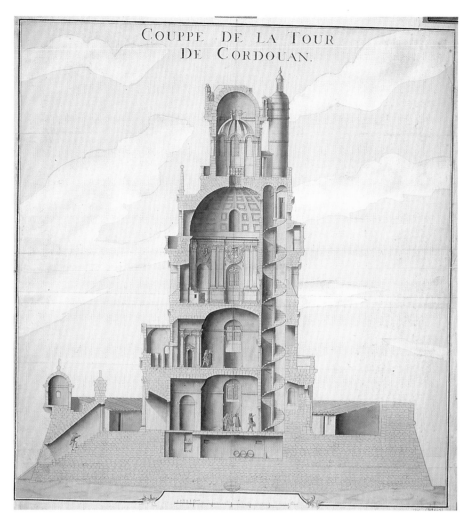

Jablier. Cross-section of the Cordouan lighthouse, built to the plans of Louis de Foix in 1594.
Pen and wash. 71.6 × 67.2 cm.
Bibliothèque de l'École nationale supérieure des Beaux-Arts, Paris.

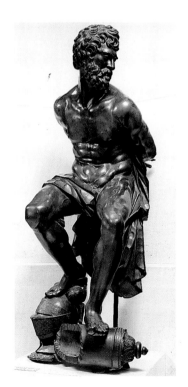

Pierre Francqueville, *Slave*. Figure from the equestrian statue of Henri IV on the Pont-Neuf. Bronze. 1618. Height: 155 cm. Musée du Louvre, Paris.

seventeenth century. The period is thus hard to distinguish from the preceding century, especially since the provinces generally moved at their own pace.

Unlike the Valois kings, Henri IV showed little interest in culture itself, apart from architecture. Cardinal Du Perron later recalled that "the late king harkened neither to music nor poetry, and for that reason there was no one who excelled in his day. Those there were, were remnants of the reign of Charles IX and Henri III." The cardinal was referring to the poet Malherbe, whose eulogies to the king (and later Marie) should not deceive. Nor was it a heyday for

the other arts—rather, a period of slow recovery. According to Filippo Baldinucci, in order to complete the equestrian statue on the new bridge or Pont-Neuf, in 1604 Henri IV summoned Pierre Francqueville to Paris, after having seen a bronze *Orpheus* by the artist at the Gondi residence. This information is doubly valuable—the statue, erected in 1614, was a major dynastic monument, and the sculptor was from the Tuscan school, Francqueville having trained under Giambologna (or Jean Bologne). The primacy of Italian art, challenged during preceding generations, was again more pronounced than ever.

The Pont-Neuf, Paris. Detail of the sculpture decoration: grotesques. 1604.

MODERNIZING PARIS

"The Pont-Neuf . . . is the main monument of this reign. Nothing matched the enthusiasm stirred by the first sight of it when, after all the work, it spanned the Seine in twelve great strides, bringing the three hearts of the mistress city closer together."[10] Thanks to this new feature, the river was wonderfully integrated into the urban environment. In his memoirs, Cellini recounted the incredible detour previously required to go from the the Nesle residence to Saint-Germain-l'Auxerrois. The bridge had been initially designed (1578) to hold houses and probably triumphal arches, but was built (starting in 1598) as a broad avenue in two segments that met at the Île de la Cité (where, on the decision of the queen in 1604, the equestrian statue of Henri IV was placed). The brackets supporting the cornice of the bridge were decorated with remarkable sculptures of grotesque masks. The narrower branch of the Seine (between the Île de la Cité and the Left Bank) was then developed, for the bridge was the catalyst for broader urban renewal—rue Dauphine was laid out (starting in 1607) to provide the old neighborhoods with reasonable access

French school, seventeenth century, *The Pont-Neuf and the Louvre circa 1673*. Oil on canvas. 97 × 219.5 cm. Musée Carnavalet, Paris.

to the Pont-Neuf. Finally, a handsome triangular square (Place Dauphine) at the tip of the Île de la Cité was lined with houses sharing a wonderfully uniform facade of brick and stone, in a tried-and-true style (abominably altered in the late eighteenth century by an oblivious municipality and abusive proprietors). Henri IV not only set the urban tone by building a bridge that provided a vantage point for sweeping views, he also endowed the riverside with a monumental facade by launching construc-

tion of the Long Gallery (1595–1656), designed to link the Louvre to the Tuileries. The gallery was connected to the Louvre at right angles to the Petite Galerie, the interior of which was carefully decorated for Marie de' Medici (destroyed in 1660).

Henri IV also commissioned an enclosed square, begun in 1605 on the former site of the Hôtel des Tournelles, a royal residence abandoned by Catherine de' Medici following Henri II's death in a jousting accident there in 1559, and demolished in 1565. The

The Place Royale (Place des Vosges)
south gate: the Pavillon du Roi. 1605–1639.

Charleville-Mézières (Ardennes). The Place Ducale (detail). 1611.

square was named Place Royale (becoming Place des Vosges in 1792), and constituted yet another long-standing plan that was finally coming to fruition. The architect must have been Louis Métezeau, in royal employ, along with Jacques du Cerceau the Younger, since 1594. Only the north and south pavilions (the Pavillons de la Reine and du Roi, respectively), with passages for access to the square, were built by the government, the rest being allocated to proprietors who were obliged to imitate the design. This did not prevent private owners from using materials of poorer quality, sometimes going so far as to place a false facade of bricks over plaster. The Place Royale, where an equestrian statue of Louis XIII was set up in 1639, established a new urban pattern based on royal squares. The most famous of these is undoubtedly the Place Louis XV, built in 1763, today Place de la Concorde.

The Place Royale had not yet been completed when it was already being

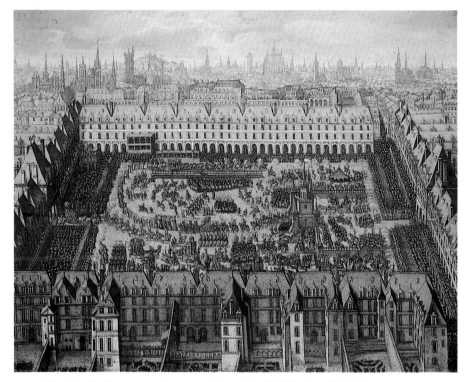

French school, seventeenth century, *Carousel on the Place Royale for the Engagement of Louis XIII, 1612*. Oil on cavnas. 41 × 52 cm. Musée Carnavalet, Paris.

One project led to another. The extraordinary development of Parisian architecture during the entire period is related to the opening of three new urban areas: the Marais district, the area around the Louvre, and the Saint-Germain neighborhood. In 1614, an entrepreneur named Christophe Marie began building the bridge that still bears his name (Pont Marie), facilitating development of Île Notre-Dame (today Île Saint-Louis) in the Seine. The capital would have been even more grandiose if the third royal square (semicircular this time, with a diameter of 150 meters) had been built. It was to have been called Place de France, and plans were commissioned from Claude Chastillon and Jean Alleaume in 1610 calling for a straightforward handling of block-like parcels (similar to the Place Royale) that would open onto eight radiating avenues. The seven pavilions had pointed roofs with gables and tall, French-style chimney stacks. It was to be built at Porte Saint-Antoine, thereby developing a whole new neighborhood. But the project came to a halt on 14 May 1610, when Henri IV was stabbed to death on rue de la Ferronnerie.

PARISIAN RESIDENCES

Perhaps builders never showed more vitality than during the days when, true to the French spirit, a long period of stagnation gave way to enthusiasm and rivalry, sparking new initiatives. A few of the noble residences built in the newly developing urban zones have already been mentioned. For thirty or forty years, lavish *hôtels particuliers* continued to blossom in the Marais district and on Île Saint-Louis. A better idea of the architectural phenomenon can be understood by dwelling on two remarkable, if totally opposed, examples—the Hôtel de Rambouillet and the Luxembourg Palace.

The Hôtel de Rambouillet, begun in 1604 near the Louvre, had an irregular appearance due to additions and alterations carried out around 1618. The house became famous for the literary salon hosted by Italian-born Catherine de

Hôtel Sully, Paris. Facade overlooking the courtyard. 1624–1629.

imitated in 1611 at Charleville in the Ardennes region, at the instigation of the duke of Nevers and with the collaboration of Clément Métezeau, brother of Louis. Sully drew inspiration from this "quiet residential square" for his diagonal-plan square in Henrichement near Bourges, architect Pierre Levesville copied it in 1615 in Montauban though without retaining separate roofs for each pavilion, and it was seen later on in the town of Richelieu (circa 1630). England and Holland imitated the design in turn. The aristocracy followed.

The duke of Mayenne, a former antagonist of Henri IV who ultimately rallied to his cause, built his own residence on rue Saint-Antoine not far from the Place Royale, on a design said to be similar to the one used for the Ligneris residence. Not far away, though long after Henri IV's death, Sully bought the residence built by Mesme Gallet around 1620, based on the same overall design but with denser, more ambitious decoration—statues, friezes, and ornate gables that contrasted with the straightforward principles of the Place Royale.

Vivonne, who in 1600 married Charles d'Angennes, the future marquis de Rambouillet. Their daughter Julie was courted by aristocratic and literary circles alike, and it was at their *salon* that Giambattista Marino read his famous poem *Adonis* in 1622. Sauval, the aging historian, praised the use of brick and stone as being particularly suitable for "grand buildings."[11] He was not the only person who thought the *hôtel* had considerable impact on Parisian architecture. The memorialist Tallement des Réaux recorded that it was "from [this residence] that it was learned to place staircases on the side [of the house] to create a long suite of rooms . . . and to make doors and windows tall and wide and opposite one another. And this is so true that the Queen Mother, when she had the Luxembourg built, ordered the architects to go see the Hôtel de Rambouillet." (*Historiettes,* vol. 2, no. 102, 1854 edition).

It is interesting to note that the distinctly modern layout and the emphasis on light and symmetry were credited to the marquise de Rambouillet, even though these innovations all predated her lavish residence. Similar suites of rooms existed in the sixteenth century (as du Cerceau's plans testify), and the tall, wall-defining windows had been used for the Place Royale. But since the marquise—called the "incomparable Arthénice"—set fashions in general, architecture was also placed under her aegis.

The gatherings, hosted by the marquise (reclining in bed because she was always slightly unwell and, after 1620, assisted by the charming Julie), met with unprecedented social success. They completely overshadowed the fact that the literary salon had already been introduced during the days of Henri III, in the form of "le Salon Vert de Dictynne," hosted by the wife of the Maréchal de Retz on Faubourg Saint-Honoré.

In the comfortable tapestry-and-leather interior of the Hôtel de Rambouillet, the famous Blue Room was decorated in an original way, as admirably described in Madeleine de Scudéry's novel *Le Grand*

Hôtel d'Alméras, Paris. The front portal. c. 1612.

Cyrus (1649). Indeed, the salon was significant not only for its commitment to the literary refinement of madrigals and *romans à clef,* but also for a type of highly wrought and "precious" painting, namely allegorical portraits. People depicted as heroes, goddesses, and shepherdesses became part of the aristocratic repertoire. Attention was more than ever focused on interior decoration.[12]

The lively architectural activity of the first third of the seventeenth century—involving initiatives in the handling of residences both in Paris and the provinces—somewhat echoes the many delightful, if somewhat disordered, innovations of the first quarter of the sixteenth century. It was another period during which the wealthy bourgeoisie from the financial and

legal spheres wanted to flaunt its prestige and culture. One example is the Hôtel d'Avaux on rue du Temple, which boasts a courtyard facade of seven bays orchestrated around fluted pilasters—a pretentious arrangement recalling the Hôtel d'Angoulême or even the Château de Verneuil, but which here bears a heavy cornice that distinguishes the composition and exuberant decoration from the 1570s.

Variations on this theme were numerous. The Hôtel de Chalon-Luxembourg, built shortly after 1608 on rue Geoffroy-l'Asnier (residence of Antoine Le Fèvre de La Boderie, French ambassador to London), has a facade with slabs of stone highlighting the brick, which overlooks the garden, and an arrangement of reliefs that give the building great charm, while two

In addition to a room for baths—listed in the 1614 death inventory as "sweat-baths"—the building boasted numerous tapestries and two galleries. One of them, "having a view of the garden, and called the Gallery of Kings," included royal portraits, paintings by the Bassanos, and townscapes. The Englishman John Thorpe was sufficiently interested in this "modern" residence to have drawings made of it.[14]

It is hardly surprising that during these highly active years Pierre Le Muet published a "manual" in 1623 (reprinted in 1647), titled *Manière de bien bastir par toutes sortes de personnes* (The Manner of Good Building by All Sorts of People). As an architect and theorist, Le Muet was clearly aware of the need to enlighten clients; following Serlio and du Cerceau, he took up the idea of proclaiming norms that were both technical and hierarchical—a dwelling should be both part of the urban fabric and a reflection of social rank. Architectural considerations were henceforth becoming part of society's shared culture.

During this active phase, plans and designs dating from previous generations were still employed. But one monumental project stands apart: the palace and park built by the widowed queen, Marie de' Medici, on a Left-Bank property containing a small residence built by François de Luxembourg, after whom the site is named. In 1611, Marie sent architect Louis Métezeau to study the design of the Pitti Palace in Florence, and asked Salomon de Brosse, the master builder, to use the same model in arranging the overall site, featuring an enormous courtyard flanked by wings forming two long galleries, and a massive central section with four projecting pavilions. In the center of the main block was a monumental staircase. It was therefore a massive complex that solidly asserted its perfect symmetry. A novelty in the stonework recalled the Pitti Palace and other works of Florentine mannerism, in the play of rustication and quoins covering the entire surface, creating a sort of dotted effect that remains unique

Luxembourg Palace, Paris. Garden facade. 1615–1631.

small lateral projections lend balance to the composition. The portal's superb fan-shaped design would appear to be posterior, displaying as it does a bold grandiloquence that suggests a date closer to the middle of the century. Yet an earlier date might well be plausible if the portal is compared to the whimsy of the so-called "tabernacle" portal, characterized by a niche in the pediment, that stands in the Alméras residence. Built in

1612 for the controller general of the Post, the Hôtel d'Alméras is another brick-and-stone structure with fine moldings. It was in the Marais district, naturally, that these stately homes rivaled for elegance.

Benefiting from the development of property near the Arsenal, a wealthy Italian from Lucca, Sébastien Zamet, naturalized in 1581 by Catherine de' Medici, built a magnificent residence on rue de la Cerisaie.[13]

in Paris. The strong gatehouse—or rather its novel handling in the form of a domed pavilion—is also worthy of attention. Finally, the exceptionally vast grounds, extending as far south as the Carthusian Monastery, were laid out as early as 1612 by Boyceau, a gardener trained in the Italian style. Many of the original terraces and shaded lanes remain, as well as the nymph's grotto built around 1630 and adorned with statues by Pierre Biard the Younger. But just as the palace was nearing completion, the queen, in conflict with her son Louis XIII and with Cardinal Richelieu, left France for good.

One architectural feature employed at Luxembourg went on to enjoy a fine future—the dome. Ever since Bramante, Sangallo, and Michelangelo, domes had been part of the modern Italian repertoire. In sixteenth-century France, however, they had been used only in marginal experiments on isolated chapels at Toul and Vannes, or to crown towers on the facades of Saint-Michel in Dijon and Saint-Gatien in Tours.

Several unusual productions of this inventive and fertile period are worth citing. More modest dwellings, though still of a certain scale, abandoned the entrance courtyard by drawing in the wings and concentrating the entire effect on the body of the main building, where rich decoration underscored the slightly projecting pavilion that housed the staircase. This was the case at Saint-Loup-sur-Thouet in Poitou-Charente, where the old system of stacked pilasters was freely interpreted in long vertical chains, giving an original and highly attractive overall effect. At Coulommiers, meanwhile, a concave colonnade linked the wings to the main residence. It is not unreasonable to refer to "theatrical" architecture in describing concave facades or rounded porticoes, often with a short terrace, that framed a courtyard suitable not only for welcoming carriages but also for staging plays and spectacles. Hence it is possible to detect a pervasive festive mentality in the

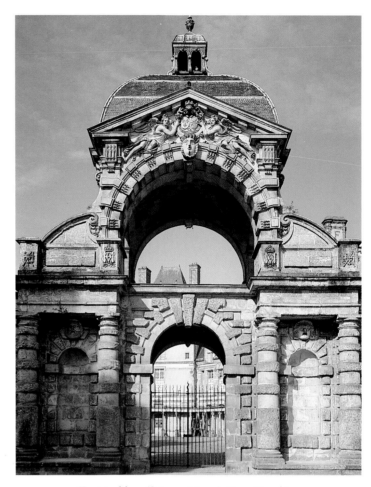

Fontainebleau (Seine-et-Marne). Porte Dauphine
(known as the Baptistry gate). 1602.

architecture at Fontainebleau and the curved facade of Grosbois to the southeast of Paris.[15] Grosbois, built by Nicolas de Harlay starting in 1597, was finally acquired by the duke of Angoulême. The stone piers worked into the brick walls (with no allusion, however, to classical orders) and above all the central concavity between the sharply angled wings endow it with an original character, even though the courtyard lacks the unifying structure of a portico (like the one later developed by François Mansart at Berny and at Blois).

Philibert de l'Orme had already experimented with central-plan chapels topped by a small dome. The first major use of this model was projected for the Valois mausoleum (after 1560), which, as mentioned previously, was never completed. Employing this "ennobling" form on the entrance pavilions to grand châteaux was therefore an interesting initiative. The arrangement had previously been suggested for Verneuil around 1568, as confirmed by du Cerceau's drawings, and appeared on the Porte Dauphine at Fontainebleau (circa 1602), thus affirming the dignity of the new Bourbon dynasty. On the central section of the Tuileries, where Philibert de l'Orme's staircase remained unfinished, his replacement as architect (probably Jacques du Cerceau) thought it appropriate to crown the whole building with a dome around 1600. The model thus became standard for royal

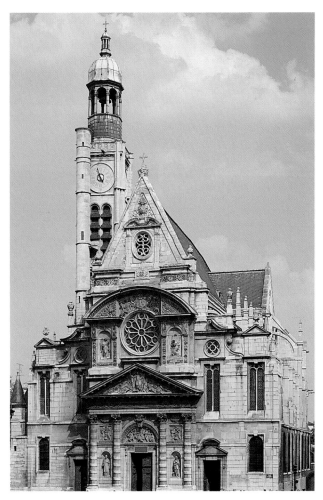

Church of Saint-Étienne-du-Mont, Paris. Facade. 1610–1622.

Geneviève before the construction of the Panthéon, and its tall beacon-like bell tower and droll staircase turret (completed in 1624) were spared.

The provinces abound with examples of such delightful and bizarre combinations, though it is usually impossible to accurately date the cumulative effects. The facade of Saint-Pierre in Auxerre, for instance, begun quite late, was indicative of a desire to organize the facade—the superimposed orders were crowned by an oculus forming a gable with lateral elements which, though clumsy, were designed to unify the whole. Niches and tabernacles were placed throughout. The late date of the work (1630–1658) should not be too surprising; a clear style did not emerge everywhere at the same time.

In 1616, the first stone was laid for the new facade of the church of Saint-Gervais-Saint-Protais, where the nave was undergoing reconstruction (the chancel having been rebuilt in the previous century). A wooden model was devised for this major composition, which conveyed a determination to return to the strict monumentality of the classical orders. The three storeys were orchestrated around strong twinned columns, the upper window forming an elegant loggia with curved pediment between elegant Corinthian columns. The middle level echoes the avant-corps (projecting pavilion) at Anet, where Philibert de l'Orme had asserted his antique-style doctrine. The same intention is clear here. The Roman model proposed by Giacomo della Porta was adapted to the typically French verticality of the existing church. Only Salomon de Brosse was capable of such a feat; Clément Métezeau, whose name appears in the accounts, must have played an auxiliary role. This church truly constituted a statement concerning the need to embrace Italian architecture. A new situation was thus emerging, as symbolized by the severe Doric portico framing the door, praised by contemporary chronicler Henri Sauval.

edifices, though not yet for ecclesiastical architecture. However Italian examples were so numerous and obvious that domes were ultimately adopted for buildings of every religious order.

CHURCH FACADES

Like the giant frontispieces set before châteaux, church facades long provided an opportunity for experimentation, or rather compromise between the cumulative, picturesque Renaissance approach and the rigorous strictures of classical architecture.

The facade of Saint-Étienne-du-Mont in Paris, begun in 1610 and completed twelve years later, charmingly sums up the complexity of the seventeenth-century repertoire. Against a broad facade with tall, symmetrical windows, there rises a portico with a triangular pediment featuring the banded columns typical of Philibert de l'Orme's work. A second pediment, recalling the central motif of the Louvre, is placed over the first, while a third, narrow pediment crowns the mannerist window on top. This church was built alongside another one dedicated to Saint Geneviève (destroyed in 1807). Saint-Étienne-du-Mont, occupied the summit of the hill called the Montagne Sainte-

4. Between North and South

While the French decorative arts and the fledgling luxury industry would be organized later in the century by Louis XIV's finance minister Colbert, Henri IV and his trusted advisor Sully were concerned above all with promoting what might be called the industrial arts, such as tapestry weaving. The most notable operation was simply the installation of two duly ennobled Flemish masters, François de La Planche and Marc de Comans, at the Gobelins workshop, founded in the fifteenth century on the banks of the Bièvre River just outside Paris. In 1609, models of cartoons on pastoral themes were solicited, which at least constituted a start for what would become the most prestigious tapestry factory in ancien-régime France.

Attention has been rightly drawn to a brochure published in 1600 by Antoine de Laval, *Des peintures convenables aux Basiliques et Palais du Roy* (Paintings Suitable for the King's Basilicas and Palaces). By suggesting that history provided useful and serious subject matter, it brought a halt to the vogue for mythology that had marked preceding generations. The new

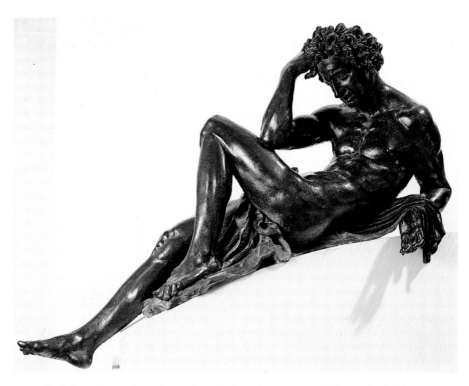

Bathélemy Prieur, *Spirit.* Statue from the funeral monument of Christophe de Thou. Bronze. c. 1585. 46 × 107 cm. Musée du Louvre, Paris.

advice was followed in the queen's gallery at the Louvre, decorated with portraits of kings (lost), as well as at the Luxembourg Palace with Rubens's famous cycle on the king's life (1622–1625).[16] Henceforth, there would be an increasing number of battle scenes and allegories—often esoteric and complex—designed to commemorate every event of the reign. Never had contemporary history been so abundantly

Mathieu Jacquet, *Victory.* Bas-relief from the Belle Cheminée at Fontainebleau. Marble. 1595. 26 × 83 cm. Musée du Louvre, Paris.

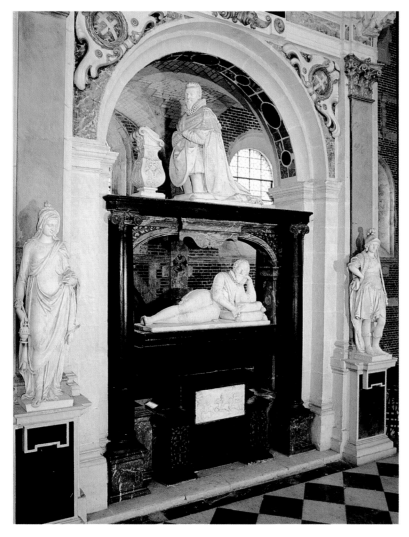

Simon Guillain. Tomb of Henri, duke of Guise. Early sixteenth century.
Jesuit College, Eu (Seine-Maritime).

Barthélemy Prieur, *Diana*. 1603. Bronze.
Musée national du château, Fontainebleau.

illustrated and pompously transposed as during this century.

Sculptors were difficult to find. Francqueville had trained in Florence and his *Orpheus* (Louvre) betrays the influence of Giambologna. He was very well received in Paris and worked on the bronze slaves for the statue of Henri IV. Barthélemy Prieur (circa 1559–1611) had spent several years in Italy, as demonstrated by the figures on the tomb of Christophe de Thou (Musée du Louvre). Prieur worked on the Petite Galerie of the Louvre and executed a bronze *Diana* for the inner garden of Fontainebleau (1603). Where Italian mannerism did not prevail, traditional French

Mathieu Jacquet, *Equestrian Portrait of Henri IV.* Bas-relief from the Belle Cheminée fireplace. Stone and marble. 1599. Musée national du château, Fontainebleau.

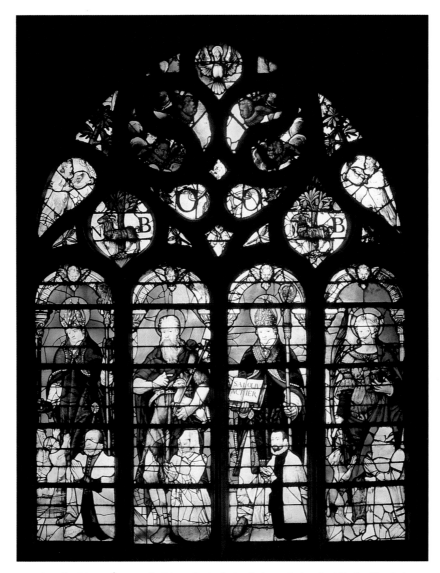

Church of Saint-Étienne-du-Mont, Paris. Stained-glass window by Nicolas Pinaigrier,
Saint Nicholas, Saint John the Baptist, Saint Oliver and Saint Agnes. 1586.

practice set the tone, as seen in the equestrian relief of Henri IV (completed in 1599) set against against the black marble hood of the famous fireplace at Fontainebleau—a vigorous work by Mathieu Jacquet (died 1611) that echoes the enthusiasm of the early years of Henri's reign.

Sculptors were required for work on the numerous tombs that members of the nobility erected in churches. Simon Guillain, from Cambrai, spent time in Italy and returned to France around 1610 to execute several

tombs including those in Chilly-Mazarin and Eu. Another example was Michel Bourdin, active in the Loire Valley, particularly on the new tomb for Louis XI at Cléry. The dearth of sculptors only eased once Jacques Sarrazin returned to France in 1628 after acquiring solid experience in Rome.

Finally, it is worth mentioning Nicolas Cordier (1567–1612). Originally from Lorraine, he spent his entire career in Rome. He carved a statue of Saint Gregory the Great from a block of marble abandoned by

Michelangelo, worked with Pietro Bernini (father of the great Gianlorenzo Bernini), restored antiques, and collaborated on the numerous chapels decorated by several artists (including Pope Paul V's chapel at Santa Maria Maggiore). Cordier was commissioned to do the bronze statue that can still be seen on the portico of Saint John Lateran in Rome, a brilliant composition that depicts Henri IV as a gallant gentleman.

Stained glass, that transparent and vividly colored form of painting, had not

Fontainebleau, Trinity Chapel: view of the ceiling decorated by Martin Fréminet.
c. 1608.

lost all its allure, as demonstrated by a family of painter-glassmakers, the Pinaigriers, who were esteemed in Paris during the entire period. The most active member of the family was Nicolas Pinaigrier, commissioned in 1586 to provide a stained-glass window of Saint Nicolas and other saints with donors for the church of Saint-Étienne-du-Mont in Paris. The boldly colored saints and bright blue background are fortunately still in place. Pinaigrier is also responsible for the nearby window of the

Resurrection and one of Saint Thomas. All these rather magnificent works, donated by rich merchants, are relatively well preserved. Nicolas also worked at Saint-Gervais around 1600; the surviving *Adoration of the Magi* has been almost entirely redone, but the *Washing of the Feet* retains its original impact. It was Nicolas's nephew Louis who was responsible for other, less solid, compositions like *Jesus among the Doctors* (1607).[17] Such glassmakers worked from cartoons inspired by Flemish and Italian

engravings, and their windows therefore reflected the mixed style then reigning in France, though with the added authority of a grand tradition of colored glass.

The Italian primacy that became manifest in the 1590s exercised exclusive attraction on all young European painters for the next quarter of a century, so it is not surprising that the phenomenon also drew French artists. Martin Fréminet (1567–1619) spent roughly ten years in Italy, working in Turin for the duke of Savoy. He returned to France

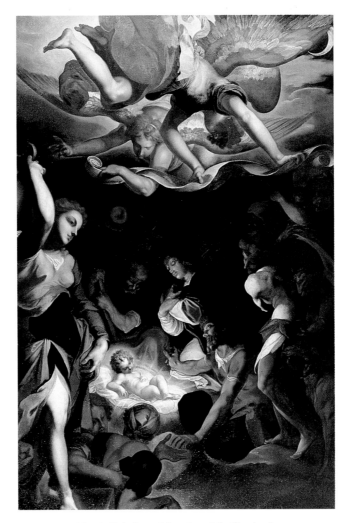

Martin Fréminet, *Adoration of the Shepherds*.
Oil on canvas. 236 × 158 cm. c. 1603. Musée Départemental, Gap.

in 1602 to take up a post as *peintre ordinaire* to the king. It was in this capacity that he gave drawing lessons to the Dauphin, the future Louis XIII. At Fontainebleau, Fréminet undertook an unusually ambitious project in the form of the ceiling of the Trinity Chapel, where he skillfully employed the teachings of Michelangelo. Fréminet's *Adoration of the Shepherds* (circa 1603, Musée Départemental, Gap) also displays Northern Italian luminosity. Painted sketches in the Louvre demonstrate the eclectic range of his sources and his fluent composition.

The situation of French painting around 1600 did not define itself exclusively in terms of Italian models. Several sources were involved. First of all, Fontainebleau models became accessible to all, and young painters went to study them, especially Primaticcio's elegant work, which represented the height of modern Franco-Italian taste. Then northern artists arrived to take up vacant posts. They in turn became gallicized and familiar with the Fontainebleau style; for example, Ambroise Dubois, who arrived in France from Antwerp perhaps as early as

1570. He was given responsibility for the third gallery at Fontainebleau, the Galerie de Diane (1600–1601, destroyed in 1810), in which mythological scenes alternated with panels bordered by grotesques. Dubois also decorated the Clorinda Room (1601–1615, destroyed in the eighteenth century), from which six paintings survive, as well as the Théagène Room (1609–1610), featuring fifteen canvases illustrating the romance, *Histoire éthiopique*, in a composite, occasionally unsystematic style consistent with international mannerism.

Ambroise Dubois, *Baptism of Clorinda.* Oil on canvas.
188.5 × 189.5 cm. c. 1605. Musée national du château, Fontainebleau.

Ambroise Dubois, *The Rape of Chariclo.* Oil on canvas. 162 × 200 cm. 1604–1605.
Musée national du château, Fontainebleau.

Toussaint Dubreuil, *Angelica and Medor*. Oil on canvas. 143.5 × 199.5 cm. c. 1600. Musée du Louvre, Paris.

Toussaint Dubreuil (circa 1561–1602), although steeped in the same sources, seems to have had a more personal approach. Nothing remains of his contribution to the scenes from the *Story of Hercules* in the Pavillon des Poêles at Fontainebleau, a work site headed by Ruggiero Ruggieri. On the other hand, several interesting canvases have survived from his paintings for the new château at Saint-Germain-en-Laye, including one cycle illustrating Ronsard's *Franciade* and another based on Ovid—a vast series that originally numbered sixty-eight paintings, according to an old inventory. Although literal and descriptive, Dubreuil's surviving canvases reveal a poetic sense of composition, as seen in *Hyanthe et Climène* (Louvre, p. 258) and his light and modulated colors naturally suggest a link to central European mannerism.

There were also many non-naturalized Flemings in Paris, who remained faithful to their own manner. Among them, Hieronymus (Jérôme) Francken (1540–1610), a member of the Flemish dynasty that specialized in small "cabinet paintings," spent most of his career in France executing church paintings, such as the *Adoration of the Shepherds* (1585) for the Chapel of the Franciscan monastery (now in Notre-Dame). Another important genre practiced by northern artists was portraiture.

The most interesting case is that of Frans Pourbus the Younger (1569–1622), from the Antwerp family of artists, who distinguished himself as a court painter in Mantua. He was taken to Paris in 1606 by Eleonor de' Medici, sister of Marie de' Medici, in order to paint portraits of the French court. His dry precision and emphasis on dress, bearing, and silhouette perfectly suited his clients. A *Last Supper* (1618, Louvre), painted for the church of Saint-Leu-Saint-Gilles, conveys a sure sense of style through sober composition and subdued coloring. Pourbus remained faithful to a style of collective portrait that did little more than juxtapose the sitters (such as the

Frans Pourbus the Younger, *Henri IV*. Oil on panel. 39 × 25 cm. c. 1610. Musée du Louvre, Paris.

Frans Pourbus the Younger, *Marie de' Medici*. Oil on canvas. 307 × 186 cm. c. 1609–10. Musée du Louvre, Paris.

Aldermen of Paris, of which fragments survive), a style also practiced by Anthonis Mor and Thomas Key.[18] Despite a certain effort to adapt to Parisian tastes, Pourbus could not be described as a French artist. That is not to say that he should be discounted. Around 1610–1614 critics like André Félibien named him as being among the artists who worked on Marie de' Medici's quayside apartment in the Louvre (along with Dubois, Bunel, and Dumée). At the north end of the Petite Galerie, Dubreuil painted a *Gigantomachie*, which suggests that Giulio Romano's famous *Fall of the Giants* in the Palazzo del Tè had not gone unnoticed. There were other painters, about whom lit-

tle is known, one being Quentin Varin. Originally from Beauvais, he probably traveled to Italy around 1590, where he absorbed the composite style of Federico Zuccaro and Cavaliere d'Arpino. He has been documented as having worked in Avignon, Amiens, and Normandy. Varin worked in Paris at the Carmelite church and painted a *Marriage at Cana* for Saint-Gervais, which deploys a vast architectural decor playing skillfully on light and dark areas around figures notable for the handling of their garments.

The Italo-Flemish mixture led to an eclectic style that no longer conveyed the elegance associated with Fontainebleau. In

1622 the decoration of the Grand Gallery of the regent queen's Luxembourg Palace was confided to Rubens, who produced a masterpiece of colorful, heroic, narrative painting. The "cabinet pictures" were commissioned from Italian painters, who sent their work from Tuscany—Orazio Gentileschi, summoned by the queen, resided in Paris around 1628. This date must therefore correspond to his startling *Diana the Huntress,* shown from the back, executed in a cold, acid palette (Musée des Beaux-Arts, Nantes). Unlike Rubens, whose powerful style was beyond the experience of French painters, Gentileschi must have appealed to a certain number of local artists.

Quentin Varin, *The Marriage at Cana*. From the Church of Saint-Gervais, Paris. Oil on canvas. 310 × 259 cm. 1618–1620. Musée des Beaux-Arts, Rennes.

Orazio Gentileschi, *Diana the Huntress*. Oil on canvas. 215 × 135 cm. 1624–1626. Musée des Beaux-Arts, Nantes.

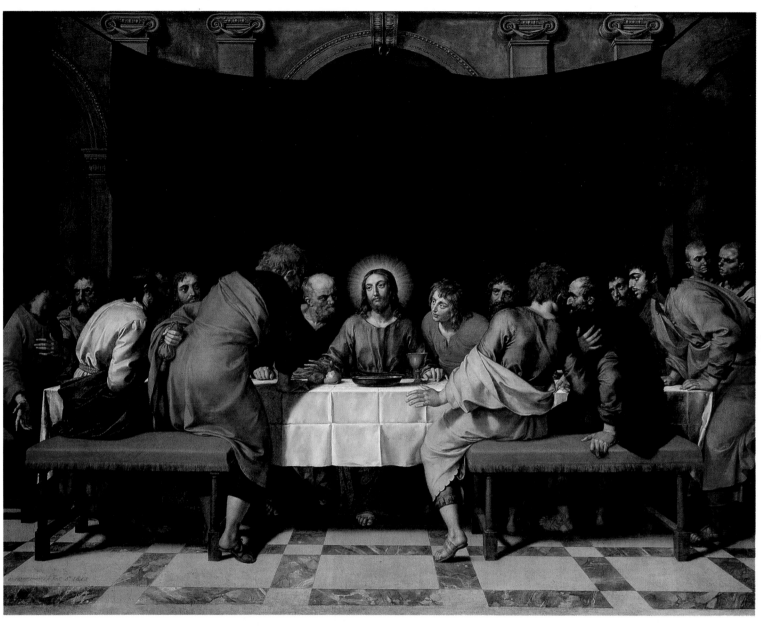

Frans Pourbus the Younger, *The Last Supper*. Oil on canvas. 287 × 370 cm. 1618. Musée du Louvre, Paris.

Jacques Bellange, *The Three Marys at the Sepulcher.* Engraving.
c. 1610. Bibliothèque Nationale, Paris (Est. Da 30).

LORRAINE ARTISTS

Although closely related, painters from Lorraine should not be confused with French painters. In this turbulent period, Lorraine artists developed an original, almost erotic (or, at any rate, exotic) version of the extreme mannerism then sweeping northern Europe from Antwerp to Prague. Jacques Bellange (circa 1574–1616) was the most stunning of them all. An exceptionally agile draftsman, painter, and engraver, he decorated the Stag Gallery at the ducal palace in Nancy with hunting scenes (1606), now known only, alas, through preparatory drawings. Bellange went to Paris in 1608. Some

Jacques Bellange, *Group of Women*. Pen and ink. c. 1610. Département des Arts graphiques, Musée du Louvre, Paris.

fifty of his prints survive—descriptive, ironic, subtle, and bizarre—on subjects alternately religious (*Annunciation, Virgin with Distaff,* and *The Three Marys at the Sepulcher,* surprisingly pictured in the manner of fashion engravings), popular (*The Watchman*), and mythological (*Diana and Actaeon,* a strange erotic representation). Approximately eighty drawings also survive—studies of figures and disheveled, almost perverse angels, and compositions like *Lot and his Daughters,* an inventive work that contemporary writers did not hesitate to describe as "licentious" in the twin senses of immoral and of taking liberties with classicism. A strange and remarkable painting, *The Lamentation* (Hermitage)

plays on effects of light and shadow with a confidence and sophistication that combines all the artifice of Emilian, Lombard, and Bohemian mannerism in a candle-lit night scene.

Jacques Callot (1592–1635) was another inspired practitioner and innovator. He left Nancy for Rome at an early age, training under engravers like Crépin Thomassin in the Lorraine colony of the city. Then he entered the service of the grand duke of Tuscany in order to record all the notable events, festivities, and entertainments, which he did with a verve both graceful and mocking, underpinned by a technique playing subtly on crowds of miniscule figures and elegantly drawn fore-

grounds, as in the *Florentine Festivities* (1619). His etchings endowed commedia dell'arte characters with irresistible vitality.

Upon returning to Nancy in 1621, Callot played the same role of documenter of festivities and everyday life, later extending this into a striking study of the *Les Grandes Misères de la guerre* (1633, Bibliothèque Nationale). He henceforth belonged more than ever to the northern school, especially in landscapes, which wonderfully convey the grays of the distant horizon. Callot's topographical skills interested politicians, and Richelieu commissioned him in 1629 to execute the large print of the *Siege of La Rochelle,* a masterpiece of such perfect craft that it long obsessed engravers.

Jacques Bellange, *The Lamentation.* Oil on canvas. 116 × 173 cm.
The Hermitage, Saint Petersburg.

Claude Deruet (1588–1660), the official artist at the court of Lorraine, could be considered a follower of Callot in terms of painting. He also stayed in Italy and was influenced by the engraver Antonio Tempesta. A painter of fantastic scenes, like Antoine Caron, he was invited on several occasions to work in France; his allegorical compositions almost always convey a ballet-like atmosphere.

Bellange and Callot made only temporary contact with Paris and French circles, whereas Georges Lallemant (circa 1575–1630), from Nancy, settled in Paris in 1601 and became an official painter, executing a *Portrait of the Aldermen* in 1611 (Musée Carnavalet, Paris). His *Adoration of the Magi* (circa 1620, Musée des Beaux-Arts, Lille) is a perfect and rather pleasant example of eclectic mannerism—one of the Wise Men painted in the style of Pisano is associated with straightforwardly conventional figures. Lallement was very prolific, and evolved toward increasingly somber forms. He worked with Philippe de Champaigne around 1620, and an entire biblical cycle in the church of Les Blancs-Manteaux (date unknown) has been recently attributed to him—dense and teeming, it is typical of his cluttered style.

The development of artistic engraving and easel painting took on new significance during this period. Almost all residences of any size included a gallery and a series of artworks. Small, decorative paintings of mythological subjects, as well as religious

Jacques Callot, *Balli di Stefania.* Engraving. c. 1672.
Bibliothèque Nationale, Paris (Est. Ed. 25 rés.).

Jacques Callot, *Les Grandes misères de la guerre.*
From top to bottom: Devastation of the monastery; The dying by the roadside; Pillage and burning of the village.
Engravings. 1633. Bibliothèque Nationale, Paris (Est. Ed. 25 rés.).

Villeneuve-Lembron (Puy-de-Dôme). The Shepherdess Room.
Late sixteenth century.

cycles, are mentioned in contemporary descriptions and inventories of private residences and châteaux. The names of the artists, though, are rarely cited. It is known that the castle of Saint-Amand-Montrond (Cher), rebuilt by Sully in 1606, was decorated by Jehan Boucher, a painter from Berry, and that in 1620, Henri II of Bourbon, prince de Condé, hung 190 paintings there. Every genre was represented, including "loves of false Gods, called Aretino's poses," which was hung in a garret.[19] But all

trace has been lost of every one of these works. To the south, in Auvergne, where several examples of that decorative fashion have survived, this regional decor with its popular touch can be seen in the château at Villeneuve-Lembron, particularly in the upstairs "Shepherdess Room."[20] Other examples are Effiat, with a grand salon, and Montvallat where the local lord renovated his château around 1630, decorating it with landscape scenes inspired by Ovid's *Metamorphoses.* The château at Ravel, mean-

while, featured an upstairs "Golden Room."

Traditional decorative styles persisted—French-style ceilings with rows of beams continued to be adorned with medallions, arabesques, and other familiar motifs. But a new feature became common—a room furnished as a "cabinet," often with wood paneling, where paintings could be hung and valuable objects kept. The era of "collections" had dawned, corresponding to a new stage in the rise and prestige of easel painting throughout Europe.

Claude Deruet, *The Battle of the Amazons: the Rescue.*
Oil on canvas. 50 × 67 cm. c. 1620. Musée des Beaux-Arts, Strasbourg.

George Lallemand, *Adoration of the Magi.* Oil on canvas.
189 × 315 cm. c. 1620. Musée des Beaux-Arts, Lille.

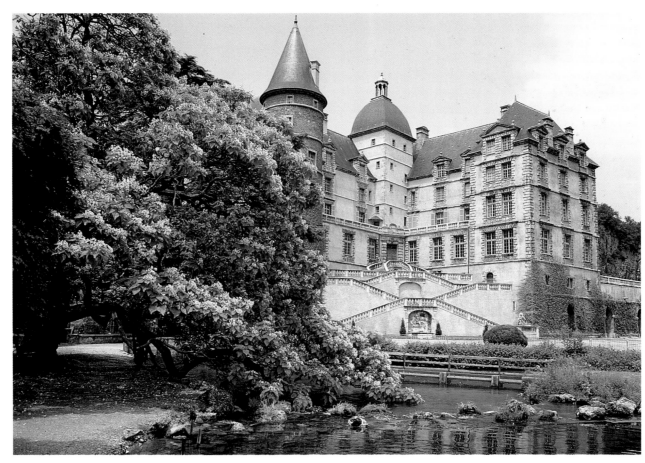

Vizille (Isère). General view. After 1600.

5. Chateau and Grounds

Maximilien de Béthune, the future duke of Sully—named finance minister in 1601 as well as grand master of the artillery (which explains his decision to live on the east side of Paris, near the Arsenal)—fought, governed, triumphed, and prospered under Henri IV. Even prior to 1600, when rebuilding his country château overlooking the Seine at Rosny, Sully employed the brick-and-stone design which he had more or less introduced. The entire plan is known today thanks to a fresco in another of his châteaux, at Villebon (Eure-et-Loir), which depicts all his estates—Rosny featured a double courtyard and two portals, with a

first terrace and broad courtyard in front of the main building, flanked by large wings. Perhaps the most remarkable thing was the large terrace along the river, and the extent of the grounds. Distant views and a broad handling of space were highly appreciated.

Henri IV knew how to reward those loyal to him. François de Bonne, lord of Lesdiguières, who had held the duke of Savoy in check during the difficult years when Henri was fighting for his crown, was made a duke in his own right (in 1622, Louis XIII would grant François de Bonne the highest military title, *connétable*). So beginning in 1600, the lord of Lesdiguières rebuilt an old castle perched on an outcrop at Vizille in the Romanche Valley, a setting rich in nat-

ural springs, where a landscaped park was feasible. Around the old keep there rose tall four-storey buildings with gable windows, carved from the gray stone of the nearby Alps. The courtyard was formed by a new pavilion and main block at the level of the park, including a handsome, tapestry-lined gallery (destroyed by fire in the nineteenth century).[21] The grand exterior staircase leading to the garden was a later addition. The château's west portal had a particularly solemn appearance—its curved pediment, borne by two pairs of banded columns, opened to receive a panel with a bronze equestrian statue of the duke below the high entablature (circa 1620). This was the work of Lorraine sculptors Jacob and Jean

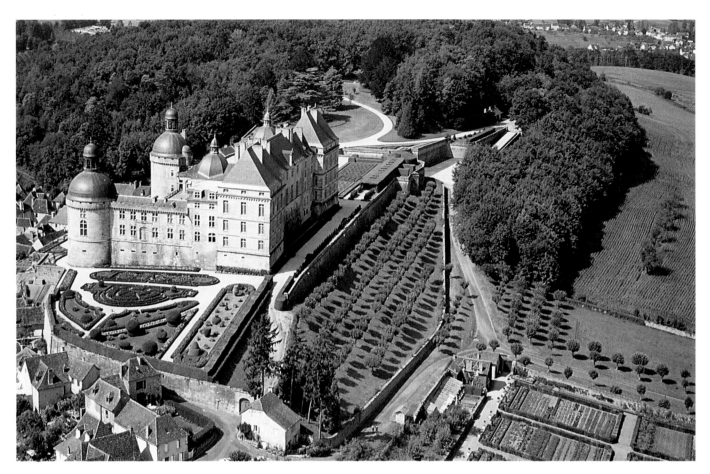

Above and below: Hautefort (Dordogne). View of the château and park. Late sixteenth–early seventeenth century.

Richier, who also worked on the tombs of Lesdiguières and his wife Claude (1612, Gap). The fine, 1602 bronze statue portraying Lesdiguières as Hercules, formerly at Vizille, is now in front of the city hall in Grenoble, the urban seat of his family. But it is the site of Vizille itself that merits attention, for it boasted grounds with exceptional landscaping, follies, and canals. Along with the grand gallery, this impressive environment made the château famous.

The Aquitaine region was not to be outdone. It was home to the duke of Epernon, another of Henri's loyal companions who, at the king's suggestion, built a large residence at Cadillac beginning in 1599. The plans were drafted by Pierre Souffron, who

was supervisor until the completion of the main structure in 1604. The vast construction project lasted twenty years, including moat, grand portal with lions, main courtyard with series of pavilions, domed avant-corps to house the staircase, and superbly vaulted underground service chambers. The rich interior decoration has often been described. French and foreign visitors flocked to the château and the court even paid a call in 1620. The numerous, heavily worked fireplaces are justly famous. Here again, fashionable features such as fountains and grottoes were incorporated into gardens landscaped by Louis de Limoges. A funerary chapel was built in the church of Saint-Blaise, with a cross-shaped tomb

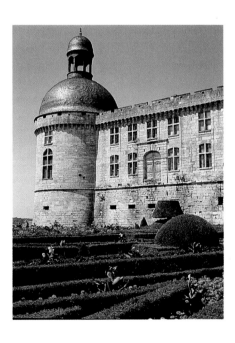

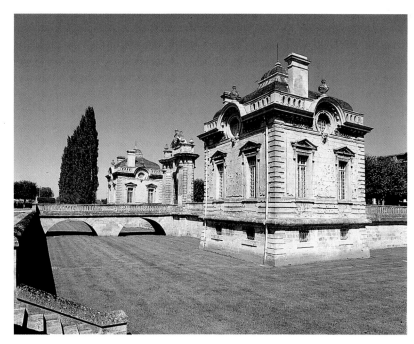

Blérancourt (Aisne). View of the entrance pavilions to the château. c. 1612–1619.

more or less imitating those at Saint-Denis executed by Pierre Biard, sculptor to the king. Thus the example had been set for a grand, new style combining a vast residence and sweepingly, elaborately landscaped grounds with their own charm.

One of the finest surviving examples, despite being abandoned in the nineteenth century and damaged by a fire in 1968, is the impressive château at Hautefort in Dordogne. It was built in the late sixteenth and early seventeenth centuries to replace the manor of the troubadour Bertran de Born. Sober in style, with a courtyard between two east-facing wings, it dominates a rocky plateau that suddenly rises from the plain and provides a large base for the admirably maintained gardens.

These developments demonstrate that while doubts about the nobility's loyalty discouraged the construction of anything resembling a castle, the architectural situation was not moribund. Things became more acute under Richelieu, of course, when

the royal edict of 1629, called the "Michaud Code," explicitly forbade the fortification of seignorial residences. The dignity of aristocratic dwellings nevertheless continued to be asserted by a moat and elevated terrace with pavilions at the corners, the whole appearance enhanced more carefully than ever by vast grounds and broad vistas.

Salomon de Brosse (1571–1626), who designed the Luxembourg Palace (at least in the initial phase), was the leading figure of the day. Grandson of Jacques Androuet du Cerceau, he remained faithful to Protestantism but was nevertheless commissioned to build two aristocratic châteaux in the greater Paris area—Coulommiers, starting in 1613 (demolished), and Blérancourt (1612–1619). The former followed the traditional plan with courtyard and wings, plus paired pavilions as at Verneuil. The latter was more massive in layout, with square pavilions abutting the main building, as well as two other highly decorative pavilions set out in front. In a sense, the plan used

at Luxembourg was, from the French point of view, a combination of these two approaches. But in the Luxembourg Palace, the strong cornice with balustrade at the base of the roof accentuates overall horizontality (p. 276), while the discontinuous roofs of the two other châteaux generate a lively play of upper elements. There was nevertheless a controlled mastery of overall arrangement that was far removed from the "house of cards" appearance for which fashionable brick-and-stone buildings were criticized. Salomon de Brosse's impressive buildings carried a polemical message by advocating an architecture of masses articulated around the classical orders, thereby putting an end to picturesque construction, or, at the very least, consigning it to auxiliary parts of the building.

Indeed, around 1660 "indifference to classical architecture [had become] total."[22] It was a period of freely combined elements that occasionally betrayed a hint of baroque complication, but which more easily fit the

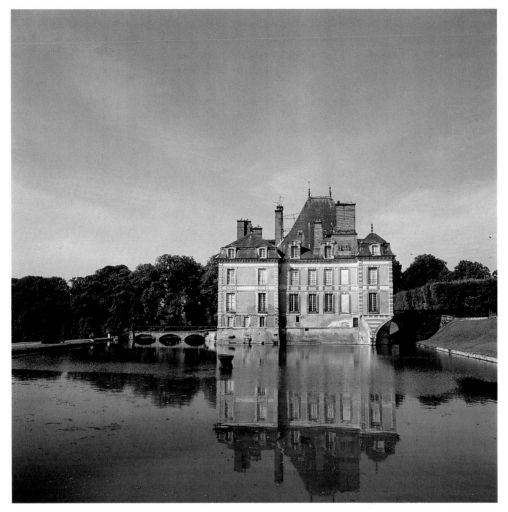

Ormesson (Val-de-Marne). General view. c. 1580.

category of late mannerism, as did almost everything produced in France at that time. This situation, moreover, makes it difficult to ascribe dates. The château at Wideville to the west of Paris was famous for its nymphaeum, a garden folly (still extant) built for Claude de Bullion in 1635. It was therefore supposed that the residence itself, on a dense and straightforward plan (open central space, two very small projecting wings, in a delightful orchestration of brick and stone) had been built for the powerful Bullion himself around 1630, when the property was purchased. Archives, however, have proven that the building dates back to 1580 or so, when the financier Benoît Milon built a large estate on the site, using a standard plan for the château found in du Cerceau's third *Livre d'architecture* (1582).[23] The models established during the reigns of Charles IX and Henri III remained valid for more than half a century. This makes it difficult to distinguish constructions of the first quarter—or even third—of the seventeenth century from earlier projects.

At Sully's château in Rosny, as at Ormesson (to the east of Paris), rounded gable windows lend a certain liveliness to the slate roof above the stone-and-brick walls. While the overall effect is not particularly striking, this turn-of-the-century model was so fashionable in the provinces that local nobles who decided to build or modernize continued to employ it for a good half century.

The most famous and most ambitious of the picturesque-style estates is surely Brissac in the Loire region. Beginning in 1606, Charles de Cossé demolished the old fortress, retaining—temporarily—only the two original towers; he then built a tall, enormous building. In what was to become the main body (six storeys high), a broad range of ornamentation (niches, rustication, and so on) was employed to create, in

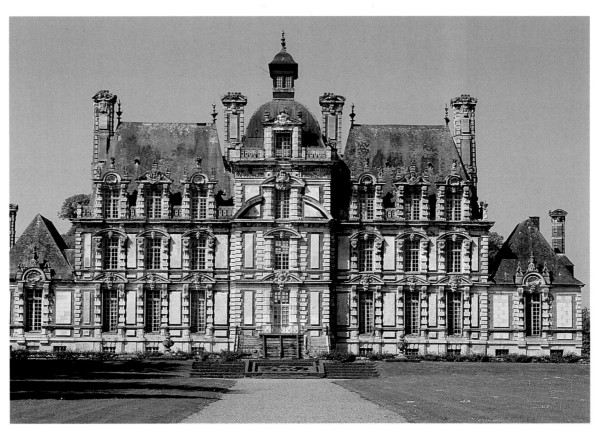

Beaumesnil (Eure). General view. 1633–1640.

conjunction with the brick-and-stone facing, a unique and strangely poetic ensemble. Many others adopted this style, ultimately well suited to the turbulent nobility on the eve of the rebellion known as the Fronde. The astonishing château at Beaumesnil in Normandy, later and better balanced than Brissac, reflects this trend, as do Pont-en-Champagne (by Pierre Le Muet) and Balleroy in Normandy (where Mansart made his debut).

The Origins of Formal Gardens

With Sully advocating a "return to the land," châteaux became the center of a vaster organization that required not only a coherent handling of outbuildings but also a rethinking of access and surrounding spaces. All sorts of complementary features had long since become a part of the château environment—parterres, *tempietti,* and porticoes, most of which have disappeared. But development of the surrounding grounds assumed greater importance during the reign of Henri IV, marked by the king's employment of Tommaso and Alessandro Francini, who were naturalized in 1600. A new era had arrived for the art of landscaping.

Claude Mollet, whose *Théâtre des plans et jardinages* was only published in 1652, was one of the grand architects of the new style, as spectacularly demonstrated at Fontainebleau. A long vista was created by the grand canal, more than one kilometer long (1609), aligned with the grand parterre (also called the Tiber Parterre, after the statue there); this can be easily construed as a precursor to Versailles. Moreover, the conventional partitioning of space was abandoned in favor of a large overall plan based on boxwood hedging, which organized the space more satisfactorily. Grottoes, fountains, and statues were placed everywhere. The Diana Garden featured Barthélemy Prieur's rather spirited statue (p. 280), while Michelangelo's *Hercules* (now lost) was placed on a small island in the Pond Garden off the courtyard facing the Galerie François I.

This new age of French formal gardens was Neapolitan in origin. Pacello da Mercogliano, who came to France in 1494

PORTRAIT DE LA MAISON ROYALE DE FONTAINE BELLEAV

Alexandre Francini.
Aerial view of Fontainebleau. 1614.
Engraving by Israël Sylvestre.
Bibliothèque Nationale,
Paris (Est. Va. 77).

Below: Jacques Androuet du Cerceau.
Aerial view of the Château de Gaillon
from the northeast with large court
and formal gardens. 1576–1579.
Pen and watercolor. 51 × 74 cm.
British Museum, London.

in the wake of Charles VIII's unsuccessful Italian campaign, was employed at Amboise and then at Blois, where he created a vast ensemble of three terraces (known thanks to du Cerceau's drawings); the second, surrounded by a portico and featuring an octagonal pavilion in the center, contained ten parterres framed by low hedges of boxwood (still extant in the days of Henri IV). The gardens at Gaillon were laid out at the same time on a high terrace overlooking the Seine. The concept had thus been established, and modern reform of aristocratic gardens, consisting of a clear, geometric organization of parterres, was permanently adopted. Du Cerceau's plans for Charleval and Verneuil (p. 263) proved that by the middle of the sixteenth

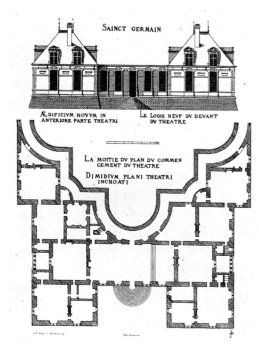

Jacques Androuet du Cerceau. Plan of the new château and the gardens of Saint-Germain-en-Laye. Engraving. From *Les Plus Excellents Bastiments de France*, vol. 1. 1576. Bibliothèque Nationale, Paris.

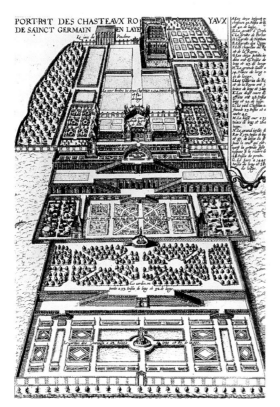

Alexandre Francini. Aerial view of the Château de Saint-Germain-en-Laye. 1614. Engraving by Israël Sylvestre. Bibliothèque Nationale, Paris.

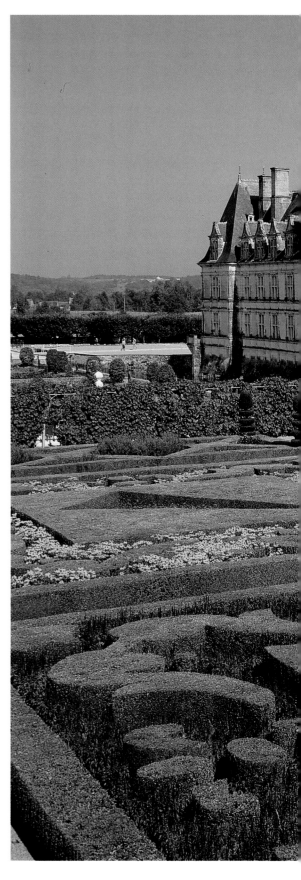

Villandry (Indre-et-Loire). The gardens.

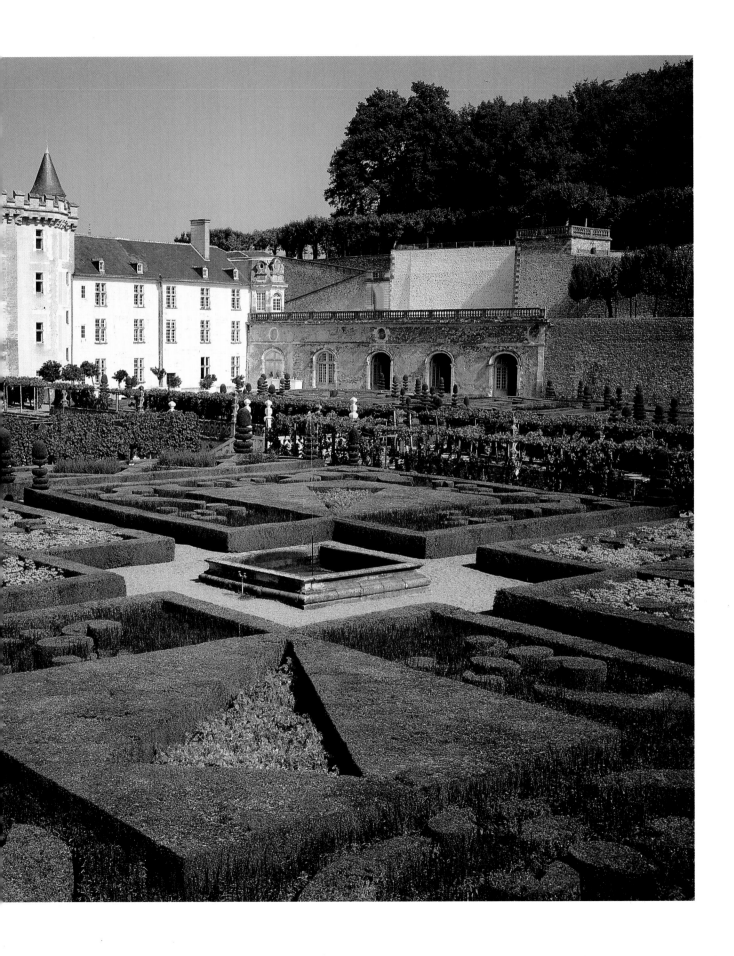

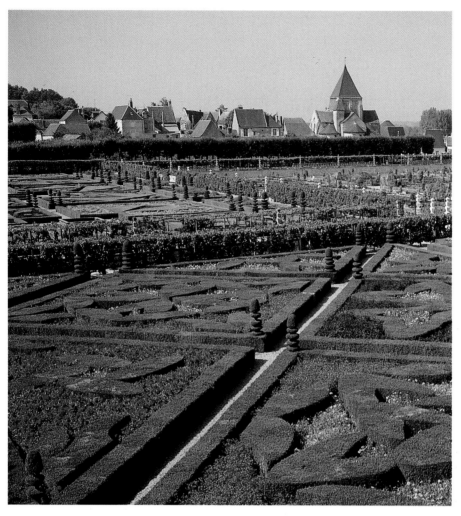

Villandry (Indre-et-Loire). The gardens.

technicians—the Francini brothers. The grottoes in the upper terraces featured automatons and theatrical effects, the delightful details of which are suggested by a superb series of engravings executed in 1614. Perseus and Orpheus were the heroes of these decors, which were far more sophisticated and lavish than the one produced by Primaticcio fifty years earlier at Meudon for the cardinal of Lorraine. Splashing fountains became a mandatory feature, alongside allegorical statues and nymphs. The Francini family, masters in this sphere, constituted a dynasty that played a key role throughout the century, particularly at Versailles. The *Livre d'architecture* published by Tommaso's son in 1631 became a reference manual.

French formal gardens stemmed from lessons learned from Italian mannerist gardens. The never-completed project at Verneuil was only a rough draft of the fanciful extravaganza produced at Saint-Germain-en-Laye, itself a wonder so fragile that it could not stand the test of time, and was permanently dismantled by the count of Artois in the eighteenth century.

But sloping riverbanks were not the only terrain that needed developing. Marie de' Medici, ever keen to borrow and, to a certain extent, adapt the Tuscan model, had Jacques Boyceau design the level grounds around the Luxembourg Palace. He laid out two main axes with curving elements (difficult to imagine today), setting a major example for urban parks.

The poet and critic Malherbe, when lauding "grand, fine buildings of structure eternal / superb in their craft and noble material," did not fail to mention "beautiful grounds and gardens walled / ever with flowers and shady walks."

A generation later, La Fontaine would praise the spectacular château at Vaux-le-Vicomte for combining "architecture, painting, gardens, and poetry." In this way "formal gardens" became a major feature of classical French art, and one of the prides of Europe.

century it was inconceivable to design a château without an esplanade of parterres, perhaps flanked or joined by canals. At Anet, for example, the moats that were only slowly disappearing were the original source of the pools that became typical of French formal gardens, just as waterfalls were typical of Italian gardens.

Everything was rethought and started again, however, at the turn of the seventeenth century.

Henri IV had commissioned the engraver Étienne Dupérac to produce a drawing of the Villa d'Este—the fame of its modern and grandiose grounds, complete with extraordinary fountains, spread everywhere. In front of Philibert de l'Orme's charming new château at Saint-Germain-en-Laye, a prodigious terraced descent to the Seine was projected, comprising six terraces linked by six different stairways, each featuring a surprising element or capriccio involving complicated gushing fountains. But in 1600, there was no engineer in France who could execute such a plan. So Marie de' Medici's brother, the duke of Florence, was consulted, and he dispatched two hydraulic

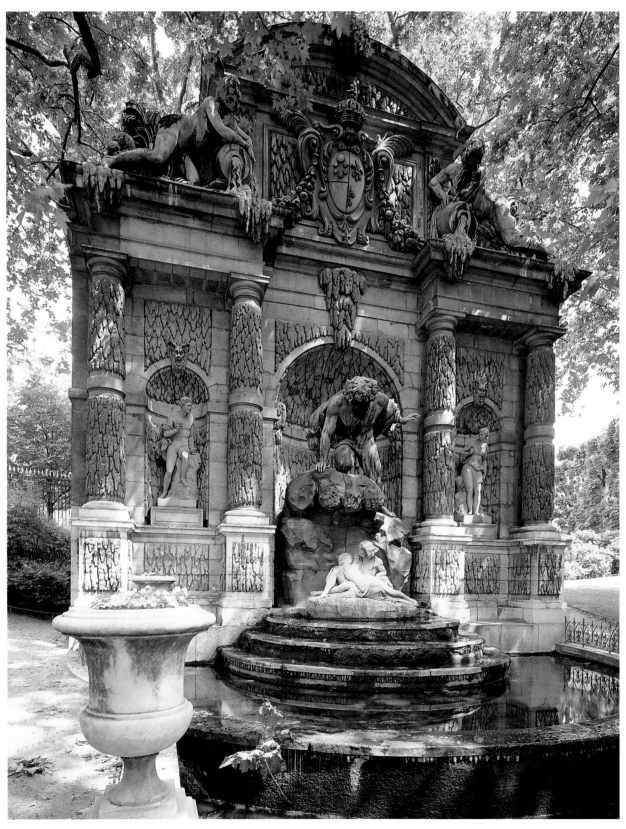

The Medici Fountain. The Luxembourg Gardens, Paris. c. 1620–1630.

NOTES

THE LATE MIDDLE AGES AND THE RENAISSANCE [PP. 9–47]

1. L. Courajod, "La part de la France du nord dans l'oeuvre de la Renaissance," *Gazette des Beaux-Arts*, 3, 1890, pp. 74–82.

2. R. Vaughan and C.A.J. Armstrong, *England, France and Burgundy in the Fifteenth Century*, London: Phaidon, 1983.

3. B. Guenée, "Y a-t-il un Etat des XIV^e et XV^e Siècles?" 1956, reprinted in *Politique et histoire du Moyen Age,* Paris: Publications de la Sorbonne, 1981.

4. J. Krynen, *Idéal du Prince et pouvoir royal en France (1380–1440). Etudes sur la Littérature politique du temps*, Paris: Picard, 1981.

5. C. Beaune, *Naissance de la nation France*, Paris: Gallimard, 1985 (see chapter VIII, "Les lys de France").

6. L. Febvre, *Origines internationales d'une civilisation: éléments d'une histoire de France*, Paris: Unesco, 1951.

7. J. Favier, *Paris au XV^e Siècle (1380–1500)*, 4 Vols., Paris: Hachette, 1974.

8. M. Mollat du Jourdin, *Jacques Coeur ou l'Esprit d'entreprise au XV^e Siècle*, Paris: Aubier, 1988.

9. R. H. Bautier, "Les notaires et secrétaires du Roi des origines au milieu du XVI^e siècle," introduction to A. Lapeyre and R. Scheuer, *Les Notaires et secrétaires du Roi sous les règnes de Louis XI, Charles VIII et Louis XII (1461–1515),* Paris: Comité des travaux historiques et scientifiques, 1978, pp. VII–XXXIX.

10. The curious might refer to Fulcanelli, *Les Demeures philosophales et le symbolisme hermétique dans ses rapports avec l'art sacré et l'ésortérisme du grand oeuvre,* Paris: Canselet, 1929 (third edition, 1965).

11. Dorothy and Henry Kraus, *The Hidden World of Misericords,* New York: Brazillier, 1975. On the Saint-Victor choir stalls, see L. Régnier, "Les stalles de l'abbaye de Saint-Victor. Contribution à l'histoire de la sculpture parisienne sous François I^{er}," *Bulletin archéologique du Comité des travaux historiques et scientifiques,* IV, 1922, pp. 165–222.

12. E. Konigson, *L'Espace théâtral médiéval,* Paris: CNRS, 1975.

13. On this significant development, see A. M. Lecoq, *François I^{er} imaginaire. Symbolique et politique à l'aube de la Renaissance française*, Paris: Macula, 1987.

14. Montaigne, *Essais* (Chapter 23, "On Cannibals," 1580), Paris: P.U.F., 1992, vol. I, pp. 201–213.

PRE-RENAISSANCE: 1420–1500 [PP. 48–101]

1. L. Grodecki, "Le 'Maître des vitraux de Jacques Coeur,'" *Etudes d'art francais offertes à Charles Sterling,* Paris: P.U.F., 1975 (reprinted in *Le Moyen Age Retrouvé*, vol. II, *De Saint Louis à Viollet-le-Duc*, Paris: Flammarion, 1991, pp. 255–277).

2. R. Recht, *Nicolas de Leyde et la sculpture à Strasbourg, 1460–1525*, Strasbourg: P.U.F., 1988.

3. A. Chatelain, *Châteaux forts, Images de pierre des guerres médiévales*, Paris: Desclée de Brouwer, 1991, p. 60.

4. Grodecki, op. cit., p. 262.

5. The identification of the Master of Coëtivy as Henri de Vulcop, suggested by P. Durrieu ("Les Heures de Coëtivy à la Bibliothèque de Vienne," *Bulletin de la Société nationale des antiquaires de France,* 1921, pp. 301–317), and accepted by C. Sterling (*La Peinture Médiévale à Paris, 1300–1500*, II, Paris: Bibliothèque des Arts, 1990, passim) has now been dismissed, notably by N. Reynaud, who initially supported the hypothesis. See N. Reynaud, in the exhibition catalogue by F. Avril and N. Reynaud, *Les Manuscrits à Peintures en France, 1430–1515*, Paris: Bibliothèque Nationale/Flammarion, 1993, p. 53. Avril, in the same publication (p. 101), attributes the illustration in Guillaume de Nangis's *Chronicle* to the Master of Michaut de Guyot Le Peley, a distant follower of the Master of Coëtivy [editor's note].

6. J. B. de Vaivre, "Les cerfs ailés de la tapisserie de Rouen," *Gazette des Beaux-Arts*, Oct. 1982, pp. 93–108.

7. J. Huizinga, *The Waning of the Middle Ages*, (trans. F. Hopman), London: Penguin, 1979, pp. 83 ff.

8. P. Durrieu, "Les armoiries du bon Roi René," *Comptes Rendus de l'Académie des Inscriptsion et Belles-Lettres,* vol. 1, 1908, pp. 102–114.

9. F. Avril, "Une 'devise' du Roi René: le toupin des cordiers," *Florilegium in Honorem Carl Nordenfalk*, Stockholm: Nationalmuseum, 1987, pp. 23–32.

10. F. Avril, *Dix Siècles d'Enluminure Italienne*, Exhibition Catalogue, Paris: Bibliothèque Nationale, 1984, No. 111.

11. F. Salet, Introduction to *Chefs-d'oeuvre de la tapisserie du XIV^e au XVI^e siècle*, Exhibition Catalogue, Paris: Grand palais, 1973–1974.

12. N. Reynaud, "Un peintre français cartonnier de tapisserie aux XV^e siècle, Henri de Vulcop, *Revue de l'Art*, No. 22, 1973, pp. 6–21. At that time, Reynaud still considered Vulcop to be the Master of Coëtivy, see note 5 above. See also G. Souchal, "Un grand peintre français de la fin du XV^e siècle: le Maître de la Chasse à la licorne," *Revue de l'Art,* No. 22, pp. 22–49, and J. B. de Vaivre, "Messire Jehan Le Viste, Seigneur d'Arcy et sa tenture au lion et à la licorne," *Bulletin Monumental*, CXLII, 1984, pp. 397–434 [editor's note].

13. J. Lafond, paper delivered to the Société des Antiquaires de France, 17 January 1962.

14. On Henri de Vulcop and the Master of Coëtivy, see notes 5 and 12 above.

15. *The Last Flowering of French Painting in Manuscripts, 1420–1530, from American Collections*, Exhibition Catalogue, New York: Pierpont Morgan Library, 1982.

16. C. Sterling, "Paoul Grymbault, éminent peintre français du XV^e siècle," *Revue de l'Art*, No. 3, 1970, pp. 17–32. Sterling subsequently adopted the henceforth conventional spelling Goybault. See Sterling, *La Peinture Médiévale*. op. cit. No. 65, 1987, p. 12.

17. F. Avril, "Le destinataire des Heures *Vie à mon désir:* Simon de Varie," *Revue de l'Art,* No. 67, 1985, pp. 29–40. J.H. Marrow, *The Hours of Simon de Varie,* London: Thames and Hudson, 1994.

18. C. Sterling, "La peinture à Tours ou la première Renaissance française," *L'Art du Val de Loire de Jean Fouquet à Jean Clouet, 1450–1540,* catalogue of the exhibition held at the Musée des Beaux-Arts in Tours, Paris: RMN, 1952, p. 19.

19. O. Pächt, "Jean Fouquet, A Study of his Style," *Journal of the Warburg and Courtauld Institutes,* IV, 1940–1941, pp. 85º–102.

20. Huizinga, op. cit.

21. Various identities have been attributed to this anonymous master, from Philippe Mazerolles (A. Châtelet and J. Thuillier, *La Peinture de Fouquet à Poussin,* Geneva: Skira, 1963, p. 55) to a Tournai master, Louis le Duc (C. Sterling, *La Peinture Médiévale à Paris,* Paris: Bibliothèque des Arts, 1990, vol. II, pp. 37–49). According to the most widely accepted hypothesis (B. Fredericksen, "A Parisian Triptych Reconstructed," *J. P. Getty Museum,* II, 1983, pp. 183–196, and F. Avril and N. Reynaud, *Les Manuscrits à Peintures en France 1440–1520,* op. cit, p. 53) the retable is the work of the Master of Dreux Budé, an artist also known for a triptych of the Passion (central panel at the J. P. Getty Museum, Malibu, California, and side panels in the Bischoff collection, Bremen, and Fabre Museum, Montpellier) [editor's note].

22. A. Châtelet and J. Thuillier, op. cit, p. 52.

23. See N. Reynaud's entry in M. Laclotte (ed.), *Larousse de la Peinture,* Vol. II, pp. 1087–1088, "Maître de l'Annonciation d'Aix," as well as D. Thiébaut's *L'Ecole d'Avignon,* Paris: Flammarion, 1983, pp. 67–74 and 218–222.

24. F. Avril, "Pour l'enluminure provençale: Enguerrand Quarton, peintre de manuscrits," *Revue de l'Art,* No. 35, 1977, pp. 9–40.

25. Vasari, *Les Vies des meilleurs peintres, sculpteurs, architects,* French edition edited by A. Chastel, Paris: Berger-Levrault, Vol 5., p. 174.

26. Museum of Art, Philadelphia, Walters Art Gallery, Baltimore, Galleria Nazionale, Rome, and the Hermitage, Saint Petersburg. Recent studies have brought to light the important role played by Josse Lieferinxe in southern painting of the day. See in particular M. Laclotte and D. Thiébaut, *L'Ecole d'Avignon,* op cit, pp. 255–264, and D. Thiébaut, "Josse Lieferinxe et son influence en Provence: Quelques propositions, *Mélanges en l'honneur de Michel Laclotte,* Milan: Electa, 1994.

27. C. Sterling, "Jean Hey, le Maître de Moulins," *Revue de l'Art,* No. 1–2,1968, pp. 27–33.

EARLY RENAISSANCE: 1490–1540 [PP. 102–165]

1. A discussion over the height of the arches took place in July 1500 between Parisian master masons and "brother Jehan Joyeulx," that is to say Fra Giocondo. See V. Fontana, *Fra Giovanni Giocondo, 1433–1515,* Vicencza: Neri Possa, 1988.

2. J. Vernet-Ruiz and J. Vanuxem, "L'Eglise de l'abbaye de Saint-Martin-aux-Bois," *Bulletin Monumental,* CIII (1945), pp. 137–173.

3. P. Vitry, *Michel Colombe et la Sculpture Française de son Temps,* Paris: Librairie Central de Arts, 1901.

4. M. L. Polidori, *Monumenti e mecenati francesi in Roma,*Viterbo: Quatrini, 1969.

5. W. Forsyth, *The Entombent of Christ: French Sculpture of the 15th and 16th Centuries,* Cambridge, Mass: 1970, and K. Weil-Garris Brandt, "Michelangelo's *Pietà* for the Cappella del Re di Francia," *Il se rendit en Italie. Etudes d'art offertes à André Chastel,* Paris: Flammarion, 1987, VIII, pp. 77–119.

6. Vasari referred to a *tempio tondo,* confusing the church with a monument to the French king, decorated with reliefs glorifying the monarch. C.L. Frommel, "S. Luigi dei Francesi: Das Meisterwerk des Jean de Chennevières," *Ibid.,* XII, 169–193.

7. A. Lenoir, *Statistique monumentale de Paris,* Paris: 1867. Viollet-le-Duc, *Dictionnaire d'architecture,* vol. VII. A. Chastel, "Les vestiges de l'hôtel Legendre et le véritable hôtel de la Trémoille," *Bulletin Monumental,* CXXIV, 1966, pp. 17–29.

8. A. Blunt, "L'influence française sur l'architecture et al sculpture decorative en Angleterre pendant la première moitié du XVIᵉ Siècle," *Revue de l'Art,* No. 4, 1969, pp. 17–29.

9. M. Laclotte, "Quelques tableaux bourguignons du XVIᵉ siècle," *Studies in Renaissance and Baroque Art Presented to Anthony Blunt on his 60th Birthday,* London/New York: Phaidon, 1967, XVII, pp. 83–87.

10. L. Pressouyre, "Les fresques de Laffite-sur-Lot et l'italianisme en Agenais," *Fondation Eugène Piot, Monuuments et mémoires,* Paris: Académie des Inscriptions et Belles-Lettres, vol. LII, 1962, pp. 95–116.

11. M. Thibout, "Le décor peint de l'oratoire de la Roque en Périgord," *Revue des Arts,* IX, 1959, pp. 50–56.

12. A. M. Lecoq, op. cit [see note 13 of the introduction]

13. Vol I, British Library, London, Ms. Harley 6205; Vol. II, Paris, Bibliothèque Nationale, Fr. 13429; Vol III, Musée Condé, Chantilly, Ms. 1139.

14. C. Sterling, "Un portrait inconnu par Jean Clouet," *Studies in Renaissance and Baroque Art,* XVIII, No. 36, 1967, pp. 89–90.

15. E. Panofsky, *Tomb Sculpture,* London, 1964, pp. 78–79.

16. J. Evans, *Monastic Architecture in France from the Renaissance to the Revolution,* Cambridge, CUP, 1964.

17. B. Jestaz, "Le château de Fontaine-Henry, Observations et hypothèses," *Congrès archéologique de France, Bessin et Pays d'Auge,* 1978, pp. 313–371.

18. R. Coope, "The 'Long Gallery': Its Origins, Development, Use and Decoration," *Architectural History,* 29 (1986), pp. 43–72.

19. M. Chatenet, "Une demeure royale au milieu du XVIᵉ siècle," *Revue de l'Art,* No. 81, 1988, pp. 20–30.

20. J. Androuet Du Cerceau, *Des Plus Excellents Bâtiments de France,* Vol. I, Paris: 1576.

21. S. Béguin, O. Binenbaum, A. Chastel *et. al.,* "La Galerie François Iᵉʳ au Château de Fontainebleau," *Revue de l'Art,* No. 16–17, 1972, pp. 5–174.

HIGH RENAISSANCE: 1540–1570 [PP. 166–245]

1. See A. Chastel, *Introduction à l'histoire de l'art français,* Paris: Flammarion, 1993, pp. 138–155.

2. Chatenet, *op. cit* . p. 29.

3. J. Jacquot (ed), *Les Fêtes de la Renaissance,* Paris: CNRS, 1956.

4. McAllister Johnson and G. Monnier, "Caron 'antiquaire,' A propos de quelques dessins du Louvre," *Revue de l'Art,* No. 14, 1971, pp. 23–30.

5. From a 1701 inventory of crown furnishings, cited in Havard, *Dictionnaire de l'ameublement,* Vol. 3. p. 19.

6. F. Yates, *French Academies of the Sixteenth Century,* Studies of the Warburg Institute, London: 1947.

7. A. Saunders, *The Sixteenth Century French Emblem book, A Decorative and Useful Genre,* Travaux d'humanisme et Renaissance, CCXXIV, Geneva: Droz, 1988.

8. The drawings by Antoine Caron were engraved by his son-in-law Thomas de Leu and by Léonard Gaultier. See J. Ehrmann, *Antoine Caron, peintre des fêtes et des massacres,* Paris: Flammarion, 1986, p. 182. These images provided models for mythological allegories for a long time to come.

9. See the special "Palissy" issue of *Revue de l'Art,* No. 78, 1987, pp. 26–83.

10. J. Boucher, *La Cour d'Henri III,* Paris: Ouest-France, 1986.

11. A. Blunt, *Art and Architecture in France, 1500–1700,* London: Penguin, 1988, p. 136.

12. V. H. Hoffmann, "DONEC TOTUM IMPLEAT ORBEM: Symbolisme impériale au temps de Henri II," *Bulletin de la Société de l'Histoire de l'Art Français,* 1978 (1980), pp. 29–42.

13. Philibert de L'Orme, *Architecture,* Paris: 1567, f. 252 and D. Thompson, *Renaissance Paris, Architecture and Growth, 1475–1660,* London: Zwemmer, 1984, p. 191.

14. M. Dubuisson, "L'hôtel de Vauluisant," *Congrès Archéologique de France,* Troyes: 1955, pp. 168–172.

15. L. M. Golson, "Serlio, Primaticcio and the Architectural Grotto," *Gazette des Beaux-Arts,* Feb. 1971, 2, pp. 95–108.

16. See note 9.

17. On the Galerie d'Ulysse, see S. Béguin, J. Guillaume, and A. Roy, *La Galerie d'Ulysse à Fontainebleau,* Paris: PUF, 1985. The attribution of drawings based on the no-longer-extant decoration is disputed, as are those of the Faur residence (see above and note 87); they were probably by Diepenbeeck and not by van Thulden. See J. Wood, "Padre Resta's Flemish Drawings: Van Diepenbeeck, Van Thulden, Rubens and the School of Fontainebleau," *Master Drawings,* XXVIII, 1990, pp. 3–53 [editor's note].

18. S. Béguin, "Luca Penni, peintre: Nouvelles attributions," *Il se rendit en Italie,* op. cit., No. 32, XVII, pp. 243–257, and C. Grodecki, "Luca Penni et le milieu parisien: A propos de son inventaire après décès," *Ibid.,* XVIII, pp. 259–177.

19. Around 1540, Claude Gouffier completed the château d'Oiron, begun by his father Artus. It was remodeled again in the seventeenth century, except for the north wing where the gallery in

question is located. The exterior of the gallery is decorated with medallions of emperors and niches with fine busts, executed by a sculptor who had clearly assimilated the lessons of Fontainebleau.

20. H. Naëf, "La vie et les travaux de Jean Duvet, le 'Maître à la Licorne,'" *Bulletin de la Société de l'histoire de l'art français,* 1934, pp. 114–141.

A TIME OF CRISIS [PP. 246–305]

1. Y. M. Bercé, *Fêtes et révoltes. Des mentalités populaires du XVIe au XVIIe siècle,* Paris: Hachette, 1976.

2. L. Pressouyre, "Trois *Mises au tombeau* ignorées en Aquitaine: Saint-Céré, Sauvagnas, Pujols," *Revue archéologique,* 1962. pp. 51–81.

3. D. Cordellier, "Dubreuil, peintre de la *Franciade* de Ronsard au château neuf de Saint-Germain-en-Laye," *Revue du Louvre,* 1985, 5/6, pp. 357–378, and S. Béguin, "Un nouveau tableau de Toussaint Dubreuil pour le Château neuf de Saint-Germain," *Scritti di storia dell'arte in onore di Raffaello Causa,* Naples: Electa Napoli, 1988, pp. 142–145.

4. See C. Jouhaud's article in R. Chartier (ed), *Les Usages de l'imprimé: XVe–XIXe siècles,* Paris: Fayard, 1986.

5. L. Châtelet-Lange, "La 'forma ovale si come costumarono li antichi romani': salles et cours ovales en France au XVIe siècle," *Architectura,* Munich, VI, No. 2, 1976, pp. 128–147.

6. S. Béguin and B. Bessard, "L'hôtel du Faur, dit Torpanne," *Revue de l'Art,* No. 1–2 (1968), pp. 38–56. (Editor's note: on the attribution of the drawings, see note 17, above).

7. D. Thomson, *Renaissance Paris,* op. cit., No. 61, p. 135.

8. Y. Bruand, "Le château de Ferrals," *Congrès archéologique de France, Pays de l'Aude,* 1973, pp. 458–481.

9. J. Guillaume, "Le phare de Cordouan, 'Merveille du monde,' et monument monarchique," *Revue de l'Art,* No. 8, 1970, pp. 33–52.

10. G. de Nerval, "La main enchantée," *La Bohême galante,* Sainte-Maxime: Editions d'aujourd'hui, 1984.

11. See. A. Chastel, *Introduction à l'histoire de l'art français,* op. cit., No. 49, pp. 151–152.

12. Exhibition on *Salons littéraires au XVIIe siècle,* Bibliothèque Nationale, Paris, 1968.

13. Zamet was entrusted with the superintendence of the Fontainebleau buildings in 1599. See B. Barbiche, "Henri IV et la surintendance des bâtiments," *Bulletin monumental,* CXLII, 1984, pp. 19–39. On the arrangement and furnishing of his residence, see C. Grodecki, "Sébastien Zamet, amateur d'art," proceedings of the symposium titled *Avènement d'Henri IV. Quatrième centenaire. Les Arts au temps d'Henri IV,* Fontainebleau: 1992, pp. 185–228.

14. R. Coope, "John Thorpe and the Hotel Zamet in Paris," *Burlington Magazine,* 124, Nov. 1982, pp. 671–681.

15. L. Châtelet-Lange, "Deux architectures théâtrales: le château de Grosbois et la cour des offices à Fontainebleau," *Bulletin monumental,* CXL, 1982, pp. 15–39.

16. J. Thuillier, "Peinture et politique: une théorie de la galerie royale sous Henri IV," *Etudes d'art offertes à Charles Sterling,* op. cit., No. 1, pp. 175–205.

17. G. M. Leproux, "Une famille de peintres-verriers parisiens, les Pinaigrier," *Fondation Eugène Piot, Monuments et mémoires,* Académie des inscriptions et belles-lettres, LXVII, 1985, pp. 77–111. See also Leproux, *Recherches sur les peintres-verriers parisiens de la Renaissance,* Geneva: Droz, 1988.

18. J. Wilhem, "Pourbus, peintre de la municipalité parisienne," *Art de France,* III, 1963, pp. 114–123.

19. C. Limousin, "Le château de Saint-Amand-Montrond et les collections d'Henri II de Bourbon, prince de Condé (1588–1646)," *Bulletin de la Société de l'histoire de l'art français,* 1986 (1988), pp. 25–31.

20. F. Enaud, "Les peintures de Villeneuve-Lembron," proceedings of the *Art de Fontainbleau* symposium, Paris: CNRS, 1975, pp. 135–197.

21. G. Gaillard, "Documents sur la construction du château de Vizille," *Urbanisme et architecture,* Studies written and published in honor of Pierre Lavedan, 1954, pp. 127–133.

22. F. Gébelin, *Les Châteaux de France,* Paris: PUF, 1962.

23. C. Grodecki, "La construction du château de Wideville et sa place dans l'architecture française du dernier quart du XVIe siècle," *Bulletin monumental,* CXXXVI, No. 2, 1978, pp. 135–175.

Introduction to the History of French Art

Extracts[1]

Access to Artworks

The artistic output of France is vast, immeasurable and dispersed.
Collections and museums ultimately provide only an incomplete idea of it.

Since chronicles and documents mention this activity only in passing, questions arise concerning the status of all these artworks, of all these artisans, of their exact role and how they were perceived at the time. Contrary to what might be expected, answering these simple questions is not easy, due to a lack of evidence. Although fortuitous information can be found in inventories, testaments and contracts, such documents are disappointing insofar as they basically provide details on prices and practices that reduce everything—furniture, paintings, tapestries—to the level of a monotonous catalogue, without enlightening us on how the owner felt about such objects, or how they were appreciated at the time.

Increasingly close study of the "context"—commissions and guild statutes—has led to a more constrained conception of the relations between artists and works. Modern museums and publications, meanwhile, make it feasible to establish an imaginary relationship among works between which no real contact was possible. Art history thus tends to take on a fantastic, exciting nature.

 Yet history nullifies much of this by raising a simultaneously modest and perverse question—how accessible were artworks? In other words, what did a Romanesque sculptor, or a Parisian painter of 1560, or an architect of 1640 know of art? Churches long served as museums for those not able to travel. The hoards of manuscripts with wonderful paintings, assembled by princely houses around 1400, were not continuously available to miniaturists, while the art collections so swiftly constituted in France and England after 1600 were far from being easily accessible. This makes it essential to understand the immense role played by prints and, often enough, by drawings and rapid sketches. Elements of visual information thus circulated in a crucial yet fleeting way. The phenomenon of chaining, or straightforward *linking*, was the principle behind the most ancient communication networks, reinforced by institutions (especially religious) and by time. But little by little styles began circulating in other patterns, along what might be called *folds* (or lines of force) and *cores* (or established centers). The Benedictine order, whose superiors traveled a great deal, thus functioned as a transmission belt between southern Italy, Burgundy, and Normandy. Workshops assumed greater authority and, to take a somewhat later example, there was an intense exchange of paintings and luxury objects in the late fifteenth and early sixteenth century between Naples and Provence, between Florence, Milan, and the Loire Valley, thereby constituting the "folds" of 1500. It was only later that a core formed—at Fontainebleau—to consolidate the situation and further disseminate artworks.

[1]From *Introduction à l'histoire de l'art français,* by André Chastel, Paris: Flammarion, 1993.

FORMS PERPETUATED BY CUSTOM

It is sometimes surprising to discover that elements of ancient art—more or less disfigured and usually re-labeled to correspond with some legend—survived in many places, including churches. A thirteenth-century fountain at a crossroads in Limoges featured an equestrian statue of an emperor called Constantine (the statue disappeared in the seventeenth century). The beauty and originality of given forms could generate a power of attraction that, although occasionally based on a vague *amor antiquitatis,* still attested to the physical quality of the *opus* or vestige.
The antique-style statues obtained by the Valois kings provide a good example of "appropriation"—Michelangelo's marble *Hercules* (circa 1493) was acquired around 1530 and set on a fountain (at Fontainebleau).

Documents refer to numerous statues of Bacchus, Neptune, and so on crowning fountains commissioned for stately residences in the last third of the century from major artists like Pilon, Bontemps, and B. Prieur (See L. Châtelet-Lange, "Die Statue 'à l'antique' im französischen Garten des 16 H.," *Osterreichischen Z. f. Kunst v. Denkemalfflege,* XLI, 987, p. 97 ff.).

As long as the antique model remained *present*—that is, lacking historical distance—it could be more or less followed, more or less disfigured, manipulated, recast, and adapted.

The antique repertoire incorporated into the French landscape was thus fragmentary, broken, poorly understood—an object of legends.

When antiquity became an object of history, a new era dawned—the Renaissance.

FRANCE, FILTER OF THE WEST

France assimilated foreign-born writers only exceptionally—Christine de Pisan comes to mind. Giambattista Marino, invited to Paris by Marie de' Medici, did not pursue his career in Paris, since the jealously of local writers would not have allowed it. The situation was entirely different, however, with artists and craftsmen who were summoned (or who offered their services) whenever local production required it.

Painters enjoyed the greatest mobility. Paris around 1400 was the major cosmopolitan center of "International Gothic" and a remarkable group of Flemish miniaturists thereby entered the sphere of French art. However, the most extraordinary case was that of the Italian artists summoned to Fontainebleau in 1530–1531. As has often been noted, thanks to royal patronage, Rosso and Primaticcio were able to develop a grand, magnificent art quite different from the one they practiced in Italy. It would meet with unprecedented success.

It is difficult not to see this development as a successful example of "accumulation" that demonstrates the power of the "milieu" established by the French court.

The relationship between France and Italy calls for special attention. General histories tend to misrepresent it by overlooking the constant contact maintained throughout the Middle Ages by the Roman Catholic magisterium, pilgrimages, and religious orders. They also overstate the impact of the "descent into Italy" by the last Valois kings, ignore the role of music, dance and theater, overlook the osmosis that emerged at the end of the Renaissance (and that, for nearly a century and a half, used Italian models to fuel an undisguised rivalry), and finally reduce to a simple question of taste the archaeological excitement that sparked the new Franco-Italian classicism of the half-century straddling the year 1800.

The relationship between France and Italy scarcely conforms to the traditional picture drawn by Voltaire and Michelet, who ascribed a revelatory cultural role to the "descents into Italy" made by Charles VIII and Louis XII. Things appear differently if two well-attested but insufficiently appreciated facts are taken into account. In the escapade that took him as far as Naples in 1492 (and ended less than a year later, much earlier than he would have liked) Charles VIII was not embarking his knights on a quest for Renaissance enlightenment, but rather offering

them the conquest of new lands and attractive booty. This unscrupulous greed gave the French nobility a reputation for being brutal and uncultivated. The king's return baggage (pillaged during the crossing of the Apennines) contained a heterogeneous mass of precious objects and domestic furnishings, and the list of people bought back to Blois also reveals the practical nature of the court's concerns—from incubating machines to gardeners, everything involved comfort. Even in the days of Louis XII, only several high-ranking nobles like Charles d'Amboise, governor of the duchy of Milan, had any real contact with Italian art. French nobles were too imbued with their own superiority to interest themselves in anything other than portable treasures and prestigious objects. The fashion for decorative "medallions" on facades was typical of stylish ornamentation, being simultaneously pretentious and facile. But, even when they portrayed a silhouette of Dante or Petrarch or copied a coin of Caesar or Diocletian, these standard medallions represented a fashionable motif rather than an artistic statement. The use of decorative elements was, moreover, considerably anterior to the French court's Italian expeditions, and such models did not make their way into France via army baggage. A similar evolution occurred throughout the fifteenth century between late Gothic and Lombard decoration: early in the century, the deployment of "international art" spurred the same concern for aristocratic elegance and charm in the Viscontis' Milanese miniatures and in paintings executed for the duke of Berry. Likewise, both Milanese painters and illustrated romances were known to the court of Burgundy. French political intrigue always involved Italian cities, and Italian was spoken at the French court in the days of Louis XI.

Designs, moldings, niches, and consoles, along with a composed window from his treatise based on the third storey of the Palazzo Farnese—these are the elements that Philibert de L'Orme retained from Michelangelo:

It was at Saint-Maclou, that surprising temple of the "hyper-Gothic," that the newest works appeared around 1540—the columns of the organ loft and the "Fontainebleau-style" doors by Jean Goujon.

As has been pointed out, the new design that used multi-leveled pilasters to organize a facade is an adaptation of a Lombard approach, but one employing an element of Gothic architecture.

Genealogy: Births

The Dauphin (later Loius XIII), son of Henri IV and Marie de' Medici and therefore head of the Bourbon line, was born in September 1601; in January 1602, a chalk drawing of him was done, and at age seven months his portrait was painted by Quesnel, engraved, "printed" in wax and in terra cotta; at age six, the child (known to enjoy drawing lessons with Fréminet) posed with ruffed collar and doublet for an official portrait by Pourbus. In 1610, a "warrior" medal was struck.

In a 1602 treatise demonstrating the "necessity to reestablish the very ancient and august public usage of true and perfect medals," Antoine Rascas de Bagarrie reminded Henri IV that a monarch was assured "glory and last fame" not only by heroic acts but also and above all by what perpetuated them, that is to say the Arts and Sciences, the most accomplished expression of which was the medal.

The Reign of Symbols

A king's ceremonial entry into a city might be treated like the Gospels or the Epiphany; a relationship was sometimes suggested with Christ's entry into Jerusalem, itself a prefiguration of entry into the heavenly Jerusalem; there was an inevitable association between the canopy used for royal processions and the one used for Corpus Christi.

For fifty years Lyon was not only a base for military operations, but also center of theosophy and the science of emblems. During Francis I's entry into Lyon, the spectacle on the Sâone River included a ship drawn by the "winged

stag" symbolizing the Valois family under an enormous pavilion with Francis's salamander emblem. The ship bore the young king as well as Queen Claude and her sister, Renée. Eight Virtues depicted on columns each held one of the letters of the king's name [François].

The emblem of the Sun King was used for Charles IX's entry into Toulouse in 1464, and again in La Rochelle, where he was feted:

"As a flaming, radiant sun Charles the Ninth on royal throne."

The crucial political importance of these visits by monarch and court have long been studied and discussed; they provided an occasion for the allegorical glorification of the king and the city welcoming him. However, here it is also worth stressing their highly diverse and sometimes crucial impact on artistic activity.

The "richly accoutered gate as a sort of triumphal arch" provides, in a way, the key to the issue. "Ancient-style" arches would become the mandatory motif for all decoration, as already practiced in Italy. But initially the gateway played a highly symbolic role marking the starting point of a procession and other key sites along the route. Thus in 1549 an "Arch of Strength" was erected at Porte Saint-Denis in Paris, while two others—"Argonaut Arches"—were set up on Notre-Dame bridge.

"The cock started to become the emblem of France during the fifteenth century." (Michel Pastoureau, *Culture et idéologie dans la genèse de l'Etat moderne*, Ecole Française de Rome, 1985, pp. 150–151). However, this symbol was imposed by foreigners, in mockery of French pretensions and it never acquired official validity.

The association of *gallus* (cock) with *Gallia* (Gaul, later France) is obvious, but it was with spite that the emblem of the cock was attributed to the battling, haughty French. A mascot imposed from the outside, often used in caricature—it was not adopted or popular until the French Revolution, in defiance of the British lion and the imperial eagle.

Its great familiarity to the French today barely disguises its unflattering image of the national character.

During the Renaissance, there was an attempt to adopt a flattering national emblem, namely Hercules as the champion of eloquence—*Hercules Gallicus.*

It was never much appreciated.

In a short poem titled *Regnault et Jehanneton* (circa 1454), King René evoked a *turtur* (turtledove) perched on a *rain* (redcurrant branch) calling her *per* (peer, or mate). It served as the point of departure for an emblematic image of Jeanne de Laval, his second wife, and was subsequently used on the back of the Laurana medal (1461) with the motto *per non per* (pair without peer). The chained turtledoves and red berries were also depicted on manuscripts, items of gold and silver, and wall paintings. Just as the passion for heraldry was waning, a new era dawned—one of emblems which provided an unanticipated outlet for inventive symbolism and imagination, extending into the heart of the seventeenth century.

An "absolute" monarch's relationship to his country is often construed naively. The monarchy was restricted by jurisdictions not to be trifled with. The Louvre is a revealing example of these limits. Philip Augustus's old castle, renovated by Charles V, originally opened directly onto the countryside, but construction had occurred both to the west (where an entire neighborhood continued to exist into the middle of the nineteenth century) and in the city to the east, where numerous aristocratic residences sprang up around the church of Saint-Germain-l'Auxerrois. The modernization of the monarch's palace therefore led to all sorts of conflict, in which the royal government did not completely triumph; the development of the Louvre could only be imperfectly carried out, which explains the long gallery built along the Seine to join the Tuileries Palace. When the Louvre received Perrault's facade, all plans for a large square leading to it from the city side were dashed. As compared to the impotent ancien régime, the Second Empire (1850–1870) was able to carry out urban development transforming the old city into a new one.

"It was in the year 1476 that the first printed version of the history of France appeared, under the title *Grandes Chroniques*. It was an old body of annals compiled in French by monks at Saint-Denis, long known as the *Chroniques de Saint-Denis*" (Augustin Thierry, "Sur les différentes manières d'écrire l'histoire en usages depuis le XVᵉ siècle," *Lettres sur l'histoire de France*, Paris 1820).

This compilation was epoch-making, especially in 1492 when adapted and abridged into a manageable volume by Nicolas Gilles, secretary to Louis XII, with the title *Annales et Chroniques de France*. Although "lacking erudition and talent," this volume enjoyed long popularity, and by 1617 sixteen editions had appeared. It is a fairly good representation, not of the state of historical knowledge, but of the global and fanciful vision of the past that was current during the Renaissance.

The abbey chronicles basically constituted France's national archives, each reign simply adding its own chronicle. It is perhaps the most complete anthology of France's "fabled" history, containing all the legends, all the stories, and all the staging of moving, dramatic, heroic scenes of the past.

As fugitives from the fall of Troy, Francio, a son of Hector, founded the city of Sicambria, and so the Greek line became French. Paris was founded. The third king was Merovech, who established the Merovingian dynasty. The Carolingian epic followed.

Around 1458, Charles VII commissioned Jean Fouquet to illustrate his copy of the *Grandes Chroniques*. All historical scenes were set in a familiar French landscape—Dagobert before Montmartre, Philip Augustus before Tours with its towering abbey of Saint-Martin.

THE GRAND MONARCH OF THE WEST

France experienced the institution of monarchy fully and passionately. The very violence with which it collapsed was proof of this intense attachment. There were three or four moments when everything seemed to coalesce around the monarch—certainly around Louis IX, and in a more poignant way around Charles VII after 1430. The first ten years of Francis I's reign were typical of the general enthusiasm that occurred whenever youth, ambition, and hedonism imparted a special aura to the monarch.

"In January 1564, King Charles IX and the Queen Mother began a tour that was to last more than two years. . . . One of the goals was to visit all the frontiers of the kingdom, frontiers that had been of minor consequence back in the days of Saint Louis; three centuries later, the boundaries of the kingdom had become the borders of France—inalienable, inviolable, and sacred," (B. Geremek, 1986).

NOBILITY AND BOURGEOISIE

When the broad lines of the relationship between government and culture are deliberately followed, without omitting any of the structural developments, something simple and grave strikes the eye. Economic activity was not favored by the traditional attitude of the aristocracy, which abandoned "merchandise" to another social group, one beneath it. However, the enterprising spirit of members of this "third estate" sometimes needed the monarch's backing, which it periodically received in the fifteenth, sixteenth, and seventeenth centuries. Yet by a vagary typical of the *ancien régime*, financiers who climbed too high inevitably displeased the king, leading to Charles VII's dismissal of Jacques Cœur, Francis I's sentencing of Semblançay, and Louis XIV's imprisonment of Nicolas Fouquet. This is probably the reason that grand capitalism was not born in France. Could a similar phenomenon have occurred in the realm of art? The question comes all the more naturally to mind insofar as—the needs of the Church excepted—the activity of painters and sculptors was constantly linked to the demands and resources of high-ranking nobility.

The importance of everything done at court, for the court, became a feature typical of France, all the easier to observe in the trajectory that the institution maintained throughout all crises.

The Spirit of Self-Destruction
The Art of Vandalism

The quai des Célestins in Paris is named after a Celestine monastery that occupied a large rectangular plot to the southwest of the Bastille (today traversed by boulevard Henri IV, with a barracks occupying the site of the monastery buildings). The monastery enjoyed the favor of Charles V, who is depicted with the queen on the portal, and above all became the site of tombs of important nobles such as Longueville and Cossé-Brissac, as well as the site of the funerary monuments holding the hearts of Henri II (the work of sculptor Germain Pilon) and Francis II. During the great wave of iconoclastic destruction, Richard Lenoir rescued what he could and the major pieces ended up in the Musée des Grands Augustins.

In 1590, the château of Anet belonged to the duke of Aumale, a brutal opponent to the accession of Henri IV; when the duke was convicted by *parlement*, it was ordered that his residence be razed to the ground as was the custom. But Henri opposed this measure "in order not to lose such a noble work, innocent of the evil of its owner." The king made a gift of the château to one of his illegitimate sons, César de Vendôme, who lived there and embellished the grounds.

Numerous studies have drawn up lists of the destruction caused by hatred or contempt. They are easy enough to understand, ultimately, when it is realized that symbols of a detested order were targeted. In France, instinctively intolerant, people were unaware or wanted to remain unaware that it was also a question of works of art erected, carved, and decorated by people like ourselves.

Iconoclastic vandalism: in 1562, the Huguenots went on a rampage in the Loire Valley: Orléans, Notre-Dame de Cléry, and the poor Cistercian church at Charité-sur-Loire were ravaged with the ferocity that only religious panic can spark. The destruction caused by the Wars of Religion was far more serious and profound than is usually recognized.

During the French Revolution, the Jacobins were able to kill two birds with one stone at the abbey of Saint-Denis by destroying the statue-columns that symbolized "superstition" and by gutting the tombs representing "oppression." This symbolic gesture was widely imitated.

Le Mans was captured by the Huguenots. At Saint-Julien Cathedral, the choir stalls, rood screen, and other furnishings were "smashed, broken, [and] ravished" according to the detailed assessment drawn up immediately afterward, with a view to reparations.

The stalls, repaired in 1576, were neglected, then destroyed two centuries later during another outbreak of violence.

"That Somewhat Dry Clarity"

Montaigne's attitude is revealing of a certain mistrust, almost aversion, regarding the pretensions of architect and decorator. . . . They should remain in their place, silent and efficient. This sheds light on one of the notable lacunae in the French mentality. The moralist's annoyance with specialists and technicians. The concern to put language to work at intellectual and moral analysis. Which led to a major purge of the very language so delightfully used by Montaigne. The logic of his argument was the elaboration of a filtered, monitored language reduced to essentials.

An admirable effort at clarity and, even better, wonderfully transparent language guaranteed a pure, perfect moment of humanity.

There had been Rabelais, Bonaventure de Périers . . . and a few eccentrics in the early seventeenth century, but after Malherbe and Charron the French "tradition" was no longer open to the eccentricities and excesses of the imagination.

It is impossible to survey the French realm without perceiving, under the veneer of clarity and propriety, a latent dryness, an intellectual resistance to anything peculiar, to the disorder of vital drives. What reigned, or tended to reign, in France was the *egotism of Reason*.

A TASTE FOR CONSTRUCTION

Recent research has shown that the evolution of urban development was cautious and tightly controlled by property interests. The organization of inhabited space was a long and complicated affair, all the more so when acquired habits were threatened. New ideas were not easily accepted, and when one of them took shape it might require an incredibly long time to effect the necessary initiatives, purchases and exchanges; in 1532 Francis I decided to build Saint-Eustache—a church as large as Notre-Dame—in central Paris. The operation lasted over a century. There was an original chapel, the chancel of which occupied more or less the right site, but to the east there was a cemetery to be moved (that dreadful practice) and an uncrossable barrier in the form of rue Montmartre. To the west, meanwhile, the border on rue Trainée was established only in the early seventeenth century, and even then the facade had to be set at a skewed angle. That facade, with its two towers, aspired to be typically French but was poorly built and had to be demolished in 1688. The ultimate facade was designed by Mansart de Jouy in 1754 to carry two heavy storeys and to create an esplanade in front. Once again, everything took a great deal of time, and work halted in 1788 with only one of the two planned towers completed, rendering the right side of the composition unintelligible with its motifs bordered with columns.

Government business included numerous decisions concerning buildings and their decoration—Henri III had a stained-glass window of the Holy Ghost placed in Cléry in 1583 and built a chapel in the Augustinian monastery.

According to French practice, the central body of a building was to be simple and "transparent" tan effect achived by the placement of windows on both sides, as can be seen in the models published in du Cerceau's first *Livre d'architecture* in 1559.

The rejection of designs more than one room deep continued into the seventeenth century and still amazed Bernini.

Residences were judged by their staircases, and it was in France that the most original and often most brilliant staircases were to be found over the ages, yielding a rich and sustained history. This was only possible in a country particularly attentive to such things.

"The large porches of churches in the Léon region of Brittany allow the columns of Philibert de L'Orme to be seen side by side with ornamentation by du Cerceau, Gothic vestiges, and overall arrangements of freely-combined forms." (A. Mussat, "Introduction à l'architecture régionale," *Culture et Création dans l'architecture provinciale de Louis XIV à Napoléon III,* Aix-en-Provence, 1988).

This juxtaposition of canonic types arranged not according to compulsory figures but as free elements can be found everywhere in France in somewhat less ostentatious form.

Architects of the day played freely with combinations of elements that could be called fashionably "mannerist"—such as pendant bosses, delightfully liberal rustication, and quoin-work. The classical "orders" were totally ignored. Arcades were embellished with decorative panels in the spandrels, as were the bases of windows. The design of a facade of a house built at Chalon-sur-Saône in 1614–1615 was included in Gentilhâtre's anthology (RIBA, London) which contains an authentic repertoire of the delightful concoctions of the day (L. Chatelet-Lange, "Dessins de Gentilhâtre," *Monuments Piot*, 1988).

A few details, both interior (the alcove—a Spanish term) and exterior (the ceramic tiling more or less similar to that found in Andalusian gardens), suffice to explain why the large château built in the Bois de Boulogne from 1528 onwards was called the Château de Madrid.

"It [the Hôtel de Rambouillet] was a house of brick, set off with stone embrasures, amortizements, quoins, cornices, friezes, architraves, and pilasters."

When Arthénice (the name chosen by Malherbe for the marquise de Rambouillet) built her house, brick and stone were the only materials used in grand buildings. They won strong applause when used at the Place Dauphine and Place Royale as well as at the châteaux of Verneuil, Montceaux, Fontainebleau, and several other royal and public edifices.

"The redness of brick, the whiteness of stone and the blackness of slate tiles produced shades of color so pleasing that they were used on all palaces of the day, and this variety only seemed to resemble a house of cards once bourgeois homes were built in this manner" (H. Sauval, *Histoire et Recherches des antiquités de Paris*, vol. II, p. 201).

PLEASURE
FRIVOLITY AND LOVE

The worship—not to say adoration—of feminine beauty had been celebrated by the medieval troubadours, who disseminated it throughout the West.

The same worship and adoration reappeared during the Renaissance, but around images, painted representations, and French art shone at Fontainebleau.

Boccaccio was abundantly illustrated in France in the fifteenth century. The slightly bawdy story of Cimo and Ephigenia (5, 1) in which a lout stumbled upon three nude girls asleep, was exploited by miniaturists.

The *Lady in her Bath* by François Clouet and the numerous variations on this theme (Dijon, Worcester, circa 1550) enjoyed great success thanks to engravings.

The Venetian model of *Venus* was transposed into a cold beauty, the bust of a reclining nude, an iconic genre composition with luxurious details such as jewelry and ornate mirrors.

According to E. Bourciez, as quoted by John O'Connor, the *Thrésor des Livres d'Amadis* (1559–1685) had more impact on the uncultivated French upper class than any other 'courtly' book.

It would seem that nowhere else was there so precocious an attention to feminine poses, to the play of toilet and dress, as demonstrated by miniatures and sculpture.

In describing the pleasures enjoyed by the beautiful Oriana and Amadís, the sixteenth-century Spanish text is brief and precise; d'Herberay, the French adaptor (1540), introduced voluptuousness by elaborating, for instance, on what had so enchanted the hero—two small bowls of living alabaster, the whitest and most sweetly breathing [breasts] ever created by Nature.

An ardent inclination to glorify femininity. Successfully. The behavior of ladies and the inventions of fashion constantly intervening to add greater sparkle and grace to dress and to gestures.

One never knows whether painting created the feminine ideal or whether the ideal woman inspired painters. Both, probably. Yet it is rarely known exactly who created the new image, the new jewel. Who made it famous is better known. The flux of fashion stimulated excitement and neglect. A world of frivolity.

There is nothing more schematic, more tiresome, more banal, or more true than this assessment.

Bold flirtation had always been the rule, prior to the wave of preciosity in the seventeenth century and the puritanical wave in the nineteenth.

The Heptameron illustrates how seriously the game of love was taken.

Why should the *Cuer d'amour espris* be one of the most exquisite painted books in the French repertoire?

The most famous compositions of the sixteenth century were the series of women in the bath.

Laughter has never been very innocent. It rings with an undertone of mockery, and this mockery is deliberately aggressive or insolent, aimed at the authorities, whether religious, social, or otherwise. But ultimately, laughter is a primordial reaction, the validity of which is confirmed by the irreverent "drolleries" of miniature and sculpture.

The brutality, violence, and coarseness that alone explain the storytellers' vulgar tales and the horrors of religious wars are probably too easily overlooked. This aspect of French society was overshadowed by the effort of royal circles to set a new tone, new manners, new rites. But it is important to remember the brutish, lively, somewhat filthy tendencies of the lower classes in order to understand all sorts of events that occurred.

The period was anything but prudish. There is no lack of strong evidence of this, from the scatological jokes on the misericords of choir stalls to the extravagant, comic caricatures that accompanied the Wars of Religion. It would be a grand illusion to believe that "courtly," refined manners triumphed thanks to the brilliant if artificial example of the court. In fact, the efforts of all those aristocratic educators who produced numerous books and manuals can only be understood in the context of barely-controlled drives and a solid tradition, so to speak, of vulgarity.

Seventeenth century. The absurd, the burlesque and, under rather transparent veils, the indecent were the preserve of the world of ballet and disguises.

Parisian "chic" for fashionable items.

From Francis I's household accounts, it appears that payments to goldsmiths, jewelers, tapestry-weavers, couturiers, and cabinetmakers did more than politics to engender the preeminence of Paris.

The bishop of Saluzzo wrote to Cosimo I de' Medici that business had no place in the courtly life of France.

"They think only of hunting, women, banquets, and voyages," (see Knecht, after Terrasse, vol. 3, p. 23).

In Bayonne, on 25 June 1565, a tournament featured eight British and eight Irish gentlemen who had come specially for the event. They entered the lists wearing medallions with Greek and Latin names, to conduct a tournament on the theme of Love and Virtue.

THE ART OF DYING

The ceremony of paying homage to an effigy of the deceased, entirely English in origin, played a major role in royal funerals for nearly two centuries. The date of the first French usage can be pinpointed to 1422, when Charles VI died. The duke of Bedford, who was regent in France in the name of the king of England, ordered that the funeral accord with what had been observed at the death of the conquering English king Henry V (see E. Kantorowicz, *The King's Two Bodies, a Study in Medieval Political Theology,* Princeton, 1957).

A correct approach to the monarchic role of art in those days can hardly be made without a preliminary analysis of the place and modalities of the mental conception of royalty. Kantorowicz's study on "the King's two bodies" rightly drew attention to the imperishable figure repeatedly incarnated through successive mortal forms. This is the key to funeral rites that assumed remarkable importance in the sixteenth century, and which is obviously stylistically related to the monumental tombs.

But given this stunning context, monarchic iconography has been mistakenly construed entirely in "sacral" terms, overlooking the *imaginative conception* of the royal personage with his specific profile, tastes, and behavior, not to mention his own flexibility, fancifulness, and magnificence. An innovative study has demonstrated how this functioned in the case of Francis I.

Once it is realized that funeral rites with effigies ceased precisely in the seventeenth century—as did, moreover, the sculpting of royal tombs—it becomes clear that the symbolic apparatus and emblematics had changed.

The proof is that the ceremonial rites devised by La Feuillade at Place des Victoires in 1686 were judged to be ridiculous.

The scholarly study by Kantorowicz underscored the principle of "sacralization" of the monarchic function via the strange "doubling" of the body at royal funerals, which prefigured the doctrine of absolutism. But not enough stress has been placed on the fact that this dissociation of mortal body from the effigy that represented its "immortal" version ended in the seventeenth century.

It is no coincidence that the finest creations of French sculpture are tombs.

Why should some of the most moving masterpieces of French art belong, precisely, to funerary art?

As in all other Western countries, small illustrated books on the "art of dying" disseminated images of the final moments to households both rich and modest. This production was particularly abundant at the end of the fifteenth century and the end of the seventeenth century (Henri Brémond devoted a famous literary study to the subject). Much attention has recently been paid to testaments, rites, and customs related to "passing away" in previous centuries, thereby measuring—in Lucien Febvre's words—"the abyss that separates the customs and feelings of people then from those of people today." This raises the question of the role, presence, and transfiguration of death in French art. It can be confidently asserted that grand and noble aspects of French art emerged from this subject, precisely one of those in which—once the motif was defined—variations and developments followed one another until a certain "funerary style" was established. Naturally, there are more or less comparable tombs throughout Christendom. But this is one of the spheres in which French "devicers" and sculptors displayed the greatest number of successful initiatives.

FASHION AND TRADES

Fanciful feminine headdresses based on superstructures called hennins (featuring "marvelously long, tall horns") made a bold appearance in the fourteenth century and lasted until the sixteenth century. Hennins were enthusiastically developed at the court of Isabeau of Bavaria, wife of King Charles VI, which was the capital of extravagance in so many respects—couturiers became artists there. The startling proportions of hennins can be seen in miniatures and a few portraits. Images of noble ladies wearing them enhanced the prestige of the sitter—and such images served as models that spread according to the already acknowledged principle of accelerated circulation. But it is worth noting that spectacular developments in fashion, such as plunging necklines and slashes in gowns, continued to be popular despite condemnation by the clergy—*fashion* had its own momentum and became an active force that could withstand banning. In the sphere of dress, it played (or was thought to play) the same liberating role as whimsical marginal decoration in manuscripts. It was a puff of pleasure, associated with a taste for luxury, for gratuitous expenditure and spectacle.

Fashion was therefore an entity that was constantly present yet almost impossible to delineate in all its oscillations. It could suddenly catapult some exotic, bizarre practice into the closed and tightly-knit milieu of a noble court. This was probably the case with hennins. Fashion resisted the religious authorities' objections, responding to swift injunctions with dispersion and acceleration. An example taken from another century illustrates quite well a tendency that is ultimately rather typical of French life.

Unchronicled Activity

Chambord.

"I enjoyed my visit to this extraordinary structure as much as if I had been a legitimist; and indeed there is something interesting in any monument of a great system, any bold presentation of a tradition." (Henry James, *A Little Tour in France,* 1882).

Several great artists tried to promote the *status* of artists—Philibert de L'Orme, for example.

As in Italy, but with no appreciable result—the only criterion of worth was *noble favor*; there was no high cultural synthesis, which explains Poussin's retreat.

In the sixteenth century, there was nothing in France to resemble Machiavelli's political statement, or Guicciardini's moral one, or Vasari's artistic one. Throughout the seventeenth century, these models were rejected as temptations. It must be recognized that the French of the past were long ill-disposed toward anything other than genealogies of political or religious rulers, or collections of *exempla* illustrating moral or philosophical ideals, which continued to appear abundantly during the Revolution and Napoleon's Empire. This observation is confirmed by the national predilection for portraits, preferably displayed in a suite of rooms or gallery.

On the other hand, the French paid precocious attention to dwellings, towns, and châteaux:
Eustaches Deschamp in the fourteenth century.
Books designed to describe and "illustrate" Paris appeared at an early date:
Guillebert de Mets
Gilles Corrozet, *Antiquitez*, 1550
Germain Brice, 1752
(See M. Dumolin, "Notes sur les vieux guides de Paris," in *M.S.H. Paris et île-de-France,* 47, 1924).

Saint-Ouen in Rouen is "one of the finest works in the world thanks to the boldness of its architecture," wrote a local writer, Noël Taillepied, in 1587 in his *Recueil des antiquités et singularités de la ville de Rouen*, obviously eager to glorify the merits of his native region.

The legalistic and administrative mentality of the France of yore resulted in a great number of notarial acts of census type, such as Guillaume Revel's circa 1450 *Armorial* that provided the duke of Bourbon with a handwritten list of fiefs and 100 of 400 projected drawings of castles and villages (Bibliothèque Nationale). Similar, but on a more spectacular level, were the volumes by Androuet du Cerceau (see Gabriel Fournier, *Châteaux, Villages et Villes d'Auvergne au XVᵉ siècle*, Bibl. S.F.A., No. 4, Paris, 1973).

French society kept up with the Italian school of modernity through numerous translations, but the veritable innovation in sixteenth-century publishing was Androuet du Cerceau's precious 1572 anthology, designed to glorify French originality and illustrate the fecundity of the Valois monarchy.

Historical Grid: Artisans

Not only is it impossible to overlook the role played by carpenters and cabinetmakers—thanks to Jacques Androuet du Cerceau—but it is even possible to find a dial case by Boulle or a clock by Marot more charming and inventive than many contemporary paintings.
Around 1500, there appeared a series of color engravings showing street hawkers identified by their respective cries

("fine turnips!". . . "Who wants good milk?"). The practice had long existed, dating back at least to Étienne Boileau's mid-thirteenth-century *Livre des métiers* (Book of Tradesmen). These engravings heralded a long tradition of depicting the "cries," as street merchants themselves were known, in which each era updated, in its own fashion, the minor street trades (sellers of almanacs, of rabbit skins, tooth-pullers). A printer on rue Saint-Jacques even produced a large medallion showing a gathering of all these everyday characters.

A finer series of forty figures was produced by Pierre Brebiette around 1640, while Abraham Bosse and J. Leblond published twelve prints around 1650.

François Guérard continued the tradition with a set that spurred numerous variants in the eighteenth century (including naïve, colored wood engravings produced in Lille and Orléans) until Jean-Charles Pellerin in Epinal cornered the market by perfecting his system of inexpensive color reproductions.

Tapestry is another long-documented domestic furnishing that entailed a regular consumption of manufactured items. Death inventories as well as chroniclers of the day abundantly confirm that sets of "hangings" were pieces of furniture properly speaking, designed to keep rooms warm, decorate walls, or serve as dividers. From the fourteenth to the eighteenth centuries, they represented a major part of domestic wealth. It would nevertheless be a mistake to suggest that tapestry was a French specialty, since Flanders—that land of wool and large textile workshops—became a Europe-wide supplier stating in the thirteenth century. French clients remained heavily dependent on Flanders despite numerous efforts to create an autonomous "wool industry" (in the days of Henry IV, for example) until Colbert finally set up powerful factories at the Gobelins and in Beauvais.

NATIVE LAND: THE FRENCH UNCONSCIOUS

It was at this moment (the sixteenth century) that French art took on certain permanent wrinkles. According to E. Ward *French Renaissance Architecture,*, France was so completely committed to a lasting architectural style that certain buildings like the so-called du Cerceau house in Orléans could, with slight modifications, have been built at almost any point between 1540 and 1870. And every reign from Henri III to Napoleon III produced works that, except for a few details, could have been built in the days of Henri II.

RUPTURES AND TURNING POINTS

Charles Sterling has pointed out that Fouquet's modernity represented a break with everything seen in French painting until that point, around 1430–1440. This sudden emergence of a grand style—fluent yet taut—was one of those elemental phenomena for which there is no simple explanation. One conclusion can be drawn: this marked development should be used to revise chronologies. Once that critical decision has been taken, all sorts of details seem to confirm it, establishing a line of rupture that might be called a new "modernity" which, even though it did not bring immediate results, lent a new tone to the recitative. The chronology of the ages benefits from this readjustment. In particular, it benefits by being able to abandon the naïve explanation of the French Renaissance as the simple discovery of Italy.

BIBLIOGRAPHY

I HISTORICAL SOURCES

ALBERTI, L.B. *L'Architecture et art de ben bastir, traduits du latin en François par deffunct Jean Martin.* Paris: J. Kerver, 1533. English edition: *The Books on Architecture.* Translated from the Latin into Italian by Cosimo Bartoli and into English by James Leoni. Edited by Joseph Rykwert. Paris: Alec Tiranti, 1955.

L'Art de bien vivre et de bien mourir. Paris: P. Le Rouge for A. Vérard, 1492. English edition: *The book Intytulyd The art of good lyvying & good deyng.* Translated by Samoht Notgynwel, i.e. Thomas Lewyngton. Paris: Anthoine Verad, XXX May, (1503).

BEAUJOYEULX, B. de. *Ballet comique de la Royne faict aux noces de Monsieur le Duc de Joyeuse et de Mademoyselle de Vaudémont sa sœur.* Paris: Le Roy, Ballard, Patisson, 1582.

BLONDEL, F. *Cours d'architecture.* Paris, 1675–1683. New ed. 1771–1777.

BRICE, G. *Description nouvelle de ce qu'il y a de plus remarquable dans la ville de Paris.* 2 vols. Paris, 1684. New ed. 4 vols. Paris, 1752. English edition: *A New Description of Paris. Containing a particular account of all the churches, palaces [...] with all other remarkable matters [...].* Translated from the French by James Wright. 1687.

BULLANT, J. *Règle générale de l'architecture.* Paris: Marnef, 1568.

CHASTILLON, C. *Topographie françoyse.* Paris: Boisseau, 1641.

COLONNA, F. *Hypnérotomachie ou Discours du Songe de Poliphile.* Translated into French by J. Martin. Paris: J. Kerver, 1546. English edition: *Hypnerotomachia. The strife of love in a dream.* New York and London: Garland Publishing, 1976. (A facsimile of the anonymous edition printed for Simon Waterson, London, 1592.)

COMINES, P. de, (Pierre de Commynes). *Mémoires,* 1464–1496. 1st ed. 1524. New ed. J. Calmette, editor. Paris: Les Belles Lettres, 1964–1965. English edition: *The Memoirs of Philip de Comines.* Edited with life and notes by Andrew R. Scoble. 2 vols. London: Henry G. Bohn, 1855.

CORROZET, G. *Les Antiquitez, Histoires et Singularitez de Paris.* Paris: Corrozet, 1550.

COUSIN, J. *Traité de perspective.* Paris: Le Royer, 1560.

COUSIN, J. *Livre de pourtraicture.* Paris: Le Royer, 1571.

DAN, le Père. *Le Trésor des Merveilles de la maison royale de Fontainebleau.* Paris: chez S. Cramoisy, 1642.

DE BEATIS, A. *Itinerario di monsignor R^{mo} et Ill^{mo} il Car^{le} d'Aragona incominciato da la cita di Ferrara nel anno del Salvatore XDXVII del mese di Maggio e descrito per me donno Antonio de Beatis.* Naples: Bibl. naz., ms XF 28. English edition: *The travel journal of Antonio de Beatis, Germany, Switzerland and the Low Countries, France and Italy, 1517–1518.* Translated from the Italian by J.R. Hale and J.M.A. Lindon. Edited by J.R. Hale. London: The Haykluyt Society, 1979.

Dessins de la collection de Roger de Gaignières. Paris: Bibliothèque nationale, Cabinet des Estampes, OA 11–12.

DU BELLAY, J. *Deffense et Illustration de la Langue Françoyse.* Paris, 1549. New ed. H. Chamard, editor. Paris: Slatkine, 1969. English edition: *The Defence & Illustration of the French Language.* Translated by Gladys M. Turquet. London: J.M. Dent & Sons, 1939.

DU CERCEAU, J. ANDROUET. *Les Plus Excellents Bastiments de France.* 2 vols. Paris, 1576–1579. New ed. D. Thomson, editor. Paris: Sand et Conti, 1988.

DUCHESNE, A. *Les Antiquités et recherches des villes, châteaux et places les plus remarquables de toute la France.* Paris: J. Petit-Pas, 1608.

Entrées royales (selected accounts and illustrated anthologies).

La Magnificence de la superbe et triumphante entrée de la noble & antique cité de Lyon faicte au Très-chrétien Roy de France Henry deuxième de ce nom et à la Royne Catherine son Espôuse le XXIII de septembre MDXLVIII (M. Scève). Lyon: G. Roville, 1549.

C'est l'ordre qui a este tenu a la nouvelle et joyeuse entrée que [...] le Roy très chrestien Henry deuxième de ce nom a faicte en sa bonne ville et cité de Paris, capitale de son Royaume, le seizième jour de juin MDXLIX (Jean Martin). Paris: J. Roffet, 1549.

C'est la déduction du sumptueux ordre plaisantz spectacles et magnifiques theatres dressés [...] par les citoiens de Rouen a la sacrée Majeste du Tres chrestien Roi de France Henry second [...] et a la tres illustre dame [...] Khatarine de Medicis la Royne [...] es jours de mercredi jeudi premier et second jours d'octobre mil cinq cens cinquante. Rouen: chez Robert le Hay et Jehan dit du Gord, 1551.

Recueil des choses notables qui ont esté faites à Bayonne à l'entrevue du Roy Très chrestien Charles neuvième de ce nom [...] avec la Royne catholique sa sœur. Paris: Vascozan, 1566.

Bref et sommaire recueil de ce qui a esté faict [...] a la joyeuse & triumphante entrée de très puissants [...] Prince Charles IX [...] roy de France, en sa bonne ville & cité de Paris [...] le mardi sixiesme jour de Mars [...] (S. Bouquet). Paris: D. du Pré for O. Codoré, 1572.

FÉLIBIEN, A. *Entretiens sur les vies et sur les ouvrages des plus excellens peintres anciens et modernes.* Paris, 1666–1688. New ed. Paris: Trévoux, 1725. Facsimile of the 1725 edition. Farnborough: Gregg Press, 1967.

FÉLIBIEN, A. *Mémoires pour servir à l'histoire des Maisons royalles et Bastimens royaux de France.* Paris, 1681. New ed. A. de Montaiglon, editor. Paris: Société de l'histoire de l'art français, 1874.

FLORIO, F. *Florium Florentinus ad Jacobum Tarlatum,* I. Bibliothèque nationale, Lat. 12879 II. *Éloge de Tours et de la Touraine.* Edited by A. Salmon. *Mémoires de la Société archéologique de Touraine,* VII, 1868.

Journal de Jean Héroard. Paris: Bibliothèque nationale, Fr. 4020–4027. Edited by M. Foisil. 2 vols. Paris: Fayard, 1989.

JOUSSE, M. *Le Secret d'architecture.* La Flèche, 1642.

LEMAIRE DE BELGES, J. *Les Illustrations de Gaule et singularitez de Troie.* Paris: Marnef, 1510–1513. New ed. Louvain: J. Strecher, 1885.

L'ORME, P. de. *Le Premier Tome de l'architecture.* Paris: F. Morel, 1567. New ed. Paris: L. Laget, 1988. Edited by J.-M. Pérouse de Montclos.

L'ORME, P. de. *Nouvelles Inventions pour bien bastir à petits frais.* Paris: F. Morel, 1561.

L'ESTOILE, P. de. *Mémoires-journaux, recueil.* Paris: Bibliothèque nationale, rés. imprimés, Grand folio La^{25} 6. Edited by G. Brunet, A. Champollion and E. Halphen. Paris: A. Lemerre, 1875–1886.

MARIETTE, P. *Abecedario.* Edited by P. de Chennevières and A. de Montaiglon. 6 vols. Paris: Archives de l'Art français, 1851–1860.

La Mer des hystoire. 2 vols. Paris: P. Le Rouge, 1488.

MONTFAUCON, B. de. *Dessins, notes et gravures pour les monuments de la Monarchie françoise, XVII^e siècle.* 2 vols. Paris: Bibliothèque nationale, Fr. 15634 and 15635.

MONTFAUCON, B. de. *Monuments de la Monarchie française.* Paris: Gandoin, 1729–1733.

PELLEGRIN, F. *La Fleur de la science de portraicture.* Paris: J. Nyverd, 1530.

PILES, R. de. *Abrégé de la vie des peintres, avec des réflexions sur leurs ouvrages.* Paris: C. de Sercy, F. Muguet, N. Langlois, 1699.

REVEL, G. *Armorial d'Auvergne, Forez et Bourbonnais. c.1456.* Paris: Bibliothèque nationale, Fr. 22297.

RONSARD, P. de. *Les Quatre Premiers Livres de La Franciade.* Paris: G. Buon, 1572. English edition: *Songs & Sonnets* Translated into English verse with an introductory essay and

notes by Curtis Higger Page. Boston and New York: Hougton Mifflin Co., 1924.

SAINCTES, C. de. *Discours sur le saccagement des églises catholiques par les hérétiques calvinistes en l'an 1562*. Verdun: N. Bacquenois, 1562.

SAUVAL, H. *Histoire et recherches des antiquités de la ville de Paris*. 2 vols. Paris: C. Moette, 1724.

SERLIO, S. *Il Primo libro d'architettura [il secondo libro di perspetiva]; Le Premier Livre d'architecture, mis en langue Francoyse par Jehan Martin*. Paris, 1545. English edition: *The first booke of Architecture, made by S. Serly*. Translated from Italian into Dutch, and from Dutch into English. London: E. Stafford, 1611.

TAILLEPIED, F.N. *Recueil des Antiquitez et singularitez de la ville de Rouen*. Rouen: R. Du Petit Val, 1587.

THYARD, P. de. *Douze Fables de fleuves ou fontaines, avec la description pour la peinture et les épigrammes*. Paris: J. Richer, 1585.

TORY, G. *Champfleury*. Paris: chez l'auteur, 1529.

VIATOR (J. PELLERIN). *De artificiali perspectiva*. Toul, 1509.

VIGENERE, B. de. *Les Images ou tableaux de platte peinture des deux Philostrates sophistes grecs et les statues de Callistrate*. Paris: Vve Angelier, 1615.

VITRUVIUS (Vitruve). *Architecture ou Art de bien bastir... mis de latin en francoys par Jehan Martin*. Paris: J. Gazeau, 1547. English edition: *The Ten Books on Architecture*. Translated by Morris Hicky Morgan. Edited and translation completed by Albert A. Howard. Cambridge, Mass.: Harvard University Press, 1914.

II ARCHIVES AND INVENTORIES

ADHÉMAR, J., LINZELER, A. *Bibliothèque nationale, Département des Estampes, Inventaire du fonds français, Graveurs du XVIe siècle*. 2 vols. Paris: Bibliothèque nationale, 1932–1939.

ADHÉMAR, J., MOULIN, C. *Les Portraits dessinés du XVIe siècle au Cabinet des Estampes*, from the *Gazette des Beaux-Arts*, Sept. and Dec. 1973.

ADHÉMAR, J. et al. *Les Tombeaux de la collection Gaignières. Dessins d'archéologie du XVIIe siècle*, from the *Gazette des Beaux-Arts*, July–Sept. 1974, July–Aug. and Sept. 1976.

BOUCHOT, H. *Inventaire des dessins exécutés pour Roger de Gaignières et conservés au département des Estampes et des Manuscrits de la Bibliothèque nationale*. Paris: Plon, 1871.

COYECQUE, E. *Recueil des actes notariés relatifs à l'histoire de Paris et de ses environs au XVIIe siècle*, n.p., 1905.

FLEURY, M.-A. *Documents du Minutier central concernant les peintres, les sculpteurs et les graveurs au XVIIe siècle (1600–1650)*. Paris: S.E.V.P.E.N., 1969.

GRODECKI, C. *Documents du Minutier central des notaires de Paris. Histoire de l'art au XVIe siècle (1540–1600)*. 2 vols. Paris: Archives nationales, 1985–1986.

Inventaire général des richesses d'art de la France. Paris, Monuments civils, 4 vols. *Monuments religieux*, 3 vols. Paris: Plon, 1883–1913.

Inventaire général des monuments et richesses d'art de la France.

Inventaires topographiques (topographical inventories by canton or groups of cantons). Paris: Direction du Patrimoine, Ministère de la Culture–Imprimerie nationale Éditions, 17 vols. published to date, 1967.

Cahiers de l'Inventaire. Paris: Direction du Patrimoine, 26 fasc. published to date, 1983.

Principes d'analyse scientifique. Méthode et vocabulaire. Imprimerie nationale Éditions–Ministère de la Culture. *La Tapisserie*, 1971; *L'Architecture*, 1972 (new ed. 1989); *La Sculpture*, 1978; *Objets civils domestiques*, 2 vols. 1984; *Le Mobilier domestique*, 1987; *Le Vitrail*, 1993.

Recensement des vitraux anciens de la France. Paris: C.N.R.S.–Ministère de la Culture: *Paris, Région parisienne, Picardie, Nord-Pas-de-Calais*, 1978; *Centre et Pays de Loire*, 1981; *Bourgogne, Franche-Comté, Rhône-Alpes*, 1986; *Champagne-Ardenne*, 1992; *Alsace*, 1994.

Répertoire des inventaires (index of inventories: annotated bibliograrphy of publcations concerning the national heritage). Paris: Imprimerie nationale Éditions–Ministère de la Culture, 1970–1991.

LABORDE, L. de. *Les Comptes des Bâtiments du roi (1528–1571) suivis de documents inédits sur les châteaux royaux et les beaux-arts au xvie siècle*. 2 vols. Paris: J. Baur, 1877–1880.

LENOIR, A. *Statistique monumentale de Paris*. Paris, 1867.

III GENERAL STUDIES

L'Art de Fontainebleau. Proceedings of an international colloquium on the art of Fontainebleau, studies selected and presented by A. Chastel. Paris: C.N.R.S., 1975.

Les Arts au temps d'Henri IV, L'Avènement d'Henri IV, Quatrième centenaire, Colloque V: Fontainebleau. 1990. Association Henri IV, Pau. Éditions J. & D., 1992.

AVRIL, F. "Une 'devise' du Roi René: le toupin des cordiers." *Florilegium in Honorem Carl Nordenfalk*. Nationalmuseum, Stockholm, 1987, pp. 23–32.

BABELON, J.-P. *Henri IV*. Paris: Fayard, 1982.

BABELON, J.-P. *Paris au XVIe siècle, Nouvelle histoire de Paris*. Paris: Ville de Paris–Hachette, 1982.

BABELON, J.-P. "L'Imaginaire du roi." *Henri IV et la reconstruction du royaume*. Exhibition catalogue. Musée national du Château, Pau. Paris: Archives nationales, 1989.

BEAUNE, C. *Naissance de la nation France*. Paris: Gallimard, coll. Bibliothèque des histoires, 1985, chap.VIII, "Les lys de France".

BÉGUIN, S., BESSARD, B. "L'hôtel du Faur, dit Torpanne." *Revue de l'art*, n° 1–2 (1968), pp. 38–56.

BÉGUIN, S., GUILLAUME, J., ROY, A. *La Galerie d'Ulysse à Fontainebleau*. Paris: P.U.F., 1985.

BERCÉ, Y.-M. *Fêtes et révoltes. Des mentalités populaires du xvie au XVIIe siècle*. Paris: Hachette, 1976.

BLUNT, A. "L'influence française sur l'architecture et la sculpture décorative en Angleterre pendant la première moitié du XVIe siècle." *Revue de l'art*, n° 4 (1969), pp. 17–29.

BLUNT, A. *Art and Architecture in France, 1500 to 1700*. London: Penguin Books, 1953. 4th ed. 1981.

BONNAFFÉ, E. *Dictionnaire des amateurs français au xviie siècle*. Paris: A. Quantin, 1884.

BOUCHER, J. *La Cour de Henri II*. Rennes: Ouest–France, 1986.

BOUTTIER, J., DEWERPE, A., NORDMAN, D. *Un tour de France royal (1564–1566)*. Paris: Aubier–Montaigne, 1984.

CHASTEL, A. *La Crise de la Renaissance, 1520–1600*. Geneva: Skira, coll. Art, Idées, Histoire, 1969.

CHASTEL, A. *Le Cardinal Louis d'Aragon. Un voyageur princier de la Renaissance*. Paris: Fayard, coll. Les Inconnus de l'Histoire, 1986.

CHASTEL, A. *Introduction à l'histoire de l'art français*. Paris: Flammarion, coll. Champs, 1993.

CHATELAIN, J.-M. *Livres d'emblèmes et de devises. Une anthologie*. Paris: Klincksieck, 1993.

COLOMBIER, P. du. *Le Style Henri IV–Louis XIII*. Paris: Larousse, coll. Arts, Styles et Techniques, 1941.

COURAJOD, L. "La part de la France du nord dans l'œuvre de la Renaissance." *Gazette des Beaux-Arts*, Oct. 1889, pp. 460–464, Dec. 1889, pp. 615–620, Jan. 1890, pp. 74–82.

DIMIER, L. *Le Primatice, peintre, sculpteur et architecte des rois de France*. Paris: Leroux, 1900.

DIMIER, L. *Le Primatice*. Paris: Albin Michel, coll. Les Maîtres du Moyen Âge et de la Renaissance, 1929.

DURRIEU, P. "Les armoiries du bon Roi René." *Comptes rendus de l'Académie des inscriptions et belles-lettres*, vol. 1, 1908, pp. 102–114.

L'École de Fontainebleau. Exhibition catalogue. Grand Palais, Paris, Oct. 1972–Jan. 1973. Paris: R.M.N., 1972. Edited by S. Béguin and M. Laclotte.

FAVIER, J. *Paris au XVe siècle (1380–1500), Nouvelle histoire de Paris*. Paris: Ville de Paris–Hachette, 1974.

FEBVRE, L., CROUZET, F. *Origines internationales d'une civilisation: éléments d'une histoire de France*. Paris: Unesco, 1951.

Les Fêtes de la Renaissance. Edited by J. Jacquot. Paris: C.N.R.S., 1956.

FULCANELLI. *Les Demeures philosophales et le*

symbolisme hermétique dans ses rapports avec l'art sacré et l'ésotérisme du grand œuvre. Canselet, editor. Paris (1929). 3ʳᵈ ed. Paris: Lib. Jean Schmit, 1965.

GÉBELIN, F. "Un manifeste de l'école néo-classique en 1549: l'entrée de Henri II à Paris." Bulletin de la Société de l'histoire de Paris et de l'Île de France, 1924, pp. 35–45.

GÉBELIN, F. Le Style Renaissance en France. Paris: Larousse, coll. Arts, Styles et Techniques, 1942.

GLOTON, J.-J. Renaissance et baroque à Aix-en-Provence. Paris: École française de Rome–De Bocard, 1979.

GRAHAM, V., Mc ALLISTER JOHNSON, W. The Paris Entries of Charles IX and Elisabeth of Austria, 1571. Toronto: University of Toronto Press, 1974.

GRAHAM, V., Mc ALLISTER JOHNSON, W. The Royal Tour of France by Charles IX and Catherine de Medici. Toronto: University of Toronto Press, 1974.

GRODECKI, C. "Sébastien Zamet, amateur d'art." Les Arts au temps d'Henri IV, op. cit. supra, pp. 185–228.

GUENÉE, B., LEHOUX, F. Les Entrées royales françaises de 1328 à 1515. Paris: C.N.R.S., 1968.

GUENÉE, B. "Y a-t'il un État des XIVᵉ et XVᵉ siècles ?" (1956). Reprinted in Politique et histoire du Moyen Âge. Paris: Publications de la Sorbonne, 1981.

HOFFMANN, V.H. "DONEC TOTUM IMPLEAT ORBEM: symbolisme impérial au temps de Henri II." Bulletin de la Société de l'histoire de l'art français, 1978 (1980), pp. 29–42.

HUIZINGA, J. Herfsttij der Middeleeuwen. Haarlem, 1919. Translated from the Dutch by F. Hopman and published under the title, Waning of the Middle Ages. London: Penguin Books, 1990.

Il se rendit en Italie. Études d'art offertes à André Chastel. Rome: Ed. dell' Elefante–Paris: Flammarion, 1987.

JESTAZ, B. L'Art de la Renaissance. Paris: Citadelle, 1984.

KONIGSON, E. L'Espace théâtral médiéval. Paris: C.N.R.S., 1975.

KRYNEN, J. Idéal du Prince et pouvoir royal en France (1380–1440). Études sur la littérature politique du temps. Paris: A. et J. Picard, 1981.

LABORDE, L. de. La Renaissance des arts à la cour de France, étude sur le XVIᵉ siècle. Paris: 1850–1855. New ed. Geneva: Droz, 1970.

LAPEYRE, A., SCHEURER, R. Les Notaires et secrétaires du Roi sous les règnes de Louis XI, Charles VIII et Louis XII (1461–1515), introd. par R.H. Bautier. 2 vols. Paris: Bibliothèque nationale–Comité des travaux historiques et scientifiques, 1978.

LECOQ, A.-M. François Iᵉʳ imaginaire. Symbolique et politique à l'aube de la Renaissance française. Paris: Macula, 1987.

LECOY DE LA MARCHE, A. Le Roi René, sa vie, ses travaux artistiques et littéraires. 2 vols. Paris:

Firmin–Didot, 1875.

LIMOUSIN, C. "Le château de Saint-Amand-Montrond et les collections d'Henri II de Bourbon, prince de Condé (1588–1646)." Bulletin de la Société de l'histoire de l'art français, 1986 (1988), pp. 25–31.

MAURICHEAU-BEAUPRÉ, C. L'Art du XVIIᵉ siècle en France. 2 vols. Paris: Le Prat, 1946–1947.

MICHEL, A., editor. Histoire de l'art depuis les premiers temps chrétiens jusqu'à nos jours. 9 books in 18 vols. Book IV, 2, La Renaissance en France. Paris: Armand Colin, 1911.

MOLLAT DU JOURDIN, M. Jacques Cœur ou l'Esprit d'entreprise au XVᵉ siècle. Paris: Aubier, 1988.

PANOFSKY, E. Renaissance and Renascenses in Western Art. Stockholm: Almqvist & Wiksells, 1960.

POLIDORI, M.L. Monumenti e mecenati francesi in Roma. Viterbe: Quatrini, 1969.

ROBIN, F. La Cour d'Anjou-Provence, la vie artistique sous le règne du Roi René. Paris: A. et J. Picard, 1985.

ROY, M. Artistes et Monuments de la Renaissance française. 2 vols. Paris: A. et J. Picard, 1929–1934.

Les Salons littéraires au XVIIᵉ siècle. Exhibition catalogue. Bibliothèque nationale, Paris, 1968.

SCHELLER, R.W. "Imperial Themes in Art and Literature of the Early French Renaissance: the Period of Charles VIII." Simiolus, 12 (1981–1982), n° 1, pp. 5–69.

TEYSSEDRE, B. L'Histoire de l'art vue du Grand Siècle. Recherches sur l'Abrégé de la Vie des Peintres par Roger de Piles (1699) et ses sources. Paris: Julliard, coll. Histoire de l'Art, 1964.

THUILLIER, J. "Peinture et politique: une théorie de la galerie royale sous Henri IV." Études d'art offertes à Charles Sterling. Paris: P.U.F., 1975, pp. 175–205.

VAUGHAN, R., ARMSTRONG, C.A.J. England, France and Burgundy in the Fifteenth Century. London: Phaidon Press, 1983.

VITRY, P. "Les études sur la Renaissance en France de 1834 à 1934." Congrès archéologique, Paris, 1934, pp. 259–271.

YATES, F. French Academies of the Sixteenth Century. London: Studies of the Warburg Institute, 1947.

IV ARCHITECTURE, TOWN PLANNING, GARDENS

ADHÉMAR, J. "Sur le château de Charleval." Gazette des Beaux-Arts, 1961, II, pp. 241–243.

AULANIER, C. Histoire du Palais et du musée du Louvre. Paris: R.M.N. I, La Grande Galerie du bord de l'eau, 1948. IV, La Petite Galerie, 1955.

AULANIER, C. "Le palais du Louvre au XVIᵉ siècle. Documents inédits." Bulletin de la Société de l'Histoire de l'art français, 1951, pp. 85–100.

BABELON, J.-P. Demeures parisiennes sous Henri IV et Louis XIII. Paris: Le Temps, 1965.

New revised and enlarged edition. Paris: Hazan, 1991.

BABELON, J.-P. "Du 'Grand Ferrare' à Carnavalet, naissance de l'hôtel classique." Revue de l'art, n° 40–41 (1978), pp. 83–108.

BABELON, J.-P., editor. Le Château en France. Paris: Berger–Levrault, 1986. New ed. 1988.

BABELON, J.-P. "D'un fossé à l'autre. Vingt ans de recherches sur le Louvre." Revue de l'art, n° 78 (1987), pp. 5–25.

BABELON, J.-P. Châteaux en France au temps de la Renaissance. Paris: Flammarion–Picard, 1989.

BARBICHE, B. "Henri IV et la surintendance des Bâtiments." Bulletin monumental, CXLII (1984), pp. 19–39.

BLOMFIELD, R. History of French Architecture, 1494–1661. London: G. Bell, 1911. New ed. New York, 1973.

BLUNT, A. Philibert de l'Orme. London: Zwemmer, 1958.

BOUDON, F., CHASTEL, A., COUZY, H. Système de l'architecture urbaine. Le quartier des Halles à Paris. Paris: C.N.R.S., 1977.

BOUDON, F., BLÉCON, J. Philibert de l'Orme et le château royal de Saint-Léger-en-Yvelines. Paris: A. et J. Picard, coll. De Architectura, 1985.

BRESC-BAUTIER, G. "Fontaines et fontainiers sous Henri IV." Les Arts au temps d'Henri IV, op. cit. supra III, pp. 93–120.

BRUAND, Y. "Le château de Ferrals." Congrès archéologique de France, Pays de l'Aude, 1973, pp. 458–481.

Centre d'études supérieures de la Renaissance, Tours, Colloques d'histoire de l'architecture, edited by J. Guillaume: La Maison de ville à la Renaissance, 1983; L'Escalier dans l'architecture de la Renaissance, 1985; Les Traités d'architecture de la Renaissance, 1988; Les Chantiers de la Renaissance, 1991; L'Emploi des ordres dans l'architecture de la Renaissance, 1992; Architecture et vie sociale, L'utilisation de l'espace dans l'architecture civile aux XVᵉ et XVIᵉ siècles. Paris: A. et J. Picard, coll. De Architectura, 1993.

CHASTEL, A. "Les vestiges de l'hôtel Legendre et le véritable hôtel de la Trémoïlle." Bulletin monumental, CXXIV, 1966, pp. 17–29.

CHASTEL, A. "Un 'portrait' de Gaillon à Gaglianico." Art de France, III (1963), in collaboration with P. Rosci, pp. 103–113. Reprinted in Fables, Formes, Figures. Paris: Flammarion, 1978, I, pp. 504–505.

CHASTEL, A. "La demeure royale au XVIᵉ siècle et le nouveau Louvre." Studies in Renaissance and Baroque Art presented to A. Blunt. London: Phaidon, 1967, XVI. Reprinted in Fables, Formes, Figures, op. cit., I, pp. 441–453.

CHASTEL, A. "L'escalier de la Cour ovale à Fontainebleau." Essays in the History of Architecture presented to R. Wittkower. London: Phaidon, 1967. Reprinted in Fables, Formes, Figures, op. cit., I, pp. 455–468.

CHATELAIN, A. Châteaux forts. Images de pierre des guerres médiévales. Paris: Desclée de Brouwer, coll. R.E.M.P.A.R.T., 1991.

CHATELET-LANGE, L. "Philibert de l'Orme à Montceaux-en-Brie, le pavillon de la grotte." *Architectura* (Munich), 1973, 3, n° 2, pp. 153–170.

CHATELET-LANGE, L. "La 'forma ovale si come costumarono li antichi romani': salles et cours ovales en France au XVIᵉ siècle." *Architectura* (Munich), 1976, 6, n° 2, pp. 128–147.

CHATELET-LANGE, L. "Deux architectures théâtrales: le château de Grosbois et la cour des offices à Fontainebleau." *Bulletin monumental*, CXL (1982), pp. 15–39.

CHATELET-LANGE, L. "Jacques Gentillâtre. Montbéliard, Geneva, Chalon-sur-Saône, Lyon." *Fondation Eugène Piot, Monuments et mémoires*, Académie des inscriptions et belles-lettres, LXX, 1989, pp. 71–138.

CHATENET, M. *Le Château de Madrid au bois de Boulogne.* Paris: A. et J. Picard, coll. De Architectura, 1987.

CHATENET, M. "Une demeure royale au milieu du XVIᵉ siècle, la distribution des espaces au château de Saint-Germain-en-Laye." *Revue de l'art*, n° 81 (1988), pp. 20–30.

CHIROL, E. *Un premier foyer de la Renaissance en France, le château de Gaillon.* Rouen: Lecerf–Paris: A. et J. Picard, 1952.

CIPRUT, E.-J. "L'architecte du palais abbatial de Saint-Germain-des-Prés." *Bulletin de la Société de l'histoire de l'art français*, 1956, pp. 218–221.

COLLARD, L. H., CIPRUT, E.-J. *Nouveaux Documents sur le Louvre.* Paris: A. et J. Picard, 1963.

COLOMBIER, P. du, ESPEZEL, P. d'. "Le Sixième Livre retrouvé de Serlio et l'architecture française de la Renaissance." *Gazette des Beaux-Arts*, 1934, pp. 42–59.

COOPE, R. "The château of Montceaux-en-Brie." *Journal of the Warburg and Courtauld Institutes*, XXII (1959), pp. 70–87.

COOPE, R. "The History and Architecture of the Château of Verneuil-sur-Oise." *Gazette des Beaux-Arts*, 1962, pp. 291–318.

COOPE, R. *Salomon de Brosse and the Development of the Classical Style in the French Architecture, 1565–1630.* London: P. Wilson–Zwemmer, 1972.

COOPE, R. "John Thorpe and the Hotel Zamet in Paris." *Burlington Magazine*, 124, Nov. 1982, pp. 671–681.

COOPE, R. "The 'Long Gallery'; its Origins, Development, Use and Decoration." *Architectural History*, 29 (1986), pp. 43–72.

Dictionnaire des châteaux de France, edited by Y. Christ. Paris: Berger–Levrault, 1983.

DUBUISSON, M. "L'hôtel de Vauluisant." *Congrès archéologique de France*, Troyes, 1955, pp. 168–172.

EVANS, J. *Monastic Architecture in France from the Renaissance to the Revolution.* Cambridge: Cambridge University Press, 1964.

FLEURY, M., ERLANDE-BRANDEBOURG, A., BABELON, J.-P. *Paris monumental.* Paris: Flammarion, 1974. New ed. A.M.G., 1981.

FONTANA, V. *Fra Giovanni Giocondo architetto, 1433–1515.* Vicence: Neri Pozza, 1988.

FROMMEL, C.L. "S. Luigi dei Francesi: Das Meisterwerk des Jean de Chennevières." *Il se rendit en Italie*, op. cit. supra III.

GAILLARD, G. "Documents sur la construction du château de Vizille." *Urbanisme et architecture, Études écrites et publiées en l'honneur de Pierre Lavedan*, n.d.n.p. [1954], pp. 127–133.

GANAY, E. de. *Les Jardins de France.* Paris: Larousse, coll. Arts, Styles et Techniques, 1949.

GÉBELIN, F. *Les Châteaux de la Renaissance.* Paris: Les Beaux-Arts, 1927.

GÉBELIN, F. *Les Châteaux de France.* Paris: P.U.F., 1962.

GOLSON, L.M. "Serlio, Primaticcio and the Architectural Grotto." *Gazette des Beaux-Arts*, Feb. 1971, 2, pp. 95–108.

GRODECKI, C. "La construction du château de Wideville et sa place dans l'architecture française du dernier quart du XVIᵉ siècle." *Bulletin monumental*, CXXXVI, n° 2 (1978), pp. 135–175.

GUILLAUME, J. "Le phare de Cordouan, 'Merveille du monde', et monument monarchique." *Revue de l'art*, n° 8 (1970), pp. 32–52.

GUILLAUME, J. "Léonard de Vinci et l'architecture française." *Revue de l'art*, n° 25 (1974), pp. 71–91.

GUILLAUME, J. "La galerie dans le château français: place et fonction." *Revue de l'art*, n° 102 (1993–1994), pp. 32–42.

GUILLAUME, J., GRODECKI, C. "Le jardin des pins à Fontainebleau." *Bulletin de la Société de l'histoire de l'art français*, 1978 (1980), pp. 43–51.

HAUTECŒUR, L. *Le Louvre et les Tuileries.* Paris: Morancé, 1924.

HAUTECŒUR, L. *Histoire du Louvre, le château, le musée.* Paris: L'Illustration, 1928. 2nd ed. SNEP, 1953.

HAUTECŒUR, L. *Histoire de l'architecture classique en France.* Vol. I: *La Renaissance*; Vol. II: *L'Architecture sous Henri IV et Louis XIII.* Paris: A. et J. Picard, 1943–1948. New ed. 1963–1967.

JESTAZ, B. "Le château de Fontaine-Henry. Observations et hypothèses." *Congrès archéologique de France*, Bessin et Pays d'Auge, 1978, pp. 313–371.

LAVEDAN, P. *L'Architecture française.* Paris: Larousse, coll. Arts, Styles et Techniques, 1944.

LOSSKY, B. "La fontaine de Diane à Fontainebleau." *Bulletin de la Société de l'histoire de l'art français*, 1968 (1970), pp. 9–18.

MARTENS, W.P. *La Rotonde des Valois à Saint-Denis.* Brussels: Le Mât de misaine, 1988.

MILLER, N. *French Renaissance Fountains.* New York–London: Garland, 1977.

MILLER, N. "Domain of illusion. The grotto in France." *Dumbarton Oaks Colloquium on the History of Landscape Architecture*, V, 1978.

MOSSER, M., TEYSSOT, G., editors. *History of Garden Design. The Western Tradition from the Renaissance to the Present Day.*

London: Thames and Hudson, 1991.

PÉROUSE DE MONTCLOS, J.-M. "Philibert de l'Orme en Italie." *Il se rendit en Italie*, op. cit. supra III, pp. 289–299.

PÉROUSE DE MONTCLOS, J.-M. *Histoire de l'architecture française: de la Renaissance à la Révolution.* Paris: Mengès/C.N.M.H.S., 1989.

ROUDIÉ, P. "Le château de Laforce en Périgord." *Bulletin de la Société de l'histoire de l'art français*, 1976 (1978), pp. 49–58.

SAINTE-FARE GARNOT, P.-N. *Le Château des Tuileries.* Paris: Herscher, 1988.

SAMOYAULT, J.-P. "Le château de Fontainebleau sous Charles IX." *Hommage à Hubert Landais.* Paris: R.M.N., 1987.

SARTRE, J. *Châteaux "brique et pierre" en France.* Paris: Nouvelles Éditions Latines, 1981.

THOMSON, D. *Renaissance Paris, Architecture and Growth, 1475–1600.* London: Zwemmer, 1984.

THOMSON, D. "Baptiste Androuet Du Cerceau, architecte de la cour de Henri III." *Bulletin monumental*, 148, 1 (1990), pp. 47–81.

VERNET-RUIZ, J., VANUXEM, J. "L'église de l'abbaye de Saint-Martin-aux-Bois." *Bulletin monumental*, CIII (1945), pp. 137–173.

VIOLLET-LE-DUC, E. *Dictionnaire raisonné de l'architecture française du XIᵉ au XVIᵉ siècle.* Paris: 1854–1868. New ed. 1966–1967. See also: *The Architectural Theory of Viollet-le-Duc. Readings and commentary*, edited by M.F. Hearn. Cambridge, Mass.: M.U.T., 1990.

WARD, H. W. *French Châteaux and Gardens in the Sixteenth Century.* London, 1909. 2nd ed. London, 1926. Reprinted New York, 1976.

V PAINTINGS, ILLUMINATIONS, DRAWINGS

ADHÉMAR, J. "French Sixteenth-Century Genre Painting." *Journal of the Warburg Institute*, VIII, 1945, pp. 191–195.

ADHÉMAR, J. "Les portraits dessinés du XVIᵉ siècle au Cabinet des estampes." *Gazette des Beaux-Arts*, Sept.–Dec. 1973.

AVRIL, F. "Pour l'enluminure provençale: Enguerrand Quarton, peintre de manuscrits." *Revue de l'art*, n° 35 (1977), pp. 9–40.

AVRIL, F. *Dix siècles d'enluminure italienne.* Exhibition catalogue. Bibliothèque nationale, Paris, 1984, n° 111.

AVRIL, F. "Le destinataire des Heures Vie à mon désir: Simon de Varie." *Revue de l'art*, n° 67 (1985), pp. 29–40.

AVRIL, F., REYNAUD, N. *Les Manuscrits à peintures en France, 1430–1515.* Exhibition catalogue. Paris: Bibliothèque nationale Flammarion, 1993.

BÉGUIN, S. "La suite d'Arthémise." *L'Œil*, n° 38 (fév. 1958), pp. 32–37.

BÉGUIN, S. *L'École de Fontainebleau.* Paris: Gonthier–Seghers, 1960.

BÉGUIN, S. "Nicolo dell'Abbate en France."

Art de France, II (1962), pp. 112–145.

BÉGUIN, S. *Il Cinquecento francese.* Milan: Fratelli Fabri, coll. I disegni dei Maestri, 1970. French edition: *Le Seizième siècle français.* Paris: Éditions Princesse, coll. Dessins et aquarelles des grands Maîtres, 1976.

BÉGUIN, S. "Nouvelles attributions à Toussaint Dubreuil." *Études d'art offertes à Charles Sterling.* Paris: P.U.F., 1975, pp. 167–174.

BÉGUIN, S. "Luca Penni, peintre. Nouvelles attributions." *Il se rendit en Italie*, op. cit. supra III, pp. 243–257.

BÉGUIN, S. "Un nouveau tableau de Toussaint Dubreuil pour le château neuf de Saint-Germain." *Scritti di storia dell'arte in onore di Rafaello Causa.* Naples: Electa Napoli, 1988, pp. 142–145.

BÉGUIN, S., BINENBAUM, O., CHASTEL, A. et al. "La Galerie François I^er au château de Fontainebleau." *Revue de l'art*, n° 16–17 (1972), and Flammarion. Paris: 1972.

BLUM, A., LAUER, P. *La Miniature française aux XV^e et XVI^e siècles.* Paris–Brussels: Van Oest, 1930.

Jacques Callot, 1592–1635. Exhibition catalogue. Musée historique Lorrain, Nancy, 1992. Catalogue by P. Behar, A. Brejon de Lavergnée et al.

Les Clouet et la cour des rois de France. Exhibition catalogue. Bibliothèque nationale, Paris, 1970. Catalogue by J. Adhémar.

CHATELET, A. *La Peinture française, XV^e et XVI^e siècles.* Geneva: Skira, 1962. New ed. 1992.

CHATELET, A., THUILLIER, J. *La Peinture française de Fouquet à Poussin.* Geneva: Skira, 1963.

CORDELLIER, D. "Martin Fréminet, 'aussi savant que judicieux'. À propos des modelli retrouvés pour la chapelle de la Trinité à Fontainebleau." *Revue de l'art*, n° 81 (1988), pp. 57–72.

CORDELLIER, D. "Dubreuil, peintre de la Franciade de Ronsard au Château Neuf de Saint-Germain-en-Laye." *Revue du Louvre*, 1985, n° 5–6, pp. 357–378.

La Collection de François I^er. Exhibition catalogue. Musée du Louvre, Paris, "Dossiers du département des peintures" n° 5. Catalogue by J. Cox-Rearick and S. Béguin.

Le Dessin en France au XVI^e siècle dans les collections de l'École nationale supérieure des beaux-arts. Exhibition catalogue. École nationale des beaux-arts, Paris, 1994. Catalogue by E. Brugerolles.

Dessins français du XVII^e siècle dans les collections publiques de France. Exhibition catalogue. Département des arts graphiques, Musée du Louvre, Paris, 1993. Catalogue by J.-C. Boyer, A. Brejon, Lavergnée et al.

DIMIER, L. *French Painting in the 16th Centuy.* London: Dyckworth, 1904.

DIMIER, L. *Les Primitifs français.* Paris: H. Laurens, 1911.

DIMIER, L. *Histoire de la peinture de portrait en France au XVI^e siècle.* 3 vols. Paris–Brussels: Van Oest, 1924–1927.

DIMIER, L. *La Peinture française des origines au retour de Vouet.* Paris–Brussels: Van Oest, 1925.

DIMIER, L. *La Peinture française au XVI^e siècle.* Marseille: Éditions françaises d'art, 1942.

EHRMANN, J. *Antoine Caron, peintre des fêtes et des massacres.* Paris: Flammarion, 1986.

FIOT, R. "Jean Fouquet à Notre-Dame-la-Riche de Tours." *Revue de l'art*, n° 10 (1970), pp. 29–46.

FOUCART, J., THUILLIER, J. *Le storie di Maria de Medici di Rubens al Luxembourg.* Milan: Rizzoli, 1962.

Jean Fouquet. Exhibition catalogue. Musée du Louvre, Paris, "Dossiers du département des peintures," no. 22. Catalogue by N. Reynaud. Paris: R.M.N., 1981.

FREDERICKSEN, B. "A Parisian Triptych Reconstructed." *J.P. Getty Museum Journal*, II, 1983.

GRODECKI, C. "Luca Penni et le milieu parisien. À propos de son inventaire après décès." *Il se rendit en Italie*, op. cit. supra III, pp. 259–277.

KUSENBERG, K. *Le Rosso.* Paris: Les Beaux-Arts, coll. Les Maîtres du Moyen Âge et de la Renaissance, 1931.

LACLOTTE, M. *L'École d'Avignon. La peinture en Provence aux XIV^e et XV^e siècles.* Paris: Gonthier–Seghers, 1960.

LACLOTTE, M. "Quelques tableaux bourguignons du XVI^e siècle." *Studies in Renaissance and Baroque Art Presented to Anthony Blunt on his 60th Birthday.* London–New York: Phaidon, 1967, XVII, pp. 83–87.

LACLOTTE, M. *Primitifs français.* Paris: Hachette, 1966.

LACLOTTE, M., editor. *Petit Larousse de la peinture.* 2 vols. Paris: Larousse, 1979.

LACLOTTE, M., THIÉBAUT, D. *L'École d'Avignon.* Paris: Flammarion, coll. Écoles et mouvements de la peinture, 1983.

The Last Flowering of French Painting in Manuscripts, 1420–1530, from American Collections. Exhibition catalogue. The Pierpont Morgan Library, New York, 1982.

LAVALLÉE, P. *Le Dessin français du XIII^e au XVI^e siècle.* Paris, 1930.

Livres d'Heures royaux. Exhibition catalogue. Musée national de la Renaissance, Écouen, 1993. Catalogue by T. Crépin-Leblond and M. Dickmann Orth. Paris: R.M.N., 1993.

Les Manuscrits à peintures en France du XIII^e au XVI^e siècle. Exhibition catalgoue. Bibliothèque nationale, Paris, 1955. Catalogue by J. Porcher.

MARROW, J.H. *The Hours of Simon de Varie.* London: Thames and Hudson, 1994.

MC ALLISTER JOHNSON, W., MONNIER, G. "Caron 'antiquaire'. À propos de quelques dessins du Louvre." *Revue de l'art*, n° 14 (1971), pp. 23–30.

MELLEN, P. *Jean Clouet, Complete Catalogue of the Drawings, Miniatures and Paintings.* London–New York: Phaidon, 1971.

MÉRINDOL, C. de. "La Pietà de Nouans et le triptyque de l'hôtel Jacques-Cœur à Bourges." *Revue de l'art*, n° 67 (1985), pp. 49–58.

Nicolo dell'Abbate. Exhibition catalogue. Palazzo dell'Archiginnasio, Bologna, Sept.–Oct. 1969. Catalogue by S. Béguin.

De Nicolo dell'Abbate à Nicolas Poussin: aux sources du classicisme. 1550–1650. Exhibition catalogue. Musée Bossuet, Meaux, 1988.

PARISET, F.-G. "Dessins de Jacques de Bellange." *Critica d'arte*, VIII, 31 (1950), pp. 341–355.

PÄTCHT, O. "Jean Fouquet. A Study of his Style." *Journal of the Warburg and Courtauld Institutes*, IV, 1940–1941, pp. 85–102.

PORCHER, J. *L'Enluminure française.* Paris: A.M.G., 1959.

PRESSOUYRE, L. "Les fresques de Laffitte-sur-Lot et l'italianisme en Agenais." *Fondation Eugène Piot, Monuments et mémoires*, Académie des inscriptions et belles-lettres, vol. LII (1962), pp. 95–116.

La Peinture en Provence au XVI^e siècle. Exhibition catalogue. Centre de la Vieille Charité, Marseille, Dec. 1987–Feb. 1988. Catalogue by M.-P. Vial et al. Marseille: Éditions Rivages et Musées de Marseille, 1987.

Les Primitifs français. Exhibition catalogue. Musée du Louvre and Bibliothèque nationale, Paris, 1904.

REYNAUD, N. "Un peintre français cartonnier de tapisserie au XV^e siècle, Henri de Vulcop." *Revue de l'art*, n° 22 (1973), pp. 6–21.

REYNAUD, N. "La galerie des Cerfs du palais ducal de Nancy ." *Revue de l'art*, n° 61 (1983), pp. 7–28.

REYNAUD, N. "Barthélemy d'Eyck avant 1450." *Revue de l'art*, n° 84 (1989), pp. 22–43.

RING, G. *A Century of French Painting, 1400–1500.* London: Phaidon Press, 1949.

ROY, A. "Un peintre flamand à Paris au début du XVII^e siècle: Théodore van Thulden." *Bulletin de la Société de l'histoire de l'art français*, 1977 (1979), pp. 67–76.

SCHAEFER, C. *Les Heures d'Étienne Chevalier de Jean Fouquet.* Preface by C. Sterling. Paris: Draeger, Vilo, 1971. English edition: New York: Braziller, 1971.

SOUCHAL, G. "Un grand peintre français de la fin du XV^e siècle, le Maître de la Chasse à la licorne." *Revue de l'art*, n° 22 (1973), pp. 22–49.

STERLING, C. "La peinture à Tours ou la première Renaissance française", in *L'Art du Val de Loire de Jean Fouquet à Jean Clouet, 1450–1540.* Exhibition catalogue. Musée des Beaux-Arts, Tours. Paris: Éditions des Musées nationaux, 1952.

STERLING, C., ADHÉMAR, H. *Musée national du Louvre, Peintures. École française, XIV^e, XV^e et XVI^e siècles.* Paris: Éditions des Musées nationaux, 1965.

STERLING, C. "Un portrait inconnu par Jean Clouet." *Studies in Renaissance and Baroque Art*, 1967, XVIII, pp. 89–90.

STERLING, C. "Jean Hey, le Maître de Moulins." *Revue de l'art*, n° 1–2 (1968), pp. 27–33.

STERLING, C. "Paoul Grymbault, éminent peintre français du XV^e siècle." *Revue de l'art*, n° 3 (1970), pp. 17–32.

STERLING, C. *Enguerrand Quarton, le peintre de la Pietà d'Avignon*. Paris: R.M.N., 1983.

STERLING, C. *La Peinture médiévale à Paris, 1300–1500*. Vol. 2. Paris: Bibliothèque des Arts, 1990.

TERNOIS, D. *L'Art de Jacques Callot*. Paris: F. de Nobele, 1962.

TERNOIS, D. *Jacques Callot. Catalogue complet de son œuvre dessiné*. Paris: F. de Nobele, 1962.

THIBOUT, M. "Le décor peint de l'oratoire de La Roque en Périgord." *Revue des Arts*, IX (1959), pp. 50–56.

THIÉBAUT, D. "Josse Lieferinxe et son influence en Provence: quelques propositions." *Mélanges en l'honneur de Michel Laclotte*. Milan: Electa, 1994.

THUILLIER, J. "La fortune de la Renaissance et le développement de la peinture française, 1580–1630. Examen d'un problème." *L'Automne de la Renaissance*. XXIIᵉ colloque international d'études humanistes, Tours, 1979. Paris: Vrin, 1984, pp. 357–370.

WILDENSTEIN, G. *Le Goût de la peinture dans la bourgeoisie entre 1550 et 1610 d'après les inventaires après décès conservés au Minutier central des notaires aux Archives nationales*, from the *Gazette des Beaux-Arts*, 1951.

WILHEM, J. "Pourbus, peintre de la municipalité parisienne." *Art de France*, III (1963), pp. 114–123.

WOOD, J. "Padre Resta's Flemish Drawings. Van Diepenbeeck, Van Thulden, Rubens and the School of Fontainebleau." *Master Drawings*, XXVIII (1990), pp. 3–53.

VI ENGRAVINGS, BOOKS

BLUM, A. *Les Origines de la gravure en France: les estampes sur bois et sur métal; les incunables xylographiques*. Paris–Brussels: Van Oest, 1927.

BLUM, A. *Les Origines du livre à gravures en France: les incunables typographiques*. Paris: Van Oest, 1928.

BLUM, A. *Les Primitifs de la gravure sur bois*. Paris: Gründ, 1956.

CASO, J. de. "Le Ballet comique de la Reine." *L'Œil*, n° 41 (mai 1958), pp. 27–31.

CHARTIER, R., editor. *Les Usages de l'imprimé: XVᵉ–XIXᵉ siècles*. Paris: Fayard, 1986: C. Jouhaud, chap. VII.

EHRMANN, J. "La vie de l'atelier du graveur Thomas de Leu, gendre d'Antoine Caron." *Archives de l'art français*, 26 (1984), pp. 43–46.

EISLER, C. *The Master of the Unicorn: The Life and Work of Jean Duvet*. New York: Albaris Books, 1979.

L'Estampe satirique et burlesque en France de 1500 à 1800. Exhibition catalogue. Bibliothèque nationale, Paris, 1950. Catalogue by J. Adhémar.

GARNIER, N. "Aux origines de l'imagerie populaire: la gravure de la rue Montorgueil à Paris au XVIᵉ siècle." *Revue du Louvre et des musées de France*, 1989, 4, pp. 225–232.

La Gravure en France au XVIᵉ siècle. Exhibition catalogue. Bibliothèque nationale, Paris, 1957. Catalogue by J. Adhémar.

GRIVEL, M. *Le Commerce de l'estampe à Paris au XVIIᵉ siècle*. Geneva: Droz, 1986.

GRIVEL, M. "Les graveurs à Paris sous Henri IV." *Les Arts au temps d'Henri IV*, op. cit. supra III, pp. 157–183.

Histoire de l'édition française. Le Livre conquérant. Du Moyen Âge au milieu du XVIIᵉ siècle. Edited by R. Chartier, J. Martin. Paris: Promodis, 1982. New ed. Fayard–Promodis, 1989.

LEVRON, J. *René Boyvin, graveur angevin du XVIᵉ siècle*. Angers: Les lettres et la vie française, 1941.

LIEURE, J. *La Gravure au XVIᵉ siècle. La gravure dans le livre et dans l'ornement*. Paris–Brussels: Van Oest, 1927.

LIEURE, J. *L'École française de gravure des origines à la fin du XVIᵉ siècle*. Paris: Renaissance du Livre, n.d. (1928).

Le Livre et l'image en France au XVIᵉ siècle. 6th International Colloquium of the Centre V.L. Saulnier, 1988. Paris: Presses de l'École normale supérieure, 1989.

MORTIMER, R., HOFER, P. *Harvard College Library, Departement of Printing and Graphic Arts. Catalogue of Books and Manuscripts, I, French 16th Century Books*. Cambridge, Mass.: Harvard University Press, 1964.

POPHAM, A. E. "Jean Duvet." *Print Collector's Quaterly*, VIII (1921), pp. 123–150.

PORCHER, J. *Les Songes drolatiques de Pantagruel et l'imagerie en France au XVIᵉ siècle*. Paris: Mazenod, 1959.

PRÉAUD, M. et al. *Dictionnaire des éditeurs d'estampes à Paris sous l'Ancien Régime*. Paris: Promodis, 1987.

ROBERT-DUMESNIL, A., DUPLESSIS, G. *Le Peintre-Graveur français, XVᵉ–XVIIᵉ siècles*. 11 vols. Paris: G. Warée, 1835–1871.

RONDOT, N. *Les Graveurs sur bois et les imprimeurs à Lyon au XVIᵉ siècle*. Lyon: Impr. Mougin-Rusand, 1896.

WANKLYN, G.A. "La vie et la carrière d'Étienne Delaune à la lumière de nouveaux documents." *Bulletin de la Société d'histoire de l'art français*, 1989 (1990), pp. 9–16.

ZERNER, H. *L'École de Fontainebleau. Gravures*. Paris: A.M.G., 1969.

VII SCULPTURE

BEAULIEU, M. *Musée du Louvre. Description raisonnée des sculptures*. Vol. II: *Renaissance française*. Paris: R.M.N., 1978.

BEAULIEU, M. "Ligier Richier (vers 1500–1567). Chronologie et attributions." *Bulletin de la Société de l'histoirede l'art français*, 1986 (1988), pp. 7–23.

CIPRUT, E.-J. "Chronologie nouvelle de la vie et des œuvres de Germain Pilon." *Gazette des Beaux-Arts*, 1960, II, pp. 333–344.

CIPRUT, E.-J. *Mathieu Jacquet, sculpteur d'Henri IV*. Paris: A. et J. Picard, 1967.

COLOMBIER, P. du. *Jean Goujon*. Paris: Albin Michel, coll. Les Maîtres du Moyen Âge et de la Renaissance, 1949.

COURAJOD, L. "Germain Pilon et les monuments de la chapelle de Biragque." *Mémoires de la Société nationale des antiquaires de France*, XLV, 1884, pp. 93–110.

DAVID, H. *De Sluter à Sambin. Essai critique sur la sculpture et le décor monumental en Bourgogne au XVᵉ et au XVIᵉ siècle*. 2 vols. Paris: Larousse, 1933.

FORSYTH, W. *The Entombment of Christ: French Sculpture of the 15th and 16th Century*. Cambridge, Mass.: Harvard University Press, 1970.

FRANCQUEVILLE, P. de. *Pierre de Francqueville, sculpteur des Médicis et du roi Henri IV, 1548–1615*. Paris: A. et J. Picard, 1968.

GRODECKI, C. "Les marchés de Germain Pilon pour la chapelle funéraire et les tombeaux des Biragues en l'église Sainte-Catherine du Val des Écoliers." *Revue de l'art*, n° 54 (1981), pp. 61–78.

KOECHLIN, R., MARQUET DE VASSELOT, J.-J. *La Sculpture à Troyes et dans la Champagne méridionale au XVIᵉ siècle*. Paris: Armand Colin, 1900.

LUC-BENOIST. *La Sculpture française*. Paris: Larousse, coll. Arts, Styles et Techniques, 1945.

MAROT, P. "Le tombeau de la duchesse de Lorraine Philippe de Gueldre à l'église des Clarisses de Pont-à-Mousson." *Bulletin de la Société de l'histoire de l'art français*, 1976 (1978), pp. 13–22.

MÜLLER, T. *Sculpture in the Netherlands, Germany, France and Spain, 1400 to 1500*. London: Penguin Books, The Pelican History of Art, 1966.

PANOFSKY, E. *Tomb Sculpture*. London, 1964; New York: Abrams, 1992.

Germain Pilon et les sculpteurs français de la Renaissance. Proceedings of a colloquium. Musée du Louvre, Paris, 1990. Edited by G. Bresc-Bautier. Paris: La Documentation Française, 1993.

PRADEL, P. *Michel Colombe, le dernier imagier gothique*. Paris: Plon, 1953.

PRESSOUYRE, L. "Trois Mises au tombeau ignorées en Aquitaine: Saint-Céré, Sauvagnas, Pujols." *Revue archéologique*, 1962, pp. 51–81.

RECHT, R. *Nicolas de Leyde et la sculpture à Strasbourg, 1460–1525*. Strasbourg: Presses Universitaires, 1988.

RÉGNIER, L. "Les stalles de l'abbaye de Saint-Victor. Contribution à l'histoire de la sculpture parisienne sous François Iᵉʳ." *Bulletin archéologique du Comité des travaux historiques et scientifiques*, IV, 1922, pp. 165–222.

Le Roi, la Sculpture et la Mort, gisants et tombeaux de la basilique de Saint-Denis. Exhibition catalogue. Archives de la Seine-Saint-Denis, Saint-Denis, 1975. Catalogue by A. Erlande-Brandebourg, J.-P. Babelon, F. Jenn and J.-M. Jenn.

THIRION, J. "Les statues de Germain Pilon pour le maître-autel de l'église de la Couture au Mans." *Fondation Eugène Piot, Monuments et mémoires, Académie des inscriptions et belles-lettres,* LX (1977), pp. 133–150.

VITRY, P., BRIERE, G. *Documents de sculpture française. Renaissance.* Paris: D.A. Longuet, 1911.

WARDROPPER, I. "Le style de la sculpture de Dominique Florentin de 1550 à 1570." *Germain Pilon et les sculpteurs français de la Renaissance,* op. cit. supra, pp. 319–337.

WEIL-GARRIS BRANDT, K. "Michelangelo's Pietà for the Cappella del Re di Francia." *Il se rendit en Italie,* op. cit. supra III, pp. 77–120.

VIII DECORATIVE ARTS. CERAMICS, FURNITURE, GOLD AND SILVERWARE, TEXTILES, STAINED-GLASS WINDOWS.

ALCOUFFE, D. "À propos de l'orfèvrerie commandée par Henri III pour l'Ordre du Saint-Esprit." *Hommage à Hubert Landais.* Paris: R.M.N., n.d. (1987), pp. 135–142.

ALCOUFFE, D. "La chapelle de l'Ordre du Saint-Esprit." *Revue du Louvre,* 1994, 1, pp. 29–42.

BABELON, J.-P. "Architecture et emblématique dans les médailles de Henri IV." *Revue de l'art,* n° 58–59 (1982–1983), pp. 21–52.

BABELON, J. "Le médaillon du chancelier René de Birague par Germain Pilon à la Bibliothèque nationale." *Gazette des Beaux-Arts,* Mar.–Apr. 1920, pp. 165–172.

BARATTE, S. "Remarques sur les émaux peints de Limoges sous Henri IV." *Les Arts au temps d'Henri IV,* op. cit. supra III, pp. 27–39.

BIMBENET-PRIVAT, M. "Nouvelles découvertes sur les orfèvres d'Henri IV." *Les Arts au temps d'Henri IV,* op. cit. supra III, pp. 63–91.

BIMBENET-PRIVAT, M. "Les orfèvres et le commerce de l'orfèvrerie à Paris sous les derniers Valois."

Bulletin de la Société d'histoire de Paris et de l'Île-de-France, 1983–1984, pp. 17–96.

BREJON DE LAVERGNÉE, A. "Masséot Abaquesne et les pavements du château d'Écouen." *Revue du Louvre,* 1977, n° 5–6, pp. 307–315.

Carreaux de pavement du Moyen Âge et de la Renaissance, Collections du musée Carnavalet. Paris: Paris-Musées, 1992.

CRÉPIN-LEBLOND, T. "Musée national de la Renaissance, château d'Écouen. Une plaque émaillée de Léonard Limosin." *Revue du Louvre,* 1991, 4, pp. 28–32.

DARCEL, A. *Musée du Louvre, Notices des émaux et de l'orfèvrerie.* Paris: E. de Mourgues, 1867.

DENIS, I. "L'histoire d'Artémise, commanditaire et ateliers. Quelques précisions apportées par l'étude des bordures." *Bulletin de la Société de l'histoire de l'art français,* 1991 (1992), pp. 21–36.

ERLANDE-BRANDEBOURG, A. *La Dame à la licorne.* Paris: M. Aveline, 1993.

Faïences françaises, XVIᵉ–XVIIIᵉ siècles. Exhibition catalogue. Galeries nationales du Grand-Palais, Paris, 1980. Paris: R.M.N., 1980.

FENAILLE, M. *État général des tapisseries de la manufacture des Gobelins. Les ateliers parisiens au XVIIᵉ siècle, 1601–1662.* Paris: Hachette, 1923.

GRUBER, A., editor. *L'Art décoratif en Europe, I: Renaissance et maniérisme.* Paris: Citadelles–Mazenod, 1993.

HEROLD, M. *Les Vitraux de Saint-Nicolas-de-Port.* Paris: C.N.R.S. (Corpus vitrearum, monographies), 1993.

LAFOND, J. *L'Art du vitrail en Normandie.* Rouen: Lecerf, 1930.

LAFOND, J. "La famille Pinaigrier et le vitrail parisien au XVIᵉ et au XVIIᵉ siècle." *Bulletin de la Société de l'histoire de l'art français,* 1957, pp. 45–60.

LAFOND, J. "L'église Saint-Vincent de Rouen et ses vitraux." *Congrès des Sociétés savantes,* Rouen–Caen, 1956. Paris: Comité des Travaux historiques et scientifiques, 1958.

LAPEYRE, A. *Louis XI mécène dans le domaine de l'orfèvrerie religieuse.* Paris: chez l'auteur, 1986.

LAVEDAN, P. *Léonard Limosin et les émailleurs français.* Paris: H. Laurens, coll. Les Grands Artistes, n.d. (1913).

LEPROUX, G.-M. "Une famille de peintres-verriers parisiens, les Pinaigrier." *Fondation Eugène*

Piot, Monuments et mémoires. Académie des inscriptions et belles-lettres, LXVII (1985), pp. 77–111.

MC ALLISTER JOHNSON, W. "Numismatic Propaganda in Renaissance France." *Art Quaterly,* 1968.

MARQUET DE VASSELOT, J.-J. *Émaux limousins de la fin du XVᵉ siècle et de la première partie du XVIᵉ siècle. Étude sur Nardon Péricaud et ses contemporains.* Paris: A. Picard, 1921.

MAZEROLLES, F. *Les Médailleurs français du XVᵉ au milieu du XVIIᵉ siècle.* 3 vols. Paris: Imprimerie nationale, 1902–1904.

OLIVIER, P. *Masséot Abaquesne et les origines de la faïence de Rouen.* Rouen: Lecerf, 1952.

PERROT, F. "Les vitraux de l'ancienne église Saint-Vincent remontés place du Vieux-Marché." *Les Amis des monuments rouennais,* July 1978–May 1979, pp. 44–98.

REYNAUD, N. "Un peintre français cartonnier de tapisserie au XVᵉ siècle, Henri de Vulcop." *Revue de l'art,* n° 22 (1973), pp. 6–21.

RORIMER, J. *The Unicorn Tapestries at the Cloisters.* New York: The Metropolitan Museum of Art, 1946. New ed. 1967.

The James A. de Rothschild Collection at Waddesdon Manor. Vol. IX. R.J. Charleston and M. Marcheix, "Limoges and other Painted Emanels." London: National Trust–Fribourg: Office du Livre, 1977.

SOUCHAL, G. "Un grand peintre français de la fin du XVᵉ siècle, le Maître de la Chasse à la licorne." *Revue de l'art,* n° 22 (1973), pp. 22–49.

THIRION, J. "Rosso et les arts décoratifs." *Revue de l'art,* n° 13 (1971), pp. 32–47.

Trésors des églises de France. Exhibition catalogue. Musées des Arts décoratifs, Paris, 1965. Catalogue by J. Taralon.

VAIVRE, J.-B. de. "Messire Jehan Le Viste, Seigneur d'Arcy et sa tenture au lion et à la licorne." *Bulletin monumental,* CXLII (1984).

VERDIER, P. *The Walters Art Gallery. Catalogue of the Painted Enamels of the Renaissance.* Baltimore: The Walters Art Gallery, 1967.

VERLET, P., SALET, F. *La Dame à la licorne.* Paris: Braun, 1960.

Vitraux parisiens de la Renaissance. Exhibition catalogue. Mairie du VIᵉ arr., Paris. Catalogue by G.M. Leproux et al. Ville de Paris, 1993.

INDEX

INDEX OF PROPER NAMES AND WORKS OF ART

PICTURE CREDITS

The figures refer to pages numbers.

Altitude/Yann Arthus-Bertrand, Paris: 65b. Artephot, Paris/Brumaire: 142t, 144t. Bayerische Staatsbibliothek, Munich: 68l, 183t. Bernard Jean, Aix-en-Provence: 31, 32t, 50bl, 66, 92tl, 110tl. Bibliothèque de l'École nationale supérieure des Beaux-Arts, Paris: 271t. Bibliothèque municipale, Grenoble: 21l, 21m. Bibliothèque nationale de France, Paris: 8, 9, 10, 11, 12, 21r, 30, 35, 37, 45, 69, 70, 77, 112, 113, 116tr, 116b, 167t, 169b, 173b, 176, 177, 179, 180t, 216t, 220b, 240, 245, 247, 248l, 251, 256, 259, 260b, 261, 264b, 290, 292b, 293, 301t, 302tl, 302bl. Bildarchiv Preussischer Kulturbesitz, Berlin/Jörg P. Anders: 26r, 80b, 88–89. British Library, London: 114t, 116tl. British Museum, London: 63b, 144bl, 150t, 180b, 181, 183b, 260t, 263, 301b. C.N.M.H.S., Paris © Spadem 1994/B. Acloque: 142b, 294; /J. Feuillie: 166; /Lonchampt-Delehaye: 20, 56, 72, 122b, 133, 136b; /Caroline Rose: 63t, 148t, 228t, 274. Courtauld Institute, London: 170. Dagli Orti, Paris: 6, 16, 17, 18, 19, 26l, 38, 39, 40, 41, 46, 49l, 51, 58, 59, 60, 61, 62, 64, 68d, 83, 85, 86, 87, 90, 93, 94, 95, 97, 99t, 100, 101, 103, 106, 107, 108, 114b, 115, 119, 122t, 123, 124tl, 124b, 125, 126, 130, 131, 138, 139, 140b, 141, 143, 144br, 145, 146, 147, 150b, 151, 152, 153, 154–155, 156, 157, 158, 159, 160, 161, 165, 169r, 182, 190, 191, 192, 193, 195, 197, 198, 199, 201, 204t, 205, 206, 207, 209, 210, 211, 212, 217, 218, 219, 220t, 228b, 229, 230, 231, 233, 234, 235, 246, 250, 252, 258, 262, 271bl, 272t, 276, 277, 278, 279t, 280r, 281, 283, 289, 303, 304, 305. Dieuzaide Jean, Toulouse: 52r, 54, 55, 184br. Explorer, Vanves/M. Cambazard: 22, 29; /J. Dupont: 34, 65tl; /H. Fouque: 297b; /J. M. Labat: 24, 52b; /J. P. Lescourret: 300; /A. Kumurdjian: 297t; /R. Lanaud: 296; /D. Reperant: 53, 124tr; /P. Roy: 120t; /G. Thouvenin: 65tr, 273tl; /H. Veiller: 273tr; /A. Wolf: 204b. Flammarion, Paris: 32b, 33, 110bl, 172, 178, 188t, 196, 236b, 265, 266, 267, 268, 269, 275, 299. Giraudon, Vanves: 118r, 121, 236t, 238, 239, 288, 291. Gris Banal, Montpellier: 189b. Herzog August Bibliothek, Wolfenbüttel: 47. Hirmer Fotoarchiv, Munich: 48, 194, 200, 270. Inventaire général, Aix-en-Provence © Spadem 1994: 67, 167b, 189t. Inventaire général, Amiens © Spadem 1994/J. Philippot: 75, 102, 134r. Inventaire général, Caen © Spadem 1994: 120b. Inventaire général, Châlons-sur-Marne © Spadem 1994/J. Philippot: 136l, 137. Inventaire général, Nancy © Spadem 1994: 50r. Inventaire général, Nantes © Spadem 1994: 127; /F. Lasa: 74br. Inventaire général, Rouen © Spadem 1994/C. Kollmann: 23, 28, 49r, 50tl, 106, 129, 184bl; /Y. Miossec: 57l, 135, 280l; /T. Leroy: 132r, 134l. Kunsthistorisches Museum, Vienna: 79, 164. Lauros-Giraudon, Vanves: 36, 78tl, 118l. Magnum/E. Lessing, Paris: 109, 128, 249. Metropolitan Museum of Art, New York: 73, 76, 84l, 105, 226. Hermitage, Saint-Petersburg: 292h. Musée départemental de l'Oise, Beauvais: 14–15. Musée départemental, Gap: 284. Musée des Arts décoratifs/L. Sully-Jaulmes, Paris: 71. Koninklijn Museum voor Schone Kunsten, Antwerp: 81. Musée des Beaux-Arts, Lille: 295b. Musée des Beaux-Arts, Orléans: 111t. Musées de la ville de Strasbourg: 295t. Musées royaux des Beaux-Arts, Brussels: 92tr. Museo Civico, Vicence: 264t. Museum of Art, Philadelphia: 98l. Museum of Art, Toledo: 223. National Gallery of Art, Washington: 232. National Gallery, London: 98r, 99b. Nationalmuseum, Stockholm: 140t. Österreichische Nationalbibliothek, Vienna: 27, 96. J. Paul Getty Museum, Malibu: 78bl. Photo Daspet, Villeneuve-lès-Avignon: 52l, 91, 117. Photothèque des musées de la Ville de Paris © Spadem 1994: 272b, 273b. Pierpont Morgan Library, New York: 82tr, 84r, 92br, 171t. Réunion des musées nationaux, Paris: front and back jacket illustrations; 25, 42, 43, 44, 74l, 78tr, 80t, 82tl, 82b, 89tr, 110m, 111b, 148b, 149, 162, 163, 168, 173t, 174, 175, 184t, 185, 186, 187, 188b, 202, 203, 208, 213, 214, 215, 216b, 221, 222, 224, 225, 227t, 237, 241, 242, 243, 244, 248d, 253, 254–255, 257, 279b, 285, 286, 287, 298. Scala, Antella (Florence): 171b. Service des objets d'Art religieux des églises de la Ville de Paris/J.-P. Moser: 57r, 132l, 227b, 282. Walters Art Gallery, Baltimore: 13.

The publisher would like to thank the following people who assisted in the preparation of this volume: Christine Claudon, Marine Decaëns, Marie-Madeleine Gauthier, Françoise Perrot, Marion Tezenas du Montcel.